Complete
Photography

An Hachette UK Company
www.hachette.co.uk

First published in the United Kingdom in 2017 by
ILEX, a division of Octopus Publishing Group Ltd

Octopus Publishing Group
Carmelite House
50 Victoria Embankment
London, EC4Y 0DZ
www.octopusbooks.co.uk

Publisher, Photo: Adam Juniper
Publisher: Roly Allen
Managing Specialist Editor: Frank Gallaugher
Art Director: Julie Weir
Designers: Eoghan O'brien
Senior Production Manager: Peter Hunt

ISBN 978-1-78157-346-4

A CIP catalogue record for this book is available
from the British Library

Printed and bound in China

10 9 8 7 6 5 4 3 2 1

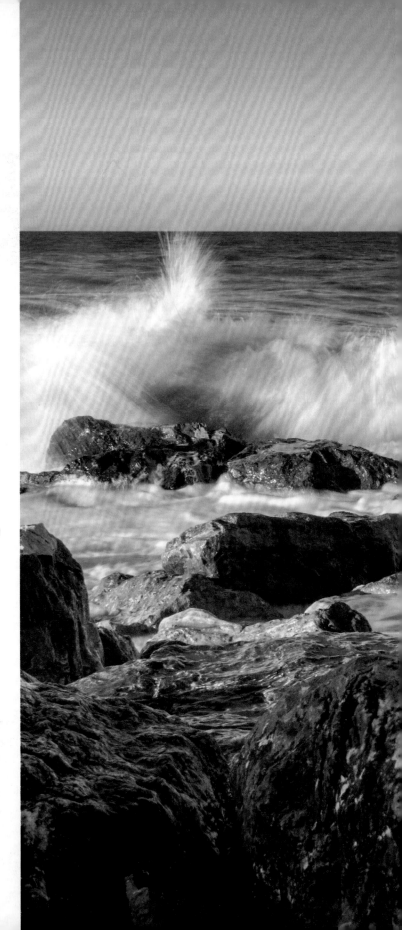

Complete
Photography

The all-new guide to getting the best possible photos from any camera

INTERNATIONAL
BESTSELLING
AUTHOR

CHRIS
GATCHUM

ilex

Contents

Introduction

Traditionally, a book like this would start by telling you that there's never been a better time to be a photographer. Unfortunately, that's simply not true: it's always been a great time to be a photographer!

You just have to look at the timeline presented here (which is by no means a comprehensive blow-by-blow account of what's happened), and you can see that any era from the last 180-odd years of photography's development has something to get excited about. Whether it's the evolution of the wet-plate process; Kodak delivering its first Brownie camera to the masses; the invention of autofocus; or Sony's latest multi-megapixel digital beast; or any one of a number of events and developments in between, photography has always been in an intoxicating state of flux.

However, despite incredible technologies, revolutionary inventions, and – in recent history – an entirely new way of recording images, photography has had one constant; one immutable fact underpinning it; and that is the very essence of what photography is: 'drawing with light'.

It doesn't matter if you're Fox Talbot or Daguerre, or any number of contemporary practitioners, at a base level, photography is simply about getting the right amount of light to your film, sensor, or whatever future tech we use, just as every photographer past or present has done.

What follows in this book are the core skills that I believe will help you take better photographs, no matter what camera you are using. The key thing to remember is that while the technology may have changed, the underlying skills have not: master those and you can master photography.

16TH–17TH CENTURY

The camera obscura becomes a popular artist's aid and, on a larger scale, a form of entertainment and 'amusement'.

CA. 400 B.C.

The Chinese philosopher and founder of Mohism, Mozi, records the image-forming effect of light passing through a pinhole into a darkened room; the basic principle behind a camera obscura, which in turn would form the basis of a camera.

1011–1021 AD

Ibn al-Haytham (or Alhazen), an Arab scientist and philosopher, writes his seven volume Book of Optics, within which are experiments involving images formed by pinholes, noting how smaller holes produced sharper images.

1837

Back in France (and following a four-year partnership with Niépce), Louis-Jacques-Mandé Daguerre reveals his Daguerrotype process to the French Academy of Sciences. The process produces a positive image in-camera on a silvered copper plate (making it the earliest form of 'instant' photography).

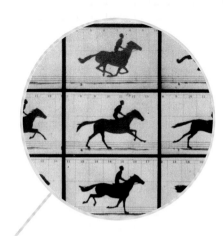

1816

Frenchman, Nicéphore Niépce, combines the camera obscura with paper sensitised with silver chloride to create the first photographic image: a view from his workroom. The image, however, quickly fades.

1841

Talbot patents the Calotype process he has been developing since 1834. Unlike Daguerre's process, Talbot's process (also known at the Talbotype) produces a negative image, enabling multiple prints to be produced from a single photograph.

1877

Eadweard Muybridge uses photography to prove that all four hooves of a horse leave the ground simultaneously when it gallops, thus settling a longstanding bet.

1834

In England, William Henry Fox Talbot uses paper soaked in silver chloride and a salt solution fix to create a permanent image. However, he does not publish or share his experiment.

1871

Although the Collodion process was popular and successful, attempts were being made to develop a 'dry' process that meant plates could be prepared in advance and processed some time after exposure. The breakthrough comes from an English doctor, Richard Leach Maddox, who proposes coating glass plates with gelatin and silver bromide.

1826

After years experimenting with a variety of light-sensitive materials, Niépce uses light-sensitive bitumen of Judea coated on a pewter plate to create what is widely regarded as the first permanent photographic image – View from the Window at Le Gras (the view from his workroom...)

1851

The English sculptor, Frederick Scott Archer, invents the 'wet plate' Collodion process, in which glass plates are coated with a light-sensitive solution prior to exposure, and processed almost immediately after. As exposure times are typically under 5 seconds and produce a negative image this new process is widely adopted.

1880

George Eastman established the Eastman Dry Plate Company in Rochester, New York, to manufacture dry plates.

1888

Following Eastman's invention of a flexible, paper-based photographic film in 1884, the company starts marketing the first Kodak camera. Using a 20ft roll of paper-based film, the camera is capable of making 100 circular negatives, measuring 6.35cm in diameter. Once the film is finished, the camera is returned to Kodak for developing and printing, and returned reloaded.

1907

In France, the Lumière Brothers start to market their Autochrome Lumière plates, the first commercial process for colour photography.

1931

Harold Edgerton invents a stroboscopic light, and in doing so makes electronic flash photography a reality. Edgerton's early experimental work would expand to include iconic photographs of droplet 'crowns' and bullets in flight.

1900

Renamed in 1892, the Eastman Kodak Company introduces the $1 Brownie; photography is brought to the masses and the 'amateur photographer' is born.

1917

Nippon Kogaku is established in Tokyo; in 1988 the optical manufacturing company would become better known as the Nikon Corporation.

1932

George Eastman writes a note saying: 'To my friends: my work is done. Why wait?'. He then shoots himself through the heart.

1901

Kodak launches its cellulose-based 120 roll film; the same format used today by medium-format cameras.

1914

While working for the German microscope manufacturer, Leitz, Oskar Barnack develops a camera that uses 35mm movie film. As a result, smaller, lighter cameras can be designed, although the First World War halts progress.

1924

A decade after it was conceived, Leitz markets a version of Barnack's small-format camera, which it calls the 'Leica' (a contraction of LEItz CAmera). 35mm photography is born

1898

In New York, Reverend Hannibal Goodwin is granted a patent for a photographic film on a transparent cellulose base; he sets up the Goodwin Film and Camera Company in 1900, but dies before film production begins.

1934

- Fuji Photo Film is founded as a Japanese producer of photographic film; it would go on to dominate its home market, just as Kodak became the dominant supplier of film in the U.S.
- Kodak introduces 135 film, which is 35mm film in the now-familiar preloaded, single-use cassette. Prior to this, 35mm film had to be loaded manually into reusable cassettes, making it a more involved process.

1948

- Edwin Land launches the Land Camera. This was the first camera to be made by Land's Polaroid company, and it used 'instant' roll film that was both exposed and processed in-camera.
- Despite producing countless lenses for other camera manufacturers, the first Nikon-branded camera – the imaginatively named Nikon 1 – wasn't launched until mid-way through the 20th Century.
- The Swedish manufacturer, Hasselblad, offers its first medium format SLR, the Hasselblad 1600F. The iconic design would continue to underpin what would come to be known as Hasselblad's V-system until the 503CW camera is discontinued in 2013.

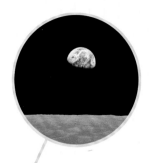

1968

Earth is photographed from the moon for the first time, using a modified Hasselblad 500EL camera with a Zeiss 60mm lens. According to Hasselblad, all 13 of its cameras remain on the moon, abandoned to free up weight for the astronauts' return journey – only the film magazines were brought back to Earth.

1936

- In Japan, Canon launches its first production camera, the Hansa Canon 35mm rangefinder with a 5cm Nikkor (Nikon!) lens.
- The German manufacturer, Ihagee, launches the Kine Exacta, the first 35mm SLR.

1954

Leica launches its iconic M3 rangefinder camera.

1963

Polaroid produces its first colour instant film.

1972

- Kodak introduces the 110 film format – a cartridge-based film producing a 17 x 13mm frame size (approximately the same size as a modern Micro Four Thirds sensor).
- Coinciding with the launch of its 110 film format, Kodak unveils the C-41 process for colour negative film. This replaces the previous C-22 process and remains the standard process used for colour print film today.

1935

Kodak introduces Kodachrome colour film; the first commercially viable subtractive colour film. The iconic film would continue to be available in a variety of guides until the last emulsion – Kodachrome 64 – was discontinued in 2009, some 74 years later.

1959

- The Nikon F is launched. The camera quickly becomes a favorite amongst photojournalists, thanks to its robust build quality; during Vietnam War, Don McCullin's Nikon F stops a bullet from an AK-47.
- Olympus launches its original half-frame Pen camera; a name that would be reborn in 2009 with the digital PEN E-P1.

1949

East German camera and lens manufacturer, Zeiss Ikon, reveals the Contax S, the first SLR to show an unreversed (corrected) image through its viewfinder.

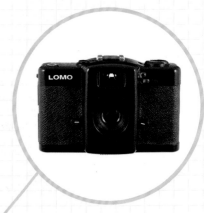

1985

- Minolta markets the Maxxum 7000 (known as the Minolta 7000 AF in Europe and Minolta α-7000 in Japan), the first autofocus 35mm SLR that doesn't rely on motorised lenses. Sony would later resurrect the 'α' (Alpha) name for its digital SLRs.
- The TIFF file format is born.

1975

At Kodak, an electrical engineer, Steve Sasson, builds the first digital still camera to use a CCD; the result shoots 0.01 megapixel, black-and-white images that are recorded onto a cassette tape.

1992

- The JPEG file format is born
- The Lomographic Society International (or 'Lomography' as it is more commonly known) is formed by a group of Viennese students inspired by the low-tech delights of the Russian-made LOMO LC-A camera. Lomography continues to produce a range of film cameras, based primarily on the 'lo-fi' aesthetic, and also manufactures its own line of 'creative' films.

1989

At Kodak, Steve Sasson and Robert Hills make a digital SLR that records images from its 1.2 MP sensor onto a memory card. However, Kodak's marketing department (rightly) fears a product like that will affect its core business – film sales – and refuses to put it into production.

1977

Konica releases the first commercial autofocus camera, the point-and-shoot Konica C35 AF.

1981

Sony demonstrates its first Mavica (from MAgnetic VIdeo CAmera). The 'still video' camera shoots images measuring 570 x 490 pixels, which are recorded to floppy disk.

1990

Adobe releases the first version of Photoshop.

1999

Nikon reveals its 2.74MP D1. This is the first DSLR to be built from the ground up, rather than being based on a modified 35mm film camera.

1976

Pentax launches its K1000 SLR. The super-simple, mechanical camera remains in production until 1997, making it one of the longest ever production cameras, with over 3 million camera bodies sold.

1987

Canon introduces its EOS system with electronic (EF) lens mount; in 2014 the company will claim to have produced its 100th-million EF-series lens.

1991

Kodak unveils its DCS-100, a DSLR based on a modified Nikon F3 camera. Containing a 1.3MP CCD sensor, the camera produces 1024 x 1280 pixel images, which are recorded to internal memory. The cost? A mere $30,000.

2000

- The first commercial camera phones are launched.
- Contax announces a 6MP full-frame DSLR – the first time a camera manufacturer has used a full-frame sensor. The camera eventually arrives in 2002 and is dogged by reviews citing poor image quality; within a year the camera is discontinued; by 2005 its parent company, Kyocera, pulls out of camera production entirely.

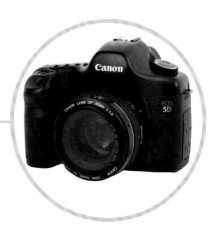

2005

Canon launches the EOS 5D, the first 'consumer priced' full-frame DSLR.

2002

- Canon introduces its EOS-1Ds. Although not the first full-frame DSLR, it is the first successful full-frame DSLR, and Canon's 11MP flagship gets photographers lusting after full frame sensors.
- Best known as a third-party lens-manufacturer, Sigma announces its first DSLR, the SD9. Unlike other DSLRs, it will use a Foveon X3 image sensor which records full colour for each pixel, rather than creating colour through interpolation. The technology is still used in the company's SD1 DSLR, but has not been adopted by other manufacturers.

2006

Three years after Konica and Minolta joined forces, Konica Minolta leaves the photographic industry for good, selling its SLR business to Sony. Shortly after, Sony launches its first DSLR, the α100.

2008

Nikon releases the D90, the first DSLR to shoot video as well as still images.

2001

Unable to adjust to an increasingly digital world, Polaroid files for bankruptcy.

2003

The digital marketplace enters a new era as Canon's 6MP Digital Rebel (EOS 300D in Europe and EOS Kiss Digital in Japan) is launched at under £1000, making digital SLR photography affordable for the masses.

2004

- Vancouver-based Ludicorp launches the photosharing website, flickr. Just over a year later Yahoo acquires both Ludicorp and flickr for somewhere in the region of £22–25 million. By 2015 the site is home to over 10-billion images.
- After more than 100 years, Kodak ceases production of film cameras. A month before the announcement is made, it files for bankruptcy protection in the U.S.
- The first mirrorless interchangeable-lens camera appears in the form of the Epson R-D1. The result of development by Epson and Cosina (which, since 1999, is also the manufacturer of Voigtländer 35mm rangefinder cameras), this digital rangefinder features a 6MP APS-C sized sensor and an M-mount bayonet fitting that allows Leica's legendary lenses to be used.
- Nikon launches its F6; the last of its pro-spec 35mm F-series SLRs.

2007

Apple launches its first generation iPhone; by 2015 700-million iPhones will have been sold.

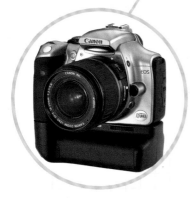

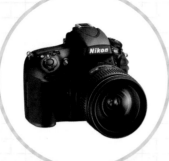

2010

- The Impossible Project buys a former Polaroid production plant and starts to (re) manufacture instant film under its own brand name.
- Photo-sharing site Instagram is launched.

2012

- Nikon announces its D800 full-frame DSLR. As well as a groundbreaking 36MP resolution, the D800E variant effectively cancels out the traditional anti-aliasing filter to maximise image resolution. Before long, other manufacturers are negating the effects of their AA filters, or removing them entirely.
- George Eastman's legacy ends, as Kodak files for bankruptcy – another victim of digital technology's impact on film, and slow reactions to the technology.

2015

Canon ups the pixel count with its EOS 5DS and EOS 5DSR models, both 50MP full-frame DSLRs.

2011

Lytro launches its first 'light field camera'. The headline technology behind the first generation Lytro Camera is the ability to adjust focus and depth of field after a shot has been taken.

2013

- Sony releases the A7R and A7R2, the first full-frame CSCs, with 24MP and 36MP resolutions respectively; in 2015 the resolution is upped to 42MP with the A7RII.
- The same year, Sony launches its QX range of 'lens cameras'. The QX lens provides a high-resolution lens and sensor, while your smartphone provides a viewing screen and camera control.

2016

- Medium format digital cameras go mirrorless with the Hasselblad X1D.
- Leica launches the 'back to basics' M-D (Typ 262) digital rangefinder camera without a rear screen.

Where next?

You only have to look at what's happened to photography in the 21st Century to see how rapidly the technology that underpins it is moving: in the year 2000, full-frame cameras were a mere suggestion; a digital SLR costing less than £1000 was a dream; and CSCs, sophisticated camera phones, and high-resolution digital video were simply unimaginable. Yet today all of these things – and more – are commonplace, while long-established, pioneering brands such as Kodak, Minolta, and Polaroid have become little more than footnotes in history.

So what will come next? Well, it's impossible to know for sure, but that's what's so exciting! In the immediate future, it's almost certain that mirrorless cameras will stride further into DSLR territory, and possible that we will see 'traditional' SLR designs become a thing of the past; you could argue it's already happening, with Sony turning its back on its SLRs, Hasselbad giving us mirrorless medium format, and other key manufacturers seemingly running low on inspiration as new DSLR releases reveal an ever dwindling list of revolutionary new features.

At the opposite end of the scale, smartphones have already eroded compact camera sales, and it's unlikely the low-end point-and-shoot market will exist for many more years: high-end compacts, yes, they'll likely cling on, but the writing's already on the wall in big bold letters for the automated compact brigade.

It's not all doom-and-gloom, though, as there are some pretty interesting technologies on the horizon to drive photography forward. At the time of writing, Light is proposing a multi-lens camera – the L16 – which uses 16 separate lenses and 16 individual sensors in a 'giant smartphone' style device to create a single high-resolution image. As with Lytro's intriguing 'light field' cameras, the focal plane and depth of field can be adjusted after the shot has been taken, providing photographers with an entirely new way of creating images. Sure, early sample images from both these technologies don't look great alongside the latest DSLRs or CSCs, but neither do the images from the flagship cameras we lusted after a decade ago. Compare shots from a £5000 Nikon D1 to a £300 Nikon D3300 and that entry-level camera will blow its pro-spec forefather out of the water: the bottom line is new technology always needs to mature.

At the same time, digital video is entering the world of '8K', with cameras offering images in the region of 8000 x 4000 pixels – that's 32 megapixels to you and me. As 4K video is increasingly seen as 'standard' in many still cameras, it's only a matter of time before higher resolution follows, and with it we'll perhaps see another new way of shooting: rather than a 'decisive moment', we'll be able to shoot every moment in glorious super-high definition, and then pick that perfect frame. Panasonic already offers this with some of its 4K-enabled cameras.

Cameras that shoot and stitch 360-degree views are also becoming more prevalent. Many are in the guise of 'action cams', but others are larger and capable of delivering a higher-resolution image – the Panono 360 will give you a whopping 108 megapixel image from its 36 combined cameras. So before long we may well be able to shoot not only every moment, but also every angle, giving us a real-time, all-encompassing view of the world around us. Of course, we'll still need to get our camera in position to start with, but it's not difficult to envisage drones becoming the airborne 'tripods' of the 21st Century;

However, just as the technology of tomorrow will bring us ways of using photography that we can't quite comprehend right now, so there's every possibility that film will experience something of a renaissance too. There are already generations of photographers who haven't experienced film photography in any form, and within that group there are signs of an awaking interest in a more 'hands on', physical form of photography in an increasingly automated digital world. And why not? After all, photography is photography, no matter what technology you use.

Above all, though, we need to remember that this is meant to be fun. No matter what the future brings, try not to worry too much about getting things 'right' and 'wrong', or whether your camera is infinitesimally sharper or has marginally more pixels than your neighbours: it really doesn't matter. What's more important is that you get out there with the kit you've got, and shoot. Like all those pioneers, both past and present, the only way that photography will move forward in any guise is if people take pictures.

PART I

Exposure

Although cameras are becoming ever more sophisticated, and film has (largely) given way to digital capture, at a most basic level, exposure hasn't changed since the dawn of photography: It is simply about getting the right amount of light onto the film or sensor for the right amount of time. Yet despite relying on just three controls, this core photographic skill can have a surprisingly steep learning curve.

Before You Begin

You can pick up almost any camera and get great exposures straight out of the box, but you need to make sure your camera is set up properly – that means choosing the most appropriate file format and image size.

File Formats

The file format is the way in which your digital photographs are saved to the memory card or device. If you're using a smartphone, tablet, or a point-and-shoot style compact camera, then you're probably not going to have much say over how your images are saved – they'll be stored using the JPEG file format. However, some cameras also let you shoot Raw files as well as, or instead of, JPEGs. So which is the best format to use?

JPEG

The reason JPEGs are so popular is because they're so versatile. JPEGs are processed in-camera, which means that any colour, contrast, sharpening, and other adjustments are applied to the image when you shoot. The image – your photograph – is then compressed when it's saved, which reduces the size of the file. This is great if you want to post your shots online or share them via email, as your photos are ready to go the moment you take them. The small files are also quick to email or upload (depending on your connection speed, of course)

JPEGs aren't perfect, though. The problem is, some of the image data is permanently discarded when the file is compressed, and the greater the level of compression, the more data is lost. So, while heavy compression can give you a super-small file size (and super-quick transfer times), it can also introduce strange artifacts. These may go unnoticed some of the time, but at other times they can have an adverse effect on image quality.

RAW

Advanced compacts, mirrorless cameras, and DSLRs will let you save Raw files as well as JPEGs. Unlike JPEG, which is a universal standard, Raw files are unique to individual camera makers, with different manufacturers using different names (and algorithms) for their camera's Raw files; Canon uses .CRW and Nikon uses .NEF, for example. Regardless of the name, the principle is the same: a Raw file essentially contains the raw, unprocessed data from the camera's sensor, making it the purest image your camera can produce.

One of the key things about Raw files is that they're output as 12-bit or 14-bit images, whereas JPEGs are 8-bit images. We'll look at bit depth later on (on page 374), but in a very general sense, a higher bit depth (bigger number) means better image quality. However, because a Raw file isn't processed by the camera, it needs to be processed elsewhere, which in this case is on your computer or other device using dedicated Raw conversion software. The good news is this lets you achieve the exact look you want, as the white balance, colour saturation, contrast, sharpness, and myriad other elements of the photograph (including the exposure) can all be tuned and tweaked during processing.

The downside is that all your Raw files need to be processed and converted to an alternative file format (usually TIFF or JPEG) if you want to do anything with them. So, while you can process the image as you like (which is great), you have to do it for all of your photos.

TIFF

A third file format that you may come across is TIFF, although this isn't something you're likely to see as an in-camera option. TIFF files are usually uncompressed, so the file sizes are large, but your digital photograph is saved in all its glory – there are no artifacts introduced, no matter how many times you reopen and resave the file. For this reason, TIFF is often used as a storage format; once a Raw file has been processed, it can be saved as a TIFF that acts as a master file from which prints can be made, or JPEGs created for sharing online.

SIMULTANEOUS SHOOTING

A lot of advanced cameras let you shoot Raw and JPEG files simultaneously, saving both file types for every shot you take. This has the advantage of giving you a JPEG file that's ready to be shared or printed immediately, alongside a Raw file that can be edited and processed for optimum picture quality. The downside is you're saving two versions of the same image, so memory cards (and hard drives) will fill more quickly.

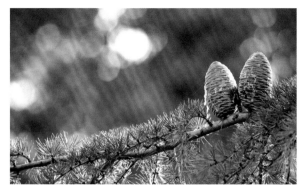

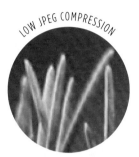

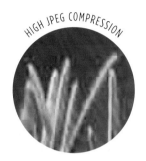

BELOW There are numerous advantages to shooting Raw, but it ultimately comes down to having greater flexibility in how the image is processed, without sacrificing image quality. The downside is that you must process your images, which takes time.

AS SHOT

PROCESSED

ABOVE This image (top) was saved with the lowest amount of JPEG compression (above left) and the highest compression level on offer (above right). Although the heavy compression resulted in a much smaller file size, it has introduced unusual artifacts that have a highly destructive effect on the image. What's worse is that the detail lost at this stage can never be retrieved.

	JPEG	RAW
PROS	• Can fit more images on a memory card/hard drive. • Images are processed in-camera, so they come out of the camera ready to use. • Smaller files sizes are quicker to upload to the Internet. • Opening, editing, and resaving a JPEG recompresses it (losing more data).	• Processing is largely non-destructive (i.e., it does not affect image quality). • Can tweak and tune images for creative effect. • Greater latitude for correction if you get it wrong in the camera. • Any compression applied to the file is lossless.
CONS	• Heavy compression can introduce artifacts. • Editing the images post-capture can reduce quality. • Any lost data is irretrievable.	• Processing files can be time consuming. • Files need to be converted to another format before they can be printed or posted online. • Larger file sizes than JPEG, so memory cards fill more quickly. • Not available on all cameras (especially point-and-shoot devices).
WHEN TO USE IT	• If you want to print or share your images straight from the camera. • When you don't want to spend time processing photos on your computer.	• When you want the highest image quality, and aren't afraid to work for it. • If heavy editing is needed or you want to process your shots for a specific look.

SMALL RAW

Both Canon and Nikon offer an sRaw, or small Raw, format on some of their cameras (Canon offers an mRaw, or medium Raw option as well). This is designed to offer the increased bit-depth and processing capabilities of Raw capture, but with a smaller image size and a compressed file format. This makes a lot of sense in a world of increasingly high-resolution sensors, as digital cameras are now capable of generating huge file sizes. Large files are slower to write to your memory card, which can restrict your shooting speed; slow download and transfer to your computer; require more memory card and hard drive space; and require more processing power on the computer. More importantly, though, not all images need to be at maximum resolution – sometimes you may want or need smaller images. Previously, this meant shooting JPEGs and limiting your processing options, or shooting Raw and resizing your shots, but with sRaw (or mRaw) you can have the best of both worlds.

Image Size

As well as deciding on the file format (assuming you have a choice), you need to set the image size, or resolution of your photographs. This is the number of pixels that will be used to create your final photograph, up to the maximum resolution of the sensor (so up to 8 million pixels on an 8 megapixel camera, 16 million pixels on a 16 megapixel camera, 24 million pixels on a 24 megapixel camera, and so on).

Different cameras express image sizes in different ways, so you may see a megapixel (MP) figure, allowing you to choose between 24MP, 14MP, 6MP, and 2MP image sizes, for example. Others give pixel dimensions, so you could see options such as 6016 x 4000, 4608 x 3072, 3072 x 2048, and 1920 x 1280, which indicates the number of pixels horizontally and vertically. And some have more esoteric labels, such as Large, Medium, and Small (although this is usually accompanied by one or both of the other options for clarity). In most cases, the size you choose will depend on what you intend to do with your pictures.

GO LARGE

The largest image size is the go-to option for most photographers: If you start with the largest possible image size, you have a lot more options when it comes to using your photographs (including making the image smaller if you need to). For printing, the simple rule is the higher the resolution, the bigger the prints you can make, and it's also useful to have a large file if you tend to crop your photographs, as cropping will remove pixels, making the image smaller. If you shoot Raw, the largest image size might be your only option: a lot of cameras will save Raw files at only the highest resolution, so you get the largest possible image (the idea being that if you shoot Raw, you are looking to achieve the highest quality image).

GO SMALL

If you shoot JPEGs, you'll find you can shoot at a variety of image sizes, from the full resolution of the sensor down to images of maybe 1 megapixel or less. At first glance, this might seem fairly pointless. After all, what's the point of buying a 24-megapixel camera and then recording 2-megapixel images? However, smaller images are quicker to work with. If you're shooting sports for a newspaper, for example, you don't need exhibition size prints, you need files that are processed and written to the memory card as quickly as possible, so your camera can keep on shooting. Similarly, if you're taking photographs that are only going to be used online (for a catalogue on a website, for example, or to sell something on eBay) then smaller images mean smaller file sizes, which are quicker to load on a webpage. In fact, if you're shooting images that will only be used online, you can use surprisingly low resolutions – a 1MP image is often more than enough for on-screen use.

LEFT The number of pixels in your images plays an important part in how large they can be viewed, either on screen or in print. For printing, images are usually sized to 300 pixels per inch (ppi), which means for each linear inch of the image there are 300 pixels. For use on screen, 72ppi is used.

The image at the left shows how large a 1-megapixel image would be if it were sized to 300ppi; the quality is fine, but the image is only 10cm wide. By comparison, the details below show how much larger the image would appear if it were at a higher resolution – at 300ppi the 24MP image would measure approximately 20x30cm

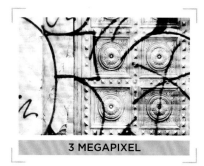

3 MEGAPIXEL

It's possible to enlarge a 1MP image so that it prints at the same size as a 24MP shot, but since you aren't adding any extra pixels, the image will only be at 60ppi (no longer 300ppi) when it's blown up to this size. Each pixel is therefore larger, and much more noticeable. This wouldn't look bad if the image were used on a screen (where 72ppi is the standard resolution), but in print, it wouldn't stand up to close scrutiny.

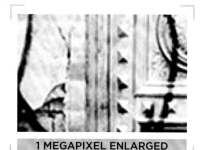

1 MEGAPIXEL ENLARGED

6 MEGAPIXEL

14 MEGAPIXEL

24 MEGAPIXEL

The Exposure Trinity

Aperture, shutter speed, and ISO: These are the three controls that determine whether a photograph looks too dark, too light, or just right.

Aperture

Apple's dictionary defines the word aperture as 'an opening, hole, or gap', and that's essentially what we're referring to in photography when we talk about the aperture setting. The aperture is usually found in the lens and is created by a number of blades that can be adjusted to vary the size of the hole. The physics is simple here: The bigger the hole (the wider the aperture), the more light can pass through it. So, in terms of making a photographic exposure, a wider aperture means more light gets through to your sensor, which means a brighter image. Conversely, a smaller aperture means a small hole, less light reaching the film or sensor, and a darker image.

While that's a simple enough concept to understand, the way in which apertures are described is less straightforward, and is the main reason why novice photographers struggle to get to grips with exposure. The problem is, the size of the aperture is expressed as an f-stop, which is a totally alien concept outside the world of photography. We'll look at what precisely a stop is on the following pages, but for now, the thing to appreciate is that an f-stop is a fraction (which is why it's written 'f/'). So, just as ½ is bigger than ¼ in math, $f/2$ is bigger than $f/4$ when we talk about apertures, which means $f/2$ is a bigger hole than $f/4$, and $f/4$ is bigger than $f/8$, and so on. The easiest way to remember it is 'bigger number, smaller hole'. Repeat this until you have it etched

on the inside of your skull and you'll have taken your first major step toward understanding exposure.

Shutter Speed

Compared to understanding aperture, shutter speed is a walk in the proverbial park, because it's based on something we're all much more familiar with: time. Inside every camera is a shutter that opens and closes to allow the light passing through the lens (and the aperture) to reach the film or sensor. The shutter speed is simply the time that this light is allowed to reach your film or sensor. Again, in terms of exposure, the concept is reasonably straightforward: The longer you let light reach the sensor, the brighter the resulting image will be.

On most mirrorless cameras and DSLRs, shutter speeds range from super-short (fast) speeds of 1/4000 second to super-slow shutter speeds of 30 seconds. Most cameras also have a B, or Bulb, setting that lets you hold the shutter open manually for as long as you like. This is typically used for extreme low-light and night photography, when exposure times are likely to be measured in minutes (or perhaps hours), rather than fractions of a second (see page 52).

$f/2.8$

$f/4.0$

$f/5.6$

$f/8.0$

$f/11$

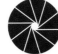

$f/16$

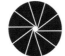

$f/22$

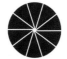

$f/32$

LEFT This illustration shows a typical range of aperture settings, from $f/2.8$ to $f/32$. These are full f-stops, which we'll look at shortly. For now, though, 'big number, small hole', is the mantra you should be repeating.

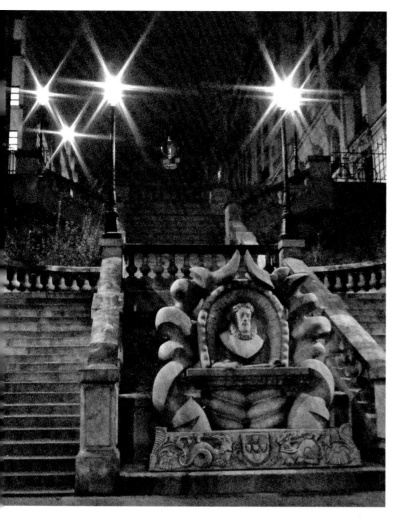

ISO

At a most basic level, ISO indicates a film's or sensor's sensitivity to light based on the original ISO (and ASA) ratings developed for film. The rule here is that the higher the ISO, the greater the sensitivity to light, so ISO 3200 is more sensitive than ISO 400, which in turn is more sensitive than ISO 100. If you changed only the ISO when you took a photograph, a lower ISO setting would result in a darker picture, while a higher ISO would give you a brighter one.

Historically, most film fell inside the range of ISO 100–800, with some more specialist emulsions (particularly black-and-white films) taking this down to ISO 25, or up to ISO 3200. However, advances in digital capture have seen ISO ratings skyrocket in recent years, with settings as high as ISO 409,600, now enabling us to take photographs with very little light at all.

LEFT ISO gives an indication of how sensitive your film or sensor is. The higher the ISO, the less light is needed to make an exposure, although as you will see on pages 58–61, this is not without its drawbacks.

LEFT As well as determining how long the sensor is exposed to light, the shutter speed also controls how movement appears in your photographs (see pages 44–53).

A Question of Balance

The aperture regulates the amount of light passing through the lens; the shutter speed determines how long that light falls on your film or sensor; and the ISO dictates how much light is needed to start with – now you need to bring these three things together to get the perfect exposure.

In this context, the perfect exposure is the one that delivers an image that is neither too light (overexposed) nor too dark (underexposed). However, there's one important thing to appreciate here: exposure is not absolute. While I'm going to be talking a lot about getting the exposure 'right', all this means is setting the exposure that you think works best for the subject. So, if you think the right exposure for your photograph means your shot comes out almost black, then that's fine. Most people will disagree and say it's massively underexposed, but if that near-black frame matches your creative vision, then you got that exposure spot on!

Over the following pages we'll look in more detail at the creative impact your choice of aperture, shutter speed, and ISO will have, as well as the various shooting modes that determine how they are combined, and the metering options that will guide you to your ideal exposure in the first place. For now, though, you simply need to appreciate that the first decision you have to make about any photograph is how light or dark you want it to be. Once you have decided that, you can choose which combination of aperture, shutter speed, and ISO will best achieve that result. Or, to put it another way, you can decide how you are going to fill the bucket.

ABOVE For every scene, there are multiple combinations of aperture, shutter speed, and ISO that will give you the exposure you're after. However, as you'll see, each control also has a specific effect on your image, so you not only need to balance your settings, but also decide how best to bring them together to achieve the look you want.

Filling the Bucket

Filling the bucket (which is by no means my own creation) is the analogy I like to use when explaining exposure, because it makes a whole lot of sense. What we have are three things: a bucket, a hose (or faucet if you prefer), and water. Here's how it works.

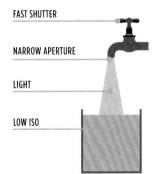

- The bucket represents your ideal exposure, with the size of the bucket depending on the ISO setting: The smaller the bucket, the higher the ISO.

- The hose (or faucet) represents the aperture: The larger the diameter of the hose, the larger the aperture.

- The flow of the water represents the shutter speed: The longer we let the water flow, the longer (slower) the shutter speed.

- The water itself represents the light that's making our exposure.

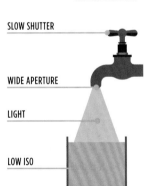

The aim is to fill the bucket to the brim, which in photographic terms is our perfect exposure: if there's not enough water (light), the bucket won't be full (our exposure will be too dark); too much water (light) and the bucket will be overflowing (our exposure will be too bright).

We have three variables here, each of which will have an effect on how we fill the bucket. If we start with a small bucket, we will not need as much water to fill it, so we could use a smaller hose and/or let the water run for a shorter time. Conversely, if we wanted to fill a larger bucket, we'd need more water so we'd need to use a bigger hose and/or run the water for longer.

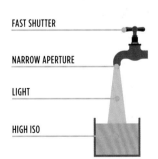

If we relate this to exposure, then a small bucket (high ISO) requires less water (light), so we can use a smaller hose (smaller aperture) or run the water for a shorter time (faster shutter speed). However, a larger bucket (low ISO) requires us to use a bigger hose (wider aperture) or let the water run for longer (slower shutter speed) to get more water (light) into the bucket.

Now, this would be hard enough if we just had a small number of buckets, hoses, and flow rates, but look at your camera and you will find there are numerous ISO settings (bucket sizes) between the largest and smallest, and multiple aperture settings (hose sizes) and shutter speeds (flow rates). Not only that, but light (the water pressure) doesn't stay the same all the time – sometimes it's bright and there's plenty of it; other times it's dark. The important thing to remember, though, is that the goal always remains the same: To fill the bucket to the brim. Not a drop more, not a drop less.

Stop!

OK, so you've got another exposure hill to climb here...

So we can make consistent and repeatable changes to our hoses, water, and buckets (aperture, shutter speed, and ISO) we need some sort of universal unit of measurement that will relate equally to each of them. The unit we use is known as stops. In practical terms, adjusting any one of the exposure controls by 1 stop results in a doubling or halving of the light reaching the sensor (or the light required by the sensor to start with in the case of ISO). So, a 1-stop adjustment to one control will have the exact same lightening or darkening effect as a 1-stop adjustment made to either of the other two (the typical full-stop values for each control are shown in the grid opposite).

For example, if you change the aperture from $f/8$ to $f/5.6$, you are increasing the aperture by 1 stop, which will allow in twice as much light. This will have the same effect on the overall exposure as

changing the shutter speed from 1/250 second to 1/125 second (also a 1-stop adjustment that doubles the amount of light reaching the sensor). And both will have the same effect as increasing the ISO from 200 to 400 (again, this is a 1-stop adjustment that makes the sensor twice as sensitive to light). For even greater control, your camera will probably allow you to adjust the exposure in ½- or ⅓-stop increments, but the bottom line is that you can start to make your exposures brighter or darker.

Stops also help us out when you want to change one of the settings for creative effect, but keep the same overall exposure. Maybe you want to use a wider aperture to get a shallow depth of field, but don't want to make the image lighter. Well, with stops as your universal measure, it becomes a little easier. If you or the camera make a change to one of the settings, and you want to maintain the same overall brightness, then you (or the camera) need to apply an equal and opposite adjustment.

FULL STOP

This grid shows the typical full stop values of each exposure control, as well as the effect they have on the photograph. In each case, your camera will probably be able to make adjustments in ½- or ⅓-stop increments for even greater control over the exposure.

EFFECT ON EXPOSURE	APERTURE	SHUTTER SPEED (SECONDS)	ISO
		30	
LIGHTER		15	
		8	409,600
		4	204,800
		2	102,400
	$f/2.8$	1	51,200
	$f/4$	½	25,600
	$f/5.6$	¼	12,800
	$f/8$	⅛	6400
	$f/11$	1/15	3200
	$f/16$	1/30	1600
	$f/22$	1/60	800
	$f/32$	1/125	400
		1/250	200
		1/500	100
		1/1000	50
DARKER		1/2000	
		1/4000	

Stops In Action

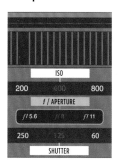
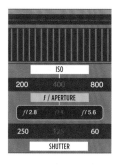
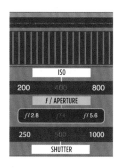
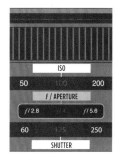
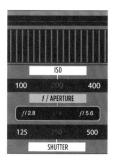

Let's say, for example, that an exposure of *f*/8, 1/125 second, ISO 400 gives you the result you are after in terms of the overall brightness of the photograph. This is what we will call '0' – it's our base exposure.

Now, we want to throw the background out of focus by using a wider aperture of *f*/4. That means opening up the aperture by 2 stops, making the image 2 stops brighter. If we leave it like this it will be too bright, or overexposed.

To keep the overall exposure the same, you or the camera will have to adjust the shutter speed or ISO by 2 stops in the opposite direction. This can be achieved in several ways. To start with, you could adjust the shutter speed by 2 stops (from 1/125 second to 1/500 second).

Alternatively, you could reduce the ISO by 2 stops (from ISO 400 to ISO 100). Again, this effectively makes the image 2 stops darker, counteracting the aperture adjustment that made it 2 stops brighter.

A third option might be to reduce the shutter speed and ISO by 1 stop each (to 1/250 second and ISO 200 respectively), to achieve a total adjustment of 2 stops. In every case, the overall brightness of the image will remain the same. However, as you will see on the following pages, the aperture, shutter speed, and ISO can do far more than simply lighten or darken an exposure.

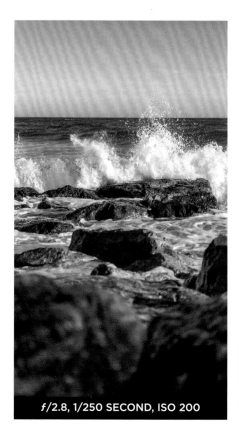

f/2.8, 1/250 SECOND, ISO 200

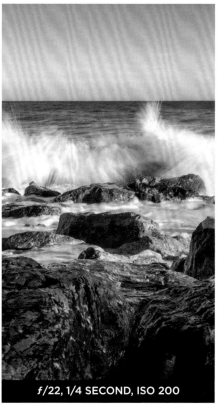

f/22, 1/4 SECOND, ISO 200

LEFT Stops give a consistent way to adjust exposures. Regardless of whether we change the aperture, the shutter speed, or the ISO, a 1-stop adjustment will either halve the light or double it.

In this example, the aperture was changed from *f*/2.8 to *f*/22, which is a 6-stop reduction in the amount of light coming through the lens (see grid, oppposite). If that were the only adjustment made, the image would be much, much darker, so I also increased the shutter speed by 6 stops, changing it from 1/250 second to ¼ second. This made the image 6-stops brighter, balancing out the adjustment to the aperture.

As a result, the overall exposure (or image brightness) remains the same, although the changes have had a profound effect on the look of the photograph.

MASTERCLASS

LANDSCAPE
David Taylor

David Taylor's interest in photography started when he was a teenager, but it wasn't until 2006 that he turned his hobby into a full-time profession. His love of the outdoors made landscape photography a natural path to follow, and it has taken him from the extremes of the Arctic Circle to tropical islands in the Indian Ocean. David now splits his time between commercial photographic work and writing articles and books on photography, including *Mastering Landscape Photography*.

When he isn't shooting for a client, David's favorite photography spot is the coast of his native Northumberland, in the North East of England. 'There's something compelling about the coast, because it's constantly changing due to the tides. There's always something new to do, even when returning to a familiar spot'.

His weapons of choice for capturing this rugged coastline are a Nikon D800 DSLR and a Panasonic GX8 CSC kit, although it's not the D800's 36-megapixel sensor that makes it his ideal camera: 'The D800 has a high-resolution sensor, but it also had a wide dynamic range. The latter quality is ideal for landscape photography, as you often have to deal with high-contrast scenes'. However, while the D800 may have the ideal resolution and dynamic range for his landscape work, it is not the lightest camera, especially when pro-spec lenses are added to the bag. This is where the mirrorless GX8 comes to the fore. Although slightly down on pixels compared to the Nikon, 'the GX8 is much smaller, and it's perfect for days when there's a lot of walking to be done and when weight may be an issue'.

Of course, lenses are just as necessary as a camera, and with landscape photography, this usually means one thing: wide-angle focal lengths. 'Wide-angle lenses (24mm on a full-frame camera) are very, very useful in helping to convey the sheer size and space of an expansive landscape scene', says David, he also suggests, 'There's no right or wrong focal length lens for landscape

LANDSCAPE ESSENTIALS

Photographing landscapes often means shooting in low light at either end of the day. A tripod is an essential piece of equipment to help keep the camera steady, and a remote release will help you avoid disturbing the camera when the shutter is fired. There's nothing worse then getting home to find out that your shots have been ruined by camera shake!

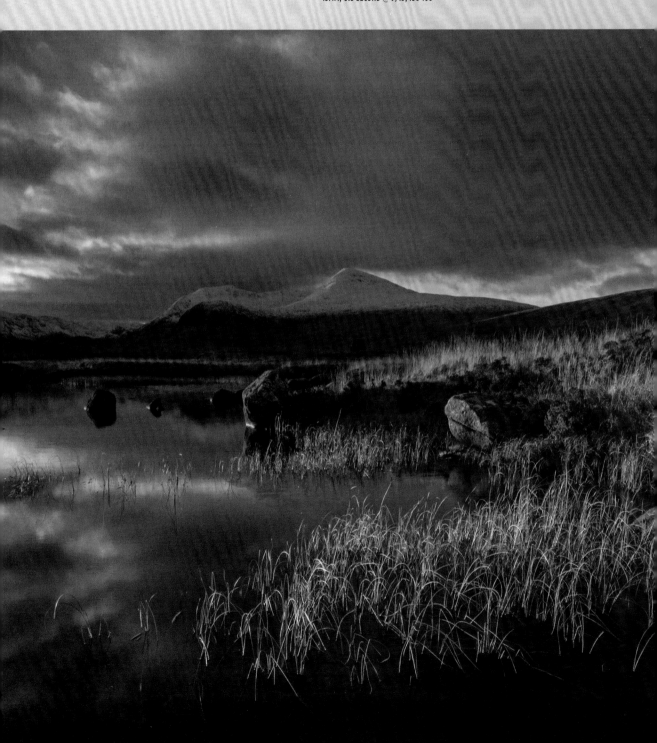

▼ Lochan Na Stainge in the Scottish Highlands. Planning is a large part of landscape photography, and knowing where the sun will rise or set is vitally important. This shot was planned after consulting maps and visiting the area earlier in the day.

13MM, 0.3 SECOND @ ƒ/13, ISO 100

photography. The focal length that should be used is the one that suits the subject. I tend to 'see' landscapes within the 24–100mm range. I don't have one lens that covers that range, so there's always a certain amount of lens swapping involved. My favorite lens is an old Nikon 35–70mm zoom, which is sharp, relatively small and light, and covers a very useful focal length range'.

Another common landscape photography practice is the use of small apertures to maximise depth of field. 'Using a small aperture is usually necessary to achieve front-to-back sharpness in a landscape photo. However, lenses aren't at their optical best when the very smallest apertures are used, so I try to use the smallest aperture that will create the required depth of field, but no smaller. Usually it's the mid-range ($f/8$–$f/11$) that produces the best results, and I'll use those if I can.

'I mainly use Aperture Priority, which lets me choose the appropriate aperture. I occasionally use Manual exposure, but this is generally when I want to shoot a sequence of photos that need to have a consistent exposure (such as when shooting a sequence to create a stitched panoramic).

'I'm happy to let the camera select the required shutter speed, but I do check the shutter speed that it wants to use. This is particularly important when there's movement in a scene. I like the movement blur created through the use of longer shutter speeds (the technique works particularly well with waves washing up onto beaches), so I often use neutral density filters to extend the shutter speed'.

To get to his final exposure setting, David uses his Nikon's Matrix metering. 'The biggest challenge with landscape photography is dealing with contrast. The foreground is often far darker than the sky above, so I'll need to use graduated ND filters to balance the exposure across the image. This type of metering works well when filters are on the lens, but it's not perfect – I always call up the histogram and check the exposure. If it's incorrect I'll reshoot after applying the appropriate exposure compensation'.

Plain and graduated ND filters are not the only filters David uses, though. Like most landscape photographers, he won't go anywhere without a polarising filter in his bag. 'Because I like to work around water a lot, I'll often use a polariser to reduce glare and increase the transparency of the water, which I find helps to reveal its true colour. A polariser can also be used to deepen the blue of the sky, which is particularly useful when it's partially cloudy, as it helps the clouds to stand out more. I wouldn't use it all the time, though, because the effect isn't pleasing when the sky is clear – it can make the blue of the sky look overcooked and unnatural'.

To see more of David's work, visit his website at www.davidtaylorphotography.co.uk.

DAVID'S TOP TIPS

- Plan a trip to a location carefully beforehand, making sure to check factors such as tide times if you're working in a coastal area.
- If you want to shoot at a specific time of day (sunrise or sunset, for example), arrive at your location in good time. Rushing to get set up will cause unnecessary stress that will lead to mistakes.
- Slow down and think about each shot. It's far better to come away with one or two great shots than hundreds of mediocre ones.
- Review each shot after shooting, checking that it's sharp where it should be.
- Don't be afraid to experiment, and be prepared to fail occasionally. Trying new techniques means that you'll learn more quickly than just shooting the same way every time.

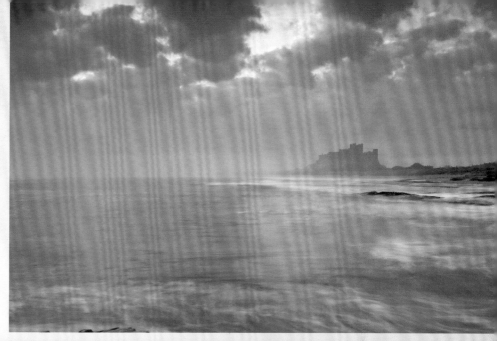

► Bamburgh Castle on the UK's Northumbrian coast. For me, landscape photography is at its most interesting during stormy weather conditions – constant blue sky and perfect weather would be very dull!

17MM, 2 SECONDS @ ƒ/14, ISO 100

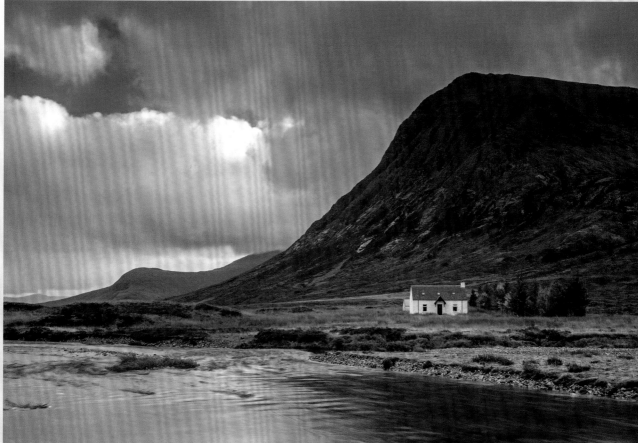

▲ The River Coupall in the Scottish Highlands. It's sometimes difficult to convey the scale of a landscape, but including something of a recognizable size – such as the bothy (cottage) in the shot – is a useful way to achieve this.

28MM, 0.8 SECOND @ ƒ/14, ISO 100

Aperture & Depth of Field

As well as determining how much light is allowed to pass through the lens, the aperture setting also plays a major part in how your images appear, thanks to what is known as depth of field.

NOT ALL LENSES ARE EQUAL

The minimum and maximum depth of field you can achieve with any lens depends on its aperture range. Most kit lenses (the lens packaged with the camera) have a maximum aperture of f/3.5–4 (or smaller), which is not especially wide. For this reason, many photographers will upgrade to a more expensive zoom lens with a wider maximum aperture (typically f/2.8) or use prime lenses that offer wider apertures still (f/1.8 is common). At the other end of the scale, a minimum aperture of f/22 is common to most lenses, although some offer f/32 or even f/45 (these typically tend to be telephoto lenses).

As you'll see in Part 3, when you focus your lens, everything at that focused distance is in focus, and everything else is out of focus to a certain degree. However, the transition from sharp to soft is not immediate or fixed, so areas of the scene that are closer to the camera and further away from the focus point can appear acceptably sharp as well. The zone of apparent sharpness is known as the depth of field, and the greater the depth of field, the more of the scene will look sharp in your photograph.

Depth of field is an incredibly powerful creative tool that allows you to achieve a range of looks, from having everything in the scene appearing sharp, to restricting the focus to just a small part of the image. It is not just the aperture that determines

depth of field – the focal length and the camera-to-subject distance also play a part, as shown in the photos opposite. The aperture setting is arguably the most versatile of the three, though, as focal length and camera-to-subject distance are often determined by where you can shoot from and how you want to frame your shot (not to mention the lenses you have at your disposal).

The rule here is that the wider an aperture setting you use, the less depth of field there will be, so shooting at a wide aperture setting (such as f/2.8 or f/4) would mean you get a much shallower depth of field than if you were to photograph the same scene with a smaller aperture (f/16 or f/22, for example).

CONTROLLING DEPTH OF FIELD

Depth of field is not only controlled by the aperture. Focal length also plays a part (the longer the focal length of your lens, the less depth of field there will be), and so too does the camera-to-subject distance (the closer you are, the shallower the depth of field). How you combine the three determines the overall depth of field: Using the widest aperture setting on a telephoto lens, and shooting close to your subject will result in the smallest depth of field possible, while using a small aperture setting on a wide-angle lens to photograph a distant subject will guarantee an extensive depth of field.

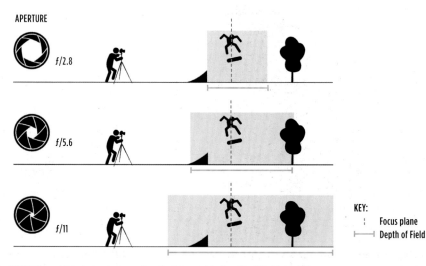

APERTURE

f/2.8

f/5.6

f/11

KEY:

⋮ Focus plane

⊢―⊣ Depth of Field

ABOVE The wider the aperture, the shallower the depth of field. Focal length and camera-to-subject distance will also have an effect.

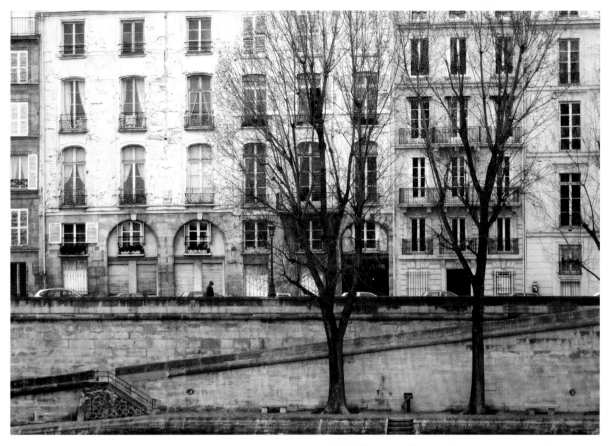

ABOVE **ABOVE** When everything in the scene is a similar distance from the camera, you don't need to use a small aperture – ƒ/4.5 was more than adequate to keep everything in this scene looking crisp.

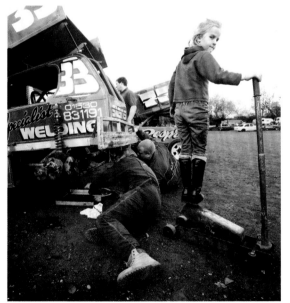

ABOVE Using a wide-angle lens and a small aperture has provided an extensive depth of field: Everything in this shot appears acceptably sharp.

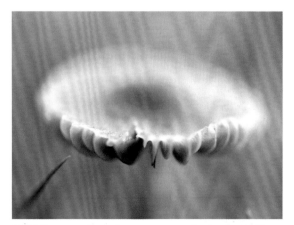

ABOVE When you shoot close-up images, the depth of field will always be shallow, but setting a wide aperture will really minimise what appears in focus.

ABOVE If you want to handhold your camera in low-light conditions and avoid camera shake you need to use a fast shutter speed. This means you have two options: increase the ISO (potentially making your image noisy) or use a wider aperture setting (and reduce the depth of field). To ensure a fast shutter speed for this shot, I had to do both, shooting at ƒ/4 and ISO 3200.

Wide Aperture

Shooting with a wide aperture, such as ƒ/1.8 or ƒ/2.8, will create a shallow depth of field, and this is arguably a way of creating some of the most striking photographs. It's a great technique for drawing attention to a specific part of a scene or subject because our eye is naturally drawn to in-focus parts of an image first. If there is one sharply focused element in a sea of blur, we'll be drawn to it double-quick.

Using a wide aperture is also useful when you're shooting in low-light conditions and want or need to handhold the camera. The wider aperture will mean you can use a faster shutter speed to avoid camera shake, without increasing the ISO and adding noise (see page 58).

However, shooting with a lens at its widest aperture setting can quickly reveal any shortfalls in the lens' optical design, with any vignetting (darkened corners) and chromatic aberration, or fringing, becoming all the more noticeable.

WIDE OPEN

With a DSLR, the lens is held at its widest aperture setting until you make your exposure. This provides you with the brightest possible image in the viewfinder, but it means that you are always looking at the scene with the least depth of field possible.

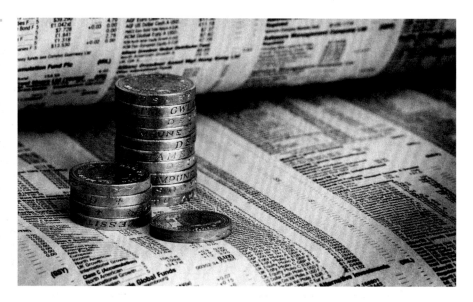

ABOVE Wide apertures are great for controlling what does and doesn't appear in focus. Here, it was important for the largest stack of coins to be sharp, but I wanted the text in the background to fall out of focus so it was unreadable.

ABOVE Using a wide aperture setting is a classic portrait technique, as the shallow depth of field ensures that any distracting background elements are thrown out of focus.

ABOVE Prime (fixed-focal-length) lenses usually have wide maximum apertures, which means they can give you a shallow depth of field. A 50mm ƒ/1.8 lens is a great, low-cost option.

ABOVE Although we usually associate wide apertures with blurred backgrounds, they can also be used to throw a distracting foreground out of focus. Here, the blurred figures act as a frame for the sharply focused figure beyond, making sure that he is the centre of attention.

DIFFRACTION

When you choose a small aperture, you risk softening your image through diffraction. This happens because the light rays passing through the lens are bent (diffracted) more as they pass through the small hole that's been created inside the lens. This bending of the light can cause its rays to overlap and blend slightly when they're recorded by the film or sensor, resulting in a loss of definition. So, although depth of field is increased when you use a small aperture, the image can also be softened overall, and the smaller the aperture, the greater the diffraction. For this reason, it is better to avoid a lens' smallest aperture setting where possible.

PREVIEW

Some cameras will allow you to manually stop down the lens to the aperture it will use to take a photograph, so you can preview the depth of field. On a DSLR, this will usually be done via a depth-of-field preview button, while mirrorless cameras may offer it as a button or a menu option that automatically previews the depth of field on the rear LCD screen or through the electronic viewfinder.

Small Aperture

Small aperture settings, such as $f/16$ and $f/22$, are called for when you want to ensure that as much of your subject appears sharp as possible. Landscape photography is a textbook example where you might want elements in the foreground to appear focused, as well as areas in the background, so every detail is crisp, from a flower just inches from the lens to mountains in the distance.

A small aperture can also be the price you pay when you want to use a slow shutter speed or you find yourself shooting in very bright conditions. In these instances, a small aperture is thrust upon you, rather than being a positive decision on your part, but hey, that's the way it goes sometimes. Filters can help in such situations (see page 198).

LEFT I wanted all of these figures to appear sharp, so focused on the second figure in and used an aperture setting of $f/14$. My camera's depth of field preview indicated this would be enough to ensure everything looked in focus.

THIS PAGE Landscape and cityscape photography often call for an 'everything sharp' approach. This can be achieved by using a small aperture setting (often in conjunction with a wide-angle lens), but beware of diffraction – sometimes you can get the depth of field you need by choosing a slightly wider aperture and focusing at the hyperfocal distance (see page 222).

Mid Aperture

It's fair to say that the most dramatic images are created when you take the aperture to one extreme or the other – either to create a thin sliver of sharpness, or a deep, all-inclusive depth of field. However, between these extremes lies the often-overlooked middle ground of $f/8$ and $f/11$ (and, to a slightly lesser extent, $f/5.6$).

These are the safe aperture settings that are often chosen when you set your camera to Auto or Program, which is perhaps why they are generally perceived as functional rather than creative options.

Do not discount them, though. Extreme aperture settings rarely perform as well as the mid range when it comes to image quality, with diffraction affecting smaller apertures, and vignetting and chromatic aberration more prevalent when the widest aperture settings are employed. Consequently, a mid aperture can produce sharper and cleaner images, or, to put it another way, better quality pictures.

BOTH PAGES A mid-range aperture is the ideal walkaround setting, especially if you're shooting from the hip. You can preset the aperture (using Aperture Priority or Manual mode) and set the focus manually, based on how close you anticipate getting to your subjects. Your mid-range aperture setting will typically give sufficient depth of field to allow some latitude over the focus, and a carefully chosen ISO should deliver a shutter speed that's fast enough to avoid camera shake.

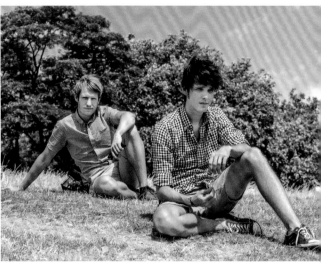

Bokeh

So much has been written about bokeh (pronounced **BO-kuh**) in magazines and online in recent years that it's easy to assume it's a creation of the digital era. However, nothing could be further from the truth. Bokeh has been in existence since the dawn of photography, it simply hasn't been the subject of such widespread discussion (or referred to in this way).

The word comes from the Japanese, *boke*, which simply means blur or haze, and in that sense, it's easy to see how and why bokeh has always been with us: for as long as lenses have produced in-focus areas, they have also produced blurred, out-of-focus areas as well. However, the word has now been commandeered and closely associated with the aesthetic quality, and particularly the shape, of points of light in out-of-focus areas in a photograph taken using a large aperture setting.

These out-of-focus areas are often described as good or bad, with some lenses now considered superior to others in terms of the bokeh they produce and some people developing a slightly unnecessary fixation with the whole thing. As a rule, bokeh gets better (by which most people mean smoother/more rounded) as the number of blades forming the aperture in the lens increases. This is because bokeh is defined by the size and shape of the lens aperture, and a greater number of blades will create a more circular aperture opening.

This is all slightly contentious, though, as such judgments are at least partially subjective. Popular opinion is that good bokeh should be round and soft, yet striking results can be created with polygonal bokeh, or the donut-shaped bokeh created by mirror lenses. Personally, I wouldn't advise obsessing too much about bokeh. The fact is, bad bokeh can create great images, and a lens that gives good bokeh doesn't guarantee better photographs!

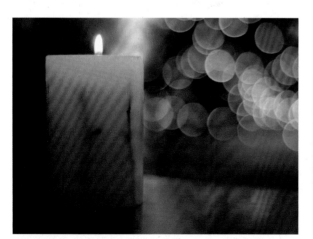

ABOVE This shot was taken using a 50mm lens at its maximum aperture setting of ƒ/1.8. The distinct background shapes are what most people would now describe as 'good' bokeh.

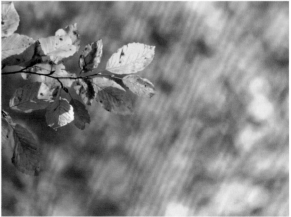

ABOVE The word bokeh comes from the Japanese for 'blur', so in that sense, the background in this image shows bokeh. However, without any of the distinct highlight shapes that are now associated with bokeh, most of us would simply describe it as 'blurred' instead.

DIY Bokeh Filters

Bokeh doesn't have to be round; you can create
your own uniquely shaped bokeh filters.

I Cut a disc of black card that's the same diameter as
the lens you want to use, and cut your chosen bokeh
shape out of its centre. The bokeh filter should push
perfectly into the front of your lens.

2 With your camera set to Aperture Priority or Manual
Exposure Mode...

3 ...Set your lens to its maximum aperture setting
(smallest number). Your cut-out shape will become
the working aperture that's used to determine the
exposure.

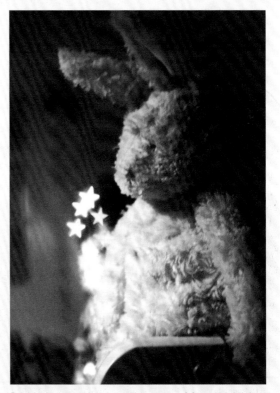

3 Now when you shoot, any out-of-focus highlights
will take on the shape of your bokeh filter.

MASTERCLASS

PORTRAITS
Ben Anker

When Ben Anker was leaving school, his older brother, Matt, was leaving college to become a photographer. Having already spent many hours in the school's darkroom (even though it didn't offer a photography course), it seemed that Ben was destined to follow in his brother's footsteps. This was confirmed five years later, in 1994, when Ben stepped out of Kent Institute of Art and Design with a Photography HND (Associate degree) and immediately set out as a freelance photographer.

As he had always enjoyed working with people, and his studies had been in portraiture, it was obvious this was going to be his chosen path, although it hasn't always gone to plan. 'My first commission was to photograph the CEO of ICI for Business Standards magazine. I arrived with all sorts of plans for the shoot, but then he arrived and told me I had 5 minutes before he had to go! All my plans got thrown out of the window and I had to think quickly. Luckily, the resulting image set up a long-lasting relationship with the magazine, as well as getting me commissions from other magazines from the same publisher. My love of music also provided me with photographic opportunities. Soon I was shooting bands for Acid Jazz magazine, and ended up doing a few cover shoots for bands such as Mother Earth and the James Taylor Quartet'.

Today, Ben's work covers an eclectic mix of clients. 'I do a lot of work with hair salons, producing large-format prints and images for international hair competitions. I also photograph authors, musicians, bands, and do work for magazines and graphic designers.' When working with such a diverse group of people, a portrait photographer needs exceptional interpersonal skills, as Ben explains: 'You have to be confident but not arrogant. You need to be able to communicate with your subject and quickly develop a rapport to ensure that you get the best out of whatever time you have. You also need to be able to quickly evaluate the type of personality your subject has and develop an ability to change your approach from one day to the next depending on who you are photographing – one day you could be shooting a head of industry and the next day a teenage band. Both would need to be handled very differently, so you need to be able to respect the situation you are in and learn to engage in very different ways'.

PORTRAIT ESSENTIALS

Although cameras, lenses, and light meters will let you take a technically perfect photograph, Ben suggests that a successful portrait photographer needs one more vital ingredient. 'You can't just "fall into" a life as a portrait photographer – you absolutely have to be the right personality yourself to make it work'.

Of course, being able to 'talk the talk' is nothing unless you can also 'walk the walk', and camera skills are equally important. With a background in film photography, using manual medium-format cameras, Ben has something of an old-school approach, even though he now also shoots digitally using Canon DSLRs. 'I still try and shoot manually as often as I can, and I prefer to use a light meter if time allows. If there isn't time to use a light meter, I'll use spot metering – possibly with Aperture Priority mode – to get the right exposure for the part of the face I want exposed correctly. I'll also bracket my exposures so I've got alternative options. Cameras are much better now at measuring light, but mistakes can happen, and I like to try and get the image right in-camera'.

▶ This was an incredibly simple shot that was lit using daylight from a window behind the camera, with a black screen placed behind the subject.

50MM, 1/60 SECOND @ f/4, ISO 100

▶ For this shot, I used a single studio strobe with a softbox. The light was flagged so no additional light fell on the grey background.

50MM, 1/125 SECOND @ f/8, ISO 100

As part of the process of getting it right in camera, Ben has a definite go-to lens, which is a popular choice among portrait photographers. 'My 85mm $f/1.2$ prime lens is stunning for portraits. If the location is uninteresting (such as a bland office) or the location has no relevance to the subject, shooting at $f/4$–$f/5.6$ will provide sufficient blur but keep the subject's face in focus. But for even more drama, I'd go to $f/1.2$ or $f/1.8$, although the focusing needs to be spot-on, otherwise the eyes can easily be out of focus, and that's no good. If I'm shooting in a location that's relevant to the subject, then I tend to shoot at $f/11$ if the lighting will allow'.

When it comes to lighting, Ben is happy to work with daylight, flash, or a mix of both, depending on how much time he has and where he is shooting. 'I prefer to use my Elinchrom studio lighting, because I'm in control of the direction and strength of the light, but if I'm on location, I'll sometimes work with daylight instead. When I'm shooting in bright sunligh,t I'll usually try and use a diffuser to soften the shadows on the face, but this can throw up exposure issues, as the light behind the subject will not be diffused and could get bleached out. If you want to keep the exposure for the subject and the background the same, then a reflector can be used instead. I tend to use white reflectors. Silver also provides a nice reflection, but you have to be careful to avoid hot spots on the face, especially at the tip of the nose and on the cheeks. It definitely helps to have someone with you to hold the reflector in the place'.

However, despite his continued success, Ben has a few words of caution for anyone looking to emulate him: 'The digital age has changed the way of life of a photographer. Once, you used to call on magazines in person and present your portfolio, and they got to know you as a person. Now, it's all done via email and websites, and the improvements in digital image quality and a reduction in the price of cameras has meant an influx of 'photographers' to compete with'.

You can find out more about Ben and his work by visiting www.benankerphotography.co.uk.

BEN'S TOP TIPS
- Have a plan for your shoot… and a backup plan!
- Research your subject and location so time is not wasted. If you're shooting in daylight, know what time of day the sun is going to be in the best position. If shooting in a studio, know what features you want to capture, or have a subject of interest to talk about to gain a rapport.
- Get your camera settings right before the shoot so you don't have the embarrassment of having to endlessly adjust your camera in front of your subject (and your client).
- If possible, have a second camera body in case something goes wrong, and you would otherwise have to reschedule the shoot.
- Always try and focus on the eye nearest the camera, as this is the first thing people look at in a portrait photograph. Use a single AF point or manual focus to achieve this.

▶ I love working in the studio with flash, because you have total control over the lighting. For this image, I used a beauty dish on one of my strobes.

85MM, 1/125 SECOND @ f/16, ISO 100

Shutter Speed & Movement

The shutter speed determines how long your film or sensor is exposed to the scene in front of you, which plays a pivotal role in how any subject movement is recorded.

PREVENTING CAMERA SHAKE

It's harder to hold a camera steady when it's at arms' length. If you have the option, holding the camera to your face and peering through an eye-level viewfinder is a more stable solution.

If you use a DSLR, then mirror slap can also cause camera shake. This is the result of tiny vibrations that happen when the mirror flips up inside the camera to make an exposure. To avoid this, some cameras have a mirror lock setting that triggers the mirror before the shutter. This is great if you're using a tripod, but usually impractical if you're shooting handheld.

All cameras use a shutter of some description that allows the sensor to receive light for a certain amount of time. On some point-and-shoot devices, this is likely to be an electronic shutter that turns the sensor on and off, while higher-end cameras tend to rely on mechanical, focal-plane shutters that sit just in front of the camera's sensor. The time between the shutter opening and closing is the shutter speed, which is typically measured in fractions of a second and full seconds. Most mirrorless cameras and DSLRs offer a shutter speed range in the region of 1/2000 second to 30 seconds.

If you are photographing a static subject, then it really doesn't matter what shutter speed you use. You can photograph a building using a shutter speed of 1/200 second, ½ second, or even 20 seconds, and you can be pretty certain that nothing's going to change in that time. However, if there's movement in the scene, then things can change while the shutter is open, and in photography, anything moving during an exposure will become blurred in your photograph. Therefore, the shutter speed you choose will determine how movement is photographed; a fast shutter speed will help you to freeze any motion, while a slower shutter speed will mean it appears as a blur.

Camera Shake

Your shutter speed can also help you to control camera shake. Camera shake happens when the camera moves during an exposure, and the shutter speed is just slow enough for that movement to blur the whole image. Thanks to improvements in camera- and lens-based anti-shake technology, it is increasingly uncommon, but it has not been eradicated entirely. Care should still be taken, especially if you're handholding the camera in low-light conditions and/or using a combination of a low ISO and small aperture.

The traditional rule of thumb is to use a shutter speed that is at least the reciprocal of the focal length being used. For example, you'd need a shutter speed of at least 1/100 second if you're using a 100mm focal length, 1/200 second with a 200mm focal length, and so on. However, this really is outdated advice in the digital world. Not only are some people naturally steadier than others, but it doesn't account for focal length magnification factors, the fact that some cameras are easier to hold steady than others, or anti-shake technology that can easily extend the safe speed by upward of 3 stops. So the best option here is to experiment with your camera and lens(es) to find the minimum shutter speed that you can handhold in the real world.

OPPOSITE This fun fair gave plenty of examples of how shutter speed can dictate the final image. The bottom-left Ferris wheel was shot at a high shutter speed, and is sharp – simple as that. The bottom-right photo of the same Ferris wheel used a very long shutter speed, with massive camera shake, and the result is less literal, more experimental. The top image shows how camera shake is relative – the spinning passengers on the ride are (somewhat) sharp, because the camera was stationary compared to them, but the background is streaked into oblivion.

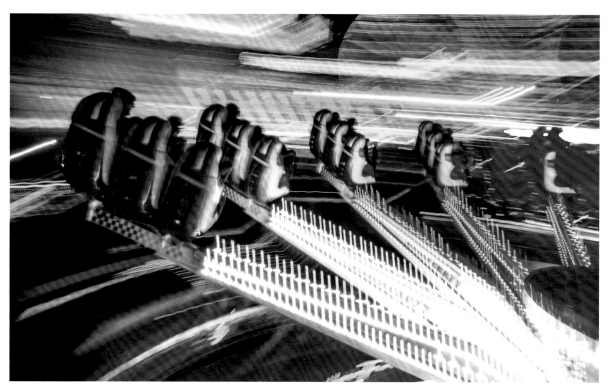

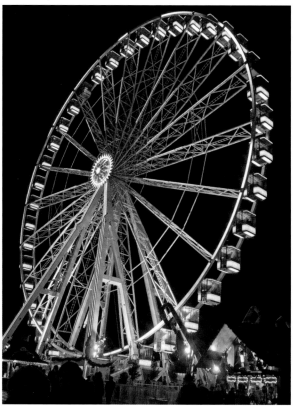

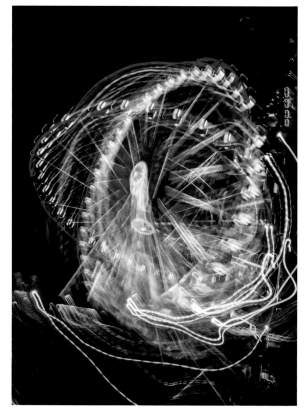

Freezing Movement

Moving subjects are problematic to still photography, as any movement across the frame during an exposure will appear blurred in the resulting image. However, preventing blur is relatively straightforward: You simply need to set a shutter speed that doesn't give your subject time to move. This doesn't necessarily mean that you need to pick the fastest shutter speed possible; you simply have to match the size of your subject, along with its speed and direction, to the speed of the shutter.

SPEED

The simple rule is the faster your subject is moving, the further it will move across the frame in any given time, so the faster the shutter speed needed to freeze it. However, the shutter speed needed to freeze someone walking is very different to the shutter speed required for a jet aircraft.

DIRECTION

The direction your subject is moving also plays an important part. A subject moving across the frame will appear to move much further in any given time than if it were moving toward or away from the camera. Consequently, faster shutter speeds are needed for lateral movement.

SIZE

The size of your subject in the frame will also determine how far it moves during an exposure: A subject close to the camera will appear to move further than a more distant subject, even if they're both traveling at the same speed.

A fast shutter speed is typically achieved by using a high ISO setting and/or wide aperture. However, the shallow depth of field that a wide aperture gives can make it harder to focus accurately, especially if you're tracking a very fast subject. In this situation, increasing the ISO might be preferable, although you could see an increase in noise.

A potential downside to freezing movement is that your subject can appear static; without any visual clues, it's impossible to tell just how fast it is traveling, if at all.

	SHUTTER SPEED	SUBJECT SPEED	SUBJECT SIZE IN FRAME	DIRECTION OF MOVEMENT
The speed, direction, and size of your subject in the frame all affect the shutter speed needed to freeze movement.	FASTER	FAST	LARGE	ACROSS FRAME
	SLOWER	SLOW	SMALL	TOWARD/AWAY FROM CAMERA

LEFT This photograph was taken handheld using an effective focal length of 240mm. That meant a fast shutter speed of 1/500 second was needed to not only freeze the moving subject, but also to prevent camera shake.

LEFT Subjects that are large in the frame need a faster shutter speed than smaller subjects moving at the same speed because any movement is more evident. Here, a shutter speed of 1/1600 second ensured this guy was tack-sharp.

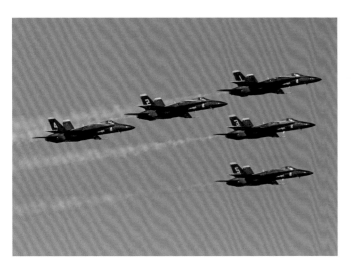

LEFT A super-fast subject traveling across the frame needs an equally rapid shutter speed to stop it in its tracks. In this instance, 1/1000 second was sufficient, but the general rule is to use the fastest shutter speed you can, even if this means increasing the ISO slightly.

Panning

Using fast shutter speeds to freeze movement is a great way of ensuring that every detail in your subject can be seen, but it does have one slight drawback: images can appear static. It's no small achievement to freeze a racing car hurtling down a straight at 200mph, but if everything's sharp, that car can look almost exactly the same as it would if it were parked in the pit lane.

A great way of injecting your shot with a sense of movement – but without your subject becoming unrecognizable – is to use a slightly slower shutter speed and pan the camera during the exposure, so you physically follow the subject with the lens as it passes you. This is a technique that needs a bit of practice – and even then, it can still be somewhat hit and miss – but if you're at an event where you can pretty much predict where the action will be (a motor racing circuit, for example), that will make it a fair bit easier.

The key thing to appreciate here is that you don't need to use a super-fast shutter speed. In fact, that would start to defeat the point of the exercise. Instead, you want to find a speed that gives you sufficient time to pan the camera and create a sense of motion, but without too much blur. Your ideal exposure time will depend a lot on the speed of your subject, but for motor racing (and similar subjects), start with a shutter speed of 1/60 second or 1/125 second and fine tune from there.

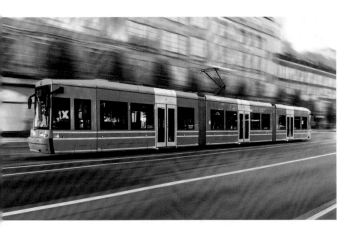

ABOVE Your shutter speed doesn't have to be ultra-slow to create successful panning shots. This tram was photographed using a relatively brief exposure of 1/50 second.

ABOVE Using Manual mode will give you full control over your panning shots (see sidebar opposite), but you can also use Shutter Priority. Here, the camera was set to Shutter Priority and the shutter speed was set to 1/25 second.

Panning Essentials

1 You don't need to use a super-fast shutter speed, so start by setting Manual mode and dialing in a shutter speed of 1/60–1/125 second.

2 To provide you with a decent depth of field, set an aperture in the region of ƒ/8–ƒ/11. Depending on the light levels, you may need to increase the ISO to enable this (or set the ISO to Auto).

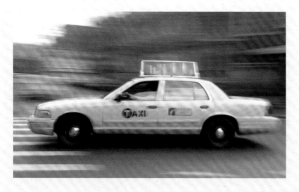

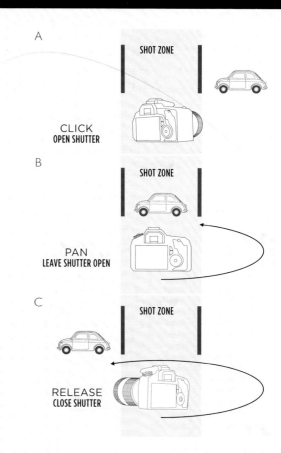

A

CLICK
OPEN SHUTTER

B

PAN
LEAVE SHUTTER OPEN

C

RELEASE
CLOSE SHUTTER

3 Switch the lens to manual focus and set the focus at the distance where you intend to photograph your subject. You might focus at infinity for distant subjects, such as boats and aircraft, or the point on a racing circuit where cars pass by every lap: this distance is effectively your shot zone. Be sure to deactivate any lens-based stabilisation, to prevent it trying to counter your panning movement.

4 With the exposure and focus locked, track your subject and just before it enters your shot zone, fire the shutter (A). Follow your subject with the camera (B) until the exposure ends, and then release the shutter button (C).

Exaggerating Movement

When you slow the shutter speed down, any movement during the exposure will start to become a blur. People can transform into ghost-like shapes, scudding clouds smear across the sky, and water takes on the appearance of silk. With the right intention and skill, you can employ these effects creatively. They're easiest to achieve when light levels are low, as this is when shutter speeds need to increase, especially when you set a small aperture to limit the amount of light entering the lens and a low ISO to restrict sensitivity. It perhaps goes without saying that the longer the exposure, the greater the blur, and you'll need to use a tripod or other camera support. Camera shake is inevitable if you shoot handheld.

However, you don't need to rely on dipping light levels and small apertures. Sometimes you may want to shoot long exposures during the day, or perhaps use a wider aperture to get a shallower depth of field. In either case, using filters over the lens is another great way of reducing the amount of light reaching the sensor. The filters to use are known as neutral density, or ND, filters, which act like sunglasses for your camera: They reduce the amount of light entering the lens, which naturally means you need to extend the exposure time. We'll take a closer look at ND filters on page 200.

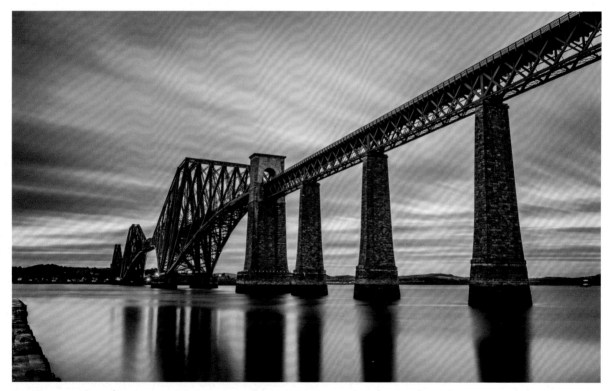

ABOVE Extending shutter speeds can give a photograph a calm, almost dreamlike quality. In reality we don't see water as smooth as this, or clouds that appear quite so silky. The long exposure introduces a serenity that we wouldn't usually experience.

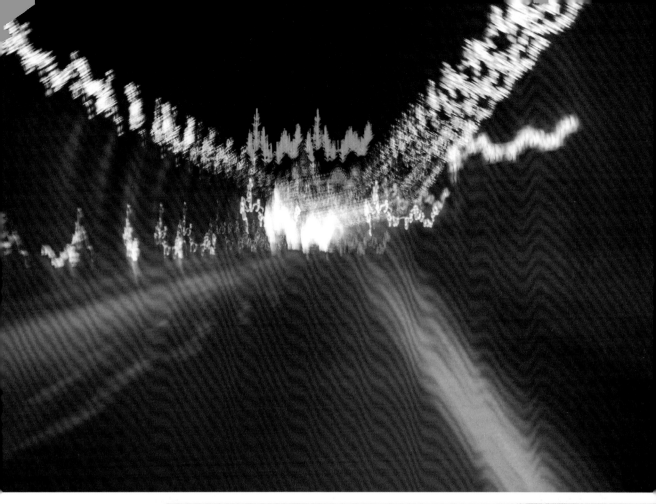

ABOVE This vibrant light-trail image was taken inside a neon-lit road tunnel from the passenger seat of a moving vehicle. Setting a slow (1½ second) exposure guaranteed a blurred result – this is an extreme example of camera shake.

RIGHT The use of an especially dark neutral density filter has turned the moving elements in this shot into ghosts – we can see the suggestion of people, but the streets are largely clear. Using super-extended exposures like this is a great way of clearing crowds from a scene!

STAR ALTERNATIVES

How your stars appear to trail across the sky will depend on the direction you point your camera: Stars will appear to rotate around the North Star (Polaris) in the northern hemisphere and around the South Star (Sigma Octantis) in the southern hemisphere. Point your camera at these stars and you will start to record perfectly circular trails; aim your camera away from them and the trails will arc across the night sky instead.

Because shooting star trails with a long exposure can increase noise, many people use a multi-shot stacking technique instead. This relies on making lots of relatively short exposures, that are combined using specialist stacking software. So, you might make 20 exposures, each lasting 30 seconds, rather than a single, 10-minute exposure. Once your 20-second exposures are combined, they will give you the same trail that you would get from a single, longer exposure. However, as the individual exposures will not be as noisy, the end result will be cleaner. Obviously, a tripod is essential here, and you should also switch off any long-exposure noise reduction.

Night Sky Exposures

Although the majority of your photographs are likely to be taken during daylight hours and measured in fractions of a second, the world around you transforms when you use exposure times that last minutes or even hours. After sunset when the light levels drop, our eyes become less sensitive to colour, so while we can often determine shapes, the world around us appears more monochromatic. Your camera doesn't have quite the same issues, though, so it can reveal colour that is imperceptible to the naked eye. In addition to this, extended shutter speeds can reveal the passage of time in a way that is unique to photography: We can photograph something as monumental as the rotation of the Earth!

Whenever your sensor is active – that is, when it's making an exposure – it starts to generate heat, which can introduce noise and hot pixels into your images (coloured speckles that are most obvious in dark areas of the picture). Most of the time, this isn't a problem, because shutter speeds are so short that the sensor doesn't get hot enough for noise to be created. However, the longer the exposure, the more heat builds up, and the more risk there is that noise will appear. It's for this reason that hardcore astro-photographers will often use specially cooled cameras and sensors for their astro-imaging adventures.

Another trick used to minimise long-exposure noise is known as dark-frame subtraction, which works because the noise created by long exposures is consistent for any given exposure time/temperature – this is known as fixed pattern noise. Consequently, two exposures can be made. The first is used to create the image, and the second is an exposure of equal duration that is made without the shutter opening (a dark frame). In theory, this second exposure should be black, as no light has reached the sensor, but in reality, it will exhibit the noise generated by the heat while the sensor is active. This dark frame can then be analyzed and the noise it contains can be removed from the main image.

This is essentially the same thing that your camera does when you activate long-exposure noise reduction, with the camera automatically taking, assessing, and applying the dark-frame subtraction before your image is sent to the memory card. While this works well, the downside is that two exposures of equal length are made every time you make an exposure of 1 second or longer – your main exposure and your dark frame. So, if your main exposure lasts five minutes, your camera will need another five minutes to make the dark frame. Clearly, this can slow down your shooting rate considerably.

there's an app for that...

Not sure where the North (or South) Star is? Apps such as Sky Guide: View Stars Night or Day (iOS) or Mobile Observatory – Astronomy (Android) tell you what's in the sky when you aim your device at the stars.

Star Trails

All you need to photograph star trails is a tripod and a remote shutter release with a locking mechanism, although you need to pick a clear night in a location with minimal light pollution (and ideally when it's a new moon).

1 Set your camera on the tripod and aim it at the sky, noting how the direction you point it in will affect the appearance of your trails (see sidebar on page opposite).

2 Switch your camera/lens to manual focus and focus at infinity.

3 Select Manual shooting mode. Dial in a low ISO (100–200), set the aperture wide (f/2.8–4 is ideal), and set the shutter speed to Bulb.

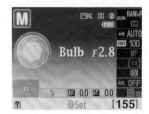

4 Trigger the shutter with your remote release... and wait. How long you make your exposure comes down to how long you want your star trails to be – the stars will appear to move 15 degrees every hour (0.25 degree every minute), so the longer your shutter is open, the more dramatic the results will be. Bear in mind that noise also increases with exposure time, though, and any light pollution will be amplified as well.

It may seem counterintuitive to set such a wide aperture, but you need your stars to appear as bright trails in the sky. Using a smaller aperture may mean they simply don't expose the sensor quickly enough to be visible.

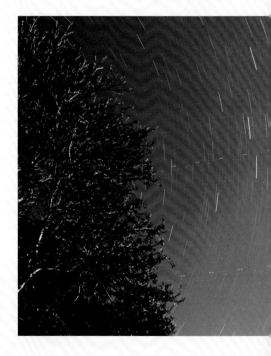

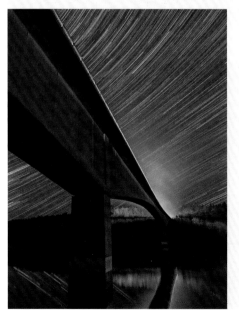

THIS PAGE Although you can simply aim your camera upward and shoot stars in the night sky, the strongest images include some sort of foreground (and perhaps even background) interest to create a much greater sense of place. However, you will usually need to set up your camera while it's still light, and balance the exposure carefully.

MASTERCLASS

SPORTS
Ian MacNicol

Ian MacNicol is an international, award-winning v photographer who has been fortunate enough to cover Summer and Winter Olympic Games, Paralympics, Commonwealth Games, World and European Athletics Championships, World Swimming Championships, Wimbledon Championships, as well as soccer World Cups, European Championships, Champions League Finals, and the English Premier League. His work regularly appears worldwide, in print and online, and he is a regular stringer and contributor to Getty Images.

However, Ian's career started on a much less auspicious scale, as he covered news, sports, and features for a newspaper. 'People noticed my sports pictures, and I was given more and more sports assignments. Consequently, my sports photography got better and better, until I was pretty much known as a sports photographer. It helps if you have a wide knowledge of all the different sports you shoot. That way, you will stand a better chance of anticipating what will happen next and get the shots that other people might miss'.

'Today, I shoot more soccer than anything else, but I think the ultimate achievement is to shoot the Olympic Games. The Summer Olympics only last for 16 days every four years, but it's some of the most emotionally charged sport you'll ever see – if a lifetime ambition comes together (or not) for an athlete, the pictures can be epic'.

To help him capture these once-in-a-lifetime moments, Ian relies on a pair of top-of-the-line Canon EOS-1D X Mark II camera bodies, which he describes as 'the best sports camera on the market'. However, unlike some areas of photography, where a second camera would be seen as a backup should the first fail, for Ian – like most sports photographers – both of his cameras are equally important. They enable him to work with different focal lengths without having to stop and change lenses (potentially missing a vital moment in the action).

For soccer, Ian's first camera will typically have a 400mm $f/2.8$ prime lens attached to record distant action. Then, as the action moves closer to him, he'll switch to his second camera, which will be fitted with a 70–200mm $f/2.8$ zoom. 'This is essential for shooting the goal mouth action – in soccer photography, capturing goals is the prime objective, closely followed by the subsequent celebrations'.

SPORTS ESSENTIALS

For the professional sports photographer, high-quality camera bodies and a selection of fast lenses are essential. However, regardless of your ability behind the lens, it's just as important to have waterproof protective gear for both you and your equipment; warm clothing for events that take place at night; and sunscreen and a hat for summer assignments.

▶ Ross Woolley of Edinburgh University competes in the 100m backstroke during the Scottish Championships at Tollcross International Swimming Centre in Glasgow.

520MM, 1/640 SECOND @ ƒ/2.8, ISO 1000

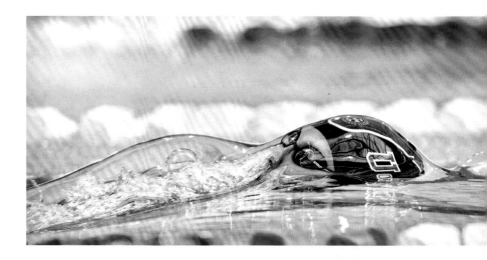

◀ Anatoly Vasilyev of Russia competes on the high bar at the finals of the Glasgow Grand Prix at The Kelvin Hall.

390MM, 1/640 SECOND @ ƒ/2.8, ISO 1250

▼ Ellie Cole of Australia dives into the pool during day seven of The IPC Swimming World Championships at Tollcross International Swimming Centre, Glasgow, Scotland.

85MM, 1/2500 SECOND @ ƒ/4, ISO 2000

Because sport is typically fast moving, capturing the moment is always going to be a challenge in terms of exposure and focus. To help ensure his shots are sharp, Ian relies on the EOS-1D X's superb 61-point AF system, selecting a single AF point manually and using that to get a lock with his lens. He also uses the camera's Evaluative metering to gauge his exposures, although he sets the parameters himself. 'I like to use a shallow depth of field to give my photographs more impact and to separate the subject and the background. High shutter speeds are also important to freeze the action, so generally I shoot in Manual so I am in total control. I would always hope to capture the decisive moment, but this is usually obtained by little bursts of two or three frames, rather than continuously just holding the button down'.

While most other genres of photography would see Raw files as their number one choice, this isn't the case for Ian: 'I see the benefit of Raw files, but one of the key elements of my day-to-day work is not only capturing the best sporting images, but transferring them from the venue to their final destination, whether that's a newspaper or websites. Raw files would be too large and time-consuming, so I shoot large JPEGs. This means that when I shoot soccer I essentially shoot live. My photos are transmitted back to an editor as they're shot, and he then captions and crops as necessary. So, other than me choosing the images I like, the editorial control is out of my hands'.

There is another reason why Raw is unnecessary for Ian's work, and that has to do with accuracy of the image. Like photojournalism and documentary photography, sports images need to be faithful to the subject. This means nothing should be added or taken out (using cloning tools), and any image editing should stay within the parameters of what could be achieved in a darkroom – exposure, contrast, and minor colour tweaks, but nothing more. This arguably makes shooting sports even harder, as most of the processing has to be done in-camera. You need to know precisely which picture parameters to set and which to avoid, and there's simply no room for a shoot now, correct later mentality.

To see more of Ian's work, check out his website at www.ianmacnicol.com.

IAN'S TOP TIPS

- If you're serious about getting into sports photography, buy the best lenses you can afford. If it doesn't work out, they will retain a good resale value, so don't be afraid to invest in yourself.

- Never be afraid to show up. Sometimes people ask me, 'Is it worth going to this event? Will you get a picture?'. My answer is always, 'I'm not sure, but if I don't go, I won't get anything'.

- Try to shoot from your subject's eye-level – it's simple, but effective.

- Many people think that large events produce the best photographs, but this is not always the case. Smaller events are much easier to gain access to, and there will be fewer restrictions on where you can go to take photographs.

▶ The Spanish 4km pursuit team take 5th place at The UCI World Championships, Appledoorn.

390MM, 1/640 SECOND @ ƒ/2.8, ISO 1250

▼ In April 2013, weather forecasters predicted epic windsurfing conditions on the Isle of Lewis. Professional Northern Irish windsurfer, Timo Mullen, abandoned a windsurfing trip in Hawaii after only three days there and raced to meet up with colleagues on the remote Scottish island.

400MM, 1/2500 SECOND @ ƒ/6.3, ISO 2500

ISO & Noise

When film ruled the roost, ISO wasn't a particularly major player in regards to exposure. But digital photography has given it a leading role. Thanks to the ability to change ISO from one exposure to the next, we have more creative control than ever before.

When you shoot with film, you can choose to load your camera with a roll of ISO 100 film as opposed to ISO 400, but that's about the only ISO decision you have to make until your whole film is shot. Certainly there isn't the freedom to shoot one frame at ISO 100, the next at ISO 400, and a third at ISO 800, as there is with digital cameras. Nor is there the range of ISO settings that are now relatively common with most mirrorless and DSLR cameras. ISO 409,600 is currently the latest eye-watering figure to grab headlines, whereas film peaked at ISO 3200. Yet, while this impressive ISO ability endows cameras with an almost night-vision-like quality, it's important to understand how this is achieved and how ISO has evolved since its crossover to digital technology.

Film ISO – or film speed – is based on the light sensitivity of silver halide crystals used in the gelatin emulsion to form a latent image: the larger the crystals, the better their light-gathering properties, and therefore the more sensitive the film is to light. When the film is developed, the chemical process creates either a negative or a positive image, with the crystals becoming random grains that may or may not be evident when the film is printed, scanned, projected, or viewed in some other way. The simple equation is the higher the ISO, the larger the grain, and the more noticeable it will be.

Although digital cameras have held onto the ISO designation, the way in which it is implemented is fundamentally different. Now, this might seem strange when so many people describe the seemingly adjustable metric of ISO as the sensitivity of the sensor, but like a single roll of film, a digital camera's sensor has a fixed sensitivity to light. I'll explain how sensors work later on (see page 164), but in a nutshell, the sensor in your digital camera does not change its sensitivity. Ever.

Instead, what happens when you increase the ISO setting is that the signal from the sensor – the light that's reached your sensor and been converted into a digital form – is amplified. So, a weak signal generated by low levels of light reaching the sensor is strengthened to make the resulting image more obvious. The common analogy is that digital ISO is like turning up the volume on a radio to hear a faint signal a bit better. The signal itself doesn't change, but turning the volume up means you can hear it more clearly.

Of course, with an old-school analog radio, cranking up the volume also makes any background hisses and other unwanted sounds more obvious. The same thing happens when you amplify the signal from your camera's sensor: as well as making the image stronger, increasing the ISO exacerbates any non-image-forming artifacts. In photography, these unwanted artifacts are what we call noise, and the higher we go with the ISO, the more obvious it becomes.

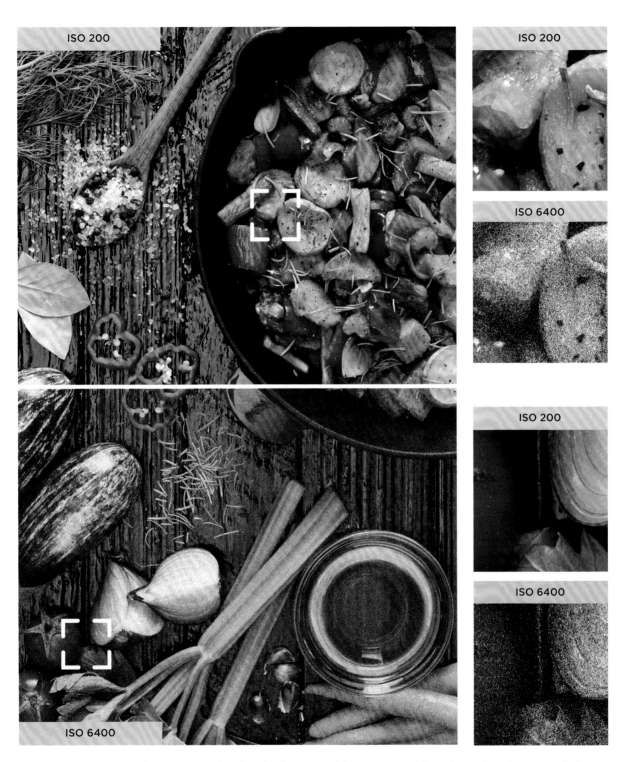

ISO 200

ISO 200

ISO 6400

ISO 200

ISO 6400

ISO 6400

ABOVE A direct comparison of ISO settings is largely redundant, as different cameras exhibit different characteristics, but the overarching fact is that as ISO increases, so does noise. The point at which noise becomes unacceptable depends on you and your camera, so it's worth experimenting to see what's desirable. Personally, I don't mind a bit of grit in my images (a throwback to my love of fast, grainy, high ISO films).

NATIVE VS. EXPANDED ISO

A lot of cameras have what are known as expanded ISO settings, which are usually indicated by an L (Low) or H (High) before them – so you may have H1 and H2 options, in addition to a numbered ISO range. However, there's usually a good reason why these don't form part of the camera's normal ISO range, so such settings should be used with caution. For example, the expanded rating may not conform to the ISO standard, making it a guide rather than an absolute measurement (and explaining why some settings are described as being equivalent to an ISO value), or it might be achieved using additional processing, so the image is exposed at a native ISO setting, but processed to appear as if it were taken at a higher/lower setting. In either case, image quality is usually compromised in some way, so expanded ISOs should be seen as a last resort, rather than a go-to option.

Types of Noise

There are two types of noise in digital photographs: fixed-pattern noise that can occur when you use long exposures, and random noise that is what affects your high-ISO images. This random noise exhibits itself in two ways – often simultaneously – both of which can degrade your photographs.

LUMINOSITY NOISE

Luminosity – or luminance – noise reveals itself as an underlying texture, most evident in mid-to-dark tones, where it can affect the smoothness of a plain dark sky, for example, and disrupt fine detail. On its own, luminosity noise doesn't affect colour; for this reason, some people refer to this type of noise

CHROMA NOISE

While luminosity noise can sometimes be accepted in an image, the same can't be said of chroma noise, which is rarely seen as a good thing. Chroma noise introduces coloured blotches which not only disrupt fine detail, but also affect the appearance of colours. The random nature of this noise also means that it is harder to remove.

Noise Control

With noise being an unavoidable factor in digital photography, it's not that surprising that manufacturers and developers alike have gone to great lengths to not only minimise how and when it appears, but to also develop sophisticated ways of reducing its appearance. This has been crucial in facilitating those super-high ISOs that have become commonplace, but what is perhaps more useful to photographers is the effect that improved noise control has had lower down the ISO scale, on the real-world settings that are more often used on a regular basis.

In the not-so-distant past, you wouldn't be surprised to see noise affecting images at ISO 800. Now, shooting at ISO 1600 or even ISO 3200 is possible on some cameras with no significant loss of quality. As a result, these settings are no longer seen as extreme, but as acceptable, usable, everyday options. Consequently, this allows us to jockey the ISO more than we might have done before, which means we can choose from a wider range of aperture and shutter speed combinations for our shots.

LEFT This shot was taken at the camera's maximum ISO setting, which reveals a lot of chroma and luminosity noise (above). Rather than try and reduce it, I decided to make a feature of it when I processed the shot, deliberately exaggerating the coarse texture. This is perhaps the only time I haven't found intense chroma noise objectionable.

Of course, there is still a point where noise becomes unacceptable, although where this point falls will depend on your camera, how big you're going to use the image, and (to a lesser extent) personal taste. A simple exercise here is to shoot a fairly detailed, static subject at all your ISO settings and view the results at a range of sizes to see what is and isn't acceptable to you. Shooting a sheet of newspaper stuck to a wall is a crude-but-effective solution, as it will quickly enable you to see the point at which fine lettering is eaten away by noise.

It's also worth exploring the various noise-reduction options you have open to you, as this can make a significant difference. Most mirrorless cameras and DSLRs have built-in noise-reduction (NR) features, usually with separate options for tackling long-exposure noise and high-ISO noise. However, unless you shoot JPEGs and intend to use your images straight from the camera, high-ISO NR is invariably best left switched off. The reason for this is that you can apply noise reduction to Raw files when you process your shots, and your image-editing software is also likely to have some sort of noise reduction feature that can deal with JPEGs. In both cases, you'll have a lot more control over what type of noise is targeted (luminosity or chroma) and how vehemently. We'll look at noise reduction in greater detail on pages 322–323.

RIGHT Shooting in low light with a high ISO setting is a surefire way of seeing just how noisy your camera is. Thankfully, most image-editing software has the ability to reduce the noise in your shots, although it's equally capable of removing detail in the process!

WITHOUT NOISE REDUCTION

WITH NOISE REDUCTION

Shooting Modes

The shooting mode determines how much (or how little) control you have over the aperture, shutter speed, and ISO, allowing you to decide whether you want to call the shots, or have the camera do some or all of it for you.

The range of shooting modes varies from camera to camera; smartphones, tablets, and point-and-shoot compacts may offer little more than fully automatic shooting, while high-end compacts, mirrorless cameras, and DSLRs will typically allow you to take more control with the turn of the mode dial.

Auto

When you set your camera to Auto, you become a passenger on the photographic journey. Typically, your only involvement will be pointing the camera in the right direction. This hand-off approach is why Auto is often labelled as a 'dummy' mode, with some people claiming you can't be a proper photographer if you use it to take your pictures.

However, that does Auto a great disservice. Many smart devices are essentially auto-only, yet still quite capable of taking a great shot. And some mirrorless cameras and DSLRs have incredibly sophisticated Auto modes that have libraries of tens of thousands of reference images that are used behind the scenes to help the camera determine what it is you are photographing and how best to achieve the optimum result.

Yet despite its potential sophistication, with Auto, you are shut out of the creative process, with the camera determining what aperture, shutter speed, and ISO to use, as well as deciding other parameters, such as the file format (typically JPEG only), focus, white balance, saturation, sharpness, and whether to use flash. In every instance, it will aim to use settings that are as close to average as possible, which may produce a well-exposed, correctly focused, colour-correct image, but it may not produce an exciting one.

SCENE INGENUITY

Scene modes don't just have to be used for the subject they relate to; you could use Sports/Action mode in any situation that you want a fast shutter speed, or Portrait mode to encourage the camera to set a wide aperture. However, if you find yourself starting to make these types of decisions, you may be better off exploring Shutter Priority or Aperture Priority mode instead.

FLASH OFF AUTO

An increasing number of cameras have two Auto modes: a full automatic mode where the camera makes every decision, and a Flash Off option, where the camera makes every decision, but will not fire the flash.

ABOVE For this shot, the average settings of the camera's Auto mode were all that I needed.

Scene Modes

Scene modes are a step up from full Auto, in that certain parameters are adjusted depending on the mode you choose. Set Landscape mode, for example, and the camera is likely to use a small aperture to create a large depth of field, while boosting blues and greens to enhance land and sky; set Portrait mode, and a wide aperture to throw the background out of focus and more muted colours to preserve skin tones are used. Switch to Sports mode and you can expect fast, motion-freezing shutter speeds. Although this gives you a modicum of control over the camera (you are at least telling it the type of subject you are photographing!) many shooting decisions are still out of your hands, with the camera ultimately choosing the exposure, focus, and colour balance.

RIGHT Portrait mode is optimised for... portraits, which is great when all you want to do is point and shoot,without worrying too much about the camera settings.

MODE	ICON	TYPICAL SETTINGS
LANDSCAPE		• Small aperture for expansive depth of field • Increased saturation of greens and blues
PORTRAIT		• Wide aperture to throw background out of focus • Neutral colours to preserve skin tones
SPORTS/ACTION		• Fast shutter speed to freeze movement • Continuous focus to track subjects
CLOSE-UP		• Small aperture to maximise depth of field • Shutter speed set to minimise risk of camera shake
SUNSET		• White balance doesn't compensate for warm colours • Increased colour saturation
NIGHT PORTRAIT		• Flash used to illuminate the subject • Long exposure used to expose the dark background

Program

When you set the mode dial on your camera to Program (P on the mode dial), you start to enter what some manufacturers refer to as the creative modes (also commonly referred to as the PASM modes, because they comprise Program, Aperture Priority, Shutter Priority, and Manual modes). These are the modes where you start to choose how your pictures look, rather than the camera. Program is the ideal starting point if you've previously been wedded to Auto, as the camera still chooses the aperture and shutter speed for your shot, so you don't necessarily have to worry about setting the exposure.

However, unlike Auto, you are not locked out of the shooting process. You are (usually) free to choose the ISO setting, the metering pattern (more on that shortly), as well as many other picture parameters, including white balance and picture styles (see the sidebar on the left). More importantly, Program allows you to adjust the aperture/shutter speed combination using Program Shift (see the sidebar on the opposite page). This immediately gives you more control over how your photographs look, enabling you to use a wider aperture to throw the background out of focus, for example, or a smaller aperture to increase depth of field, a slower shutter speed to introduce motion blur, or a faster shutter speed to freeze a moving subject.

ABOVE I selected the Standard Picture Style for this series of shots at a buggy race. The Standard setting on a Canon camera provides vivid colour, saturation, and sharpness.

Using Program Shift

1 With your camera's mode dial set to P, press halfway down on the shutter-release button, and the camera will show you in the viewfinder or on the rear LCD screen the aperture and shutter speed it's intending to use.

2 If you want to adjust the exposure, you'll need to turn the control wheel on your camera. Turning it one direction will make the aperture wider and the shutter speed faster; turning it in the opposite direction will close the aperture down and make the shutter speed longer.

3 The great thing about Program Shift is that when you make a change, the camera will do its best to ensure the overall exposure stays the same. This means you don't have to worry about your photograph coming out too dark or too light.

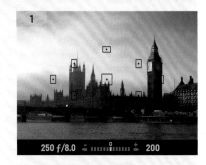

250 f/8.0 200

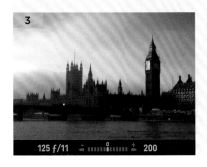

125 f/11 200

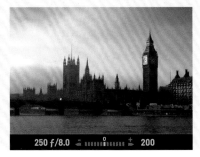

250 f/8.0 200

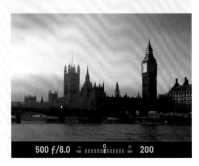

500 f/8.0 200

ABOVE There wasn't a lot of light for this quirky museum exhibit, so because I was shooting handheld, I needed to raise the ISO and shift the exposure to give me a faster shutter speed.

LEFT Program mode wanted to set an aperture of f/8 here, but I wanted to minimise the depth of field. The simply meant shifting the exposure pair so the aperture was f/1.8 instead – the camera adjusted the shutter speed accordingly.

Priority Modes

The priority modes are seen as a step up from Program, in that you take a little more control over exposure and other parameters. In Aperture Priority mode (A or Av on your mode dial), you set the aperture and the camera will decide which shutter speed will give you the correct exposure; in Shutter Priority mode (S or Tv on your mode dial), you choose which shutter speed is used and the camera selects the most appropriate aperture. In both instances, you can also set the ISO manually, or stick it on Auto and allow the camera to decide that as well.

Priority modes are most useful when you know that you want at least one of your exposure controls to be fixed, but are happy to let the camera choose the other(s). For example, you might be shooting a landscape under broken cloud cover, with the sun making fleeting appearances and having varying effects on the light levels. If you shoot using Program (or Auto), your camera is likely to be changing the exposure constantly, tuning the aperture and shutter speed to match the prevalent lighting conditions, which will affect the depth of field on a shot-to-shot basis. However, switch to Aperture Priority, and you can ensure that the aperture doesn't change. So, if for example, you want the deep depth of field offered at a small aperture of $f/16$, simply dial in $f/16$, and the camera will only adjust the shutter speed (and ISO if it's set to Auto) to maintain a constant exposure.

Similarly, if you're shooting racing cars, for example, you might want to set Shutter Priority and dial in a fast, motion-freezing shutter speed to guarantee sharp results. The camera can then adjust the aperture to give you what it thinks is the correct exposure.

The drawback with priority modes is that it's possible to drift outside the range of achievable exposures. Although the camera will warn you when this is going to happen (usually by displaying something in the viewfinder or on the rear LCD screen), it won't prevent you from taking a shot that it knows will be over- or underexposed. This out-of-range exposure is most likely to happen in Shutter Priority mode when you want to use an extremely fast or slow shutter speed. Most cameras have far more shutter speed options than aperture settings, making it harder to pair the two. In this case, setting the ISO to Auto can help, as it provides the camera with another adjustment option.

ABOVE For this abstract shot, I wanted to move the camera along and across some trees during a long exposure, to blend and blur the silvery-white bark with the gentler colours in the background. The answer was to set the camera to Shutter Priority mode and dial in a slow shutter speed (here, ⅙ second).

ABOVE This painted wall wasn't going anywhere, so shutter speed wasn't an issue. Instead, I shot in Aperture Priority mode, setting an aperture that would keep everything sharp. The image was then converted to black and white, and subsequently processed in the CameraBag 2 app.

ABOVE The depth of field was already shallow, thanks to the close camera-to-subject distance, but I wanted to further minimise it through the aperture setting. The answer? Set Aperture Priority and dial in ƒ/4.

Manual

When you switch to Manual (M on your mode dial), you take full control of the aperture, shutter speed, and ISO. Although your camera is there to guide you toward the correct exposure, it's not going to interfere with what you're doing, so you're free to get the exact exposure you want, no matter how dark or light that is. It also means you can quite easily get it wrong, although the instant review and histogram (see pages 76–79) on the back of your digital camera will quickly let you know if that's the case, enabling you to reshoot. If you're shooting film, then you're in for a potential disappointment when it's processed.

Although you could shoot in Manual all the time (and some people do), it really comes into its own when you're using a grey card, a handheld meter, spot metering from multiple areas, or you want to lock the exposure down so there's no risk of it changing. The latter is useful if you're shooting a panoramic image or focus

stacking. If you're not doing any of these things, then you can usually get the same result using a priority mode and exposure compensation, but without quite so much risk of things going wrong. (By the way, if you're seeing terms here that you don't yet understand, don't worry! They will be explained throughout the course of this book, and you can always check the index for a quick reference as needed.)

There is one occasion where manual exposure becomes compulsory, and that's when you set the shutter speed to B (Bulb). When you do this, you are free to hold the shutter open for as long as you like (or for as long as your battery holds out), enabling you to shoot star trails, paint with light, or do anything else that needs the shutter to be held open for longer than the camera's slowest shutter speed. You'll find the B setting on your camera's mode dial, or by dialing past the camera's slowest shutter speed (usually 30 seconds).

BELOW Certain multi-shot techniques, such as stitched panoramas, rely on consistent exposure settings. Shooting manually is the only way to guarantee your exposure won't change from one shot to the next.

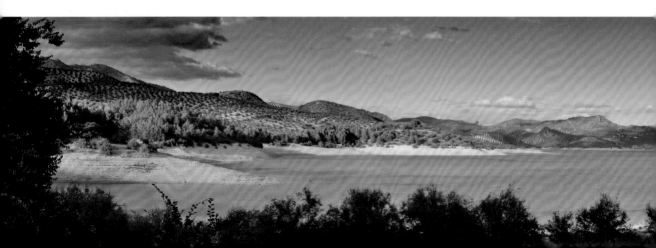

Using Manual Exposure Mode

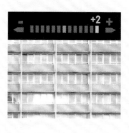

I Setting the exposure manually will typically rely on an exposure scale that you can see in the viewfinder or on the rear LCD screen. This usually consists of an exposure bar that indicates the level of exposure, with a 0 or an arrow at the centre, and an exposure level indicator beneath it.

2 Increasing the exposure (by opening up the aperture, using a slower shutter speed, or raising the ISO) will move the exposure indicator to the right, toward a + icon. When this happens, the camera tells us the image will be too bright (overexposed).

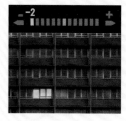

The further the exposure indicator is from the centre, the more pronounced the overexposure will be.

3 When you decrease the exposure (by closing the aperture, using a faster shutter speed, or lowering the ISO) the exposure indicator will move to the left, toward a – icon. This is the camera telling you that the image will be too dark (underexposed). The further the exposure

indicator is from the centre, the more pronounced the underexposure will be.

ABOVE Learning to set the aperture and shutter speed manually – perhaps in conjunction with using a handheld exposure meter – is a great skill to have, as it lets you explore a whole range of cameras. This shot was taken with a square-shooting Bronica SQ-A medium-format camera. As the camera is fully manual, shooting any other way isn't an option.

4 To set the exposure recommended by the camera, adjust the aperture, shutter speed, and/or ISO until the exposure indicator is central (directly under the 0 or arrow).

Often, this will involve setting the ISO first (to determine image quality), then either the aperture or shutter speed (depending on whether depth of field or motion control is most important). Finally, the third setting is chosen to give the correct exposure.

Exposure Metering

Exposure metering is all about measuring the brightness of the scene you want to photograph and translating that into the exposure settings – aperture, shutter speed, and ISO – you need to get your shot.

Before we look at how you can 'read' the light, we first need to appreciate the way the light meter in a camera works. To start with, in-camera light meters take what are known as through-the-lens (TTL) reflected light readings. This means they measure the light being reflected off your subject and entering the camera through the lens.

The camera is essentially assessing the same light we see when we look at the world ourselves, but there's one important difference. Whereas we can appreciate the differences between a bright scene and a dark scene (we see snow as white, for example, and nighttime as being dark), your camera assumes everything it's aimed at is tonally average.

The easiest way to understand this is to imagine that every scene you photograph is a fresh oil painting that's been painted with black and white paints: The brightest highlights might be white, the deepest shadows black, and everything in between will be a shade of grey. Your camera's light meter would look at this and essentially mix all the wet paint together until it's a single shade of grey. It would then suggest an exposure that would render that grey mix as mid-grey (this shade of grey is also

referred to as 18% grey, as this is the amount of light it reflects).

Now, this is great if all the tones in your scene average out to mid-grey when they're mixed together, and a lot of times that's precisely what happens. The bright sky in a landscape might be countered by a dark foreground, for example, so when the camera averages out the bright and the dark it may well end up with that average midtone.

However, it's not always the case. A snow scene would average out as a much lighter grey, perhaps almost white, while the darkest night would average out as to be much darker grey, closer to black. In both cases, your camera will still set an exposure that gives that mid-grey average. The result? That snow scene will look too dark (underexposed) and that night shot will be too bright (overexposed). Thankfully, as you'll see, your camera probably has plenty of tools that will help you identify, prevent, and perhaps even correct this before the exposure is saved to your memory card.

BELOW This relatively simplistic graphic shows how a camera would typically see this scene and determine the exposure based on a mid-grey average. The problem is, the walls and shutters should be lighter than average, so the camera's exposure is a little dark for my liking. An exposure that's ½-stop brighter would be preferable.

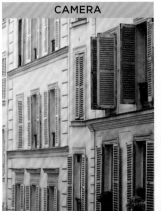
CAMERA

+½ STOP

Metering Patterns

To read the light in your scene, your camera will offer one or more metering patterns. Unless you're using Auto or a Scene mode (or a camera with a single metering option), this lets you tell the camera which part of the scene it should read the light from.

MULTI-AREA

This is a catch-all term for the default metering pattern on most cameras. Different manufacturers call it different names, such as Evaluative (Canon), Matrix (Nikon), Segmented (Pentax), and Multi (Sony), but they all work in broadly the same way: The frame is broken down into multiple areas, and the light is measured for each of these zones. The camera then averages out the individual light readings to determine the overall exposure. Depending on the camera and lens, some multi-area metering patterns will also take the focus point into consideration, and – assuming the area you've focused on is your main subject – shift the exposure to best expose that point. It may also call on a database of reference shots, which give it an idea of what it is you are photographing, and how best to expose it.

Because it measures the entire scene, multi-area metering is a great go-to mode, but it can be influenced by large areas of light or dark tones in an image.

If you're photographing someone against a particularly bright background, the background could have an unwanted effect on the exposure, making it darker than it should be. It is safe to say that if you want the exposure for an image to be determined based on a singular portion of the frame, then it is best to employ one of the camera's other metering modes.

CENTRE-WEIGHTED

Before multi-area metering became commonplace, centre-weighted metering was often the most widely used metering pattern; it was often the only option on a lot of manual 35mm film SLRs. However, just because it's been around for decades, that doesn't mean it's obsolete. While multi-area metering can be thrown off by very bright or very dark areas at the edge of the frame, centre-weighted metering pays the edges far less attention, concentrating instead on the central area of the frame. So, for those backlit portraits, it's definitely worth a go, although it's fair to say that in most other situations, multi-area metering will usually turn in a more accurate result.

BELOW At a basic level, multi-area metering works by splitting the image into a number of distinct areas (the number varies depending on the camera you're using). These segments or zones are measured individually to determine the most appropriate exposure overall.

BELOW Centre-weighted metering biases the exposure toward the centre of the frame. This is particularly useful when your subject is central and surrounded by an overly bright or (as here) overly dark background that might otherwise influence the camera into under- or overexposure.

SPOT METERING

Spot metering turns your camera into
an ultra-precise light-reading tool, which
can measure the light falling on an area
that occupies maybe as little as 2% of
the frame. On some cameras, this area
is fixed at the centre of the frame, while
on others, it can be moved around the
frame or linked to the focus point for
even greater flexibility. This is incredibly
useful for taking light readings in the
most challenging conditions, but it works
only if you successfully identify a midtone
to take your exposure reading from.
If you base your exposure on anything
other than a midtone, you risk immediate
under- or overexposure. For this reason,
spot metering can be incredibly frustrating
to start with, and it can take a lot of
practice before you get used to reliably
spotting those midtones. However, once
mastered, it is an exceptionally accurate
exposure tool.

PARTIAL METERING

Partial metering can be thought of as a
smaller centre-weighted or larger spot
metering pattern, as it sits somewhere
between the two. As with centre-weighted
metering, the brightness is read from the
centre of the frame, but from a much
smaller area. This is great when your
subject is small and central, or you want
to take a light reading from a more specific
part of the frame – a shaded hillside in an
otherwise sunny landscape, or a single
grey rock in a backlit river perhaps.

Exposure Lock

Sometimes you'll need to take an exposure reading from a different part of the scene to the area you want to photograph. It might be because you know a particularly bright or dark part of the scene is going to affect the exposure (so you want to exclude it from the frame when you take your exposure reading), or you might want to take a spot reading from a midtone area that's not central in the frame. In either case, using exposure lock and reframing will help you out.

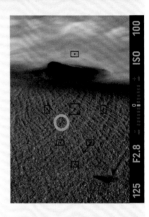

I Aim your camera at the area you want to take your meter reading from to exclude any unwanted light or dark elements, or – as here – so your spot meter area sits over your midtone target.

2 Press your camera's exposure lock button to lock the exposure. This button is usually marked AE-L* (Auto-Exposure Lock) and on the back right of the camera where it can be reached easily with a roving right thumb.

3 Reframe your shot so it's composed as you want it. On some cameras, you need to keep the AE-L button pressed while you do this, while on others, AE-L is activated with a single press of the button (and deactivated when you press it again or take a shot). In either case, you need to press the shutter-release button down fully to take your shot.

Note: Exposure lock usually shares the same button as focus lock, so pressing it may lock exposure and focus together. To avoid this you will need to change your camera's settings. There's usually an [Assign AE-L/AF-L Button] (or similar) option in the menus. This will typically allow you to set whether the button locks the exposure and focus together; only locks the exposure (allowing the focus point to change); or just locks the focus (allowing the exposure to be changed).

METERING PATTERN	GOOD FOR...	CAN STRUGGLE IF...	YOU MIGHT USE IT WHEN...
• Multi-Area	• General photography	• Subject is very light • Subject is very dark	• You want to set the exposure with minimal fuss (or thought)
• Centre-Weighted	• Shots where a medium-bright subject is surrounded by dark or light areas	• Subject isn't central • Subject is very bright • Subject is very dark	• You're taking a portrait against a particularly bright or dark background
• Partial	• Taking an exposure reading from a more precise area than centre-weighted metering	• The area you meter from doesn't average out to a midtone	• You're shooting a landscape and don't want a bright sky to influence the exposure • You're taking a portrait of a smaller/distant subject against a light or dark background
• Spot	• Ultra-precise light readings from a tiny part of the scene	• You don't take your reading from a midtone area	• You're shooting in Manual mode • You can readily identify a midtone (or are using a grey card) • You want to measure the exposure difference between two parts of the scene

Ultimate Accuracy

While your camera's built-in light meter will do a great job a lot of the time, the simple fact is that it's always going to be thrown by predominantly light or predominantly dark subjects. This is because it bases its exposure readings on the light being reflected off the subject, which it wants to average out to that mid-grey tone we looked at on page 72.

A very simple solution to this is to carry a photographer's grey card. This distinctly unsexy item of photographic paraphernalia is nothing more than a grey card with 18% reflectance – the exact midtone your camera craves. As long as the card is held in the same light as your subject, you can take an exposure reading from it (ideally using your camera's partial or spot metering pattern) and that will be the perfect midtone exposure. Of course, you might want your shot to be a little lighter or darker than average, but that grey card reading will give you a very precise start point.

An equally old-school approach is to use a handheld light meter to take your light readings, rather than relying on the camera. The key benefit is that most handheld light meters can take incident light readings (as well as reflected readings), which means it reads the light falling onto your subject. This means a handheld light meter isn't swayed by the brightness (or otherwise) of your subject, and instead it's measuring the light itself.

Handheld light meters aren't for everyone, though. For a start, they're slower to use – you need to take a light reading with your handheld unit, and then transfer it to your camera, which you'll need to use in Manual mode. So straight away, a handheld meter isn't the best option if you're shooting fast-moving action, or something under constantly changing lighting. If you use filters, they can also complicate things, as the reading you get from the light meter isn't 'through the lens', so it doesn't take any filters into account. You'll have to factor those into your exposure yourself.

On the flip-side, a handheld light meter that can read both flash and ambient lighting can be a real life-saver when you're using studio strobes (or any other non-dedicated flash unit), or want to mix flash with ambient lighting. Unlike your camera's meter, a handheld unit will be able to read that split-second flash, allowing you to meter even the most complicated mixed-light setups.

ANATOMY OF A LIGHT METER

The Sekonic L-308s is a great introduction to the world of handheld light meters. It can take both reflected and incident light readings; measure flash as well as ambient lighting; and give readings in 1/10-stop increments.

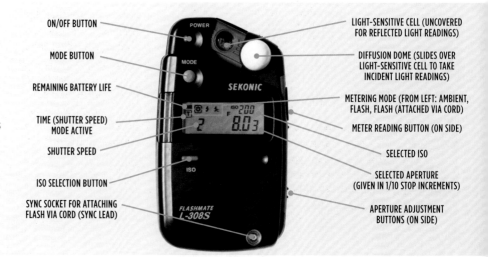

ON/OFF BUTTON

MODE BUTTON

REMAINING BATTERY LIFE

TIME (SHUTTER SPEED) MODE ACTIVE

SHUTTER SPEED

ISO SELECTION BUTTON

SYNC SOCKET FOR ATTACHING FLASH VIA CORD (SYNC LEAD)

LIGHT-SENSITIVE CELL (UNCOVERED FOR REFLECTED LIGHT READINGS)

DIFFUSION DOME (SLIDES OVER LIGHT-SENSITIVE CELL TO TAKE INCIDENT LIGHT READINGS)

METERING MODE (FROM LEFT: AMBIENT, FLASH, FLASH (ATTACHED VIA CORD)

METER READING BUTTON (ON SIDE)

SELECTED ISO

SELECTED APERTURE (GIVEN IN 1/10 STOP INCREMENTS)

APERTURE ADJUSTMENT BUTTONS (ON SIDE)

ABOVE The dark foreground and lighter background in this shot needed careful metering to ensure detail wasn't lost in either area. Using a handheld light meter avoided any problems caused by the subject's brightness, and the histogram (see page 76) shows a good spread of tones. There's a slight amount of clipping in the extreme highlights, but as this only affects the upper right corner, it could easily be resolved by cropping.

LEFT This modern take on the classic grey card folds into a small pouch and pops up when you need to use it – a lot like a commercial reflector, but smaller. One side is grey, which serves as both a grey card and white balance reference, while the other side is white, which is perfect for setting a custom white balance.

there's an app for that...

Don't want to invest in a dedicated light meter? Then why not use your smart device instead? ES Devices' Luxi app will turn your smart device into a light meter, and with the addition of one of the company's white diffusion domes you can also take incident light readings.

Grey Card Metering

1 Set your camera to Manual mode, choose your ISO, and set the aperture (or shutter speed) you want to use.

2 Activate your camera's spot meter.

3 Position the grey card in the same lighting as your subject. For a portrait you could get your subject to hold the card in front of their face, but for a wider shot you just need to ensure the meter is held in the same lighting conditions (so don't put your card in a shaded spot if your landscape is bathed in sunlight).

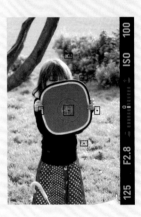

4 Aim the camera's spot meter at the grey card and adjust the shutter speed (or aperture if you set the shutter speed first) to set the exposure (as outlined on page 69). Now, as long as the lighting doesn't change, your exposure will be set for the mid-grey average, and you're free to reframe and shoot as you wish.

Histograms

So you think you used the right metering pattern and shooting mode to set and control your exposure, but how do you know for sure that you've nailed your shot? If you're shooting with your phone or tablet, then a quick glance at the screen is perhaps all you'll do to decide if you've got a keeper. A lot of photographers using point-and-shoot compacts will do the same, and even some of the guys lugging high-end gear around with them will cast an eye over the screen to make sure everything looks OK.

The problem with this is your camera's screen just isn't accurate, so when it comes to exposure, we check histograms, not the on-screen image. Histograms are those funky little graphs that you can call up alongside your image after you shoot, or have on the LCD screen in Live View or through your electronic viewfinder before you take your shot. The histogram that is most useful here is the luminance histogram, which shows the brightness of the pixels in your image from black (at the left of the scale) to white (at the right of

the scale), with all other tones in between. The height of the graph indicates how many pixels have a specific tone: the taller the graph, the more pixels there are of that tone.

Histograms are great at telling you if your image might be under- or overexposed: if the bulk of the graph is shifted to the left, it's showing us that the image is made up predominantly of dark pixels, so might be underexposed; shifted to the right, it's mainly light tones, so might be overexposed. However, the thing to appreciate about histograms is that there's no perfect shape. It all depends on the image. By definition, a light scene (think snow, or a sunlit beach) will be made up of mostly light tones, so we'd expect the histogram to be shifted right. A night scene, on the other hand, would probably give us a histogram shifted to the left, thanks to its mostly dark tones. The time to worry is when your histogram is shifted in the wrong direction, so that bright snow scene has a histogram shifted to the left, or the bulk of a dark scene's histogram is over to the right.

HIGHLIGHT WARNING

An alternative to the histogram is your camera's highlight warning. When activated, it can give you a quick indication of clipped highlights (and sometimes shadows), usually by making affected areas flash when you review the image. This is great if you want to check your images on the fly, but the histogram will tell a fuller story about your exposures. (Here, the camera's usual warning colour of black has been changed to red for clarity.)

You also want to pay attention if the histogram is stacked up against one end of the graph, as this is telling you that the shadows or highlights have been clipped. What this means is that your deepest shadows have turned pure black (if the histogram crashes into the left edge of the graph), or your highlights have blown to white (if the histogram crashes into the right edge). In extremely contrasty scenes, you may even manage to clip both ends of the histogram. When this happens, it's time to adjust your exposure, either before you take your shot (if you're using a live histogram) or before you take another shot (if you're looking at your histogram in review mode).

Histograms Explained

SHADOWS **MIDTONES** **HIGHLIGHTS**

The left edge of the histogram tells us the story of what's going on in the shadows. Here, there are some dark tones, and the histogram extends to the very end of the graph. In fact, it looks like it goes off the scale, which means the very darkest areas are pure black. In this shot, that isn't a problem, but it does mean there are a few small areas with no detail in them.

The right edge of the histogram relates to the lightest tones in the image – the highlights. This histogram just about reaches the end of the scale, but doesn't go beyond it, which tells you there are areas that are very close to white, but nothing has blown or burnt out (terms used to describe areas that are pure white, with no picture information in them).

The middle of the histogram is where your midtone areas are represented. Here, the graph has a small peak in this area, indicating a slightly higher number of true midtones compared to the areas immediately to the left and right.

The height of the graph tells you how many pixels there are in the image with a specific tone. In this example the graph is fairly low, although a couple of larger peaks at the right tell us there are slightly more mid-to-light tones than darker-than-mid tones. Or, to put it simply, the image is bright.

Histograms, continued

RIGHT: These histograms both tell us a similar thing: the tones are split into two distinct groups. In both cases, the left block represents darker-than-mid tones, while the smaller section at the right represents a cluster of lighter tones. However, notice the gap at the right edge of the scale. This left shift means there are no bright whites or highlights, which could (and does) indicate slight underexposure.

ABOVE This histogram is shifted heavily to the right, with the bulk of the graph close to the highlight (right) end. This tells us the image is made up of lighter-than-mid tones, with very few dark pixels; either the scene has been overexposed, or it is naturally light in tone. In this instance, the photograph is a minimalist snowscape, so the right-shift histogram is to be expected. Note that the histogram doesn't reach the right edge, though. I wanted a softer, slightly darker image, rather than pure whites.

RIGHT When a histogram is skewed to the left, it means the image is primarily composed of dark tones; either the scene has been underexposed, or it's simply dark in tone. This castle interior was naturally gloomy, so the histogram reflects this. It is also unsurprising to see a rise at the very right edge of the scale. The extreme brightness of the windows meant clipping the highlights was inevitable.

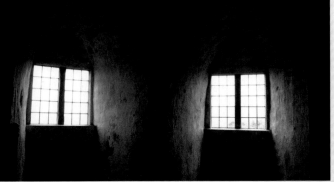

ABOVE When a histogram crashes into the left edge of the graph, dark tones have become pure black and contain no detail; these pixels are as dark as they can possibly be. Whether this is important or not will depend on the photograph. Here, I don't mind the blocked up shadows.

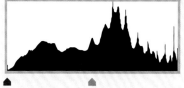

ABOVE When a histogram crashes into the right edge of the graph, light tones have become pure white; these pixels are as bright as they can possibly be and don't contain any detail. Generally speaking, this is less desirable than shadow clipping as, visually speaking, we accept black shadows more readily than glaring white highlights.

RIGHT When the histogram crashes into both ends of the graph simultaneously, it's telling you you've got solid black areas and solid white areas. In the backlit photograph of an audio cassette, the split is extreme – the image is almost entirely composed of very light and very dark tones, with little in between. Areas of solid white and solid black were exactly what I was after to get a graphic-looking image, though, so although there's a lot of clipping, it's what I was aiming for.

LEFT However, it's less desirable for the portrait shot. The clipped shadow areas aren't a huge problem, as they suggest a pure black background, but the suggestion of clipped highlights is less ideal. When a histogram splits like this, you've got a dilemma – adjusting the exposure to save the highlights will only make the shadow areas darker; lightening the exposure to rescue shadow detail will simply make more of the lighter tones burn out to white. There are potential solutions, though, as we will see later on.

Exposure Compensation

Whether your camera's been fooled into giving you the wrong exposure, or it's a case of good old-fashioned user error, there are going to be times when you look at your histogram and realise your shot has come out lighter or darker than you'd like. When this happens (or before it happens if you're being guided by a live histogram), you can apply exposure compensation to set things straight. On your smart device or point-and-shoot camera, this is almost certainly going to be a menu option, but on a mirrorless camera or DSLR it's more likely to have its own dedicated button or dial, usually around the right side of the camera close to the shutter-release button.

Exposure compensation is a simple way to make your shots brighter or darker. Depending on your camera, you'll either have to press a compensation button (usually marked +/-) and turn your control wheel to make the exposure brighter or darker, or you'll have a retro-style

exposure compensation dial on top of the camera. In both cases, you'll usually be able to adjust your exposures in precise, ⅓-stop increments, enabling you to correct your wayward exposure and shoot again.

How exposure compensation is applied depends on the shooting mode you're using. In Auto and Scene modes, it's fairly typical for exposure compensation to be disabled. If you're shooting in Manual mode it's wholly redundant, as you're free to change the aperture and shutter speed whenever you like. However, if you're shooting with one of the priority modes, you'll find the compensation affects the other exposure control. So if you're shooting in Aperture Priority, exposure compensation will adjust the shutter speed, and in Shutter Priority mode, it tweaks the aperture. In Program mode, the camera will decide which parameter gets changed, based on the starting exposure.

ABOVE/RIGHT The extremely bright stained-glass was always going to result in underexposure if I used a multi-area or centre-weighted metering pattern, but dialing in +1 stop of exposure compensation quickly brightened things up. However, this also lost the brilliance of the dazzling colours, so ultimately I chose to use HDR imaging (see page 83) to keep the dark, brooding sky and enhance the contrast between it and the cheery message on the sign (right).

Bracketing

As well as adjusting the exposure manually, most mid- to high-end cameras will let you bracket your shots. This simply means the camera will fire off several frames at different exposure settings; a typical three-shot bracket will give you one shot at the camera's recommended exposure, another shot that's lighter, and a third that's darker. The idea is that you can then pick the best shot.

In tricky lighting conditions, or with a fast-moving subject where you haven't got the luxury to adjust the exposure in a more refined way, bracketing can often help you get the shot. However, it's arguably more beneficial if you're shooting JPEGs, than Raw files. I'm not advocating getting your exposures wrong, but you can typically adjust the exposure of a Raw file by at least I stop during processing, and still get a great result, whereas JPEGs are far less forgiving. So, as long as your shot isn't clipped to start with, you can use your software to recover the exposure, rather than bracketing.

Exposure Bracketing

I Because you'll typically want to shoot your bracketed exposures in rapid succession (to minimise any subject movement between frames), set the camera's focus and drive mode and focusing to Continuous (usually indicated by the multiple-frame icon pictured right).

2 Activate bracketing mode. This may be done with a button or a menu selection, depending on your camera.

3 Set your bracketing parameters: This will be the number of frames you want to shoot, and the exposure increment between them (in full stops, or fractions of a stop). Here I want the camera to shoot three frames at +/- I stop (3F I.0).

4 Now, you can hold down the shutter-release button and rattle off your frames, giving you three different versions of the same subject. Note that some cameras automatically deactivate bracketing after a sequence has been shot, while others continue to bracket until you switch AEB off yourself.

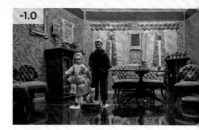

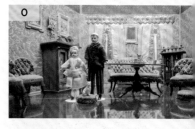

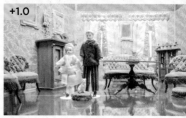

Dynamic Range

To some people it's exposure range, and to others it's simply contrast, but in the digital arena the term 'dynamic range' has stuck when it comes to describing a range of tones between light and dark.

HIGHLIGHTS OR SHADOWS?

If you opt for a single exposure, accepting you'll lose detail somewhere, you need to decide where that somewhere is: Do you want to preserve detail in the highlights, at the expense of the shadows, or vice versa? If you're shooting digitally, then it's definitely better to hold the highlights. It is impossible to recover any detail from an area that's been exposed as pure white, as it has no data in it to start with. Shadows, on the other hand, can often be lightened to reveal detail in the darker areas (albeit with an increase in noise). Visually, we also tend to accept deep, black shadows more readily than pure white highlights.

THE ISO EFFECT

The dynamic range of your camera will usually change depending on the ISO setting: higher ISOs typically have a smaller dynamic range.

When people talk about dynamic range, it may be in the context of the scene being photographed. The difference between the brightest highlight and the deepest shadow is known as scene dynamic range. Or, the phrase 'dynamic range' can be used to refer to the sensor or film's capacity to capture, and record detail in, a range of exposure values. Whether you shoot film or digitally, this can often be a limiting factor.

The reason dynamic range is important is because anything outside the camera's range will record as pure white or pure black; it will have no data in the image file, and this means no detail in the image. The most useful way of measuring dynamic range (for photographers, at least) is to measure it in terms of stops. So, let's say, for example, that your camera's dynamic range is 10 stops, and you want to photograph a scene with an 8-stop dynamic range. That's great – the scene's dynamic range is smaller than the camera's, so as long as you don't under- or overexpose your shot too much, you'll

be able record all the detail in the shadows and all the detail in the highlights in a single shot.

However, if the difference between the shadows and the highlights in your scene is 12 stops (and your camera has a 10-stop dynamic range) you're going to have to sacrifice detail in either the shadows, the highlights, or both because the dynamic range of the scene exceeds that of the camera – there's just no way of getting every tone in a single exposure. You might try and make your exposure lighter to bring out detail in the shadows, but your highlights will blow out even more and lowering the exposure to hold the highlights will only block up the shadows. This leaves you with a number of choices: You can take your shot and accept that you'll lose detail somewhere; you can see what tools your camera has to help you; or you can shoot for HDR.

RIGHT Dealing with a high-contrast scene in a single shot is about making compromises. Here, for example, it doesn't matter if the street lights or the illuminated building facades are slightly overexposed – visually, we accept they are bright. What was more important was retaining some tone in the sky, to create separation between the sky and the distant buildings.

High Dynamic Range

With a high dynamic range scene, retaining detail in the highlights and shadows simultaneously can be impossible. As the illustrations below show, the camera can record only part of the scene's range; the rest will be clipped. A mid-exposure is likely to clip both ends of the tonal range; shifting the exposure to make it darker or lighter simply changes which parts of the image are clipped.

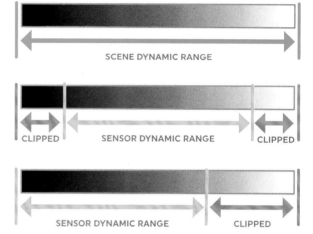

SCENE DYNAMIC RANGE

CLIPPED SENSOR DYNAMIC RANGE CLIPPED

SENSOR DYNAMIC RANGE CLIPPED

CLIPPED SENSOR DYNAMIC RANGE

IN-CAMERA OPTIMISATION

Most manufacturers have some sort of on-board dynamic range optimisation tool – Canon's Auto Lighting Optimiser, Nikon's Active D-Lighting, and Sony's D-Range Optimiser, for example. Although each system is subtly different, the general premise is the same: The exposure is set to preserve detail in the highlights, while shadows are lightened during processing to prevent them blocking up. You'll usually find several optimisation strengths, so you can match the correction to the scene – the greater the contrast in the scene, the more optimisation it is likely to need.

Low Dynamic Range

When there isn't a huge difference between the lightest and darkest parts of a scene you will be able to record the full tonal range in a single shot. Mist and fog naturally create low-contrast scenes.

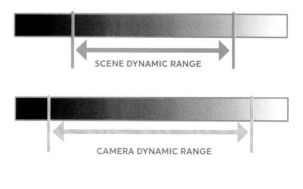

SCENE DYNAMIC RANGE

CAMERA DYNAMIC RANGE

Holding the Highlights

I'm not ashamed to say that I started out shooting with Olympus OM cameras back when they produced grain, not pixels. At the time, one of the most exciting metering technologies was the highlight and shadow spot metering found in Olympus' high-end OM3 and OM4 cameras. Essentially, this allowed you to inform the camera that the area you were taking your spot meter reading from was a highlight (if you pressed a Highlight button) or a shadow (via a Shadow button), rather than a midtone (although midtone metering was also possible). In each case, the camera would tweak the exposure so that the highlight you metered from came out as a bright highlight, or your shadow was exposed as a dark shadow. You basically picked what you wanted to be the brightest or darkest area in the shot, and the camera did the rest.

So what's so great about that? Well, it is way easier to identify the brightest highlight you want detail in, or the deepest shadow area, than the midtone. Don't believe me? Look out the nearest window right now and ask yourself what part of the view is the brightest – I guarantee that area is much easier to spot than the area reflecting the midtone average.

Fast-forward to the digital age. Histograms and exposure compensation – and have made it much easier to check and correct exposures. However, you can still use the principle of highlight spot metering to set exposures that hold your highlights. What we're basically doing is choosing the brightest part of the scene that we want detail in, deliberately metering for that highlight area, and then adjusting the exposure to make sure it's bright, but not overexposed. This guarantees that those areas won't be clipped, preserving your precious highlights. See the sidebar opposite for more information.

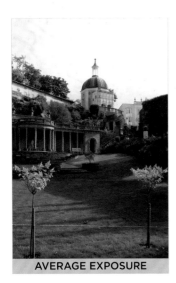

AVERAGE EXPOSURE

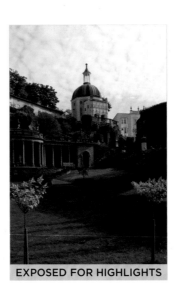

EXPOSED FOR HIGHLIGHTS

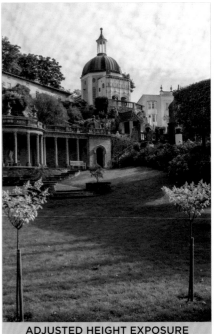

ADJUSTED HEIGHT EXPOSURE

ABOVE/RIGHT With an average exposure made using the camera's multi-area metering pattern, the brightest parts of the sky have burnt out (left). However, setting the exposure for the highlights reveals a lot more cloud detail (centre), while the shadows can be lifted during the Raw processing stage (right).

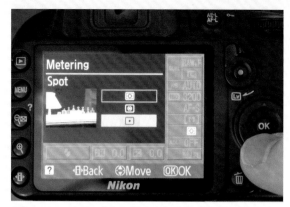

1 Set your mode dial to Manual and switch to spot metering. You'll also need to make sure you're shooting Raw files so your camera records the maximum amount of data possible.

2 Aim your camera's spot meter at the target highlight area (indicated above in red). If you can, zoom in, to ensure your reading isn't affected by any surrounding areas.

3 Set the exposure, as outlined on page 69.

4 Now, increase the exposure by 1⅔ stops (or 1½ if your camera is set to ½-stop increments). You can use the aperture, shutter speed, or ISO, but the total adjustment needs to be 1½ or 1⅔ stops brighter. This will ensure that when you shoot, your targeted highlight area will be bright, but not clipped.

ABOVE If I'd relied on the camera's multi-area metering pattern for this shot, it would have been very likely to overexpose to compensate for all the dark tones. Instead, I metered for the highlights to hold the brightly lit building at the end of the alleyway. In this scenario, you expose for the highlights and let the shadows fall into place; if they're slightly clipped, so be it.

NOTE: This exposure technique works best when there's a specific (perhaps small) highlight area that you want to preserve detail in, or any scene where you simply want to make sure the highlights aren't clipped.

HDR Imaging

If the dynamic range of your scene exceeds that of the camera, but you absolutely require that every single detail in that scene be recorded, the only answer is to take multiple shots at different exposure settings and blend them together. While you can do this blending by hand, using your image-editing software, most people turn to dedicated HDR (high dynamic range) programs, which take the exposure variants, combine them into a single image, squash and squeeze the exposure range, and deliver you an image that contains full shadow and highlight detail.

At its simplest, HDR imaging require three shots – one for the highlights, one for the shadows, and one for the midtones. Although if the scene dynamic range is very high, you might need to shoot more. A good way to decide how many exposures you need to make is to measure the dynamic range (see sidebar opposite) and then shoot between the highlight and shadow settings, adjusting the exposure in 2-stop increments. So, if you've got 10 stops between the highlights and shadows, make six exposures to cover the range. Note that that's just my way of working –

some people would say six exposures is overkill, while others might prefer 1-stop increments. Either way, each shot is essentially free, so you've got nothingto lose from shooting more than you need.

When you take your exposure sequences, there are a few things to consider. First off, when you change the exposure, you only want to change the shutter speed, not the aperture. This is because changing the aperture will change the depth of field, leading to artifacts when the software tries to blend sharply focused and soft-focus areas. For much the same reason, you also want to avoid any subject movement between frames, as this can result in ghosting in your final shot. Some HDR programs have ghosting reduction, which will attempt to remove or prevent this artifact, but it's generally best to shoot with the camera on a tripod, and avoid moving subjects. If subject movement is unavoidable, then shooting Raw and cheating (see box below) is one potential solution.

Once shot, your image sequence can be opened in your HDR software, where the images are combined and processed.

RAW CHEAT

If your scene's dynamic range isn't huge, and you shoot Raw, you can often get away with tone mapping a single exposure. Process the Raw file three times to generate three different exposures and then run those through your HDR software. The result won't be as good as a genuine three-shot exposure (you've cheated, remember), but can offer an improvement over a single exposure, especially if your subject was moving.

Some HDR software doesn't even need you to make the three exposure conversions – Photomatix Pro, for example, will happily extract as much detail as it can from a single Raw file.

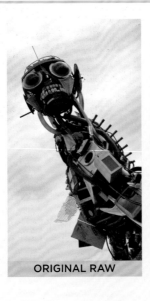

ORIGINAL RAW

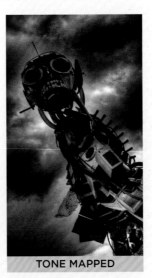

TONE MAPPED

LEFT This was a single Raw exposure of a sculpture made from domestic waste. The colour version (far left) is a straight conversion from the Raw file; the monochrome alternative (left) is the same single file, opened and tonemapped in Photomatix Pro.

This involves a technique known as tonemapping, which determines how the tone, contrast, colour, and other image elements are brought together. All software differs in terms of the controls on offer, and depending on how you use them, you could end up with a relatively natural-looking result, or a graphic, almost cartoonish version of your original scene. Personally, I tend to limit my HDR work to black and white, but there's no right or wrong here – it's what you're happy with that counts.

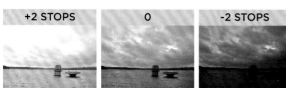

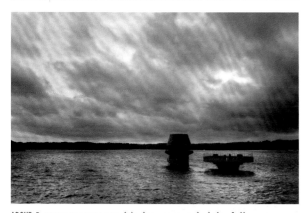

ABOVE A correct exposure (0) almost recorded the full tonal range of this scene in a single shot. However, shooting a bracketed sequence at +/-2 stops ensured that I could extract every last highlight and shadow detail through HDR processing.

Measuring Dynamic Range

1 The easiest way to (roughly) measure the dynamic range of a scene is with your camera's built-in spot meter, so activate the spot meter, switch to Manual mode, and set a mid aperture ($f/8$–$f/11$) on your lens.

2 Aim your camera at the brightest part of the scene you want to photograph, targeting it with the spot meter. Zoom in if you can, so you're getting a really precise reading, and adjust the shutter speed until the exposure bar shows the correct exposure. Make a note of the shutter speed required.

| 125 | $f/2.8$ | ISO | 100 | → | 1/2000 second |

3 Turn to the darkest part of the scene and take a spot meter reading from there as well, zooming in and adjusting the shutter speed once more. Again, make a note of the exposure.

| 125 | $f/2.8$ | ISO | 100 | → | ½ second |

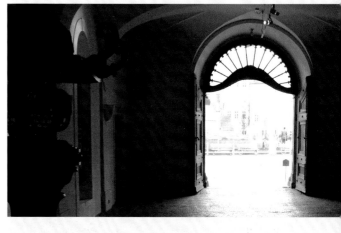

4 Use the chart on page 24 to determine how many stops there are between the shutter speed needed for the highlights and for the shadows. For example, if the highlight reading is 1/2000 second and the shadow reading is ½ second, that's an 11-stop range – depending on your camera, you may need to think about how you're going to deal with the high dynamic range.

Silhouettes

Although a lot of time is spent trying to overcome high scene dynamic range, it's also the ideal situation for shooting silhouettes. Strong, bright backlighting and a dark, shadowed subject are precisely what you need to create stunning silhouettes. The path to success starts with the subject – readily identifiable shapes work best. It's a good idea to avoid overlapping silhouetted elements, because while they may look visually strong and dramatic in the real world, they might not look so great when they're seen as flat black silhouettes. Two people with a gap between them will read as two people when they're in silhouette, for example, but overlap them and they could easily look like some sort of multi-limbed, two-headed monster.

As well as the subject, you need to pay attention to the background. Clean, plain backgrounds will exaggerate a graphic silhouetted shape, while cluttered backgrounds may interfere with your subject. A classic silhouette background is the sky at sunset, and while it's arguably a visual cliché, there's no doubt that the strongly saturated colours work spectacularly well with a pure black subject. However, you may need to get down low and shoot upward to photograph against a clean patch of sky; shoot from too high an angle and intrusive foreground and background elements can encroach into the frame.

The key to exposing your silhouette successfully is to set your exposure for the background, rather than your subject. There are several ways of doing this. The first option is to use your camera's multi-area or centre-weighted metering pattern, which may automatically underexpose your subject due to the bright background.

If the underexposure isn't enough to make it a silhouette (or the background isn't dark enough), then simply apply negative exposure compensation and reshoot.

Alternatively, you can use your camera's spot meter to take a reading from a bright part of the background. Use exposure lock or shoot in Manual mode so the exposure doesn't change when you reframe your subject. For example, if your subject is against bright a blue sky, take your exposure reading from a bright patch of sky and set the exposure manually. The area you meter will be treated as a midtone in your photograph, and rendered darker.

However, even when you expose for the background, you may find that your camera still reveals little details in your subject. When this happens you can darken your exposure even more using exposure compensation, or decreasing the aperture or shutter speed by a stop or two. This will also darken the background, though, so you might be better off enhancing your silhouettes when you process your images. If you want your silhouetted subject to be pure black, then bringing in the black point using Levels (see page 297) or Curves (see page 320) are both viable options, or you could burn in the darker areas to make them even more intense.

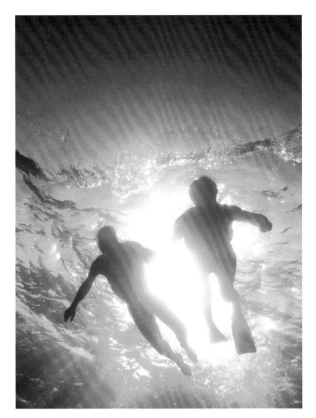

ABOVE When the light behind your subject is extremely bright, it can start to eat into the silhouette of your subject. This is essentially lens flare, caused by the extreme contrast between the backlight and subject. Although sometimes undesirable, it can create an atmospheric alternative to the more traditional hard-edged silhouette.

ABOVE This shot contains multiple silhouetted elements, and it was important to make sure they remained as readable as possible: the bridge, the figures, and the Parliament building in the background all needed to remain identifiable, despite being stripped of detail.

RIGHT Taken on a smartphone using its default point-and-shoot settings, the figure of a monk is seen as a silhouette against the much brighter background. However, a small amount of colour remains in the figure, which provides a strong connection to the distant robes.

High Key

Sometimes, you'll find yourself faced with a scene that you might think has a high dynamic range, but actually has not. Say, for example, you're shooting a snowy landscape. Throw some sunlight onto it and you might think that all that white is going to cause you no end of dynamic range problems. Well, not necessarily. Even though that snow scene is blindingly bright, it might actually have quite a small dynamic range; pretty much everything is light or white.

This is essentially what constitutes a high-key image: a shot primarily made up of tones lighter than mid grey, with very few (if any) obvious shadows. Now, strictly speaking, it's the subject and the lighting that create a high-key image, so we're talking about subjects that are either light in tone, or can be flooded with light to make them appear that way, filling in shadows and generally reducing everything

to shades of white. Studio portraits with white backgrounds are very popular subjects for a high-key treatment, and ring-lighting (see page 106) can help reduce the appearance of shadows.

The exposure in a high-key image is also important. You want to get your whites looking white, not grey, so exposing for the highlights is one way of working. However, simply increasing the exposure for any given subject doesn't make it high key. Yes, it makes it brighter, but this is because it has been overexposed, not because it has been given a deliberate high-key treatment.

RIGHT This study in white takes the idea of high key to the extreme: the white model was standing in front of white background paper and lit with a studio strobe fitted with a large softbox. The combination of multiple white elements and a large, diffused light source ensured the shadows were flooded with light.

Low Key

The opposite to high key is low key. This is the world of shadows, where the majority of the image is made up of darker-than-mid tones. Although the contrast can look high in these images, the dynamic range is often well within the bounds of most cameras, as even highlights are likely to be mid grey or lower. Again, all that has happened is that the dynamic range lives within the mid to dark tones rather than the lights.

As with high-key photography, low-key images are dependent on lighting (or an apparent lack of it), and your exposures need to be chosen to reflect this. With so much black, your camera will likely want to render your low-key images too bright, so this is the perfect scenario to use a handheld meter or for dialing in some negative (-) exposure compensation. You may also find that your low-key explorations lend themselves well to a monochrome treatment, recreating that classic film noir look.

BELOW This urban detail (stencilled words and a security mirror) was spotted in a dimly lit underpass and photographed using a 1970s Olympus Trip 35. The camera has minimal exposure control, so all I could do was set a small aperture (with no exposure metering to guide me), in the hope that it would retain the low-key atmosphere.

MASTERCLASS

INTERIORS
Adrian Wilson

Way back in the 1980s, Adrian Wilson was one of the first photographers exploring the potential of combining photography with computer graphics. 'I attended Blackpool College in the UK, and learnt to use a computer that was on loan to them called a Quantel Paintbox. It was very much like a first version of Photoshop, except it was the size of a filing cabinet and cost a quarter of a million pounds'. Adrian funded his pioneering work by photographing interiors, but soon realised that he actually preferred working on location than sitting in front of a monitor. He has since photographed over 2000 homes, hotels, restaurants, bars, clubs, and stores, for clients including Apple, Chanel, and Victoria's Secret. More recently, Adrian has designed and opened the unique, award-winning gallery/store The Inutilious Retailer in NYC, where everything is free.

When he started out in interiors photography Adrian relied on a Mamiya RB67 medium-format camera. 'I always shot on one camera with one lens and still pretty much do. In my early career it was an RB67 with a 50mm lens; that camera was indestructible, never let me down, and the lens was wide angle but with little distortion.' When Adrian transitioned from film to digital, he initially stuck with medium-format cameras, starting with a Hasselblad H1 ('I got a refund because the quality was poor') and then a Phase One P45+ on a Cambo Wide DS ('much better, but also the most annoying and expensive (£35,000) camera I had the misfortune to buy').

However, with such poor experience it was perhaps inevitable that Adrian's reliance on medium-format cameras would be short-lived. 'At the same time I was using the Phase One back, I had a Canon EOS 1Ds MkIII, which I used as a back-up camera. A lot of my clients preferred the images from that, as well as the speed I could shoot at, so I switched to become a "35mm" photographer'.

Although interiors photography is often about shooting in fairly confined spaces, with the aim to make them look bigger than they actually are, Adrian isn't a fan of ultra-wide lenses. 'I currently take two D800E cameras on each shoot, one with a Nikon 24–70mm zoom lens and the other with a Zeiss 21mm lens permanently attached. For me, the best lens for interiors is anything over 20mm; focal lengths that are wider than that produce ugly distortion and ellipses instead of circles'.

INTERIORS ESSENTIALS

It is the little things that make an interiors shoot easier. I carry two door wedges because I got sick of trying to stick folded paper under doors. Also, fire exit signs are easy to retouch away if you cover them with a paper sleeve made by taping or stapling sheets of paper together. It can also pay to have your camera instruction book in your bag – there's a lot to remember in those menus!

For this hotel lobby shot I needed to show the striation of the marble, so I combined two images that each had been polarised, one to reduce the reflections on the floor (below left) and the other to reduce the reflections on the wall (below right). Once I'd combined the exposures, I removed the ugly lighting highlights above the reception desk and filled in the empty space in the lighting cove. I then removed the metal rail at the left of the lobby desk, all of the exit signs, and the blue daylight cast on the front of the lobby desk.

NIKON D800E WITH 21MM ZEISS, 15 SECOND, ISO 100 (APERTURE UNRECORDED)

As well as tackling distortion, interiors photographers also regularly face the challenge of high dynamic range, where dark interiors are punctuated with bright windows, doors, and lights. This makes it crucial to get the exposure 'right' in camera, and for Adrian that means switching the camera to Manual. 'I always shoot manual, at either $f/11$ or $f/16$, because sharpness is most important to me. My ISO is always 100, so I just vary the shutter speed for each image. I use my camera's multi-area metering and always take a couple of shots at the best exposure (a throwback to my worries about corrupted files!) and possibly bracket, depending on the subject. I started shooting using transparency film, which has an exposure latitude of about 1 stop. I think my D800E can handle over 3 stops, which gives me some leeway, but that doesn't make me lazy. I still want to get it right in-camera.

'The biggest challenge is balancing the light and dark areas. The human eye is amazing at seeing "everything", but to replicate that in an image can often look fake. We know we are looking at a photo, not real life, so I think it's best not to get hung up about shadow detail or being able to see the shape of every lit light bulb.

'I quite often use multiple exposures to create an HDR image, but I'll then just take elements of that image and add them to the original exposure. So I might end up with four or five elements cut and pasted over the original image to balance it, which I feel looks far more natural than a full HDR image. I must admit that I'm always frustrated balancing interior and exterior light, especially when they are different colour temperatures. In my experience, there's still no software that can do a great job'.

Adrian also uses multiple exposures with a polarising filter. 'A polarising filter is essential, because it's one of the few filters that Photoshop cannot replicate. I'll use it to cut down reflections on glass and other surfaces, but you need to be careful, as you can get a moiré pattern on certain types of glass. To avoid this I'll often combine two images where the polariser has been rotated to cut down reflections on both the horizontal and vertical planes'.

To see more of Adrian's seamlessly retouched interiors, visit his website at www.interiorphotography.net

ADRIAN'S TOP TIPS

- Avoid showing two corners in any room as that will make it look smaller.
- Position the camera so the eye will be drawn easily into the room, in the same way that a person could easily walk through the room.
- Use a polarising filter for every image.
- There is no such thing as 'nearly symmetrical' – it either is or it isn't. Lines, corners, and angles should not be 'off'.
- Work as a team with the client. Give them the angle they want, but also shoot one that you believe may look better. Architects take 2D and make it 3D, while photographers take 3D and make it 2D again, so we think in different ways.

A restricted shooting position meant I couldn't shoot the entire interior in a single shot (right) so I took two overlapping frames and combined them using Photoshop's Photomerge tool. This gave me the full height from the corner of the ceiling recess to the corner of the pool, without any of the severe distortion I would have got using a wider lens.

I then used HDR to bring out the cove details and touched out all the exit signs, sprinklers, ceiling vents, and so on. I also cleaned any watermarks off the stone floor and pool steps, and added a missing underwater pool light.

NIKON D800E WITH 21MM ZEISS, 6 SECOND, ISO 100 (APERTURE UNRECORDED)

PART 2
Light & Colour

I've lost count of the number of time I've read (and written) that light is an essential part of photography, but it's worth reiterating the simple fact that without light you cannot take a photograph, no matter how high the maximum ISO setting on your camera. However, light in photography is about much more than having some or having none. As you will see in this section, the quality and direction of the light (and its source) is just as significant as its intensity when it comes to shaping your images.

Basics of Light

To drive a car you don't need an intimate understanding of how gasoline is made, or how internal combustion engines work, and the same applies to light in photography: Yes, it's a fundamental part of the process, but not knowing everything about it will not affect your ability to take stunning photographs. So, if physics isn't your thing, feel free to glaze over and skip these pages – but please, zone back in for Quality of Light on page 100.

The Electromagnetic Spectrum

To start with, we need to appreciate the electromagnetic spectrum, which comprises varying wavelengths of electromagnetic radiation, ranging from gamma rays at one extreme to radio waves at the other. Within this broad spectrum of energy nestles what we refer to as the visible spectrum, or visible light spectrum, which are the wavelengths that can be detected by the human eye. As the illustration below shows, the visible spectrum ranges from the shorter violet wavelengths of around 400nm (nanometers), through to the longer red wavelengths of around 700nm, with – quite literally – the colours of the rainbow in between.

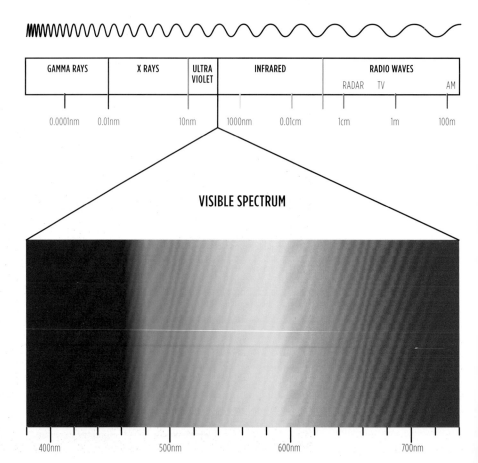

GAMMA RAYS		X RAYS	ULTRA VIOLET	INFRARED	RADIO WAVES		
					RADAR	TV	AM

0.0001nm 0.01nm 10nm 1000nm 0.01cm 1cm 1m 100m

VISIBLE SPECTRUM

400nm 500nm 600nm 700nm

RIGHT The visible spectrum – the visible light we can see – occupies a very small part of the much wider electromagnetic spectrum.

The reason this is of (relative) interest to photographers is because the visible spectrum is the narrow band within which our photographs exist, both in terms of the subject we see, and the print or on-screen image we later look at. Through absorption, transmission, and reflection, almost every object we see is absorbing some wavelengths of light, while transmitting or reflecting others, and this is what creates the colours in the world around us. For example, grass and other leafy foliage generally reflects the green part of the spectrum, while absorbing the other wavelengths, so we see these leaves as green. At the same time, the Earth's atmosphere scatters the blue wavelengths as light from the sun passes through it, while transmitting the other wavelengths. The result? We see the blue part of the spectrum, so the sky appears blue. And so it continues with every other object, and every other colour. The exceptions here are black and white, which are – in their purest forms – a complete absorption of light (black) and the transmission or reflection of all wavelengths in equal measure (white).

Of course, in the real world, there will be very few (if any) occasions when you find yourself thinking about the electromagnetic spectrum or wavelengths of light when you are out taking pictures. However, it's worth at least noting the idea of absorption, transmission, and reflection of different wavelengths, and appreciating that light is not white – something that may help you when it comes to making sense of colour temperatures and white balance.

RIGHT This wooden building is painted a single shade: black. However, the area closest to the camera is noticeably warmer (more orange) than the more distant section that is a cooler blue. This is purely because of the way in which the wavelengths of light have been transmitted and reflected. The building may be black, but the light has created multiple colours.

Quality Of Light

When photographers talk about the quality of light, they're referring to how hard or soft it is. This can have a profound impact on your images, whether you're working outdoors in daylight, or shooting in the studio with artificial lighting.

Hard Light

A hard light source is one that is smaller than the subject you are photographing (a point light source), and it is often direct and undiffused. This is the type of light that you'll encounter at midday on a clear, sunny day or when you aim a flash directly at your subject, resulting in deep, clearly delineated shadows with a hard edge.

There will usually (but not always) be plenty of light to make an exposure with, so you'll be able to choose from a wide range of aperture, shutter speed, and ISO settings. However, used on its own, a hard light source will often create high contrast levels, with brilliant highlights (especially on reflective surfaces) and almost impenetrable shadows. Depending on the direction of the light, this can be ideal for picking out texture and detail in your subject, but it can also create problems with dynamic range: if the contrast is too high, you risk clipping the highlights or shadows.

INTENSITY

Quality of light can also be described in terms of its intensity. This is simply how bright (or not) it is, which has a fundamental impact on the specific combinations of aperture, shutter speed, and ISO are available to you: When the light are intense you may need to use small apertures, fast shutter speeds, and low ISO settings; when the light is less intense you may need to rely on wide apertures, slow shutter speeds, and high ISO settings.

Although intensity is also a quality of light, it is worth noting that how hard or soft a light source is has nothing to do with its intensity: a hard light can be dim, just as easily as a soft light can be bright.

QUALITY OF SUNLIGHT

Although the sun is undeniably huge (its radius measures just under 700,000 kilometres, compared to Earth's puny radius of just under 6400km) it appears very small relative to your photographic subjects on Planet Earth. It is that apparent size in relation to the subject – rather than the star's actual size – that makes it a hard light source.

ABOVE Hard light is specifically avoided for standard portraiture; for artistic portraiture, however, it can be striking.

RIGHT Spotlights on stage are a classic form of hard light. Here, the brightest areas accent the dramatic gesture of the subject.

To help bring the contrast down to more manageable levels, you can use additional lights (fill flash, perhaps), reflectors, and diffusers. Alternatively, if you can reposition the light you are working with, you could simply move it closer to your subject. Although this might sound counterintuitive, moving the light source closer to your subject effectively increases its size relative to your subject, and the larger the light source is, the less hard its light will be.

Soft Light

Soft light is created when the light source is larger than your subject, resulting in a gentle gradation from lit to shaded areas (if indeed shadows exist at all). It is typified by the light you'll encounter on an overcast day, when sunlight is scattered by layers of cloud that effectively transform the entire sky into one giant soft light source. The same softening effect happens when you fit a softbox,

umbrella, or diffuser in front of a flash, or bounce light off a wall, ceiling, or reflector to increase its apparent size. All of these techniques are commonly used in portrait studios to create gentle, romantic images.

When it comes to gauging exposures, soft light is far easier to work with than hard light. There is usually little difference between the lit and shaded parts of a scene in terms of brightness, so there are no dynamic range issues to worry about. Indeed, the overall flatness of soft light will rarely challenge your camera's light meter, unless the subject is particularly bright or dark overall.

Yet while soft light is easier to work with, its inherent flatness doesn't necessarily make for the most exciting images. The problem is, our eye is naturally drawn to areas of heightened contrast, and this is the exact opposite of what soft lighting provides. Where hard light can scratch out

THE DIFFERENCE

The simple way to determine whether a light source is hard or soft is to look at the shadows it creates: hard light sources create hard-edged shadows, while the shadows created by a soft light source will have much softer edges.

ABOVE Soft light is commonly encountered when you shoot outdoors on an overcast day or in a shaded area. Images have soft shadows (if any shadows at all), so contrast is low.

a chiaroscuro image comprised of black and white, soft light paints its pictures in shades of grey. Consequently, detail becomes less pronounced, textures are less obvious, and the effect is far subtler. This isn't intrinsically worse, but it is a lot harder to create an image that leaps off the page or screen when you're working with soft light.

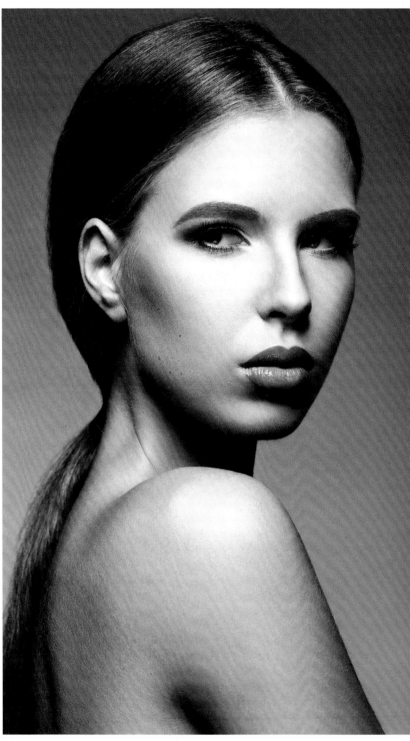

ABOVE This may look like a hard-light image, but this studio shot was created using two soft light sources: a studio strobe fitted with a beauty dish and a hotshoe flash fitted with an octagonal diffuser. Although shadow falls on one side of the subject's face, the shadow is soft, not impenetrably dark.

Changing the Quality of Light

While it is easier to work with soft light in terms of your exposures and contrast, starting with a hard light can give you far more creative options. It is much easier to soften a hard light source than it is to make a soft light harder. We'll look at the options if you're using flash later on in this chapter. For now, we'll concentrate on two low-cost solutions that will work with any light source.

REFLECTORS

In the most basic sense, a reflector is nothing more than a surface that reflects light, so it can be something as simple as a whitewashed wall or a sheet of white card, or a commercial pop-up photographic reflector panel. More often than not, reflectors are used to fill-in the shadows created by a main light source, but they can do so much more than

that. In skilled hands, they can be used to create extravagant multi-light setups. This is possible because as soon as light is reflected from it, a reflector effectively becomes a light source. In this way, it can quite easily act as the primary source of light reaching your subject (if you aim a flash away from your subject, toward a reflector, for example).

Reflected light is scattered more than direct light, so it naturally becomes softer. It will become softer still the larger the reflector. And, as with regular lights, the reflector-to-subject distance also plays a part in determining the reflected light's quality; the closer your reflector is to your subject, the softer the light becomes. Consequently, if you use a large reflector close to your subject, the light can become so soft that it appears to wrap around your subject, creating almost shadow-free lighting.

RIGHT This figurine was simply lit by the light from a window on an overcast day. Using window light alone (right) has resulted in dark shadows on the left side of the face, which have been emphasised by the split-tone treatment. Positioning a silver reflector to the right of the subject effectively fills these shadows, lowering the overall contrast (far right).

You can see the effect in the accompanying histograms. The histogram for the image taken without a reflector extends much farther to the left, indicating the presence of shadows.

However, using a reflector has meant there are virtually no tones to the left of centre, so the entire tonal range for the with-reflector shot sits in the mid-to-highlight region.

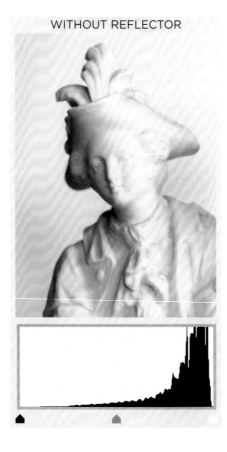

WITHOUT REFLECTOR

WITH SILVER REFLECTOR

The surface of the reflector offers yet another level of control, and the classic options are white, silver, and gold. Silver reflectors bounce a harder (and brighter) light than the more traditional white reflector, while gold combines a harder look with a warming effect that works well for portraits.

DIFFUSERS

A diffuser is made of translucent material – often on a frame of some sort – which is invariably positioned between the light source and the subject. The light passing through the diffusion panel is scattered (or diffused), which is primarily what makes it softer. However, as with a reflector, a larger diffuser has a greater softening effect than a smaller one and the light is softened more if it is used closer to the subject.

The translucence and construction of the diffusion material will also play a part in its softening prowess. In this respect, there is a vast range of options, especially if you make your own diffuser: plastic sheeting of various types, baking parchment, tissue or tracing paper, frosted glass, a white bed sheet, or even a simple white shower curtain can all be pressed into service to diffuse the light.

WHAT YOU NEED:

2.5–3cm plastic/PVC pipe
4 right-angle corners for pipe
2 T pieces for pipe
Translucent white shower curtain
Saw or similar cutting tool
Electrical tape
Glue for pipe (optional)
Hook and loop fastener

ASSEMBLY:

Cut your lengths of pipe to length and assemble the frame using your corners and T pieces (these usually just slot together). You can glue the joints if you want, or tape them together.

DIY Diffuser

If you're semi-competent with hand tools, it's very easy to make a lightweight, collapsible diffuser frame using plastic conduit pipe and a translucent white shower curtain.

RIGHT ANGLE 'CURVED'
T-PIECE
PIPE

1 Decide on the size you want to make your diffuser and plan your frame. For this panel, I chose to make a jumbo rectangular diffuser measuring 1.5 x 1m.

2 Once the frame is assembled, attach self-adhesive Velcro fastener to each of the corners and the T-pieces. This will enable you to attach and remove your diffusion material.

3 Lay your frame down flat and stretch your shower curtain across it, sticking it down onto the Velcro fastener at each intersection.

4 Finally, trim the curtain material to the size of your frame and you'll have yourself a diffusion panel that can be assembled and dismantled in a matter of seconds, which weighs and costs very little.

Direction of Light

In a three-dimensional world, light can fall (or be made to fall) on your subject from almost any direction, and this can dramatically change its appearance. There are four broad lighting directions to consider.

Front Lighting

When the light is falling on your subject from the same direction as the camera, that's called front lighting. This is the exact type of lighting that's created when you use your camera's built-in flash camera (or a hotshoe-mounted flash), or when you have the sun behind you. From an exposure point of view, frontal lighting guarantees your subject will be evenly lit. If you're working with a hard front light source, any shadows will be cast behind the subject, out of sight of the camera, avoiding any problems with dynamic range.

However, as shadows play a key part in suggesting depth in a photograph and revealing texture, images can appear flat and two-dimensional without them. So, while front lighting will make your exposures straightforward, it is rarely the most exciting way to light your subject. Possible exceptions to this are when you are photographing something that is essentially two-dimensional to start with (a painting, for example), or you're using a ring flash.

GET A HEAD

If you want to practice lighting, a dummy head can prove invaluable. It doesn't matter if it's a phrenology head (the classic photography book prop), a child's doll, or some other twist on the theme – they will all serve the same purpose, which is to provide you with an identifiable and consistent subject that will happily sit in the same place for hours or days while you play with your lights. In case you were wondering, my head is made of glass and was salvaged from a skip outside an opticians many years ago. Since then it's been covered in wire, plastered over, and treated to a rather fetching party hat.

ABOVE Frontal lighting is easy to expose for, but the result is typically flat and lacking in contrast. The first image (left) has the light coming from above the lens and the second image (right) has the light below the lens. It makes a slight difference, but neither is particularly compelling.

Side Lighting

When the light comes from the side of your subject, things can start to get very dramatic very quickly, especially if that side light is a hard source. The more side-on the light source is, the longer and more obvious any shadows will become, revealing fine textures and resulting in photographs with a strong three-dimensional quality.

This can work very well for landscape photographs taken at either end of the day; for stark, graphic architectural studies; or for gritty and earnest portraits that reveal every crease and blemish in your subject.

The main thing to be aware of when employing side lighting is problems with high contrast. When you have a strong light on one side of your subject, you may need to use HDR, fill flash, and/ or reflectors and diffusers to bring the contrast down to a manageable level.

RIGHT Side lighting creates shadows that give your subject a three-dimensional appearance. However, high contrast can be a problem when you have a single, bright light source, such as the sun or a single flash. In these situations, a reflector can be a great help.

RIGHT Side lighting doesn't have to be at a 90-degree angle to your subject; it can also be slightly from the front or from behind. Here, the light has been moved first to about 45 degrees to the camera (right) and then even closer to the camera position (far right). Note how the closer the light is to the camera, the flatter the lighting becomes.

Backlighting

Backlighting is closely associated with silhouettes, and the two often go hand-in-hand in a photograph, especially if the only light source you're using is coming from behind the subject.

However, backlighting doesn't just refer to a light that's directly behind your subject. A backlight can be higher or lower than your subject, or slightly to one side, and when this happens you can get some really striking results. For example, a light that's behind and above, below, or to the side of a portrait subject can create a beautiful hair or rim light, helping to separate the subject from the background.

Backlighting can also introduce lens flare of varying degrees, ranging from strongly coloured polygons dashing across the frame through to an overall veiling of the image. At times this might not be what you're after, but with the right subject, a certain amount of flare can enhance the atmosphere and take your shot to another level. Some photographers even go to the extreme of using old, uncoated lenses (or lenses with primitive coatings) to enhance the level of flare they can achieve.

ABOVE When the light is directly behind your subject, it can turn your subject into a silhouette (left). However, if the light is at a slight angle, it can create a rim-light effect instead (right). This is a classic portrait lighting technique, where a lamp is placed behind and above the subject to backlight their hair.

Top Lighting

As the space around a subject is three-dimensional, light can be directed from above, as well as from the front, back, and sides. Lighting that comes from above is very similar to side lighting, in that it will cast shadows that reveal shape and form; the main difference is in the direction those shadows are thrown.

From a visual perspective, top lighting is something we are very in tune with, as the sun and most domestic lighting (the two main light sources we encounter in our everyday lives) both come from above. We therefore accept top lighting quite readily.

RIGHT Top lighting appears most natural if it comes from a slight angle (far right) rather than directly overhead (right), purely because the sun is usually not right above us.

BOTTOM LIGHTING

If you're using a portable light source, it's possible to light your subject from below. However, this is not a lighting direction that we usually encounter in our day-to-day lives, so it can make an image look unnatural. While it can work in certain situations – such as studio still life and stylised horror portraits – it is best used sparingly.

FOOD
Stuart Ovenden

Stuart Ovenden has been working in the food industry for more than a decade, regularly shooting for cookbooks, magazine features, and food packaging in his London studio. His career as a photographer wasn't immediate, though, as he had spent the previous ten years as a designer and art director, commissioning, briefing, and working with food and lifestyle photographers. However, he'd always been interested in photography and wanted to move on creatively. Taking the photographs himself seemed to be a natural progression.

Stuart started out with a humble Canon EOS 1000D, and has stuck with the same make ever since, saying that he never really thinks about changing, as he knows exactly what Canon can do. As a result of this brand loyalty, he currently shoots using an EOS 5DS R or EOS 5D MkII, mounting these DSLR heavyweights on a tripod and fitting either a 50mm $f/1.2$ lens or a 100mm $f/2.8$ macro lens.

As his photography is primarily studio based, using daylight, there's plenty of time available for Stuart to get things right and maximise the image quality. 'I shoot Raw and use Manual mode, especially in the studio, because it gives me full control over the process. It also keeps in touch with the basic principles of photography – exposure, and aperture in particular. As I mostly shoot using daylight, with the camera on a tripod, shutter speed is less of an issue, but the aperture I use is very important. I favor using a wide aperture ($f/2.8$ for the most part) and like to think that a shallow depth of field has become part of my look'.

To help guide him to the perfect image, Stuart shoots with his camera tethered to a computer with a regularly calibrated monitor, using Capture One software. 'The photo pops up on screen seconds after I have taken it, which lets me check the exposure and adjust it accordingly; sometimes I might be going for a slightly under- or overexposed look, and I can set the exposure more accurately when I can see the image clearly on a large screen'.

As well as the on-screen image, histograms also play a key part in Stuart's exposure assessment. 'Histograms are a godsend, and I use them all the time – especially when I'm on location. A quick glance at a histogram tells you immediately if you've got the detail you require in a Raw file'.

FOOD ESSENTIALS

As simple as it sounds, a hot-shoe spirit level saves an age in getting horizon lines straight when you're working quickly. Diffusers and black and white cards are also good for manipulating light and shadow.

▶ Soft, directional light was used here, with close attention to the histogram to ensure detail wasn't lost.

50MM, ¼ SECOND @ ƒ/6.3, ISO 100

Yet even with time on his side, and the benefit of a large screen, there's still room for error. 'With food photography, it's often less about things going wrong photography-wise and more about factors that are out of your control. If something goes wrong on the day, it's normally due to a recipe not being tested properly beforehand or a problem with the product. In this situation, we all have to think quickly on our feet and just start again'.

This is where working as part of a team be invaluable. 'I'm very fortunate to work with some of the best prop and food stylists in the country, so every shoot is very much a three-way team effort. No matter how good your photography is, if you have bad-looking props and bad-looking food you're always going to struggle to get a good shot'.

Of course, if you're starting out in food photography, it's unlikely you'll have the luxury of prop experts and food stylists, but a few simple tricks can help elevate your shots, as Stuart explains: 'Colour is an integral part of my work, and the background and prop choices are often driven by the food itself. Autumnal reds and plum colours can really pop against dark greys and black, whereas pale blues always tend to work with summery salads and chocolate; for a dappled, summery feel I might also fire a flash through leaves attached to a light stand'.

Stuart also suggests adding 'a few misty bursts of water with an atomiser to transform still-life pictures of fruits and vegetables. Subjects that look a bit lifeless will instantly appear as if they've been plucked from a crisp, dewy garden. The same trick works with cooked meat, although brushing it with a little olive oil is better here'.

To see more of Stuart's mouthwatering photography, check out his website at www.stuartovenden.com.

STUART'S TOP TIPS

- Trust your instinct when a composition isn't quite working; don't be afraid to break it down and start again.
- Don't shoot in direct sunlight.
- Shoot Raw, not JPEG.
- Always back your work up!
- Take time to choose an angle that's sympathetic to your food.

▶ Shooting a 'slice out' option on a cake is always a tense moment. It worked well in this instance and you can really see the texture of the sponge.

50MM, ½ SECOND @ f/4.5, ISO 100

▼ A still life of fruit or veg needs a bit of work to get right: A natural balance is key, otherwise compositions can start to look contrived.

50MM, 1/40 SECOND @ f/2.8, ISO 100

▶ Diffusing the light you are using helps tone down any surface highlights (in this case 'dulling down' the painted black board used as a background).

50MM, 1/50 SEC. @ f/2.8, ISO 100

The Colour of Light

From the warm glow of a candle to the cool of dusk, it is important to be aware of the colour of the light you are capturing.

In our day-to-day lives, we don't often notice how the light around us changes, but its colour is almost constantly changing, depending on where we are and when. As shown opposite, these colour shifts can be fairly obvious if we stop to think about them – the blue of daylight and the orange of incandescent (tungsten) lighting, for example – or they can be more subtle, such as when the sun ducks behind clouds and reappears again. The reason we tend not to notice these changes much is because the human visual system (HVS) does a great job of compensating automatically for any shifts in colour; essentially, we are hard-wired to see white as white under most lighting conditions.

Unfortunately, your camera is nowhere near as smart. A digital sensor has one single response to colour, and any shifts in the colour of the light away from this will be quite obvious. Or at least they

would be if the camera makers didn't include a white-balance control. As the name suggests, white balance (WB) uses in-camera systems to determine what white (or neutral grey) should look like. And, when your neutrals are truly neutral, every other colour in a scene will naturally fall into place, so the grass looks green, the sky looks blue, and people's skin looks… well… as varied as it does in the world around you.

However, because light can have so many different colours, or temperatures (see opposite), there is no single perfect solution. As you will see on the following pages, white balance offers a broad range of options that can be called upon to compensate for the light around you, each of which has its benefits.

COLOUR FILM

Most colour film is balanced for daylight, so colour-correction (CC) filters are usually needed to counter specific colour casts (to convert the colour temperature of tungsten or fluorescent lighting to suit daylight film). However, a small number of tungsten-balanced films used to be available (and some still are), which can be a better solution if you know you're going to be shooting under incandescent lighting.

ABOVE Daylight- and tungsten-balanced films, such as Kodak's Ektachrome Elite and 160T, were once commonplace, but now you'll have to search a little harder for your film fix.

WHITE BALANCE SET FOR DAYLIGHT

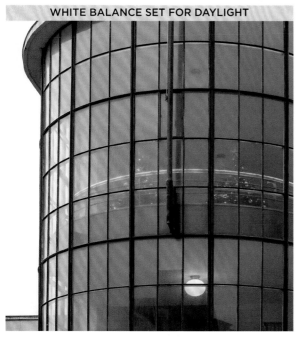

WHITE BALANCE SET FOR INTERIOR LIGHTING

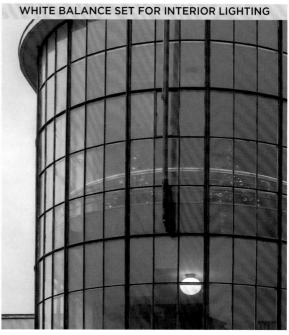

THE TEMPERATURE OF LIGHT

The various colours of light are measured in degrees Kelvin (K), which assigns to various types of light a value known as a colour temperature. The scale ranges from warm oranges at one end (the glow of a fire or candle), through neutral temperatures (midday on a clear, sunny day), to cooler hues (overcast days). Because the Kelvin scale is also used by your camera's white balance system, it's worth having an idea of where various key temperatures fall. Note, however, that these temperatures are not absolute: Most light sources fall within a (relatively loose) range.

ABOVE One of the most striking contrasts in colour temperature facing photographers comes from scenes that contain a mix of both daylight and interior, incandescent (tungsten) lighting. Daylight typically has a cool colour temperature, in the region of 5500–7500K, while incandescent lighting is closer to 2500–3500K. The practical result of this is that incandescent lighting will look very warm (orange) when a daylight white balance is set, while daylight will appear excessively cool (blue) when an incandescent white balance is applied.

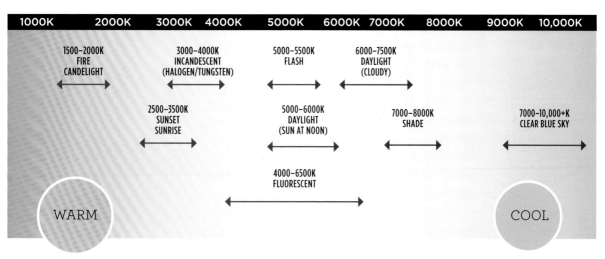

| 1000K | 2000K | 3000K | 4000K | 5000K | 6000K | 7000K | 8000K | 9000K | 10,000K |

1500–2000K
FIRE
CANDLELIGHT

3000–4000K
INCANDESCENT
(HALOGEN/TUNGSTEN)

5000–5500K
FLASH

6000–7500K
DAYLIGHT
(CLOUDY)

2500–3500K
SUNSET
SUNRISE

5000–6000K
DAYLIGHT
(SUN AT NOON)

7000–8000K
SHADE

7000–10,000+K
CLEAR BLUE SKY

4000–6500K
FLUORESCENT

WARM

COOL

Auto WB

Every camera has an automatic white balance (Auto WB) facility; without it, no digital camera would be able to realise a colour-accurate result. Essentially, Auto WB assesses the light falling on the sensor and adjusts the white balance to neutralise any colour bias. So, if the camera determines that an indoor scene is quite warm (orange) because of incandescent lighting, it will adjust the white balance in the opposite direction, adding more blue to compensate.

It's not just warm and cool adjustments; your camera can also identify the green of fluorescent lighting (which, technically, sits outside the Kelvin-based colour temperature scale) and many other colours as well, applying automatic adjustments to neutralise the colour.

However, this sophistication is also Auto WB's weakness. The camera will attempt to make an equal and opposite adjustment whenever it senses one dominant colour, even if that colour is a fundamental part of the scene. For example, fill the frame with a lush green landscape, and there's a good chance that your camera will see all this green as a colour cast and automatically dial in some red to compensate. The result? Your foliage will go from fresh green to a slightly muddy, brownish hue.

RIGHT Your camera's AWB is most likely to struggle when there are large areas of a single colour in the frame. In this example, the large swath of blue sky caused the camera's AWB to shift the colour toward yellow to compensate. Choosing a Daylight WB preset prevents this from happening.

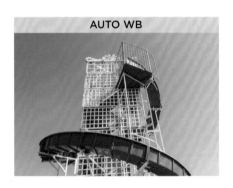

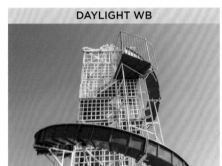

Setting White Balance
Most cameras offer one of two methods for setting the white balance:

METHOD I

1 Open the camera's menu and navigate to White Balance (found in the Shooting Menu on this camera).

2 Select your preferred WB setting from the list of options.

METHOD 2

1 Press and hold the WB button on the back of the camera.

2 Use the main control wheel to scroll through the WB options; here, they are shown on the camera's top LCD display.

WB SHIFT

High-end and enthusiast DSLRs and compact system cameras (CSCs) allow you to fine-tune the white balance presets using white balance shift. This usually relies on a colour grid, as shown below. By moving the WB target away from the centre you can make the white balance more blue (B), green (G), magenta (M), or amber (A), or a combination of these.

You may also be able to bracket your WB, in much the same way you can bracket your exposure, allowing you to produce three versions of your image, each with a subtly different WB setting.

WB ICON	SETTING	NOTES
AUTO	AUTO	• Camera sets the WB automatically.
	DAYLIGHT	• Set for daylight and clear blue skies. Colour temperature around 5200–5500K.
	CLOUD	• Set for overcast or cloudy conditions. Colour temperature around 6000–6500K.
	SHADE	• Set for open shade. Colour temperature around 7000–7500K.
	INCANDESCENT	• Set for artificial incandescent (tungsten/halogen) lighting. Colour temperature around 3000–3300K.
	FLUORESCENT	• Set for artificial fluorescent lighting. Colour temperature around 4500K (with a strong magenta bias).
	FLASH	• Set for electronic flash. Colour temperature around 5500K.
K	MANUAL	• Allows you to pick a specific colour temperature in degrees Kelvin. Options typically range from around 2000–10,000K.
	CUSTOM	• Enables you to set a custom white balance using a neutral reference target.

Preset WB

Because Auto WB is not infallible, most cameras will also let you pick a white balance setting from a range of preset options that cover the most common lighting situations. When you use a preset WB option, you're basically telling your camera what the lighting conditions are and fixing the white balance so it won't be swayed by the colours of the elements in the frame.

However, you need to be aware that a preset WB is unlikely to be 100% accurate, because the colour temperature of a light source is rarely absolute. The colour temperature of daylight at the middle of a sunny day is usually around 5500K (typically the colour temperature of a Daylight WB preset), but it is not guaranteed to be exactly 5500K, so images may appear slightly warm or cool.

A single WB preset also cannot deal with mixed lighting conditions. If you want to photograph someone indoors under tungsten lighting with a window in the background, for example, then you would typically choose to set the WB for the interior lighting or the daylight – it would be impossible to neutralise both with a fixed setting.

Besides helping you get your colours correct, a preset WB can also allow you to get creative. Setting a Cloudy or Shady white balance on a sunny day will inject warmth into an image, which for a portrait can be preferable to a more clinical, technically accurate result. Similarly, using an Incandescent white balance preset on a clear day will deliver a strong blue colour cast; on a winter's day this can enhance the notion of freezing temperatures.

Preset WB, continued

TUNGSTEN (2850K)

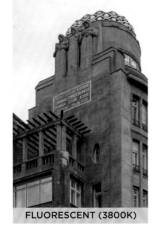

FLUORESCENT (3800K)

THIS PAGE This beautifully brutal piece of architecture (the Palác Koruna in Prague) was photographed on an overcast day in early spring.

The Raw file was converted using Adobe Camera Raw in Photoshop, with a range of different white balance settings applied. What's immediately noticeable is that, while it was a cloudy day, the Cloudy setting is too warm. It's not wrong, but the Daylight preset is more faithful to the scene (as I remember it).

In the end, I opted to start with an even cooler result by setting a manual colour temperature of 4500K. Why? I felt this better reflected the vibe of the building, and helped make the gold crown pop.

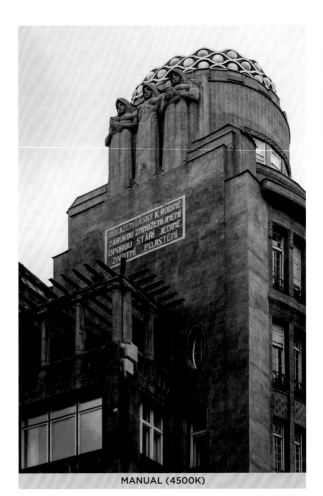

MANUAL (4500K)

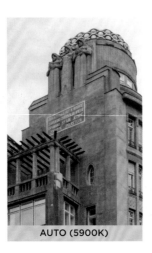

DAYLIGHT/FLASH (5500K)

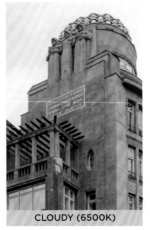

AUTO (5900K)

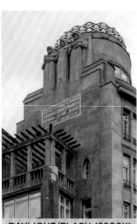

CLOUDY (6500K)

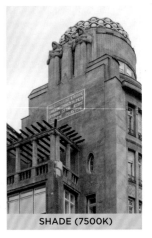

SHADE (7500K)

5000K (CUSTOM WB)

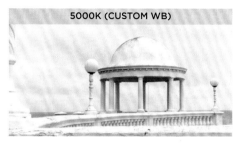

5500K (DAYLIGHT WB)

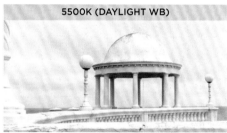

6000K (CUSTOM WB)

6500K (CLOUDY WB)

7000K (CUSTOM WB)

THIS PAGE WB presets are a useful start point, personal preference and the subject should guide you to the right result. Shooting Raw makes it far easier to adjust and tweak your shots, as you can see in the subtle colour variations shown here, which were all created from the same Raw file during processing. I eventually settled on the slightly cool, 5500K Daylight white balance setting, which evolved into the image below.

WB FILTERS

A white balance filter fits over your lens to provide you with an instant white-balance target, which is a lot more convenient to carry around than a grey card. However, since they measure reflected light, they can be tricked into giving an inaccurate results if there are strongly coloured subjects in your scene.

Custom WB

For the ultimate WB accuracy (and if your camera allows it) you might want to consider setting a custom white balance. The actual process differs between camera makes and models, but the principle is essentially the same: You shoot a neutral colour target – either white or grey – under the same lighting conditions as your subject, and the camera uses this to set the white balance for subsequent shots.

The advantage here is that the neutral reference shot tells your camera categorically what neutral should look like under the specific lighting conditions you are shooting under, and that means that any and all colours will fall naturally into place. As long as the lighting doesn't change, the white balance will remain consistent and your colours will be as accurate as they can be.

There is a downside, though. A custom white balance only applies to the specific lighting conditions it is created under, so if the lighting changes – even slightly – the custom setting will no longer be accurate. So, to ensure continued accuracy you need to refresh your custom white balance from time to time. Remember, your eyes and brain do a great job of adjusting automatically, so you may not notice slight changes in the lighting.

Setting A Custom WB

The process for setting a custom white balance varies between different camera makes (and models), so you should check your camera manual for specific details. However, many cameras use a process that is broadly similar to this:

1 Select your camera's custom/manual WB option from the white balance setting.

2 Set the camera to manual focus. This will prevent the autofocus zipping back and forth as it tries (and fails) to lock focus at the next stage.

3 Fill the frame with a neutral grey or white target (a photographer's grey card is ideal). This must be in the same lighting as your subject, but there's no need to focus on the target; it simply needs to fill the frame.

4 Take a shot of your test target. Now, when you select your camera's custom/manual WB setting, the reference image will be used to set the white balance, resulting in perfectly neutral photographs (as long as the lighting doesn't change).

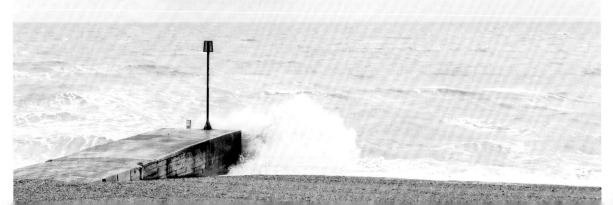

1 This shot was taken from the top of the Spinnaker Tower in Portsmouth, England. Because of the thick, green-tinted glass around the viewing platform, a Daylight WB preset simply wouldn't work, as the preset retains the colour of the glass.

2 In this situation, Auto WB is actually a better option, as the camera attempts to neutralise any colour cast. It is not always entirely successful, though.

3 Shooting Raw offers a third solution that can be applied in post-processing: to target an area in the scene that should be neutral grey, and use that to set the white balance. In Adobe Camera Raw, this simply means selecting the White Balance Tool and clicking on the image. A single click on a should-be-neutral area is (usually) all it takes to get things right.

Grey Target

If you shoot JPEGs, it's essential that you try and set the white balance you want when you shoot, as subsequent colour adjustments can be difficult to make without adversely affecting image quality. Setting a custom WB at the shooting stage is arguably the best option. However, if you record Raw files, the WB can be changed freely when you convert the file on your computer. You can switch the preset, dial in a specific colour temperature, or target part of the image that you want to be neutral, all without affecting the image quality. In this way, WB becomes far less critical at the shooting stage, but ideally you want to ensure there's a suitable neutral target in the scene you are photographing.

GREY CARD

If there isn't a grey target area in your image (and time allows), you can use a photographer's grey card to create a reference point. Make two Raw exposures: one with the grey card in it, and a second, final shot, without the grey card. Then, open both images in your Raw editing package, set the white balance for the grey card (using the process outlined in the sidebar opposite), and apply the same setting to your main image.

Colour Space

The colour space you choose for your photographs determines the range of colours (the gamut) of an image, which can have a profound effect on how it is perceived.

Perhaps one of the biggest challenges to accompany digital photography is the representation of colour. From digital cameras to computer monitors to printers, every device in the digital chain has its own way of recording, displaying, or printing colour, which means it has its very own, unique colour space. Therefore, there are countless colour spaces to describe the capabilities of these various tools, so it is unsurprising that colour theory and colour management are vast and complex subjects, with weighty academic tomes devoted to it. However, the good news is that I'm not going to try and cover everything here, just the essentials of choosing the right colour space for your purpose.

CIELab

At a basic level, digital photography involves working with three primary colours – red, green, and blue (RGB). The CIELab colour space (below) is the master RGB colour space, which contains every single colour we can perceive, from the subtlest hue to the most saturated.

However, the range of colours it contains (known as its gamut) far exceeds that of our cameras, monitors, and printers. As you can see opposite, the three main photographic colour spaces – the colour spaces that we actually use – sit within the CIELab space, occupying varying amounts of the overall space. This can have a profound effect on the colour information in your photographs.

JPEG CAUTION

Getting the colour space right is particularly important if you shoot JPEGs. It is easy to change an image from AdobeRGB to sRGB in your image-editing software, but switching from sRGB to AdobeRGB (or ProPhoto RGB) will not magically expand the colour gamut. However, shoot Raw, and you can choose your colour space at the conversion stage: sRGB for images that will only be seen on screen or sent to a photo kiosk, AdobeRGB for pre-press work or ProPhoto.

CMYK

Although most digital devices rely on mixing red, green, and blue, if you print images at home, you will find yourself using inks based around cyan, magenta, yellow, and black (CMYK). This has a different gamut to the RGB colour spaces we will look at on the following pages, and is typically less able to deal with highly saturated colours. However, photo printers often get around this by incorporating additional inks, which expand the printer's capabilities. Hence, some of the leading photo inkjet printers use as many as eight different inks.

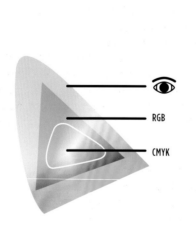

sRGB

The sRGB (super red green blue) colour space is the default colour space on most cameras, and is often the only colour space on phones and some compact cameras. The reason it's so widely used is because it was designed to closely match the colour capabilities of most computer screens, so it's the standard colour space of the Internet. It's also likely to be a near match for a lot of the photo printers used by photo stores and online print services, which makes it a good fit in terms of matching your camera's colour output to the printer's.

BEST FOR... photographers that share most of their shots online, or get them printed at a local lab or photo kiosk.

AdobeRGB

A lot of enthusiast and high-end cameras let you choose the AdobeRGB colour space, instead of sRGB. As you can see in the illustration opposite, AdobeRGB has a much wider gamut than sRGB, which means it can record a greater range of colour tones, especially in the green areas of the spectrum. This has two key benefits. First, it gives you greater flexibility when you edit your images, as you can perform slightly more extreme colour adjustments. Second, it is great if your images are likely to be printed in books or magazines (or via some inkjet printers), as the CMYK (cyan, magenta, yellow, and black) inks used for this type of printing produce a similar gamut.

BEST FOR... photographers who shoot for magazines, calendars, books, or any other traditional print media (including high-quality inkjet prints), or simply like to edit their images heavily.

ProPhoto RGB

If you do a lot of heavy editing work on your images, or just want to make sure you're working with the most information (currently) possible, then ProPhoto RGB is the way to go. It isn't an option on most cameras, so to benefit from it you need to shoot Raw files and assign them the ProPhoto RGB colour space when you convert them, ideally choosing to output them as 16-bit images as well. Even if your image doesn't reach the limits of the colour space (which has an impressively large gamut that exceeds the CIELab space in some areas) you will find you can push the saturation of your pictures to extremes, without detail disappearing in the process. However, bear in mind that you may need to switch an image to sRGB to reduce the gamut for on-screen use.

BEST FOR... photographers who seek the ultimate image quality and colour fidelity (although it is highly recommended that you explore colour management in much greater detail before you begin).

Theory vs. Practice

If you choose to explore colour spaces in greater detail, you'll quickly discover there is wide ranging and often conflicting advice when it comes to just how important they are and which one is right. Yet, while colour space is definitely important, it's not something to obsess over. Sure, ProPhoto RGB and AdobeRGB both have a much wider gamut than sRGB, but that doesn't mean they are automatically superior. When you shoot, a wider gamut benefits you only if the scene has an equally expansive gamut: if the colours in the scene naturally fall within the colour capabilities of sRGB, then AdobeRGB and sRGB will both be equally capable of rendering the scene accurately. An increased gamut may subsequently prove beneficial if you want to increase the colour saturation in the image, but if that's not your intention, then sRGB would do the job from the get-go.

It is also worth noting that the pixel peeping associated with colour spaces can sometimes overplay their importance. Infinitesimal improvements seen when an image is viewed at 400% magnification may prove that colour space A is technically superior to colour space B in a specific area, but such differences are likely to disappear when the photograph is viewed at a more realistic print size.

Moreover, your images will rarely (if ever) be seen side-by-side with alternative colour space interpretations, so it's exceptionally unlikely there will ever be a direct good-and-bad comparison. Twhe images opposite are very much an exception to this rule!

So, yes, it's good practice to get the colour space right, based on your intended use of the image, but it's rarely catastrophic if you down't. If you want to ensure that every image contains as many colours as it possibly (or at least could contain as many colours as possible) then by all means shoot Raw files and convert them to 16-bit ProPhoto RGB, but don't obsess about it; if the shot you've got looks good to you, then that's what really counts. The bottom line is that the vast majority of people viewing your shots will simply not care which colour space you used.

Although the way in which books are printed will have an effect on how the images appear on the page, the accompanying colour histograms can't lie, and they show us how each one deals with the colours in the scene, which was deliberately chosen for its intense, saturated colours.

In the sRGB histogram, you can see that there's a large block of red crashing into the left-hand edge. This tells us that a significant number of red pixels are fully saturated and no longer contain any useful detail. Like heavily overexposing or underexposing an image, this detail is gone forever.

Things look better in the AdobeRGB histogram, which is to be expected, as this colour space is larger and capable of recording more highly saturated colours. But while the reds are clipped less, there are still some yellow and green areas that appear to be hitting the left edge of the histogram, so detail has still been lost – it's better, but not perfect.

Finally, we come to the ProPhoto RGB histogram, which shows minimal clipping of any of the colours. In short, the ProPhoto RGB colour space has accommodated pretty much all the colours in the scene, which proves the theory that it can record a lot more detail in saturated areas of an image.

However, as the comparative details show, these improvements may only be evident in certain areas or under certain (heavy) processing. Even then, the real-world advantage can be extremely marginal, so my advice is not to get too hung up on it. For a lot of people, sRGB is where any talk of colour spaces starts and ends, and great images are made.

sRGB

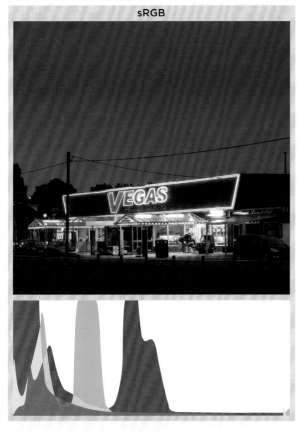

AdobeRGB

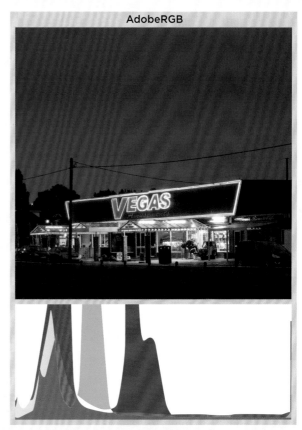

ProPhoto RGB

| sRGB | AdobeRGB | ProPhoto RGB |

MASTERCLASS

STILL LIFE
Daniel Brooke

Daniel Brooke has been a professional photographer for 25 years, although he started developing an interest in photos at the age of 14. 'It was a toss-up whether I went to college to do interior design or photography. I went for interior design, but finished after a year and started working as an assistant photographer in a major London auction house. There has always been the debate of whether you should go to college to learn about photography, or work as an assistant, and my advice would be to start as an assistant. However, it pays to mix it up and work in as many disciplines as possible. If you assist a fashion photographer, an architectural photographer, a food photographer, and so on, you'll find the best option for you, as well as picking up a broad range of skills.

'I became a photographer after 18 months of assisting, and stayed at the auction house for 7 years. I've now been a freelancer for 19 years, specialising in still life, artwork, and interiors. In some ways, I fell into that area of photography, but I prefer that compared to photographing people. I've always had an interest in art, antiques, and objects and the creativity involved'.

As well as his commercial photography, Daniel also works on personal projects, such as these images from his Evidence series. 'The majority are sets, or dioramas, that I construct and then photograph. The resulting prints are big – sometimes over a metre in length – which creates an intentional paradox of scale. This initially fools the viewer into thinking that the environment is real, as opposed to a small set'.

'There is a narrative style to the photographs, but I never say what is going on in my mind. I like the viewer to make up his or her own story and I don't want to influence that. There is no right or wrong, or definitive outcome. I don't know where the ideas come from, but images I see, books, and films constantly influence me. They all go into my subconscious and I jot things down, or make a little drawing, as things come to me. I rarely sit down and force myself to come up with ideas, as that never works for me.

'The sets are approximately 40cm in size, along the longest side. Initially, I'll draw my ideas for the set, and then go from there. The constructed sets are made from wood or thick foam board, and most of the objects come from architectural model stores or dollhouse suppliers! The sets can take anywhere from a day to a few days to construct, which sounds like a lot of time for such a small staging, but they quite often need tweaking and adjusting as I go along. This is mainly because once the camera is in place, I can see how the framing is going to work, and the set may have to be added to, or adjusted, so what is important to me becomes evident. The positioning of the lights can also be a factor. Sometimes the initial set up doesn't work and I have to move a wall or ceiling, to achieve the lighting effect I want.

STILL-LIFE ESSENTIALS
Holding objects in place is vital in still-life photography. Gaffer tape, adhesive putty, string, chopsticks, and spray adhesive can all come in handy when you need to keep things steady.

▶ I backlit this set with two flashlights, one on each side of the shed. The 'earth' is actually instant coffee.

MAMIYA RZ67, 80MM, 4 SECONDS @ *f*/5.6.

◀ A single, diffused flash was used from the front for this shot. A pale blue gel was fitted in front of the light to add a little more blue to image.

MAMIYA RZ67, 80MM, 1/60 SECOND @ *f*/11

'This particular work [for the Evidence series] was shot on medium-format film, using a Mamiya RZ67 and either a 75mm tilt-shift lens, or an 80mm lens, which are approximately equivalent to 40mm in 35mm terms – so a touch wider than standard. The reason for using film is mainly for the feel that it gives. Even though I can play around in Photoshop to achieve film-like qualities, it isn't quite the same. In fact, none of these images have any digital manipulation – they are all straight out of the camera.

'Also, because the resulting prints are big, I need a decent-sized negative to print from. When I started this style of photography, the price of medium-format digital backs was prohibitive to me, so film was a happy necessity. That's something that has stuck for now.

'I will use a variety of ways to light the set, depending on the mood I'm after. In addition to using conventional studio flash, I've used flashlights, desk lamps, and candles. I always shoot on daylight film, but using tungsten bulbs with it gives a warm, yellow effect, as in the image of the shed. I may also use gels on the lights; the photo of the room with gloves was lit with blue gel filters on the lights, for example.

'Initially, I'll shoot a roll of transparency film, tweaking the exposures as I go (both shutter speed and aperture). I use a handheld light meter to take exposure readings, as quite often there's a lot of contrast in the scene. I expose for the area that's important to me, but I'm very conscious of not letting the highlights burn out; as long as there's enough detail in the shadows, I'm happy.

'When I'm shooting on transparency film, I'll also move the lighting around and might even move the items in the set as well, keeping notes of all the changes I make to each shot. Then, once that film is processed, I can see what has worked and what hasn't. If I'm not happy with the way things are looking, I'll shoot another roll of transparency – it's actually quicker and cheaper than getting contact sheets printed! However, if I'm happy with a particular option, I'll shoot the final setup straight onto negative film'.

To see more of Daniel's personal work visit www.danielbrooke.com; his commercial photography can be found at www.danielbrookephotography.com

DANIEL'S TOP TIPS

- Don't stick to one viewpoint: Change the camera angle or position and move the subject as well.
- Use your imagination. The first idea you have can be developed and pushed further. It might not work, but there's no harm in trying.
- If a photograph isn't working, just leave it. Come back to it again later, with fresh eyes.
- Keep shooting to develop your style. Not every photo you take will be a winner, no matter how experienced you are.
- You don't need expensive kit, certainly not initially. Any camera and your imagination is the best starting point. Creativity really counts these days.

▶ A single flashlight was shone through a 'window' in the set that is just out of the frame at the left. A blue gel was used to filter the light and the exposure was timed to capture the flame.

MAMIYA RZ67, 75MM TS LENS, 2 SECONDS @ ƒ/8

▼ This was lit using a desk lamp fitted with a homemade snoot to narrow the beam. A pale blue gel was used to take some of the yellow out of the light.

MAMIYA RZ67, 75MM TS LENS, 4 SECONDS @ ƒ/8

Flash

When it comes to adding light to a scene, the two basic options you have are the same as they have been for decades: You can either use flash (discussed here) or you can use continuous lighting (which we'll look at later).

Both flash and continuous lighting have their advantages (and disadvantages), but flash is still the longstanding favorite for photographers. At a most basic level, an electronic flash comprises a flash tube filled with gas (typically xenon) and a capacitor that can build up and store a high-voltage electrical charge. When a flash exposure is made, the capacitor discharges some, or all, of its charge into the flash tube. The gas in the tube reacts to this sudden electrical charge, producing a momentary burst of light – the flash. The capacitor then builds up its charge again, and the process can be repeated.

Flash has numerous positive traits, not least the fact that it's daylight balanced (making it relatively easy to use as a fill light, as outlined on pages 134–135); it can offer a near instantaneous burst of bright light; and it can often be controlled in a variety of ways, from manual control through to total automation. The downside is that you can easily find yourself in the dark with regards to how exactly the flash light will appear – until it fires and the exposure is made, it is quite difficult to visualise precisely the effect it will have.

BELOW Slow-sync shots combine a flash's ability to freeze action with a long shutter speed's potential to record motion blur.

The Fundamentals of Flash

Flash photography brings with it a whole new language, which can be incredibly daunting at first. However, here are the key issues to be aware of.

GUIDE NUMBER

A flash's guide number indicates how powerful it is: The higher the guide number (or GN), the more powerful the flash. A guide number is given as a distance (so it can be in metres) at a specific ISO (usually 100 or 200) and a specific focal length (often 50mm), so comparisons can be made between different flashes. In the past, the guide number was also used as a way of determining exposure. While this is still possible, there is rarely any reason why you would want or need to do this. (Note that guide numbers only apply to built-in and hotshoe-mounted flashes. Studio flash units tend to use watt-seconds/Ws or joules/J to indicate their power.)

RECYCLING

The recycling (or refresh) time for a flash is the time it takes for the capacitor to build up its charge after the flash is fired. If a flash is fired at full power, the capacitor is drained fully, so it takes the maximum amount of time to recycle. However, fire a flash at ½ power and the capacitor is only drained of ½ its power, so the recycling time will be quicker.

FLASH DURATION

The actual duration of a flash – that split-second burst of light – is exceptionally brief, and almost always faster than the shutter speed you're using. So, while you might be using a shutter speed of 1/125 second, the flash duration may be 1/2000 second or faster. What this means is that the flash, not the shutter speed, is effectively determining the exposure time; so you could set a shutter speed of 1/30 second and the flash would appear just as bright as it would if you set 1/125 second However, the different shutter speeds will affect the appearance of parts of the scene lit by ambient lighting. The thing to remember when you use flash is that the aperture changes the exposure for the flash, while the shutter speed changes the exposure for the ambient lighting.

BELOW The short duration of a flash means that it can create exceptionally fast, motion-freezing exposures.

PROS	CONS
• High power.	• Can't preview lighting (unless using a studio flash with a modeling lamp).
• Most cameras have a flash built in.	
• Versatility (many hotshoe units offer TTL and Manual control).	• On-camera flash tends to deliver unflattering results.
• Options range from built-in flash units to studio flash.	• Unsuitable for shooting video.
• Easy to control and modify flash output.	• Generally more expensive than continuous lighting.
• Daylight-balanced colour temperature (around 5500K) makes it easy to use flash in daylight.	

SYNC SPEED

DSLR and mirrorless cameras (and any other camera with a focal-plane shutter) has what is known as a sync speed. This is the fastest shutter speed at which the camera's sensor is exposed in its entirety to light and the fastest shutter speed that should be used with flash (although see High Speed Sync, below, for an exception to this). If the shutter speed is set any faster, the sensor is exposed to a rapidly moving slit of light, and the flash will therefore only illuminate part of the frame, as illustrated below (the faster the shutter speed, the smaller the area of the frame that is exposed). On most cameras, the sync speed is usually in the region of 1/200–1/250 second and the camera will not allow you to exceed this when you are using the built-in flash or a dedicated hotshoe unit. However, if you use a manual flash (or studio strobes) you will find you can set any shutter speed you choose and the flash will still fire.

SLOW SYNC

When you use flash at night (or anywhere else that's dark or dimly lit), there's a strong possibility that you'll end up with a bright subject and a pitch-black background. Slow-sync flash prevents this by combining flash with a slow shutter speed, so you can illuminate your subject with flash, but still record the ambient light of a low-light scene as well. You may need to avoid your subject moving immediately after the flash has fired, though, as any subsequent movement may be recorded as a blur if the shutter is still open.

HIGH-SPEED SYNC

This is a feature found on some (but not all) hotshoe-mounted battery flash units, which allows you to shoot with a shutter speed that is faster than the camera's sync speed. This can be particularly useful if you want to use fill flash on a bright day, but also want to use a wide aperture. The way high-speed sync works is by pulsing the flash, so it effectively becomes a

LEFT As long as your shutter speed is equal to or slower than the camera's sync speed, the entire frame (sensor or film) will be exposed to the flash (right). However, if you exceed the sync speed, your flash will only expose part of the frame. The section covered by the closing shutter blind will only be exposed by the ambient light, resulting in a darker area at one side of the frame (far right).

continuous light source as the slit created by the shutter travels across the sensor. In this way, the entire frame is exposed equally, although to achieve such rapid bursts of light, the intensity of the flash is reduced, so you may need to be closer to your subject than if you were using regular sync flash.

FIRST & SECOND CURTAIN

This describes when during the exopsure the flash is fired. As noted previously, the flash duration is usually far faster than your camera's shutter speed, which means you can choose to have the flash fire at the start of the exposure (first-curtain sync) or at the end of the exposure (second-curtain sync). The difference is most noticeable when you are photographing a moving subject, as below.

RED-EYE REDUCTION

When you have a flash positioned close to the lens axis, and take a picture of a person there's a chance that the light from the flash will reflect off the various blood vessels at the back of their eyeball, creating the ubiquitous – and slightly demonic – red-eye look. Ironically, this most often happens when you photograph some in low light conditions (the exact time when flash can be beneficial), as your subject's pupils will naturally be wide. To overcome this, most built-in and hotshoe-mounted have a red-eye reduction feature that uses a pre-flash to dilate the subject's pupils, followed by the main flash to take the shot. Although this can work, it is not infallible (hence reduction not removal) and there's also a risk that your subject will move after the pre-flash, thinking the shot has been taken.

RIGHT Whether you choose first- or second-curtain sync can have a major impact when you photograph a moving subject.

With first-curtain sync, the flash fires at the start of the exposure, so your subject is immediately frozen by the flash, and any subsequent movement is recorded as a blur (which appears in front of it).

Because second-curtain sync fires the flash at the end of the exposure, the motion blur is recorded first, with the frozen, flash-lit subject at the end. This causes the motion blur to appear behind the subject, which usually appears more natural (like speed-blur lines in a cartoon).

However, using first-curtain sync can make it easier to get your subject where you want it in the frame, as you know precisely where it will be when you trigger the shutter, rather than at the end of a longer exposure.

FIRST-CURTAIN SYNC

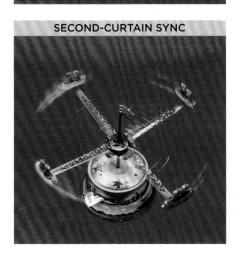

SECOND-CURTAIN SYNC

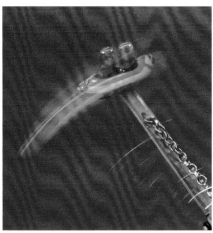

Built-in Flash

There are essentially three types of electronic flash: built-in, hotshoe mounted, and studio. Your camera's built-in flash is at the bottom of this flash food chain and is the number one cause of people complaining that their flash shots don't look great. This happens for several fundamental reasons. The biggest issue is that a built-in flash is usually very close to the lens, aimed straight at your subject. The can disappoint in two ways. First off, you've got front lighting, which we looked at on page 106. This is never flattering, and with a flash-lit subject, it can lead to hard, dark shadows being thrown onto the background if it's closeby. It can also lead to a phenomenon known as red eye.

The second issue is power. That built-in flash has to fit in your camera, so by definition it has to be small. When it comes to flashes, then the general rule is that the smaller the flash unit, the less powerful it is likely to be, so the less light it will produce. Consequently, you may find that you need to open up the aperture to let in as much light as possible; increase the ISO; move closer to your subject; or combine two or three of these options to get the shot you are after.

FILL FLASH

Arguably, your built-in flash is most useful when it's used as a fill light, rather than the main light source in a shot. On sunny days, for example, it's really easy to end up with hard shadows falling across your subject. Sometimes this can add a graphic edge to the image, but a lot of the time, these shadows are just too hard, particularly when it comes to photographing people.

One solution is to use a reflector to bounce some light into the shadows, but unless you're specifically shooting portraits, a reflector probably won't be high on your essential-things-to-carry list. Instead, you can simply activate your camera's built-in flash, and this will add a pop of light that is guaranteed to lift those heavy shadows. The default option for most cameras is to fire the flash and automatically balance it with the ambient light, so the flash appears to have equal intensity. This is fine, but it will be obvious that flash has been used. If you want a subtler result, experiment with flash exposure compensation to alter the flash-to-daylight ratio; reducing the flash exposure by $\frac{1}{2}$–1-stop (I typically use $-\frac{2}{3}$ stop) will still lift the shadows, but the result will not look quite so artificial.

FLASH MODES

When you use a built-in flash you will typically have a number of control options, as shown here.

ICON	MODE	ABOUT
AUTO	AUTO	• Flash fires automatically when the camera decides it is needed. This is usually when the light levels are low.
⚡	FLASH ON	• Forces the flash to fire each time a shot is taken. Useful when you want to employ fill flash.
🚫⚡	FLASH OFF	• The flash will not fire. Useful when you are photographing at an event where flash is prohibited, or you want the camera to use a long exposure.
👁	RED-EYE REDUCTION	• The camera uses a pre-flash to help prevent red eye.
🖼★	SLOW SYNC	• The camera combines flash with a slow shutter speed.

LEFT Built-in camera flashes come in a variety of styles, but all share similar negative traits: low power and close proximity to the lens. On the plus side, they are usually good at providing a burst of fill flash.

Fill Flash Options

These shots all fall unashamedly into the category of family snapshots. Their purpose is to demonstrate just how useful your camera's built-in flash can be.

The first shot (top left), is a classic example of when fill flash is beneficial. As the light is coming from behind the subject's left shoulder, her face would have been in shade if I'd only relied on natural light. In this situation, the simple solution is to pop up the flash on the camera (in this case a DSLR). At its default (automatic) setting, the camera will set the flash power to match the ambient light exposure. In this example, the obvious use of flash, combined with a shallow depth of field, has ensured that the subject stands out from her background. However, the shadow created under the hat by the on-camera flash is less than ideal.

In the second shot (left), the backlighting is extreme. The sun was immediately behind the subject, so this was almost certainly going to come out as a silhouette unless I used flash. Normally, I would set the flash power at -$\frac{2}{3}$ stop using flash exposure compensation, but in this instance, there was no need. The built-in flash on the point-and-shoot compact I was using was never going to be powerful enough to match the sun's intensity. However, it has done enough to fill in what would have otherwise have been heavy shadows on the subject's face.

In the final shot (bottom left), I wanted the flash to be the dominant light source, which is only possible when the ambient light level is low (on a bright day, your built-in flash won't be powerful enough to overpower the ambient light). To achieve this effect, I increased the flash power by + 1 stop using flash exposure compensation and decreased the ambient exposure by - 1 stop using regular exposure compensation. This darkens the exposure for the daylight, but lightens the flash exposure to bring it back up to the correct level.

In all three cases, the camera's built-in flash has been used as a fill light, but in three different ways: as a standard fill; a weak fill; and a strong fill.

THIRD-PARTY CAUTION

As well as the camera manufacturers' own flash offerings, there are numerous third-party dedicated flash units available, such as the Yongnuo Speedlite YN568EX shown opposite. These flashes can offer a significant cost saving over the manufacturer's own equipment, while delivering similar.

However, while you can get plenty of bang for your buck, full compatibility is not guaranteed – you may find some features that you would find on a manufacturer's flash don't work as expected (or at all) on a third-party unit. This is particularly true when you use an older third-party flash on a newer camera; if the manufacturer subtly changes the way in which its cameras and flashes communicate, then a third-party flash may no longer work properly. This is worth considering if you regularly upgrade your camera or are thinking of replacing your camera in the near future.

Hotshoe-Mounted Flash

Many of the limitations of a camera's built-in flash can be overcome by investing in a separate, battery-operated flash that slides into the electrical socket on top of your camera (this socket is your camera's hotshoe). A wide range of models is available, but for most people, a dedicated flash is the best option, as it allows the flash and camera to communicate, enabling a whole host of sophisticated features, including fully automatic exposure control.

The simplest dedicated hotshoe flashes are often little more than larger versions of your camera's built-in flash, with increased power. As such, they can still create unflattering results when used on-camera, but the major benefit of a separate flash is that you can take it away from the hotshoe and use it off-camera; on a bracket beside the camera, or a light stand at a distance. We'll explore off-camera flash on page 144.

More sophisticated flashes will not only allow you to use them off camera, but also open up more creative on-camera options, such as the ability to bounce and swivel the head so the flash can be directed in a range of directions (see page 142). You may also be able to access high-speed sync modes and other advanced features.

WARNING: Trigger Voltages

There are some fantastic older, manual flash units available at bargain-basement prices, and these can form the basis for a great off-camera flash kit. BUT, you should be very wary about attaching them directly to your camera's hotshoe. In many cases, the trigger voltage for an older flash designed to work with mechanical film cameras is much higher than a modern digital camera can cope with. The result? Firing the flash while it is in the camera's hotshoe could damage the circuits in your delicate digital delight!

RIGHT Having the option to tilt the flash head means you can bounce the light off a ceiling or, as was the case here, a small card. This allows you to soften the light, even when the flash is in the camera's hotshoe.

Hotshoe Flash Anatomy

This third-party flash unit offers a comprehensive range of features that are typically found on high-end flashes.

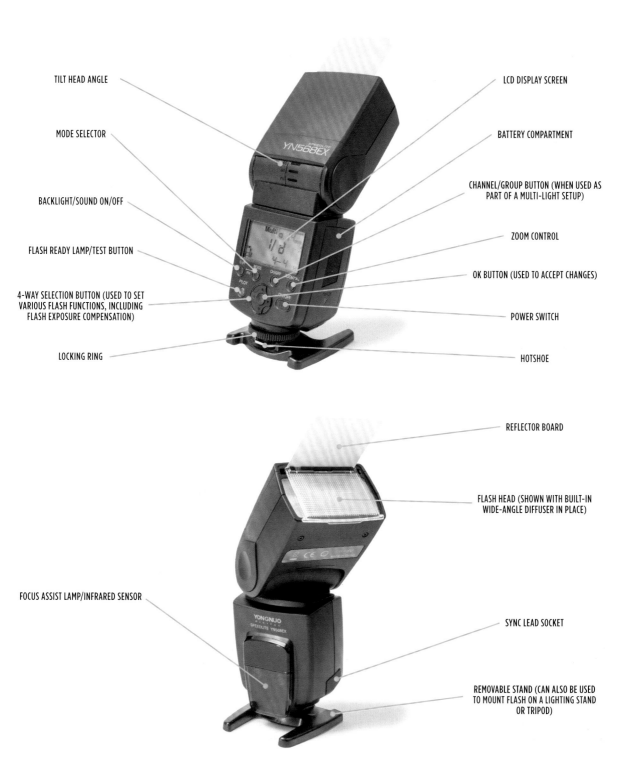

TILT HEAD ANGLE

MODE SELECTOR

BACKLIGHT/SOUND ON/OFF

FLASH READY LAMP/TEST BUTTON

4-WAY SELECTION BUTTON (USED TO SET VARIOUS FLASH FUNCTIONS, INCLUDING FLASH EXPOSURE COMPENSATION)

LOCKING RING

LCD DISPLAY SCREEN

BATTERY COMPARTMENT

CHANNEL/GROUP BUTTON (WHEN USED AS PART OF A MULTI-LIGHT SETUP)

ZOOM CONTROL

OK BUTTON (USED TO ACCEPT CHANGES)

POWER SWITCH

HOTSHOE

REFLECTOR BOARD

FLASH HEAD (SHOWN WITH BUILT-IN WIDE-ANGLE DIFFUSER IN PLACE)

FOCUS ASSIST LAMP/INFRARED SENSOR

SYNC LEAD SOCKET

REMOVABLE STAND (CAN ALSO BE USED TO MOUNT FLASH ON A LIGHTING STAND OR TRIPOD)

Before TTL flash control, Auto was the common alternative to full manual control. However, Auto flash existed at a time when cameras were relatively mechanical; autofocus was either primitive or non-existent, multi-area metering was unheard of, and digital cameras were simply inconceivable. Consequently, it was up to the flash to determine the exposure, rather than the camera.

To start with, the photographer would tell the flash what aperture they wanted to use, based on their film speed (ISO) and flash-to-subject distance. Then, when the exposure was made, a sensor in the front of the flash unit would measure the light reflected from the subject. When the flash determined that enough light had been produced for the aperture the photographer had set, it cut the flash.

Although relatively crude, with practice, it was possible to produce decent results, although the wide exposure latitude of negative film often helped cover up any exposure errors. Today, you are unlikely to encounter Auto flash unless you decide to shoot film and invest in a retro flash unit. If you do, then you could do a lot worse than the Vivitar Auto Thyristor 283 or Metz 45 flashes. Both were great workhorses that are still used by a lot of hardcore strobists today (albeit in manual mode).

Controlling Flash

Whether it's the flash built in to your camera or a hotshoe-mounted unit, you may find that you have multiple control options, which determine just how automated your flash exposures are.

TTL FLASH

Digital through-the-lens flash metering (i-TTL for Nikon, E-TTL II for Canon) is the most recent, most sophisticated, and most automated exposure control system. It places control of the flash exposure with the camera (rather than the flash), which measures the light coming through the lens. The precise details of different manufacturers' TTL systems differ slightly, but the overarching principle is similar:

1 When the shutter button is fired to take a shot, the flash fires a very brief (and usually very weak) pre-flash.

2 The pre-flash hits your subject and is reflected back through the camera's lens.

3 Based on the pre-flash, the camera determines just how much light is required to make the proper exposure.

4 The flash fires a second time, this time at the correct output to make the exposure.

This sequence of events happens so rapidly that there is often no indication that a pre-flash fired, and no discernible delay between the shutter-release button being pressed and the exposure being made.

The main benefit of TTL control is that the camera does the complex math when it comes to determining your exposures. This is particularly useful when you bounce the flash, attach accessories such as diffusers and softboxes, or use the flash off-camera, especially if it is part of a multi-light setup.

However, as with regular, non-flash exposures, TTL exposure metering is not infallible, because it makes the same assumption that all of your subjects balance out to a midtone. The problem is, the light entering the lens is the light reflected by your subject – and bright subjects reflect a lot more light than dark ones. Consequently, very bright subjects can fool the camera into underexposing the flash exposure, while dark subjects can lead to overexposure (a particular problem if you're using flash at night). This is one instance where flash exposure compensation can be beneficial (see right).

Flash Exposure Compensation

1 Depending on your camera, you may need to open the menu or access a quick-control screen to set the Flash Exposure Compensation.

2 Or, you might need to press and hold a flash compensation button (picture right) and turn the control wheel.

3 As with regular exposure compensation, flash exposure compensation is set in ½- or 1/3-stop increments. Applying positive (+) compensation will increase the flash exposure, while negative (−) compensation will reduce it. It does not affect the exposure for the ambient light, though.

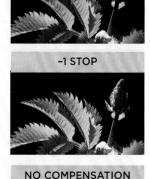
−2 STOPS

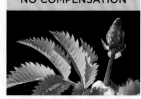
−1 STOP

NO COMPENSATION

+1 STOP

BELOW For this shot (a variation on the sequence above), I used an off-camera TTL flash fitted with a softbox, as well as the camera's built-in flash. Using the camera's wireless control, I reduced the power of the built-in flash by -2 stops to give me a weak frontal fill, and set the off-camera hotshoe flash to +1 stop, holding it at arm's length to the right of the camera. This enabled me to create a shot that looks like it could be a studio still life, yet was actually taken on location.

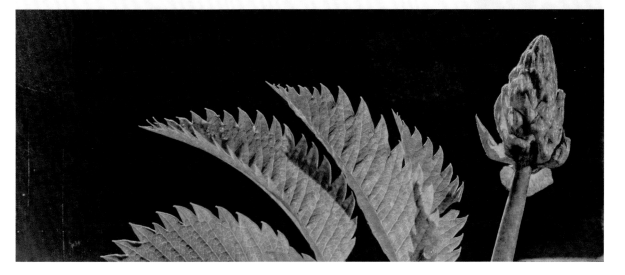

Manual Flash

When you switch your flash to manual, you have full control of its power output. With external flashes, you can typically set the power from 1/1 (full power) all the way down to 1/128 power, which can be useful when you have very specific needs: A lower flash power setting will give you a faster recycling time (helpful when you want to shoot a rapid sequence) and it will also reduce the duration of the flash (enabling you to freeze exceptionally brief moments in time). Whatever your reason for using manual flash, you will need to set the necessary aperture and ISO yourself (as noted previously, the shutter speed is less important as it only affects the ambient exposure, not the flash exposure). Determining the exposure can be done in a number of ways, depending on what you're shooting and how you prefer to work, but perhaps the simplest solution is to use a handheld light meter that can take flash readings. This is typically the way that most pro photographers would work with large studio strobes, and in most instances it's the quickest and easiest way of nailing your exposures.

BELOW Manual flash is a studio staple, although a flash meter is almost essential if you want to make it easy to get the exposure right the first time.

However, you could also determine the exposure based on your flash's guide number. Basically, to determine the flash exposure you use one of these formulas:

guide number / distance = aperture
guide number / aperture = distance

So, if you had a flash with a guide number of 36 meters (at ISO 100) and your subject was three meters away, you could use the first formula to determine that the aperture setting you'd need to use would be $f/12$ (36/3=12). In practical terms, $f/11$ would be the closest full aperture setting.

Alternatively, if you wanted to use an aperture setting of $f/4$ with the same flash, you could apply the second formula, which will tell you that your flash-to-subject distance needs to be 9m (36/4=9). In both cases, it's important to note that they only apply if the flash is used at full power, its zoom head is set at the focal length used to determine the GN (where applicable), and the camera is set at the GN's ISO setting.

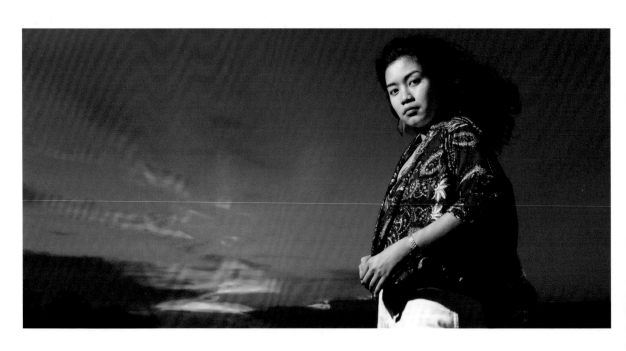

INVERSE-SQUARE LAW

Whether you're using manual or TTL flash (or most types of continuous lighting), it pays to be aware of the rather imposing-sounding Inverse-Square Law. This is a physical law that describes the way light falls off or reduces over distance. This fall off is inversely proportional to the square of the distance from the source of the light.

What this means in real terms is that when the distance between the light and subject is doubled (2x the distance), it receives ¼ of the amount of light; when the distance is tripled (3x the distance) it receives 1/9 the amount; when the distance is quadrupled (4x the distance) it receives 1/16 the amount of light, and so on. Basically, if you multiply the increase in distance by itself (1x1, 2x2, 3x3, and so on) and stick the answer at the bottom of a fraction, you know how much less light there will be. If you'd rather see that presented as an equation, then it's:

$$i = \frac{I}{d^2}$$

Where: i = illumination level
 d = distance

Why is this important? Well, a lot of the time it isn't – at least not in a practical sense. However, it is worth being aware of for those occasions when you have multiple subjects at different distances from your flash and you find yourself struggling to light them all evenly (moving the flash farther away will mean the light fall off is less noticeable).

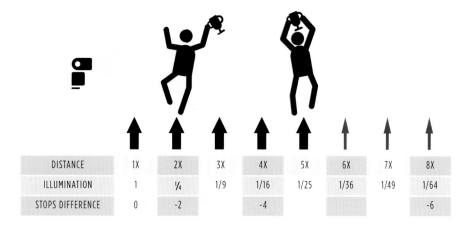

DISTANCE	1X	2X	3X	4X	5X	6X	7X	8X
ILLUMINATION	1	¼	1/9	1/16	1/25	1/36	1/49	1/64
STOPS DIFFERENCE	0	-2		-4				-6

ABOVE The main thing to remember about the inverse-square law is that light falls off more quickly the closer it is to your subject. Also, each time you double the flash-to-subject distance, the amount of light is ¼ of what it was (not ½).

For example, if you put the distances in this illustration into meters, a subject 2m from the flash would receive ¼ as much light as a subject 1m from the flash, which is a difference of 2 stops. The exact same thing would happen if you had a subject 10m from the flash and another at 20m from the flash: the light intensity would drop by 2 stops. And if you had one subject at 100m, and another at 200m? Yup, the same rule applies; it's a 2-stop difference (despite the huge distance).

EXPOSURE TABLE						
ASA ▶ 25	50	100	200	400	**m.** ▼	
3	8	11	16	22	32	1
5	5.6	8	11	16	22	1.5
7	4	5.6	8	11	16	2
10	2.8	4	5.6	8	11	3
15	2	2.8	4	5.6	8	4.5
20 ▲	1.4	2	2.8	4	5.6	6
ft.	15	18	21	24	27 ◀ DIN	

LEFT Some manual flashes (especially older, non-dedicated models) have a flash table printed on them, which indicates the aperture setting to use based on the ISO (or ASA) and flash-to-subject distance. As long as you know the guide number, you can generate flash tables for any flash using the formula given above.

there's an app for that...

Rather than struggle with flash formulas, you can download an app such as Manual Flash Calculator 2 (available for both iOS and Android devices), which will do the math for you.

Bounce Flash

The easiest way to soften the light from a hotshoe flash is to bounce it off another surface, such as a wall, ceiling, or reflector. (Your flash will, rather obviously, need a head that can be tilted upward and/or swivelled to the side.) Bouncing the light has several effects:

To start with, bouncing the flash effectively makes your light source bigger as the surface the light is reflected from becomes the light source. A larger light source is a softer light source, and reflected light is more diffuse, again meaning that it's softer. As the flash is no longer aimed directly at the subject, it is no longer a frontal light; instead, it will act more as a top light (if bounced from a ceiling or reflected above the flash) or a sidelight (if bounced from a wall at the side, for example). And, finally, add to the list of benefits that since the flash is coming from above the subject, or from the side, there is no chance of it creating red eye.

Bouncing will not only change the quality of the light, helping you lose the hard shadows, but it also changes the direction. If you're using TTL flash control, then all you need to do to make these quite significant alterations is tilt or turn the flash head; the camera will automatically compensate for the changes in the light.

However, you need to be aware that the effective power of the flash will be reduced, as the distance between the flash and the subject increases. The camera-to-subject distance might not change, but the flash is no longer traveling directly to your subject – it now has to travel to and from your reflective surface. As noted, TTL flash control will automatically compensate for this, but if you are setting the flash manually, you will need to compensate either by opening the aperture to let in more light, increasing the ISO to effectively make your sensor more sensitive, or by increasing the flash power (assuming it isn't already set to maximum).

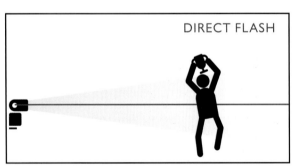

DIRECT FLASH

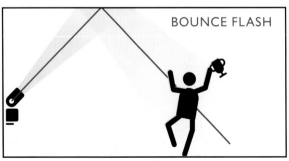

BOUNCE FLASH

LEFT This pair of illustrations demonstrates a number of key differences between direct and bounced flash.

1 Bounced light is no longer directly from the front; it is top lighting, not front lighting (see pages 106–109).

2 The light falling on the subject is more widely spread when it is bounced; this makes it more diffuse (softer).

3 The light has to travel farther when it is bounced; in this illustration, the bounced light is traveling 1.5x farther than the direct flash. This means it will fall off less quickly when it reaches the subject (see Inverse-Square Law on page 141). It also means it is less powerful, so the exposure needs to be increased (or the flash power increased to maintain the same exposure).

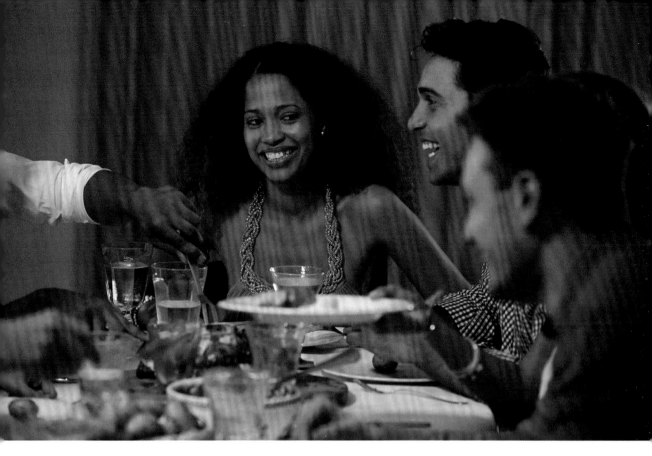

ABOVE Photographing most types of social events, such as weddings, birthdays, or anniversaries, will almost certainly involve working indoors with little or no control over the lighting. So flash is almost essential, but nothing's worse than the light from a hard, direct flash. However, all you need to do is tilt the flash head to bounce it off of the ceiling, a reflector, or a wall. In this example, the flash was bounced off the white ceiling, giving it a soft, naturalistic look.

LIGHT MODIFIERS

As hotshoe flashes have become used more prolifically, an ever-growing range of accessories has appeared alongside them. These accessories range from simple bounce boards that you can bounce the flash light off of, to plastic diffusers and softboxes for softening the light; snoots to narrow the beam; and ringlight adaptors that turn your hotshoe flash into a pseudo-ring flash.

With a little ingenuity, you can make your own versions of many of these lighting accessories, allowing you to control the light from your flash without spending a small fortune.

ABOVE This universal hotshoe flash softbox cost a few quid on eBay, and while it's not the best-made accessory, it does soften the light. A viable alternative is to make your own using thin card and tracing paper, which would also let you customise the size (and shape) of your diffuser.

Off-Camera Flash

As soon as you take your flash away from the camera axis, so it's not direct and frontal, your photographs will gain a more professional edge. Why? Because direct, frontal flash is the lighting style that typifies compact cameras and phones, so we naturally associate it with snapshots rather than considered photographs. By extension, as soon as we see an image where the flash is coming from a different direction, we almost unconsciously think of it as being more accomplished and proficient. Of course, this isn't always the case (I've seen – and indeed created – some dreadful shots using off-camera flash), but as a general rule I would suggest that getting your flash away from your camera is almost always a good thing.

SYNC LEADS

At a basic level, all you need to get your flash away from the camera is a means of triggering it. Arguably, the simplest solution is to use a sync lead, which is an electronic cable that enables a trigger voltage to be sent from the camera to the (remote) flash. While some sync leads allow you to retain TTL control over the flash – which is certainly beneficial – all sync leads have the same notable shortfall, which is that you can only position the flash within the reach of the cable. If you're using a 1 meter cable, that's the farthest your flash can be from the camera, which will definitely limit your creativity.

WIRELESS TRIGGERS

Thankfully, overcoming the disadvantages of a physical cable is pretty straightforward. Many modern camera systems feature wireless flash units that are triggered by either the camera's built-in flash, another flash mounted in the hotshoe, or an infrared signal (which might come from a dedicated control unit). The level of sophistication offered by wireless flash systems is growing all the time, and now even modestly priced units are capable of being a controlling master flash or a remote slave flash in a multi-light setup. It's also possible to assign your flashes to different groups, allowing elaborate lighting setups to be created and then managed using TTL flash exposure control.

Of course, you might not necessarily need (or want) such automation, in which case, far simpler (and less expensive) flash options are available, including a whole host of powerful manual flash units that are no longer seen as desirable due to their lack of TTL support (my personal favorite is the Metz 45 lineup). These flashes can be fired using simple optical cells that trigger the flash when they detect another flash firing, or you can use radio triggers.

Radio triggers come at a range of price points, with varying levels of sophistication, but in almost all cases, the basic operation is similar. A sender unit is attached to the camera (usually sitting in the camera's hotshoe) and a compatible receiver is attached to the flash. When the camera fires, a signal is sent from the sender unit to the receiver, and the remote flash is triggered. However, while the most basic kits will simply fire a remote flash, more sophisticated products add TTL control, multiple channels, increased range, and even the ability to fire remote cameras at the same time as triggering off-camera flashes.

THIS PAGE These photographs were taken in the narrow confines of a basement corridor in an office building. The behind-the-scenes shot (left) reveals that there wasn't much room for positioning lights, but I still took the flash away from the camera, triggering it via a sync lead and determining the exposure with a flash meter.

As you can see in the main photographs above (especially the closer shot), this slight movement away from the camera axis has resulted in some subtle shadowing on the left side of the subject's face, which helps keep the shots from appearing too flat.

The light was softened by bouncing it off the ceiling of the corridor, and I also attached a super-simple reflector (a piece of white card held on with an elastic band) to kick some of the light forward. However, while that was the only light I took with me, it was not the only light source: The white walls acted as giant reflectors, helping to ensure that the lighting remained soft by bouncing it back onto the subject. The wall-mounted fluorescent striplight acted as a fill light as well.

Continuous Lighting

Digital imaging has revolutionised the use of continuous lighting. There is now a wide range of lighting options based around different technologies, ensuring that there's going to be something to suit your needs (and budget).

Continuous lighting is the catch-all term that includes any light source that is turned on and stays on – the same way you'd turn on the lights in your home or workplace. This type of lighting was once the mainstay of photographic studio shooters (especially around the 1930s–1950s, during the Golden Age of Hollywood cinema), but it was rapidly replaced by daylight-balanced flash in the 1960s, as colour film became more widely used.

The main problem was that traditional incandescent photoflood lamps had a very warm colour temperature (around 3300K), which made them appear overly orange on colour film, unless filters were used on the lamps, over the lens, or on both. However, in the digital age, the once-problematic issue of colour temperature has been resolved through in-camera white balance and image-editing software, allowing colour-accurate results to be achieved in most conditions, regardless of whether incandescent, fluorescent, or some other lamp is used.

In addition, almost every digital camera now has the ability to shoot video, as well as still images. I'm not going to cover movie-making in this book (it is a very different discipline to photography), but one thing that separates still and moving images is the fact that video demands a constant light source – flash is simply unsuitable. Consequently, continuous lighting has seen something of a renaissance in recent years, with an increasing number of lamp types and configurations appearing on the market.

For photographers, one of the main advantages of continuous lighting is 'what you see is what you get' (awkwardly abbreviated as WYSIWYG). Unlike flash, there's no surprise when the exposure is made, because the effect of continuous lighting is evident before you shoot. This can make it far easier to achieve a specific look, and much simpler to determine the exposure (free from any sync speed restrictions and recycling time delays).

PROS	CONS
• What you see is what you get (WYSIWYG).	• Typically less powerful than flash.
• Suitable for shooting both video and still images.	• Wide range of colour temperatures, depending on the lighting type; OK if you're using the lamp on its own, but can make it harder to mix with daylight.
• Multiple illumination technologies available.	
• Generally lower cost than flash.	
• Options range from battery-powered lamps to large studio units.	

In almost all other respects, the same rules that apply to flash apply to continuous lighting, so the direction can be controlled; the light can be hard or soft (and modified using reflectors, diffusers, and lighting accessories); the inverse square law dictates how rapidly the light's intensity falls off; and so on.

Indeed, the main downside to using continuous lighting is it's not as powerful as flash can be, meaning you often have to use a wider aperture, faster ISO, or slower shutter speed. This can also make it slightly harder to freeze movement effectively, unless you have an exceptionally powerful lamp.

CONTINUOUS POWER

While flash guide numbers (broadly) enable you to compare the power output of different flashes from different manufacturers, the same can't be said of continuous lighting.

Watts are the unit of measurement associated with incandescent and fluorescent lighting, but while this indicates a lamp's power consumption (and higher consumption=brighter light), it doesn't allow a direct comparison between the two technologies. In fact, as a very rough guide, an incandescent lamp consumes around 4 times the power of a fluorescent lamp to produce the equivalent amount of light, so a 100W fluorescent bulb will be roughly as bright as a 400W incandescent bulb.

To complicate things, LEDs use lumens instead of watts, which is a measure of the amount of light they produce (rather than the power they consume). Unfortunately, as watts is a measure of power and lumens is a measure of energy, converting between the two isn't easy, especially as the lumen output of fluorescent and incandescent lamps doesn't increase in the same linear fashion as their wattage.

ABOVE These shots were used in a pair of camera-specific expanded manuals. They were both shot using two battery-powered, continuous, LED video lights fitted with coloured plastic gels.

Continuous lighting was ideal, as it meant I could precisely position the lamps, and immediately see the effect. The reduced power of LEDs wasn't an issue, due to the close proximity of the lamps to the subject.

Continuous Lighting Types

Four types of continuous lighting are used regularly in photography:

ABOVE This diminutive lamp can accommodate incandescent bulbs of up to 1000 watts. However, the technology is so inefficient that I now use two of these in my outdoor workshop for heat as well as light!

INCANDESCENT

Incandescent lighting is essentially the same technology as the domestic light bulbs we have relied on for many years. It works by passing an electrical charge through a filament, which heats up and glows, producing light (this filament is often made of tungsten, hence incandescent lighting also being known as tungsten lighting).

Although once popular with studio photographers, incandescent lighting has plenty of drawbacks, as outlined opposite, and for most still imaging purposes, it has now been superseded by fluorescent and LED lighting.

ABOVE HMI lighting is more commonly used in the motion picture industry than by photographers, although it is ideal if you're using a large-format digital scanning camera back.

HMI

HMI lighting (or Hydrargyrum medium-arc iodide lighting, to give its full title) is a cool-running, flicker-free, daylight-balanced light source. Although it was developed as a more efficient alternative to incandescent lighting for the film and television industries, the technology is ideal for still photographers working with medium- and large-format digital backs that scan an image, rather than recording it in a split-second exposure.

However, while HMI lighting offered a near-perfect solution from a technological standpoint, it was (and still is) eye-wateringly expensive, which has tended to limit it to high-end, big-budget commercial applications, with photographers renting rather than buying the equipment.

ABOVE Daylight-balanced fluorescent bulbs come in a range of shapes and sizes: This 85-watt photographic bulb is almost 30cm long and is roughly as bright as a 350-watt incandescent lamp.

FLUORESCENT

Thanks to the digital camera's built-in white balance control, fluorescent lights have become a viable, low-cost solution. The styles of the various systems vary as widely as their power outputs, but all rely on the same basic principle of passing an electrical charge through a sealed tube containing a gas that glows (fluoresces) to produce light.

However, light modifying accessories are few and far between and, more importantly, the colour balance of enthusiast fluorescent lighting can be somewhat vague. To guarantee colour accuracy, pro kit from the likes of Kino Flo is the way to go, but this carries a suitably professional price tag.

LED

LED lighting is the new kid on the photographic lighting block, with options ranging from high-power studio-style lamps and flat panels, to portable, battery powered units that can sit in the camera's hotshoe like a traditional flash. Although in its infancy (relatively speaking), LED lighting has already indicated that it could usurp flash as the primary form of artificial photographic lighting. Recent developments include portable units that offer both continuous and flash modes to cater for both video and still imaging; units that allow you to adjust the colour temperature for technical accuracy or creative effect; and studio flash-style LED heads that are fully compatible with existing flash lighting accessories. It's early days, but the future looks (reasonably) bright.

LIGHTING TECHNOLOGY	PROS	CONS
INCANDESCENT	• Low purchase, running, and repair costs. • Some lamps allow the light beam pattern to be adjusted from spot to flood.	• Generate a lot of heat with high power consumption. • Warm colour temperature (around 3300K) needs to be filtered to balance with daylight. • Colour temperature of bulb changes over time. • Limited range of modifying accessories available. • Heat-resistant accessories can be more expensive
HMI	• Cool running. • Daylight-balanced colour temperature (around 5500K). • Flicker-free (making it ideal for video). • High power.	• High purchase, running, and repair costs • Requires a bulky electronic ballast pack. • Needs time to reach daylight colour temperature. • Colour temperature of bulb changes over time. • Minimal accessory range for still photography
FLUORESCENT	• Cool running. • Low power consumption. • Some (not all) kits are balanced to daylight colour temperature. • Enthusiast kits available for a very low purchase cost • Unique strip-light designs available.	• Even a daylight-balanced kit may not have an accurate daylight colour temperature. • Some low-cost units can pulse, producing visible differences in light intensity and colour . • Generally low power. • Few lighting modifiers available.
LED	• Cool running with Ultra-low power consumption. • Daylight-balanced colour temperature. • Flicker-free (making it ideal for video) . • Some allow you to adjust the colour temperature. • Some exceptionally low-cost options.	• Generally less powerful than flash. • Many models based on a rectangular panel design. • Few lighting modifiers.

MASTERCLASS

FASHION
Dixie Dixon

Dixie Dixon is a commercial fashion photographer, born and bred in Texas. Just a few years out of college, this 20-something's career is skyrocketing, with an enviable client list that has seen her shoot for Disney, Virgin, and Nikon, in locations such as Cannes, Toronto, Vancouver, New York, Miami, Los Angeles, Ibiza, and Barcelona.

The main draw for Dixie is the freedom that fashion photography offers. 'There are no rules, no boundaries, just pure self-expression – that is what I truly love about it! A lot of the images you see in magazines break all the rules of photography because it's more about an idea, expression, or mood. It's the vision of the photographer or client that makes the shot happen and that, to me, is what makes it so exciting. In fashion, you have the opportunity to bring to life anything you can dream up'.

The freedom offered not only applies to the creative vision that underpins a shoot, but also to how and where images are made. Depending on the shoot, Dixie might be on location using daylight, or in a studio using artificial lights, so it's important to have the skills to maximise the potential of every situation. 'Creative-wise, I love shooting location work – there is a lot of room for serendipity on location. That feeds my creativity because the light, weather, and location are always changing on any given day. I like that kind of freedom. However, if it's an ad shoot where everything needs to be controlled, studio suits it best.

'The lighting I use depends on the job, rather than where I am. I work with natural light and reflectors a lot when I'm shooting lifestyle fashion, and one of the most effective tools in fashion photography is the reflector. This allows you to bounce light to use it as the main light source, as well as adding in a rim light. I love backlighting; placing the sun behind the model and then using a reflector in front to give the image a dreamy feel.

'I'll often work with strobes and continuous lights as well. If a job requires both video and stills, I love working with tungsten or HMIs, so I can shoot and my cinematographer can shoot alongside me. With constant light, what you see is what you get, which is nice, especially for photographers starting out and learning lighting.

FASHION ESSENTIALS

You can really take your photography to another level by upgrading from a kit lens to a fast, high-quality lens. The Nikkor 85mm f/1.4 is one of my go-to lenses – it has a wide aperture for shooting handheld in very low light, and it's great for both headshots and full-length images. If I could only have one lens, this would be it.

'On the other hand, strobes are perfect for photographing fashion advertising, either in the studio or on location. They can freeze motion and overpower the sun, so you're in control of the light even when you're outdoors. When we are on a time crunch, battery powered mono heads like Profoto B1's are perfect, because you don't have to plug them in anywhere. For strobes, I love using a beauty dish, which gives soft light with a nice contrast to it. I utilise it a tonne in my fashion photography; you can create beautiful work with just one light and a beauty dish'.

► This image was originally part of a personal project, but it ended up being used on the cover of Professional Photographer Magazine in the UK. This is all natural light, with the model facing a window. I wanted to capture her soul in this one and really focus in on that connection!

135MM, 1/250 SECOND @ ƒ/2, ISO 160

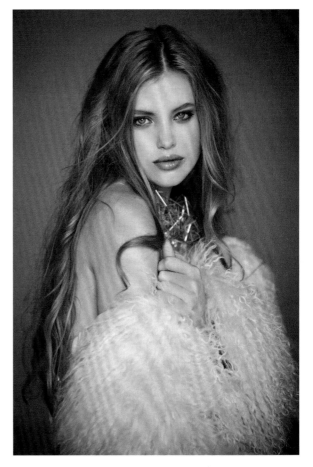

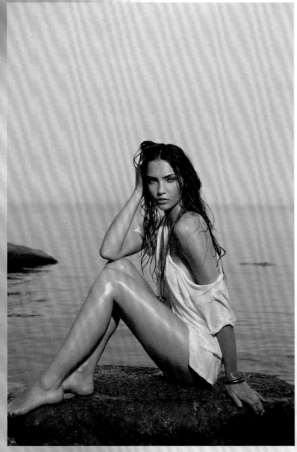

◄ I photographed this advertising image for a cable TV show on. We were in Toronto, Canada, and it was very cold outside and often overcast. For this shot, I used an Arri HMI lamp to add some direction to the lighting.

50MM, 1/800 SECOND @ ƒ/5.0, ISO 200

Given that she is one of the 16 original Nikon Ambassadors of the United States, it's hardly surprising what badge Dixie's cameras and lenses wear. A top-of-the-line Nikon D3x has given way to a Nikon D810 DSLR, which delivers her high-resolution images, backed up by a range of fast prime lenses that includes a trio of go-to options – a 50mm f/1.4, 85mm f/1.4, and 200mm f/2. 'The focal length you use changes your whole perspective, which makes lens choice an importrant decision. I prefer fast prime lenses over zooms, because they are insanely sharp. This requires me to be my own "walking zoom", but I love that – it makes me feel more creative and active during the shoot'.

The most important thing in fashion photography, however, is not the equipment you use, but the people. 'The hair, makeup, and wardrobe must all match the vision you are going for, so it's important to build your dream team of artists. This means people skills are extremely important! You have to not only be able to make your subject comfortable in front of the lens, but you also have to be able to manage a whole team of people toward the same vision. On most high-end fashion and advertising sets, there are an enormous amount of creatives present during the shoot, including makeup artists, hair stylists, models, wardrobe stylists, art directors, the client, a producer, as well as the photographer's assistants, which might include a digital technician, retoucher, lighting assistant, and grip assistants. In fashion photography, your team is everything!'.

You can see more of Dixie's fashion shots on her website, www.dixiedixon.com.

DIXIE'S TOP TIPS

- It's important to start out with a vision for your shoot. What story are you trying to tell? Come up with unique ideas for hair, makeup, and wardrobe beforehand that fit your story and communicate this vision to your subject.

- Lighting is everything. If I'm using sunlight, I'll start shooting in the early morning, break for lunch during harsh midday sun, and then continue shooting until the sun sets. Or if you are stuck shooting at midday, always look for shade or create your own shade with a scrim.

- Overexpose skin tones to make skin glow. I overexpose my skin tones by about 1/3- to ½ stop, which tends to make my subject's skin more luminous. In turn, less retouching is needed.

- For beauty headshots, I always shoot from a slightly high angle. This makes the subject appear more imporant, because they're closer to the camera. It's also more flattering for a subject's chin.

- Place your subject at an angle. Everyone loves looking thinner in photographs, and a great way to do this in camera is to angle your subject's shoulders slightly away from camera to make their frame appear smaller.

- Use a longer focal length lens. I always use longer lenses for beauty headshots. I absolutely love using the Nikkor 200mm f/2 and 300mm f/4 lenses, and the reason is that these longer lenses have a compression effect on faces and backgrounds, because you have to work from a distance.

- Using complementary colours will give your photograph a three-dimensional look, so if the background is green, try having your subject wear red so they stand out.

- Connection is everything! Once you've mastered your settings, lighting, and composition, focus on getting great energy out of your subject. I always have music playing and give tonnes of positive feedback as I shoot.

▶ This was part of a calendar I shoot each year for a company called Magpul, and is definitely one of my all-time favorite shoots. Magpul makes equipment for the military and was looking for a high fashion calendar that included its products; proceeds from the calendar go to veterans and military families.

This particular image was shot in the middle of downtown Dallas, with two policemen blocking traffic. We only had 15 minutes to pull it off, so I lit it with a single battery-powered strobe and beauty dish.

35MM, 1/200 SECOND @ ƒ/3.2, ISO 200

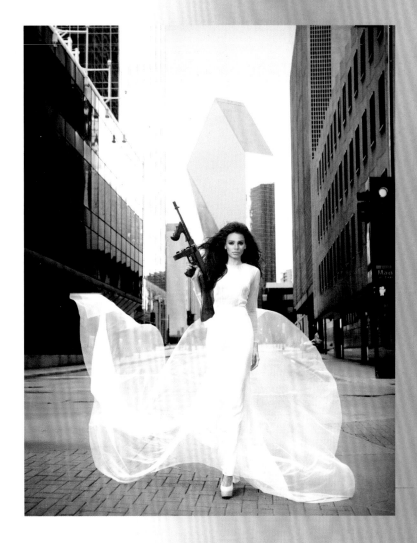

▶ This was originally shot as part of a retro series of fashion images with a Ford Mach 1 car. I used two battery-powered Profoto B1 strobes and a beauty dish. Although it was shot on a very cold day, I set my camera to a warm colour balance to make it look sunny.

50MM, 1/250 SECOND @ ƒ/2.8, ISO 100

Lenses

It's a simple truth that no matter how much your camera costs, it will never be able to deliver its full potential if you attach a poor-quality lens to it. Conversely, even the most humble camera can be made to shine when you mate it to some high-quality glass.

In this chapter, we'll explore all the lens-based options available to you, and take a look at just what you need to take your photography to the next level.

Lens Basics

A lens has one main role to perform: to transmit the light in the scene you're photographing onto your film or sensor. However, that's not its only role – lenses do far more than that!

As well as transferring your scene from reality to the sensor, the lens also determines how sharp (or not) the image is; how much depth of field there is; how much (or how little) appears in the shot; how much detail is recorded; and a whole host of other things that are fundamental in terms of making a photographic image.

Fixed Lenses vs. Interchangeable Lenses

The type of lens or lenses you can use is mainly down to your camera. If you're shooting with a phone or a point-and-shoot compact, then you're going to have a fixed lens, which means it's an integral part of the camera. You might be able to zoom in and out (more on that later), or attach various adapters, but good or bad, the lens that's attached to the camera is the only one you've got.

However, if you're using a DSLR or mirrorless camera, then your choice becomes much greater, because you'll be able to swap lenses. This enables you to use a wide-angle lens when you want to get as much in the shot as you can; a telephoto lens if you really want to close the distance between you and your subject; a macro lens for extreme close-up work; and more besides.

Attaching A Lens

1 Most interchangeable-lens cameras use a bayonet mount for attaching lenses, with matching alignment indicators on both the lens and the camera.

3 Depending on your camera you will need to turn the lens either clockwise or anticlockwise. An audible click will tell you it's locked in place and ready to use.

2 Line up the alignment indicators and push the lens gently into the camera body. Do not force it.

4 To remove a lens, press and hold the lens-release button on the camera body (usually beside the lens mount), and turn the lens in the opposite direction to step 3.

MAKING CONTACT

The electronic contacts between your camera and lens allow the two to communicate. These contacts are also the number one reason for lens-related error messages, so it's essential they are kept clean. Fit a rear lens cap on the lens and a body cap on the body anytime the lens isn't attached to the camera.

As well as the ability to switch between different focal length lenses, an interchangeable-lens camera also gives you a choice of using prime or zoom lenses, lenses with a wide maximum aperture (great for low light and shallow depth of field), and – perhaps most importantly – the option to invest in high-end lenses that will let you achieve the highest image quality possible with your camera.

Lens Anatomy

As discussed on pages 158–161, there are two different types of lens – prime and zoom – but both share a number of key characteristics.

PRIME LENS

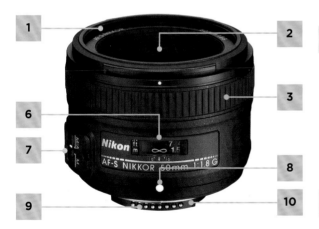

ZOOM LENS

1. Filter thread
2. Front lens element
3. Manual focus ring
4. Zoom control
5. Focal length indicator
6. Focus distance scale
7. Manual/autofocus switch
8. Lens alignment indicator
9. Electronic contacts
10. Lens mount

Lens Types

Lenses come in two broad types: prime lenses and zoom lenses. Which you choose will largely come down to what you shoot, and how.

Zoom Lenses

Almost every enthusiast-level, interchangeable-lens camera is available as part of a kit, comprising the camera and a general purpose zoom lens. There's a very good (and very straightforward) reason for this: a zoom lens is incredibly versatile. This is because it covers a range of focal lengths, so you can change how much of the scene the camera 'sees' by zooming in and out. If you want your subject to fill the frame more, you can zoom in; if you want a wider view, you can zoom out.

The range of focal lengths in a typical 'kit' zoom (the basic, inexpensive lens that comes packaged with the camera in a kit from the manufacturer) is around 18–55mm (on non-full-frame cameras), which, as you'll see, will take you from a reasonably wide-angle view to a mild telephoto view. While this is a good starter, if you're serious about photography you will at some point want (or need) to extend your range of focal lengths, simply because different focal lengths allow you to achieve different results. In this case, most camera systems let you access a wide range of different zooms with a variety of focal length ranges, maximum aperture settings, and prices.

LENS HOODS

Lens hoods are designed to minimise the risk of lens flare (see page 170), so are generally seen as a good thing. Unfortunately, lens hoods and zoom lenses don't work well together. The problem is, the hood needs to be designed for the widest focal length setting, so it doesn't intrude into the shot. However, this limits its effectiveness at longer focal lengths, so the greater the zoom range, the less effective a hood will be.

Zooms at a Glance

PROS	CONS
• Covers a range of focal lengths in a seamless fashion, so there are no gaps.	• Enthusiast lenses typically have a small maximum aperture ($f/4$–$f/5.6$, for example); this can prevent super-shallow depth of field effects and also make the camera's autofocus less efficient.
• Being able to change the angle of view without changing your position is very useful when you can't get physically closer to or farther from your subject.	• Build and optical quality of some low-cost enthusiast zooms can be disappointing.
• A great walkaround solution, when you don't know exactly what you will be photographing.	• Some zooms have a variable maximum aperture, so the maximum setting gets smaller as the lens zooms in; a maximum aperture of $f/6.3$ at the telephoto setting is not unusual.
• One lens can cover most (or all) of your photographic needs.	• Lens hoods are less effective.e.
	• Multiple focal lengths can mean compromises need to be made in the design.

LEFT There's a marked difference between enthusiast-orientated zooms and pro-spec lenses. A pro lens, like that shown at far left, will typically have a much faster maximum aperture (here ƒ/2.8), a more robust build quality, and better optical performance. However, enthusiast lenses (left) are often lighter and more compact, making them easier to carry around, and are also far less expensive.

ABOVE A longer-reaching zoom lens will help you to fill the frame with your subject by appearing to get you closer to it. I was on the opposite side of Venice's Grand Canal when I saw this aging building, but the 300mm setting on a telephoto zoom lens meant I could quickly get the tight shot I wanted.

ABOVE Most cameras come in a kit with a standard zoom lens that covers moderately wide to mild-telephoto focal lengths. If you don't already own any lenses, this is a great all-round option. This shot was taken with a standard zoom.

Prime Lenses

A prime lens has a single focal length, such as 24mm, 50mm, 85mm, 105mm, and so on. This means it delivers a fixed angle of view, so if you want to get more in the frame, you'll need to move farther away from your subject, and if you want to fill the frame, you'll need to get closer. Consequently, prime lenses are not as versatile as zooms, and this is the main reason why they are nowhere near as popular.

However, prime lenses have a number of very desirable traits, so they shouldn't be overlooked. For a start, most prime lenses have a fast maximum aperture, which is great for shooting in low light or using a shallow depth of field. They also only need to be designed for one focal length, which means the design can be optimised more easily, resulting in the best possible image quality. This is doubly appealing when you

realise that high quality doesn't necessarily come with a high price; certain prime lenses are far less expensive than pro-spec zooms, but can deliver superior results.

Of course, the counter-argument here is that you'd need more than one prime lens to cover a range of focal lengths, but it's worth remembering that the choice between zoom and prime lenses doesn't have to be a one-or-the-other debate; the two can happily coexist in your camera bag. Just adding a single, fast, low-cost, standard prime lens (a 35mm or 50mm $f/1.8$, for example) will enable you to shoot a whole range of shots that might otherwise prove impossible.

Primes At A Glance

PROS	CONS
• Typically have faster maximum apertures than zoom lenses ($f/1.4$–$f/1.8$ is common on a 50mm prime lens, for example).	• You need to physically move forward or back if you want to fill the frame more or get a wider view.
• Wide maximum apertures give a brighter viewfinder image and optimal AF performance.	• Multiple lenses are needed to cover a range of focal lengths (and even then, you won't have in-between options).
• Designed for a single focal length, so potential aberrations and other optical defects (see page 168) are easier to control and overcome, resulting in higher image quality.	• You can find yourself changing lenses more often, depending on what and how you shoot.
• Often cheaper than zoom lenses.	
• Some great legacy lenses are available (see pages 192–193).	

RIGHT For this botanical shot I used a 135mm legacy lens on a digital camera. Older prime lenses like this are often far less expensive than their modern counterparts, but are often capable of producing equally sharp results.

LEFT/ABOVE Prime lenses come in a wide variety of focal lengths, ranging from wide angles, such as Sigma's 8mm ƒ/3.5 fisheye, Canon's 14mm ƒ/2.8, and Nikon's 20mm ƒ/1.8 lenses (left), through to telephoto lenses such as Canon's super-fast 200mm ƒ/2 and Sigma's super-long 800mm ƒ/5.6 (above).

Focal Length

Every lens has a focal length (or range of focal lengths), which indicates how wide or long it is.

With the exception of phones and some point-and-shoot cameras, if you look at pretty much any lens, you'll see the focal length stamped it. This will be a measurement given in millimeters, so you might see 18–55mm on a DSLR kit zoom, 35mm on a prime lens, or 4.3mm by the lens on a compact camera.

Technically, this measurement is telling you the distance from the optical centre of the lens to the focal plane when focus is set at infinity. However, whilst it's great to know the scientific definition, it's another of those things that you really don't need to worry about too much. Instead, the real-world things to understand about focal length are as follows.

Shorter focal lengths (smaller numbers) indicate the lens is wider, so it sees more of the world in front of it. Longer focal lengths (bigger numbers) indicate the lens is longer, so it has a much narrower view

of the world. Because focal length is a physical measurement, it never changes, no matter what camera it's on, with what sensor size. A 50mm focal length lens will always have a focal length of 50mm, for example, no matter what.

Angle Of View

Although photographers usually use focal length to describe how wide or long a lens is, the angle of view is equally important. The angle of view is how much of the scene the lens and sensor combination can 'see'. The greater the angle of view, the more of the scene it will take in. Usually, the angle of view is given as a single figure, which depends partly upon the diagonal measurement of the sensor or film frame, as shown opposite. This method of measuring a lens' angle of view is important, because while the focal length of a lens will never change, the angle of view can, depending on the size of the sensor.

RIGHT Angle of view and focal length both indicate how much a lens can 'see', whether that's a wide view (right) or a much narrower view (far right).

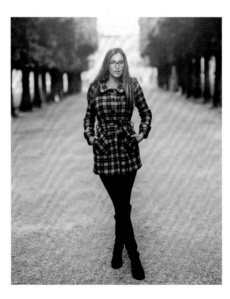

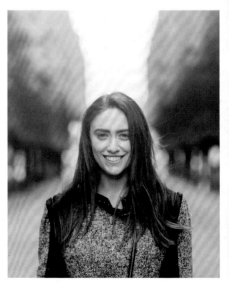

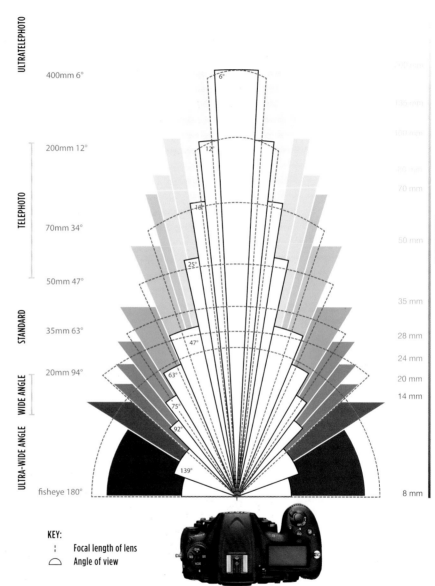

ULTRATELEPHOTO

400mm 6°

TELEPHOTO

200mm 12°

70mm 34°

50mm 47°

STANDARD

35mm 63°

WIDE ANGLE

20mm 94°

ULTRA-WIDE ANGLE

fisheye 180°

FOCAL LENGTH

50 mm

35 mm

28 mm

24 mm

20 mm

14 mm

8 mm

6°
12°
18°
25°
47°
63°
75°
92°
139°

KEY:

⋮ Focal length of lens

△ Angle of view

ABOVE This illustration shows how focal length and angle of view are related. As focal length increases, so the angle of view narrows and the lens 'sees' less (as shown in the accompanying images). However, it's important to appreciate that a lens' angle of view is affected by the size of the sensor in the camera: Smaller sensors effectively narrow the viewing angle, as explained on page 164.

Crop Factor

When 35mm film was the staple for most photographers, a focal length of 'X' gave an angle of view of 'Y' and that just didn't change. This meant that a 28mm lens on one 35mm camera would give the same angle of view as a 28mm lens on a different 35mm camera, regardless of the make and model, or whether it was an SLR or a compact. However, digital imaging sensors come in a wide range of sizes, which means this is no longer the case. While a 28mm lens will deliver an angle of view of 75 degrees on a camera with a full-frame sensor (as shown on the previous page), the angle of view will be much narrower if the same lens is used on a camera with a smaller format sensor (APS-C or Micro Four Thirds). The reason this happens is illustrated opposite.

What this means in practical terms is that when you use a lens on a camera with a non-full-frame sensor (a cropped sensor) the focal length is effectively extended by a certain amount. To determine the effective focal length of a lens, its actual focal length needs to be multiplied by a 'crop factor' that is dependent on the sensor size: for APS-C sensors, the crop factor is either 1.5x or 1.6x (there isn't a single, fixed size for APS-C sensors), while Micro Four Thirds cameras have a 2x crop factor. So, that 28mm lens we referred to earlier would effectively behave like a 42mm or 45mm focal length on an APS-C format camera, and a 56mm focal length on a Micro Four Thirds camera.

It's worth reiterating here that in each case, the focal length doesn't physically change (a 50mm focal length is always a 50mm focal length), but the narrower angle of view means it is equivalent to a longer lens. Hence the term 'effective focal length'.

CROP FACTOR

GOOD FOR...

Sports and wildlife. If you want or need to keep your distance from your subject, the crop factor can definitely work in your favor, as all your lenses will effectively become longer. This means a 200mm focal length would become a 300mm+ equivalent focal length, depending on your camera's sensor size. Not only will this let you more easily fill the frame from a distance, but it means you don't necessarily need to buy expensive, specialist telephoto lenses – 200mm lenses are usually significantly cheaper than 300mm lenses, for example.

NOT SO GOOD FOR...

Wide-angle enthusiasts. If you like to shoot broad landscapes, tight interiors, or anything else that generally needs a wide angle of view, you might struggle. While a 20mm lens on a full-frame camera will deliver a 94-degree angle of view, you'd need to be using a focal length of 10–14mm on a cropped-sensor camera to achieve a similar result. Unfortunately, the wider a lens is, the more expensive it tends to be, and the more susceptible it is to distortions.

RIGHT The crop factor created by a smaller-than-full-frame sensor can really help photographers who tend to rely on telephoto lenses. This shot was taken with a relatively inexpensive 70-300mm zoom on a camera with an APS-C sensor with a 1.5x crop factor. Once the crop factor is taken into account, that's the same as a focal length range of 105-450mm on a full-frame sensor.

| FULL-FRAME SENSOR | APS-C SENSOR (1.5X CROP FACTOR) | APS-C SENSOR (1.6X CROP FACTOR) | MICRO FOUR THIRDS (2X CROP FACTOR) |

WHAT THE SENSOR SEES

RECORDED IMAGE

ABOVE All camera lenses project a circular image, and the camera's sensor records a rectangular section of it. As illustrated above, a lens designed for 35mm film or full-frame digital cameras will typically project an image circle that is only slightly larger than a full-frame sensor/35mm film frame. However, fit the same lens to a camera with an APS-C or Micro Four Thirds sensor, and things change slightly. While the focal length of the lens and its projected image circle remain the same, the sensor records a smaller section of the image circle. This means the lens/sensor combination has a narrower angle of view, which is the same as cropping the full-frame image or using a longer focal length lens.

'DIGITAL' LENSES

Most camera and lens manufacturers have two lens lines: full-frame lenses, which are suitable for full-frame digital and 35mm film cameras, and 'digital' lenses that are designed specifically for cropped-format sensors. The advantage of these lenses is that they are smaller and lighter than their full-frame counterparts, as the image circle they project is designed for a smaller sensor size. The downside is that they cannot be used with full-frame cameras – although the lens may fit a full-frame camera, the result is usually heavy vignetting, as the image circle doesn't fully cover the full-frame sensor.

| CROPPED SENSOR | FULL-FRAME SENSOR |

LEFT A digital lens on a cropped-format sensor will project an image that is only slightly larger than the sensor area. If this lens were used on a full-frame camera, the result would have heavily vignetted corners.

Perspective

Perhaps one of the greatest myths about lenses in photography is that focal length affects perspective. So, you might hear or read something about wide-angle lenses increasing the space between elements in the frame to 'expand' the perspective, while telephoto lenses stack elements in the frame together to 'compress' perspective. I'm not disputing that it can look like this is happening, but I assure you that it is not the focal length of the lens that's doing it.

The fact is, it's the camera-to-subject distance that determines perspective, nothing else. The reason people confuse this with focal length is because wide-angle lenses are typically used closer to the subject, while telephoto lenses are usually employed from a greater distance. Still don't believe me? Then perhaps the example shown here will help clear things up.

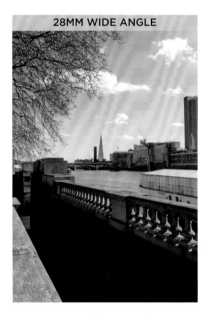
28MM WIDE ANGLE

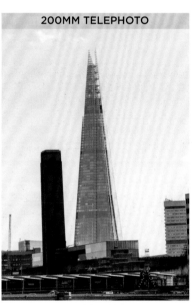
200MM TELEPHOTO

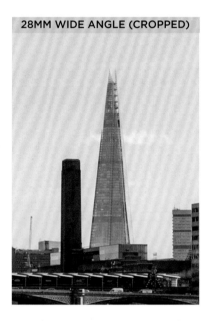
28MM WIDE ANGLE (CROPPED)

DIGITAL ZOOM

Some compact cameras and smartphones have what is known as a Digital Zoom. This essentially crops a wider-angle shot and enlarges the result to give the impression that a shot was taken with a longer focal length. However, just like the example above, cropping in on a wide-angle shot reduces image sharpness, resulting in a lower-quality result.

ABOVE The images above are views of London's Shard building, taken moments apart from the same position. The far left image was taken using a 28mm wide-angle focal length setting and the central image was taken at a 200mm telephoto focal length.

At first glance, the perspective looks radically different: The wide-angle image appears to exaggerate the space between near and far, while the buildings in the telephoto shot appear to be very close together. This would seem to support the idea that wide-angle and telephoto focal lengths deliver a different perspective

However, look what happens when the wide-angle image is cropped to match the framing of the telephoto shot (above right). Sure, the image quality isn't as good (it's a pretty severe crop, after all), but the image has an identical 'stacked' perspective to the telephoto shot.

The conclusion? Wide-angle and telephoto lenses may appear to deliver different perspectives, but the reality is, the perspective is identical. It is only the lens-to-subject distance that changes perspective.

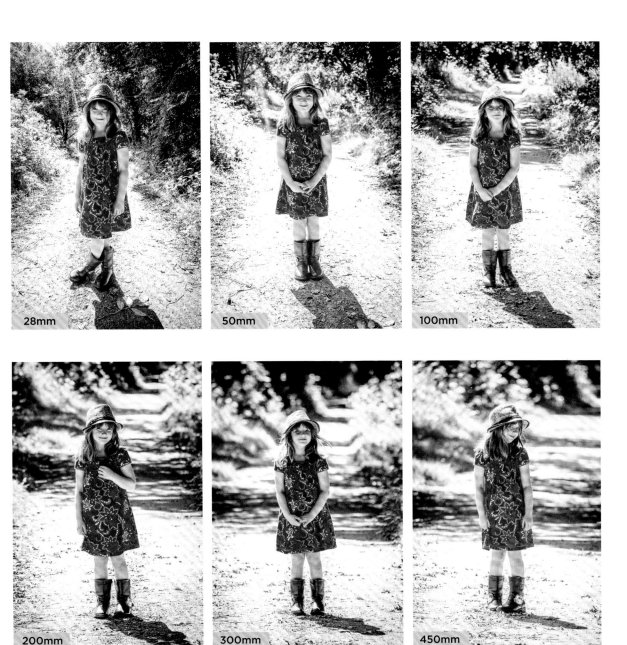

28mm 50mm 100mm 200mm 300mm 450mm

THIS PAGE Perspective changes only with distance. For this sequence of shots, I used a range of focal lengths (28–450mm equivalent), while keeping the subject approximately the same size in the frame. This meant moving closer to the subject when I was using a wide-angle lens and backing away to use a telephoto lens.

This has a significant effect on perspective: Shooting close with a wide-angle lens seems to increase the distance between the foreground and background elements, while shooting from a greater distance with a telephoto lens really compresses the perspective. You can see this most clearly in the shadows in the pictures: notice how the shadows in the distance appear to draw closer to the subject as the focal length increases, and also how the shadow she is casting becomes shorter. It's also worth noticing what happens to the path: the sides appear to converge far more aggressively the wider the focal length is.

However, it's worth repeating that it is the camera-to-subject distance, and not the focal length that is performing this visual trickery.

The Imperfect Lens

No matter how much you spend, or which brand you invest in, no lens is truly perfect (although some come exceptionally close).

Designing a lens is all about overcoming problems in an attempt to get the light from the scene to the sensor as purely as possible. To achieve this, high-end photographic lenses consist of multiple glass elements made from different types of optical glass and treated with a variety of coatings, each designed to minimise or negate various defects.

Chromatic Aberration

As you saw in the previous chapter, white light is made up of a range of wavelengths, from red to violet. The classic way of demonstrating this is to pass white light through a prism and watch as a rainbow of colours emerges.

The same thing also happens as light passes through a camera lens. Although not as pronounced, the glass elements in a lens change the angle of different wavelengths by different amounts. As a result, the red wavelengths might exit the lens at a different angle to the blue wavelengths, and the two won't be

focused on the sensor at the same point. This misalignment will result in coloured fringes appearing around elements in the image (especially high-contrast edges toward the corners of the frame).

To minimise this, camera lenses use elements made out of different types of optical glass. Each element affects the wavelengths of light in a different way, with the overall aim being to bring all the wavelengths to focus at the same point on the sensor. However, this doesn't always happen perfectly, especially with extreme wide-angle lenses and zoom lenses that cover an expansive focal length range.

IMAGE CORRECTION

Although aberrations and distortions are generally undesirable, the failings of a lens are both specific and measurable. This means that an equal and opposite adjustment can usually be applied to remove them. A lot of cameras (and some software) will do this for you automatically if you're using the manufacturer's current lenses; the camera automatically recognises a lens when you attach it and applies the relevant corrections after an exposure is made.

LEFT/ABOVE Chromatic aberration is most often seen along high-contrast elements in a scene, especially toward the edges of the frame where the light rays have to be 'bent' more to pass through the lens.

Barrel Distortion

Barrel distortion, or barrelling is typically associated with wide-angle focal lengths. When this is present, straight lines appear curved, bowing outward from the centre of the frame like the sides of a barrel. The effect is most apparent when should-be-straight lines are close to the sides of the frame; care should be taken with seascapes and landscapes that include a clear horizon line and architectural shots with straight-edged buildings.

Pincushion Distortion

The opposite to barreling, pincushion distortion is seen as a pinching of the image toward the centre, so lines appear to bend inward. Again, the distortion is strongest at the edges of the frame and made most evident when an image contains should-be-straight lines. It's unlikely to be seen in a rolling landscape with an uneven horizon, for example. Pincushioning is generally restricted to long, telephoto focal lengths.

MUSTACHE DISTORTION

A third (and fairly uncommon) type of lens distortion combines both barreling and pincushioning, so images are pushed out at the centre of the frame, but sucked in toward the corners, as shown in this illustration. This creates a shape that's vaguely reminiscent of a curled mustache – hence the name!

PRIME LENSES

Prime lenses generally exhibit little or no distortion, as the design only has to correct a single focal length. Zoom lenses, on the other hand, can feature both barreling **and** pincushion distortion if the lens covers both wide and telephoto focal lengths – to fully correct one would emphasise the other.

BARREL DISTORTION

PINCUSHION DISTORTION

SHADING

Like vignetting, shading appears as a dark shadow at the corner of the image, but it is caused by a physical obstruction in front of the lens, such as multiple filters stacked on the lens; a filter holder that is too small is attached to the lens; or having the incorrect lens hood fitted. In each case, the effect is usually visible through the viewfinder, so it's worth checking the edges of the frame before you shoot.

Flare

A lens is designed to 'see' the light within it's angle of view (the light that's going to form your image) and pass it to the sensor. However, it is sometimes possible for non-image-forming light to strike and enter the lens – sunlight hitting the lens at an acute angle, for example – which can create reflections within the lens (known as internal reflections). These reflections can then appear in the shot as coloured polygons streaking across the frame or as an overall reduction in contrast.

The only way to avoid flare entirely is to shade the lens from any light that might hit it from the sides or above/below. A lens hood is the first choice, although these are a better option on prime lenses than zooms (on a zoom lens, they can only be designed for the widest focal length so the corners of the hood don't appear in shot). Alternatively, shading the lens with your hand or a piece of card is often successful, although you need to take care that your shade doesn't appear in the shot.

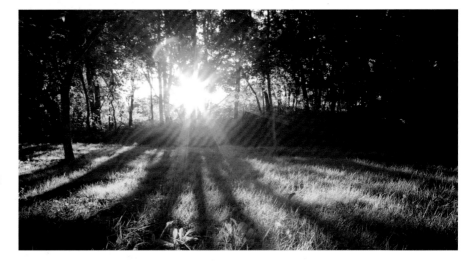

RIGHT Although it's considered a defect, lens flare isn't always bad – sometimes it can be used deliberately to heighten the atmosphere of a scene.

Vignetting

Vignetting happens when the corners of the sensor or film receive less light than the centre, resulting in a visible fall off or darkening of the exposure at the extremities of the image. We'll look in more detail at how sensors work at the end of the book, but vignetting is caused primarily by light entering and exiting the edges of the lens at an acute angle, which results in the edges of the sensor receiving less exposure than the centre.

Because the angle of view is wider with wide-angle lenses, shorter focal lengths tend to be the worst offenders (and zooms are generally worse than prime lenses), and the problem intensifies at

wide aperture settings. As this suggests, there is a relatively simple solution: closing down the aperture will reduce the level of vignetting.

However, while vignetting is classed as a defect, it can also have a creative benefit, as the slightly darkened corners will naturally draw attention to the brighter centre of the frame, which is ideal if that is where your subject is.

Edge Softness

As well as the exposure falling off toward the edges of the frame and causing vignetting, image sharpness can also fall off, leading to photographs with slightly soft or blurred corners.

Ironically, the cause is the glass elements that make the lens – those very elements that are designed to deliver the best possible image. The problem is, all of the elements in most lenses have a spherical surface, but your sensor (or film) is flat. Suffice to say, it's very difficult to make a group of curved lenses produce a perfectly flat image, so most lenses project an image that is very slightly curved.

With a lot of lenses, this curve is so slight that there's no problem at all, but with other lenses, the edges will bring the image to focus at a noticeably different plane to the centre of the lens. As a result, when the centre is sharply focused, the edges will look slightly soft (and vice versa).

The effect is most apparent when the widest aperture settings on a lens are used, so stopping the aperture down can help (most lenses have a sweet spot at around 2 stops from maximum).

ABOVE Soft edges can go unnoticed a lot of the time, but here, there's no escaping the fact that the blue and white lettering at the bottom right corner is noticeably softer than the red sign toward the centre.

IMPERFECTIONS & SENSOR SIZE

Although the distortions and aberrations shown here are functions of the lens, the size of your camera's sensor will affect how obvious they are.

As you saw on page 165 (and as illustrated here, at right), if you are using a full-frame lens on a full-frame camera, the image frame is typically very close to the edges of the image circle. This is where distortions and aberrations are at their worst, so is where they will be most apparent.

However, with a cropped-format sensor, only the area projected by the central part of the lens' image circle is recorded (right). This means that most distortions and imperfections will fall outside the area recorded by the sensor, so they simply won't appear in your photographs.

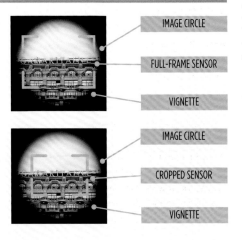

IMAGE CIRCLE

FULL-FRAME SENSOR

VIGNETTE

IMAGE CIRCLE

CROPPED SENSOR

VIGNETTE

V

STREET PHOTOGRAPHY
Brian Lloyd Duckett

Brian Lloyd Duckett is a photojournalist and street photographer, who can be found pounding the streets of London and some of the charismatic Italian cities, such as Rome and Venice, looking for photographic gold. He had his first newspaper picture – of a dead dog in a trash can – published at the age of 15, and since then has photographed all of the UK's recent prime ministers, documented life in slaughterhouses, and been caught up in riots. His work now covers two main areas: He runs StreetSnappers, which provides training workshops for street photographers, and he does commercial photography, which consists primarily of editorial portraits of politicians and business leaders.

When he's out on the streets, Brian's philosophy is to keep things simple when it comes to equipment. 'I'm a great fan of mirrorless cameras and I'm currently using an Olympus Pen F. My perfect camera for street photography is quiet, small, rugged, and has interchangeable lenses – all of which is more important than having a huge sensor. It's also important for me to be able to turn all the camera sounds (and lights) off so that I'm as invisible as possible'.

STREET ESSENTIALS

For me, a small, light bag is essential. It needs to be very comfortable and have plenty of pockets for notebook, pens, water bottles, and so on. I'm a firm believer that less is more in street photography, so I don't walk around with loads of extra lenses, a flash, or a tripod. A shoulder bag is ideal, as everything is quickly accessible, but ideally, choose one that doesn't look like a photographer's bag – you don't want to draw attention to yourself.

I also never go out without a supply of rubber bands! When I have four or five camera batteries in my bag, I can easily identify the exhausted ones if they have a red elastic band wrapped around them.

While many street photographers – especially those starting out – will err toward longer focal lengths that allow them to keep their distance from their subject, Brian is not a fan of this approach. 'Shooting from a distance feels like cheating! By getting in close with a short lens, you almost become part of the scene you are shooting, and the emotion, drama, or feeling in that scene comes across in the image. Something between 28mm and 35mm is ideal for street photography, as it forces you to get close to the action, but also allows you to include context. Street photography is all about context and using the environment, as well as the main subject, to tell a story. My current favorite is a 17mm wide-angle lens, which gives a full-frame equivalent of 35mm on my 2x crop sensor camera. This is my 'lens for all seasons' and is rarely off the camera'.

Brian also has a fairly specific way of shooting, which typically starts with a high ISO and mid-range aperture. 'My default ISO is around 1200, and I usually shoot in Aperture Priority with the aperture set at $f/8$ or $f/11$. This does two things: It gives me a fast shutter speed, which helps reduce the chances of blur or camera shake, and it gives me a large depth of field, which I combine with zone focusing.

▶ We are surrounded by the written word – keep your eyes open for contradictions or juxtapositions.

23MM. 1/80 SECOND @ f/8, ISO 2500

▼ Look for places where there are commuters, because people all doing the same thing or going in the same direction can make an interesting composition.

45MM. 1/800 SECOND @ f/4, ISO 400

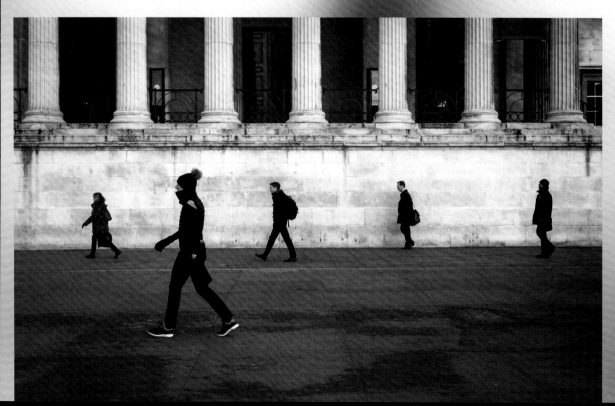

'Zone focusing is a manual focusing method, which basically turns your camera into a point-and-shoot. If you use autofocus for street photography, there are two dangers: firstly, that the camera locks onto the wrong area, and secondly, that the AF takes too long to focus and you miss the shot. Zone focusing has been the preferred method for street photographers for many years and is pretty much foolproof: you simply set the focus at, say, 2m, and with a wide-angle lens and a mid-range aperture the depth of field will ensure that everything between about 1.5–3.6m will be perfectly sharp. This distance range becomes your "zone" and all you need to do is ensure your subject is within it – there's no need to shift focus at all'.

While Brian focuses manually – at least before he starts shooting – he lets the camera take care of his exposures. 'I'd love to be able to use a handheld meter, but fast reactions are usually needed, so I prefer to use multi-area metering, which gives me the best chance of exposing the whole frame correctly. The downside is that a 'spot-on' exposure is a bit of a luxury, but for me, getting the right composition is more important. I think it's better to get the shot, so I'm happy with an exposure latitude of 10–15% either way'.

As well as worrying about the technical side of their craft, street photographers also have to consider the legal and moral aspects of what they do, and in recent years they have come under increased pressure when they're out and about. 'You need to be ready to deal with officious officials – those people in yellow jackets who always tell you 'no photo.' The problem is, they usually have no idea what we can and can't do, so I usually ignore them and carry on regardless. It is, however, a very good idea to read up on your rights as a street photographer so you can stand your ground when necessary'.

There are also certain issues when it comes to choosing your subjects, as Brian explains: 'I usually recommend avoiding areas where there are small children – not because of any legal restrictions, but because of the paranoia photographers face regarding their intentions. It's just not worth the hassle. Another "red line" for me is places where homeless people congregate. The homeless have always been a target for street photographers, but to me it feels voyeuristic and exploitative.

'If you want some great, largely hassle-free shots, my advice is to find a place where there are lots of commuters. People going to or from work are usually lost in their own worlds and are far less likely to notice you taking their photo. The modern or old buildings in major towns and cities can also make great backdrops'.

To find out more about Brian, his work, and his StreetSnappers workshops, visit his website at www.streetsnappers.com.

BRIAN'S TOP TIPS

- Walk slowly, blend in, and absorb your surroundings. You'll be surprised at how much of the world you'll see.
- Don't make eye contact with anyone – it gives the game away that you are about to take (or have just taken) somebody's picture. Sunglasses can really help!
- If you spot a potential opportunity for a great street shot, pick a good vantage point and wait for all the elements to come together – it's usually worth the wait!
- Manage your expectations. Don't expect to go home with a hundred terrific shots. I'm happy with two or three keepers from a hard day's shooting.
- If you've just taken somebody's photograph and they challenge you, just smile, say 'thank you', and walk away.

▲ Sometimes you'll need to play the waiting game. When you see a potential opportunity, be prepared to wait until all the elements come together.

23MM. 1/400 SECOND @ ƒ/4, ISO 200

Zoom Lenses

Most manufacturers produce a wide range of lenses, with a mix of primes and zooms that fall into three main categories: standard, wide angle, and telephoto.

Standard

A standard lens is one with a focal length that roughly approximates human vision. It's not identical to human vision (the lens doesn't cover our peripheral vision, and can't recreate the complexities of binocular vision, for example), but in the broadest sense, it pretty much sees the world in a similar way. The upshot is that shooting with a standard lens will usually produce a natural-looking image.

The definition for a standard focal length is one that matches the diagonal measurement of the sensor or film. With 35mm film (the standard still used for focal length measurements), the diagonal measurement is 43mm, but the photographic industry settled on 50mm instead (purportedly because this was

an easy and cost effective prime lens to make for 35mm cameras). Thanks to the versatility of zoom lenses, we can now shoot closer to the 43mm ideal, but in real terms, any focal length in the region of 40–55mm can be considered standard.

Of course, that only applies to full-frame digital and 35mm film cameras: On cropped sensors, the diagonal measurement of the sensor is reduced, so the standard changes. For APS-C cameras, with a 1.5x or 1.6x crop factor, this means the standard focal length is around 30–35mm, while Micro Four Thirds cameras have a standard that is closer to 25mm.

PRIME TIME

Most manufacturers offer a range of inexpensive 50mm prime lenses, with fast maximum apertures of f/1.4 or f/1.8. These lenses are not only great for producing shallow depth of field effects, but they also tend to produce high-quality, distortion-free results at smaller apertures. If you're using an APS-C camera, a 35mm f/1.8 lens is a good alternative.

STANDARD FOCAL LENGTHS

GOOD FOR...	NOT SO GOOD FOR...
• Natural-looking images street, travel, and documentary photography, where an undistorted view of the world is desired. • Handheld low-light photography (assuming the lens has a wide maximum aperture). • Producing a shallow depth of field.	• Shots taken with a standard focal length can lack the visual drama of an image taken using a wide-angle or telephoto lens.

ABOVE A standard zoom, such as this 24-70mm lens from Sigma, is a zoom lens that covers the standard focal length, as well as providing slightly wider and slightly longer focal lengths. This wide-to-mild-telephoto range makes a standard zoom a great walkaround lens.

RIGHT Standard focal lengths are typically affected less by the artifacts than wider and longer lenses. This is ideal when you need your image to be as distortion-free as possible, as was the case here, with the front of the Centre Pompidou in Paris, France.

LEFT A fast, prime standard lens is ideal when you're shooting handheld in low light. During this entirely torch-lit parade, flash would have ruined the atmosphere, so a 40mm ƒ/1.7 lens was the only way to get the shot.

Wide Angle

A lens with a wider-than-standard focal length (less than 40mm on a full-frame digital camera) is known as a wide-angle lens, due to its wide angle of view. This means it sees more than a standard lens, so it is great when you want to capture more of a scene in the frame.

However, you need to take care when using wide-angle focal lengths, more so than with standard or telephoto lenses. Because they include more in the frame, everything appears smaller than it does to the naked eye, so it's quite easy to end up with photographs that look empty. The simple solution is to move closer to your subject to better fill the frame, although this will impact perspective, with elements close to the lens looking far larger than those that are more distant. While this can benefit some subjects – it can help you include something in the foreground of a landscape, for example – it is less ideal for others (portraits, especially).

It is also worth noting that wide-angle lenses tend to exhibit more imperfections than standard lenses, with barrel distortion, vignetting, and chromatic aberration the three worst offenders. The general rule is the wider the lens, the more apparent and aggressive these distortions are likely to become, with zoom lenses typically affected more than primes.

WIDE-ANGLE FOCAL LENGTHS

GOOD FOR...	NOT SO GOOD FOR...
• 'Getting more in', whether that's because you want a wider shot, can't physically move backward to fit more in the frame, or are shooting in a confined/limited space (indoors, for example).	• Portrait photography; you'll need to get close to your subject to fill the frame, and this will distort your subject.
• Landscape photography (although it's easy to create images with too much sky and too little foreground).	• Sports, wildlife, or any other subject that usually requires you to shoot from a distance.
• Architecture and interiors (assuming any distortions can be corrected).	

ABOVE Wide-angle focal lengths come as both prime lenses, like this fast Canon 24mm ƒ/1.4 lens (top), and as zoom lenses like the Sony 16–25mm ƒ/2.8 lens shown below it.

ABOVE Wide-angle lenses encourage you to get closer to your subject, and it is this shorter working distance that gives these lenses their exaggerated perspective.

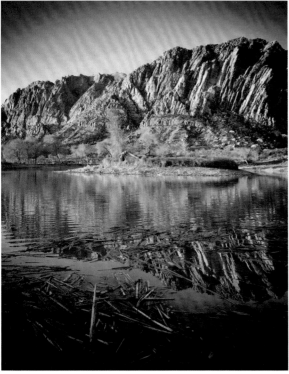

LEFT No landscape photographer would be without a wide-angle lens (or two). The wide viewing angle is ideal for 'filling the foreground' to avoid dead space.

Telephoto

Lenses with a longer-than-standard focal length (roughly 60mm and above) are known as telephoto lenses. This type of lens produces a narrow angle of view, so even distant subjects can appear to fill the frame. The easy way to remember this is to think of a telescope, which sounds similar and has a similar effect.

At the mild end of the telephoto range are focal lengths in the region of 80–135mm. These are often described as portrait lenses, because they allow a comfortable working distance between you and your subject, but still offer a fast aperture that will let you throw the background out of focus.

Longer lenses are more useful for areas such as sports, wildlife, and news photography, where physical restrictions mean you can't get close to your subject, although the precise focal lengths used will vary; a 70–200mm zoom with a fast aperture might be ideal for a photojournalist, but a sports photographer shooting from the sideline of a football game might need a 300mm or 400mm lens to get close to the action.

One of the main things to be aware of when you're shooting with a telephoto lens is camera shake: The lens not only magnifies your subject, but it also magnifies the slightest tremble. Using a tripod is the most reliable way of keeping your shots shake-free, but it's not always the quickest option, so you might think about using a monopod instead (see page 387), or simply relying on fast shutter speeds and image stabilisation if you're shooting handheld.

TELEPHOTO FOCAL LENGTHS

GOOD FOR...	NOT SO GOOD FOR...
• Wildlife photography, when getting physically closer to your subject might make it run off, or would simply be too dangerous.	• Interiors. Unless you're shooting details, a telephoto lens often can't get enough in the frame.
• Sports photography, catwalk fashion, news/paparazzi work, or any other event that means you have to work at a distance from your subject.	• Sweeping landscapes. Again, a long lens can be useful for picking details out of the landscape, but it's often too restrictive for broader views (with the exception of 'stitched' panoramas).
• Mild telephoto focal lengths are great for portraits.	

ABOVE Telephoto focal lengths cover a wide range: from mild telephotos like this Nikon 85mm ƒ/1.8 lens (top) to more extreme lenses such as Sigma's 150–500mm ƒ/5–ƒ/6.3 telephoto zoom (above).

TELECONVERTERS

If you want to extend your focal length without extending your overhead, a teleconverter could be the answer. These small lens-like items fit between your camera and lens, effectively extending its focal length (which explains why Canon calls them Extenders, rather than teleconverters).

The actual extension depends on the converter you use. The most widely used options are 1.4x and 2x converters, with a 1.4x converter extending the focal length 1.4 times (so a 100mm focal length becomes 140mm) and a 2x converter doubling the focal length (so 100mm becomes 200mm).

The trade-off for this extra reach is that image quality is reduced slightly and less light reaches the sensor. So, you'll need to increase the exposure by 1 stop if you're using a 1.4x converter, and 2 stops with a 2x. This light loss can also affect the performance of your camera's autofocus system, so much so that it might not work at all unless you are using a fast (and expensive) telephoto lens with your converter.

Teleconverters (or Extenders) aren't perfect, but they are smaller and lighter than a telephoto lens, and often far less expensive. This makes them a sensible solution for occasional use, but if you find yourself reaching for them regularly, it might be time to invest in a new lens instead.

ABOVE A 200mm lens on a full-frame camera (in this instance a 35mm SLR) let me crop tightly on this rocky outcrop, even though I was shooting from some distance away, from the deck of a cruise ship!

ABOVE A mild, 85mm telephoto focal length was all that was needed to get a little bit closer to these seed heads growing on an overhead branch of a tree.

Macro

Arm yourself with a macro lens, and you can set off on a voyage of discovery in a world of the small and often overlooked.

In the strictest sense, macro photography is about photographing something at its actual size or larger so it is recorded on the sensor at least as large as it is in real life. This is different to close-up photography, which is a vague catch-all term used to describe anything close.

MACRO TIPS

A lot of zoom lenses claim to have a macro setting, but only manage a 1:2 or 1:4 reproduction ratio. In the strictest sense, this is not macro, merely close-up.

A macro lens isn't only useful for macro photography: A focal length in the region of 90–100mm also makes a great portrait lens.

Reproduction Ratio

Macro lenses are measured in terms of their reproduction ratio, which is how large something will appear on the sensor. A true macro lens will enable you to record life-size images, which is more often referred to as a reproduction ratio of 1:1 (this is the point at which a 1cm-wide object measures 1cm when it's projected by the lens onto the sensor). Although it is possible to go beyond this (2:1 would be twice life size, for example), you will usually need to use a macro lens in conjunction with extension tubes or bellows (see pages 186–187) – the exception here is Canon's MP-E 65mm ƒ/2.8 1-5x Macro, an extreme lens that allows you to photography at up to five times life size (a 5:1 reproduction ratio).

Focal Length & Working Distance

Like all lenses, a macro lens has a focal length that indicates how wide or long it is. However, this also gives you an idea of its working distance, which is the minimum distance required to achieve a 1:1 reproduction. Why is this important? Well, if you have a penchant for small-scale wildlife subjects, you'll quickly discover that it's far easier to photograph flighty prey from a distance, rather than trying to position your lens inches away from them. In this instance, a longer focal length will provide you with a greater working distance. Longer focal lengths are also useful if you want to work with additional lighting, as there's more space to position flashes or lamps, without the camera and lens casting shadows on your subject.

OPPOSITE A macro lens is the obvious – and often easiest – path to close-up photography. For this shot, I used a 100mm macro lens and a wide aperture to limit the already shallow depth of field.

ABOVE Macro lenses come in a range of focal lengths, from standard focal lengths of 40–60mm, such as Nikon's 40mm ƒ/2.8 (above left), to telephoto lenses, such as Canon's 100mm ƒ/2.8 (above centre) and Sigma's 150mm ƒ/2.8 (above right). Which focal length you choose will depend largely on the most suitable working distance for your preferred macro subject(s).

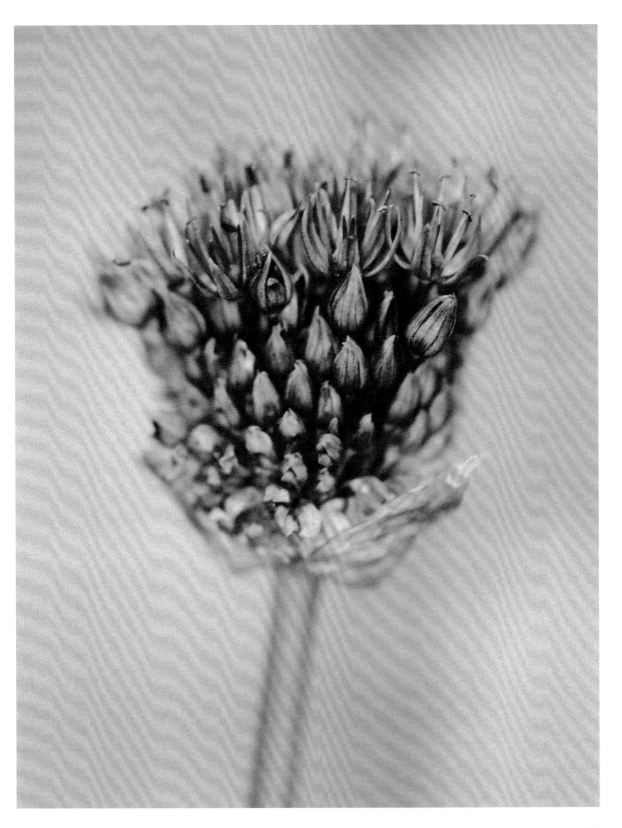

Macro Accessories

A dedicated macro lens is not the only way to explore the world of close-up photography: There are numerous other options that will let you give it a go, often without such serious expense.

Close-Up Lenses

Often wrongly called close-up filters, a supplementary close-up lens screws to the front of your lens like a filter, and simply reduces that lens' focusing distance. Close-up lenses come in a range of strengths, which are measured in diopters; the stronger the lens, the closer you can focus. The great thing about close-up lenses is that you retain full control over your camera because you're still using a regular lens, so exposure, focus, and any other settings can be used as normal. You can also stack the lenses for even closer focus, although this can lead to shading and a disappointing loss of image quality. A single close-up lens on a prime lens is the best option for quality-conscious photographers.

BELOW It's easy to see why close-up lenses are often mistakenly called filters; they essentially look identical to screw-in filters. This vintage set comprises +1, +2, and +3 diopter lenses and came in a neat leather pouch.

ABOVE Close-up filters are an economical way of exploring macro photography, as they can make any lens you already own focus closer.

Reverse-Lens Adapter

A reverse-lens adapter is precisely that: an adapter that screws into a lens' filter thread, allowing you to fit that lens back-to-front on a camera. This instantly gives the lens macro-shooting potential for very minimal cost, although you will be limited to manual exposure and focus. You can reverse any lens you like, but the best results come from focal lengths under 100mm. A manual-focus, manual-aperture prime lens is ideal, and the good news here is there are thousands of pre-owned lenses like this for sale. You don't even need a lens that's designed for your camera – as long as the adapter has a filter-thread size that matches that of your chosen lens and a lens mount to attach to your camera, you are free to mix-and-match.

ABOVE With the right adapter you can reverse any lens on your camera, without worrying about make and model. This setup combines an old Olympus 50mm ƒ/1.8 lens with a Nikon DSLR.

RIGHT The greatest challenge when you're using a reversed lens is focusing, as the depth of field is marginal; the aperture won't be wide open as it usually is, making the viewfinder dark; and the lens' focus doesn't work as normal because the lens is backward. Because of this, you may need to move the camera or subject to get things in focus, rather than relying on the lens.

LOSING LIGHT

Extension tubes (and bellows, opposite) increase the distance between the lens and sensor, which means less light reaches the sensor. If you are shooting manually, you will likely need to compensate for this light loss, as your camera may not do it automatically.

Extension Tubes

An extension tube is quite simply a hollow tube that fits between the camera and the lens, increasing the distance between the lens and the sensor (or film). Extension tubes usually come as a set, consisting of different sized tubes that can be used singly or combined, and the farther the lens is from the sensor (or film), the closer it focuses.

At the bottom end of the extension tube scale are ultra-cheap unbranded sets like the one shown below. These tubes are totally mechanical, so there's no communication between the camera and lens, meaning manual focus and manual exposure are the order of the day (and you may also lose your TTL metering). However, since they're very cheap, it's hard to complain too loudly.

At the opposite end of the scale are extension tubes that have the same build quality as a lens (albeit without glass elements), with electronic connections that allow you to retain TTL exposure and, in some cases, full autofocus as well, so you can continue to shoot in an automated fashion if you choose. This sophistication is reflected in the price, though; a single extension tube from the major camera manufacturers can cost 10 times as much as a complete set of unbranded tubes.

ABOVE Extension tubes often come as sets of tubes of different lengths, allowing you to vary the magnification factor from mild (using a single, thin extension ring) to extreme (by combining multiple extension rings).

ABOVE As with most macro lens adapters, using prime lenses is usually the best path to take with extension tubes. It also helps if your lens has manual aperture control so you can regulate the depth of field.

Bellows

In the days of the 35mm SLR, most camera manufacturers offered a set of bellows that could be used to move the lens away from the camera body in much the same way as extension tubes, but with the advantage of continuous adjustment that enabled much greater precision when it came to setting the level of magnification.

Today, however, that situation is reversed, and none of the major camera manufacturers offers bellows in their current catalogues. Consequently, the choice is now between cheap, unbranded online offerings of dubious build quality and secondhand bellows that may (or may not) have passed their prime – both of which provide a fully manual experience. Alternatively, for the ultimate in macro bellows, Novoflex offers a Canon EOS-compatible bellows set that retains full focus and exposure control, plus universal bellows units with and without tilt and shift capabilities.

Regardless of the level of sophistication, the main issue with bellows is speed: They are far slower to set up and use than any of the other options shown here, and demand a tripod if you want to have any chance of setting your magnification and focus accurately. This tends to limit them to indoor, studio use, but if that's your thing, and speed's not a problem, there's no denying that bellows offer a genuine alternative (perhaps even a better alternative) to a dedicated macro lens.

BELLOWS LENSES

Standard prime lenses work well on bellows, but enlarger lenses that are designed for printing from film in a darkroom are often a superior option. This is because they are designed to exhibit very little distortion, deliver superb sharpness across the image area, and resolve incredibly sharp detail. Most (but not all) enlarger lenses have an M39 screw mount, but adapters are available to convert them to most regular camera mounts.

ABOVE Using vintage equipment can let you explore bellows photography without breaking the bank. This set of M39-mount bellows and a 50mm enlarger lens needed only an adapter to attach to my camera.

Extreme Lenses

As well as regular lenses, certain manufacturers offer some slightly more esoteric optical options that can help you achieve stunningly singular results.

Fisheye

At the extreme wide-angle end of the focal length scale, you find fisheye lenses, with focal lengths as short as 4.5mm. These lenses are typified by bulbous front elements and a 180-degree angle of view. However, while all fisheye lenses deliver the same super-wide angle of view, there are two different ways in which they do it, depending on whether you use a diagonal fisheye lens or a circular fisheye.

A diagonal fisheye lens is one that projects an image circle larger than the sensor. So, just like a regular lens, you will get a rectangular image that fills the frame, albeit with the extreme wide-angle distortion that comes from imaging a 180-degree view. The second type of fisheye lens – the circular fisheye – is arguably more extreme, as the image circle fits inside the sensor area. This means that your fisheye photographs will consist of a perfectly round image at the centre of the frame, with a black surround.

In general, circular fisheye images are usually the more eye-catching of the two, but this can often be due to their round shape rather than their content – the circular shape can be gimmicky, whereas diagonal lens shots simply look ultra wide.

RIGHT It's very difficult to compose a shot with a fisheye lens. With the wrong subject, the effect can easily appear gimmicky, but get it right, and the distinctive look can really enhance your shot

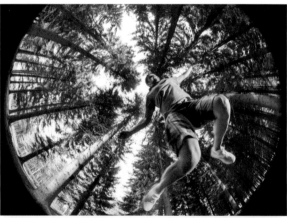

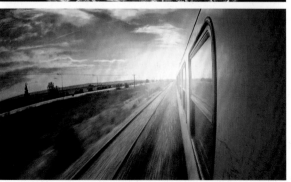

RIGHT Fisheye photographs are typified by extreme distortions, especially at the edges of the frame.

ABOVE Fisheye lenses have super-short focal lengths, like Sigma's (cropped format) 4.5mm circular fisheye lens and Canon's unique 8–15mm fisheye zoom.

Mirror

The design of most photographic lenses relies on the same basic principle: light comes in one end, travels directly through the lens, and exits the other end. The problem is, the longer the focal length, the bigger the lens needs to be, to the point where telephoto lenses can easily become so big and heavy that handholding them is no longer practical.

A catadioptric (or mirror) lens gets around this problem by replacing the glass lens elements with mirrors that extend the light path in the exact same way as a reflecting telescope. The result is that an extremely compact telephoto lens can be made, which is exceptionally light and incredibly inexpensive.

If this sounds like it's too good to be true, then... well... it is. For a start, a mirror lens has a fixed aperture (usually $f/8$ for a 500mm lens and $f/11$ for a 1000mm lens), so you have no control over depth of field and have to rely on the shutter speed and ISO to set your exposure. It also goes without saying that this cheap a lens that uses mirrors is not going to deliver the same image quality as a high-quality lens that contains multiple optical glass elements. Finally, out-of-focus areas can take on the donut shape of the front of the lens, especially defocused highlights in the background. This isn't always a bad thing, but it can sometimes distract from the subject.

It's not all doom and gloom, though, and in good light, a mirror lens can deliver a great shot. You just need to be aware of its limitations, and perhaps temper your expectations a little.

ABOVE The dark circle at the front of this mirror lens is actually the back of the mirror that bounces light back toward the sensor. It is also what is responsible for a mirror lens' telltale donut-shaped bokeh.

BELOW If you get the light and the subject right, a mirror lens can deliver a great result. Even the donut-shaped, out-of-focus areas in the background aren't distracting in this early-morning study.

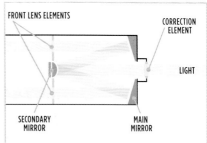

ABOVE This cutaway illustration shows the light path through a mirror lens. The light enters through the front of the lens; is reflected off the main mirror at the rear of the lens; is reflected a second time by a secondary mirror at the front centre of the lens; and then passes through a correction element as it travels to the sensor (or film).

Tilt Shift

There are certain physical constraints that can't be overcome with a conventional lens, no matter how expensive it is. For example, if you want to photograph a tall building and need to tilt the camera upward to get it in the frame, the walls are guaranteed to look as though they're converging toward the top. The effect can be extreme if you're using a wide-angle lens, or it can be subtler if you're shooting with a telephoto, but it will be there regardless, as it's simply down to perspective: Just like railway lines or the sides of a road appear to get closer together the more distant they are, the walls of a building will head toward a single vanishing point when you look up at them.

Now, the simple way of avoiding this is not to look up, but to keep the back of the camera parallel to the building. However, if you're standing on the ground, and the building's tall, this might mean you have to be some distance from it to fit it in the frame, which is not always possible. It can also mean that you end up with a large expanse of empty foreground, with the building occupying just the upper half of the frame. Getting higher can also help fix the problem: if you're shooting from a greater height your subject will be above and below the centre of the frame, allowing you to keep your camera parallel and avoid an empty foreground. But again, this might be impossible. A third option is to use a lens that's designed specifically to make the impossible possible: a tilt/shift or perspective-control lens.

SHIFTING

Unlike a conventional lens, a tilt/shift lens allows you to move the front of the lens in relation to the rear, which essentially changes what the lens sees without you moving the camera. This is made possible because a tilt/shift lens projects a much larger image circle than a standard lens. As illustrated below, this means that the projected image can be moved (shifted) to the left, right, up, and down, and the sensor will still be exposed in its entirety – in effect, the sensor is picking out the part of the image circle to use.

ABOVE Nikon's 85mm ƒ/2.8 PC lens shown with an upward shift. This is the exact type of movement you would need to avoid converging verticals.

ABOVE When you point a camera upward to photograph a building, its sides will start to converge to some degree (above left). However, using the shift movement on a tilt/shift lens lets you keep the back of the camera parallel to the subject (avoiding convergence), while still allowing the top to appear in frame (above right).

TILTING

Correcting converging verticals is not a tilt/shift lens' only party trick, though – you can tilt the lens, as well as shift it. While shifting the lens changes what appears in the frame, tilting it changes the plane of focus (which we'll look at on page 198). In a nutshell, instead of the lens focusing at a distance that is parallel to it, it can be made to focus at an angle. There are both technical and creative reasons why you might want to do this, but the three main tilt effects are:

- Making the focus extend vertically or diagonally through the frame, with blurred areas at each side.

- Creating a super-shallow depth of field to produce small world photos where towns and cities start to look like models.

- Extending the depth of field to get full front-to-back sharpness without having to use the lens' smallest aperture settings.

Of course, making a lens that can tilt and shift is considerably more involved than making a regular lens, and this translates as more expensive. Tilt/shift lenses are also more difficult to use: They are manual focus only; some limit you to Manual exposure (or Aperture Priority); and then there's the practical challenge of applying and tweaking movements, which generally restricts you to using a tripod. However, for architectural photography, and the creative possibilities they offer, a tilt/shift lens can prove invaluable.

ABOVE Tilting a tilt/shift lens down (as shown here) is a great way of extending the depth of field at any given aperture in a landscape shot. Tilting the lens upward (or sideways) is generally used to creatively reduce or reposition the zone of focus.

ABOVE Changing the direction of the focal plane can create some interesting results. For this shot, I tilted the lens as far down as I could and set a small aperture to deliver a thin slice of focus across the image.

Legacy Lenses

Buying lenses can quickly become expensive. However, most camera systems predate the digital age, so if you're willing to travel back in time you'll find there are some great optical bargains to be had.

When most of the main camera brands started to transition from film to digital SLRs, they naturally (and logically) based their digital models on their existing 35mm cameras, which included using the same lens mount. This is great news, because – for the most part – it means you can pick any lens from the last 20 or 30 years (or longer in the case of Nikon and Pentax), attach it to your digital camera body, and start shooting.

I'm not talking here about autofocus zoom lenses (although these are an option), but the plethora of manual focus, manual aperture lenses that many people considered obsolete when fully automatic digital cameras came to town. Of course, using a lens that predates digital technology is not without its challenges, but if you are willing to work a little harder, it's possible to get some great shots using some inexpensive lenses.

LEFT This shot was taken using an old-school Olympus OM Zuiko 50mm lens (shown above) mounted on an early FourThirds camera. Manual focus and manual exposure were the order of the day, but the result is super-sharp.

METERING

How well your camera's metering will work depends on the make and model. Some retain full TTL exposure control, and allow you to shoot using Aperture Priority, while others demand that you set your exposures manually. Most, however, will at least let you use the in-camera exposure meter as a guide to getting it right.

FOCAL LENGTH

When it comes to lens choice, prime lenses are the ones to go for, and a nifty 50 (a 50mm lens) is the perfect start point: It will deliver superb quality, the fast maximum aperture is perfect for creative shallow depth of field shots, and they cost little because there are so many of them. As a general rule, wide-angle legacy lenses are slightly less impressive, as they can tend to produce heavy chromatic aberration (especially on full-frame cameras), but telephoto legacy lenses can work well.

FOCUSING

When you attach a manual focus lens to your digital camera, you can only focus manually. However, with this type of lens, that's not a problem – manual focus is what they were designed for, so focus rings tend to be wider and smoother than modern autofocus lenses, and far easier to set accurately.

PRIME OR ZOOM?

If you're using legacy lenses then it has to be prime lenses all the way. While modern zoom lenses perform superbly, a lot of the manual zoom lenses from the 1970s and '80s were definitely second best in the image-quality stakes.

Alternative Lenses

The great thing about DSLRs and mirrorless cameras is that you can change the lens. But that doesn't just mean switching focal lengths; there is also a wide range of less conventional options available.

For the most part, photographers tend to look for the best possible image quality when they buy a lens, which is great if recording the tiniest detail in a scene is the aim of the game. However, some lenses replace technical finesse with artistic license, introducing blurs, distortions, and other defects that can enhance the mood and atmosphere of an image. Invariably, these less-conventional lenses need you to modify your shooting approach, which usually begins with a switch to manual exposure and manual focus.

Pinhole

A pinhole is the most elementary method of projecting light onto your camera's sensor, as a tiny hole transmits the light, rather than glass elements. Although a pinhole image will never be tack-sharp, optimising the pinhole's size for its focal length (the pinhole-to-sensor distance) can produce some relatively clear results. There are three ways of going about this: either make your own pinhole in a piece of thin brass or aluminum (the thinner the better) and mount it in an old lenscap; purchase a ready-made pinhole shim and mount that in a lenscap; or simply buy a cap-and-pinhole combo, like the one shown below, where all the hard work is done for you.

In each case, shooting will involve a certain amount of trial and error, especially as you won't be able to see a live image through the viewfinder (or the rear LCD screen) unless the light is particularly bright.

LEFT/ABOVE Pinhole lenses don't deliver tack-sharp results, but that's part of their charm – as is exposure times that are often measured in minutes, rather than seconds!

Determining the exposure can also be a challenge, especially if you make your own pinhole and don't know what the aperture is. Buying a commercial pinhole can be beneficial here, as you will at least know its aperture (which could be in the region of $f/128$ or $f/256$). Then, you can arm yourself with a pinhole calculator (or app) and use that to guide you to the correct exposure.

Holga

Although the first medium-format Holga film cameras appeared in the 1980s, they were largely ignored until the toy camera fad exploded in the last decade. Fuelled primarily by Lomography, there has since been a huge rise in demand for plastic cameras of often dubious quality that produce some fantastically lo-fi images.

Although the Holga system is primarily film based, they do make lenses that allow digital camera users to experience photography through a low-tech lens, which means you can expect severe vignetting, a distinct lack of sharpness, lens flare, and heavy chromatic aberration.

You will need to work hard to get a good result, though: The fixed aperture of $f/8$ is rarely accurate (it's typically much smaller), and the focus (which consists of four preset distances) is equally vague.

ABOVE The images from a medium-format plastic Holga are typified by heavy vignetting, minimal sharpness, and a generally lo-fi appearance. An interchangeable Holga lens (top) allows you to downgrade your digital camera to achieve similar results.

there's an app for that...

If you're struggling to work out your pinhole exposures in the field, Pinhole Assist (iOS) and Pinhole Camera Calculator (Android) can help.

Lensbaby

Lensbaby produces a range of alternative lenses, including a 185-degree fisheye and a soft-and-dreamy portrait lens. However, the company is perhaps best known for its flexible lens designs, which started in 2004 with the original Lensbaby, shown below.

This super-simple design combines a single lens element with a flexible tube (the lens' body) that can be manually twisted and turned to move a focus sweet spot around the frame. The result? A single, relatively sharp area of focus swimming in a sea of blur. Since this initial iteration, Lensbaby has produced models with locking mechanisms and fine-focus adjustments that allow greater precision, and Optic Swap lenses that enable you to change the effect your lens produces.

RIGHT The flexible Lensbaby design allows you to adjust the area of sharpness in your image. Today, there are different versions of the lens available, which offer varying degrees of sophistication and refinement, but their roots all trace back to the Lensbaby 1.0 from 2004.

BELOW For this shot of the dome of St. Paul's Cathedral, London, I used the original Lensbaby 1.0, which gives the rawest images of any Lensbaby lens.

DIY Tilt Lens

With a few low-cost items and a modicum of DIY know-how, it's possible to make your own Lensbaby-style lens. There are no hard-and-fast rules as to how this is done and what you can use – the following build was based entirely on items I had lying around, so don't assume you have to rush out and buy a bunch of supplies.

I This type of lens requires three basic elements: a lens, a flexible tube of some description, and something with a bayonet mount for your camera. For this build, I used an old 5cm enlarger lens, a rubber fork boot from a motorcycle, and a short extension tube. Like I say, this was simply because I had these things already.

2 First, I fit the lens to the bellows. I totally lucked out here – the lens was a perfect snug fit for the narrow end of my bellows!

3 Next, I needed to push my extension tube into the wider end of the boot. This was a much tighter fit, requiring a bit more muscle to stretch the rubber, but again it was near-perfect. It's like these three items were made to go together!

4 Although the lens and extension tube seemed to be held firm in the boot, I decided to add a hose clip around each end for added safety.

5 And that's it! In a little over 15 minutes, I'd built myself a simple, flexible lens. The downside to this particular design is that the boot is so long (even when compressed) that it can only be used to shoot macro images. However, it wouldn't be too difficult to cut the boot down to modify the design, or to use a different item altogether. Like I said at the start, there are no set rules!

Filters

While a lot of effects filters have been replaced by options in image-editing programs, there are still a few filters that can have a beneficial effect when you stick them in front of your lens.

Polarising Filters

A polarising filter is a rare thing: It just cannot be recreated using image-editing software, no matter how hard you try. This is because the filter polarises the light passing through it, having a physical effect on it – something that no computer program can achieve.

The science behind this is fairly complex, but it boils down to the fact that wavelengths of light normally vibrate in different directions to one another: This is unpolarised light. When you use a polarising filter, only the light vibrating in one particular direction is allowed to pass through: This is polarised light.

So why is that useful? Well, in photography, polarising the light can reduce the glare from (non-metallic) reflective surfaces, such as glass, wet leaves, or water. A polarising filter can also darken a blue sky, helping to intensify the contrast between the sky and any clouds, and generally appearing to boost saturation.

These effects rely on two things: the angle between the filter and the light source (usually the sun), and the strength of the polarisation. While the first is usually determined by the direction you're pointing the camera, the second can be controlled using the filter. Turning the outer ring of the filter will increase or decrease the polarising effect.

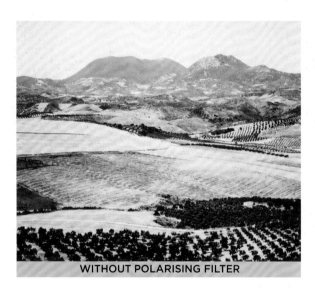

WITHOUT POLARISING FILTER

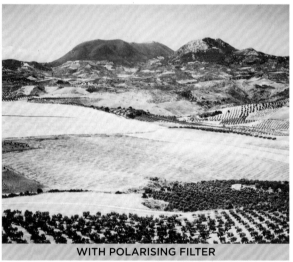

WITH POLARISING FILTER

ABOVE These images were taken moments apart, with and without a polarising filter. Even after processing, the effect of the filter is clear: the sky is notably darker; the distant mountains appear much clearer; and the colour is more saturated overall. Because a polarising filter modifies the light passing through it, its effect cannot be recreated digitally – software can do a lot, but it still cannot alter the physical qualities of light.

FILTER TYPE	PROS	CONS
SCREW-IN 	• Usually cheaper than slot-in filters. • As they attach to the lens, there is no chance of light getting in behind the filter, hitting the rear surface, and creating flare. • The best option for 'protection' filters, as they can be left permanently on the lens.	• Filters only designed to fit one filter thread size: If you have lenses with different filter thread diameters you will either need to buy multiple filters of the same type or use stepping rings (which may lead to vignetting with wide-angle lenses). • Graduated filters simply aren't a viable option, as you can't adjust the position of the gradient. • Stacking multiple filters can lead to corner shading (especially with wide-angle lenses).
SYSTEM 	• Adapter rings allow the same filters and filter holder to be used on lenses with different filter thread diameters. • Differently sized systems are available, enabling you to pick the optimum size for your lenses (you can use smaller filters if you only use long lenses). • Some filter systems have dedicated bellows-style lens shades, which are far superior to regular plastic lens hoods.	• System filters are usually more expensive than screw-in filters (and cost also increases with filter size). • Need to buy a filter holder. • Light can get behind the filters, potentially increasing the risk of flare and reducing image contrast.

FILTER TYPES

There are two basic types of filter: circular ones that screw into the filter thread on your lens, or system filters that are square or rectangular and slide into a dedicated filter holder. Each type has its advantages and disadvantages.

POLARISER CAUTIONS

There are two types of polarising filter – circular and linear – which describes how they polarise light. Linear filters can interfere with a camera's As system, so circular polarisers are the best option for any autofocus lens.

Polarising filters reduce the amount of light coming through the lens, and the stronger the polarisation effect, the greater the light loss.

Be careful using polarising filters with wide-angle lenses. Sometimes the wide angle of view means the polarisation doesn't affect the entire frame, so the sky can look uneven and unnatural.

ABOVE Usually the surface of any body of water is difficult to see through because of all the light being reflected. Because a polariser blocks this reflected light, it allows you to see straight through the bottom.

there's an app for that...

Apps such as NDTimer (iOS) and ND Filter Calc (Android) will help you calculate your exposure times when using ND filters. This is especially useful when you're shooting in Bulb mode with extreme ND filters a nd/or combining multiple filters.

Neutral Density (ND) Filters

In the simplest sense, a neutral density filter reduces the amount of light coming in through the lens, without affecting the colour. Why would you want to do this? Well, there are numerous reasons – you might want to use a slow shutter speed or shoot with a wide aperture on a bright day, for example, or you might want to intentionally shoot with a high ISO setting to get a gritty image. Whatever the reason an ND filter will help.

To control precisely how much light is blocked, ND filters come in a number of strengths, and the stronger the filter, the greater its darkening effect. Confusingly, there is no single strength measurement used by all filter manufacturers, so the strength of an ND filter might be given as an optical density figure, an ND rating, or measured in terms of how many stops the light transmission is reduced (see chart below).

With ND filters in the region of 1–3 stops, you can simply fit the filter and shoot as normal. The viewfinder will be a bit darker, and your camera's AF may be slightly less responsive due to the

decreased light passing through the lens, but your camera should be able to sort out the focus and exposure and get you your shot.

However, switch to an ND filter in the region of 6–12 stops and this is likely to change. Because of the extreme light reduction the viewfinder, will be almost black, so you will be unable to see to frame your shot, and it's highly unlikely that your camera's autofocus will have enough light to work with either. Therefore, it's best to frame and focus manually before attaching the filter, taking care not to knock the lens when you do. Unless you're shooting in especially bright conditions, the exposure time might also exceed the camera's longest shutter speed (usually 30 seconds), so you may well need to call on Bulb mode and hold the shutter open manually (see page 68).

ND POWER

This grid shows the most common values used to measure ND filters, and how they relate to each other. Stops is the most useful measurement for photographers, as it can be applied directly to the exposure: A 3-stop ND filter will require you to extend the shutter speed by 3 stops, for example.

OPTICAL DENSITY	ND RATING	STOPS
0.3	ND2	1
0.6	ND4	2
0.9	ND8	3
1.8	ND64	6
3.0	ND1024 (OR ND1000)*	10
3.6	ND4096*	12

*Not typically used to refer to extreme ND filter strength

ABOVE Because you need to be able to position an ND grad to match the scene you're shooting, they only really work as slot-in filters.

BELOW In landscape photography, the difference in brightness between the land and the sky can often be quite high. If you expose for the sky it will make the foreground appear too dark (top left), while exposing for the foreground will often mean the sky washes out (top right). However, use an ND grad and you can balance the two (bottom).

Graduated ND Filters

Like their plain counterparts, a graduated ND filter (or ND grad) is designed to reduce the amount of light entering the lens; the major difference is that it doesn't do this across the entire frame. Instead, the density covers one half of the filter, while the other half is clear, which means you can selectively darken parts of an image. Because graduated ND filters need to be positioned precisely, they're only really worth getting for a slot-in filter system, so you can rotate the filter holder to change the filter's angle, and slide the grad up and down in the filter slot.

The most common use for ND grads is reducing the exposure difference between a bright sky and darker foreground in a landscape, as shown below, but they can be used anywhere you want to balance out light falling across the frame – if you're shooting an interior and have bright light coming through a window at one side of the frame, for example.

As with plain ND filters, graduated ND filters come in different strengths (usually 1–3 stops), and with different grades of transition from coated to uncoated areas (the transition can be soft, hard, or very hard). Soft transitions are best used when the line between the dark and bright areas in a scene is irregular (a mountainous landscape, for example), while harder transitions are better suited to clearly delineated separations (such as the horizon on a seascape).

With so many choices, you can quickly find that you end up with multiple ND grads to cover all your options. However, it's worth noting that unlike plain ND filters, the effect of a graduated ND filter can be recreated digitally, either by applying a filter effect to an image (which is not always convincing) or by taking two shots at different exposures and combining them (which is 100% successful).

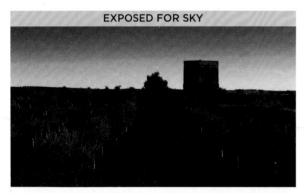

EXPOSED FOR SKY

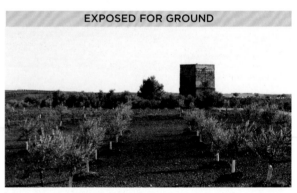

EXPOSED FOR GROUND

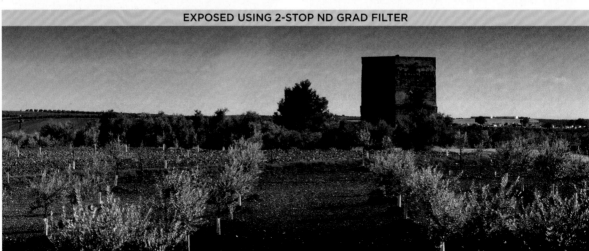

EXPOSED USING 2-STOP ND GRAD FILTER

Choosing the Right ND Grad

1 Before you can use an ND grad, you need to know which strength you need, so set your camera to Manual exposure and switch to spot metering.

2 With the aperture set at ƒ/8*, aim the spot meter at the area that you want to be a midtone in your final shot (here, it's the sunlit grass at the right of the scene). Adjust the shutter speed until the camera indicates the correct exposure.

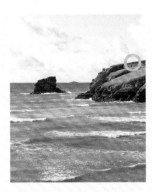

* It doesn't actually matter what aperture you set at this stage, but ƒ/8 is found on all lenses and is a pretty central choice.

3 Turn the camera so the spot meter area is over the brightest area of the scene that you want to be a midtone (here, it's a relatively bright patch of sky). Again, adjust the shutter speed until the camera is showing the exposure is correct.

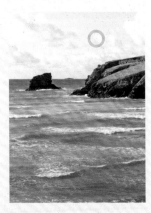

4 Work out how many stops difference there are between the two readings. In this example, the grass was giving me a shutter speed of 1/125 second and the sky was giving me 1/250 second – a 2-stop difference.

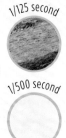
1/125 second

1/500 second

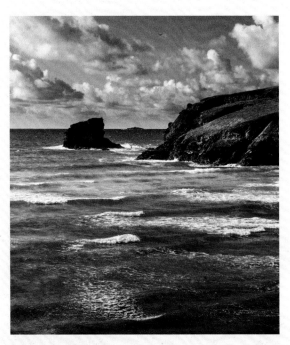

5 Choose an ND grad filter based on the effect you want to achieve. If you want both areas to be the same, choose a filter with a strength equal to the exposure difference (so, a 2-stop filter for a 2-stop difference). Alternatively, if you use a filter with a strength that is 1-stop lower than the difference (a 1-stop grad if the brightness difference is 2-stops, for example) the effect will be more subtle; this generally produces a natural-looking result. Finally, reach for a stronger filter if you want a more dramatic look; using a 3-stop filter when the difference is 2-stops would create a stormy sky, for example.

For the shot at the left, I started with a 2-stop ND grad filter on the sky (to darken it from the top) and used a 1-stop ND grad filter on the sea (positioning it upside down so it was darker at the bottom).

MASTERCLASS

WILDLIFE
Richard Garvey-Williams

Richard Garvey-Williams is an award-winning wildlife and landscape photographer, and the author of multiple photography books and articles. His interest in photography developed while he was growing up in East Africa, where he recalls spending hours stalking lizards in his garden, armed with his first camera, a Zenit-E. Although he in now based in the UK, Richard regularly returns to Africa to lead photographic safaris. 'I am drawn to African reserves and, in particular, to the mammals found there. I enjoy producing simple, graphic imagery, particularly revealing the amazing shapes of animals such as giraffes and elephants that make them such a strong feature in broader images of their environment'.

Working with this type of wildlife – predominantly large mammals that might not appreciate a photographer trying to cozy up to them with a camera – makes it essential to get your kit right. 'My first DSLR was a Canon, simply because it appeared to offer the best value for my budget at that time in the particular store I was in. Once you start to buy into lens systems, there has to be a very good reason to change brand – there hasn't been, so I've happily continued with Canon. I currently use an EOS 5D Mark III and EOS 7D, which both have their strengths. Because the EOS 5D is a full-frame camera, it offers advantages in terms of image quality in low-light situations when you have to raise the ISO, whereas the EOS 7D has a smaller sensor with a 1.6x crop factor that extends the reach of my telephotos. For macro work, the EOS 7D also offers a slightly greater depth of field for a given magnification. In general, having a second camera body can be a great benefit at times, as it can save you having to change lenses, which lets you react quickly to circumstances'.

As you will have seen in this chapter, the lenses you use are important, no matter what your preferred subject is. Although wildlife photography is typically associated with long focal lengths, Richard points out that they're not the only option: 'There is a time and a place for virtually any focal length in wildlife photography, including wide-angle and even fish-eye lenses. I enjoy a variety of wildlife photography, including taking wider views that reflect the creatures in their environment, so a range of focal lengths is important to me. It isn't just about producing frame-filling shots of animals that are often difficult to get close to.

'However, it is generally important to have a relatively long telephoto lens in your armoury for those frame-fillers and detail shots, and for participants on my photographic safaris, I tend to recommend an effective focal length of 400–500mm. To give you options when shooting in low light, and to provide nicely blurred backgrounds, it's worth having a fast telephoto prime lens, and my go-to lens is a Canon EF 500mm f/4L. This will also potentially help you make best use of your camera's autofocus and focus-tracking capabilities, as these systems work better with large apertures. Although prime lenses tend to offer better image quality, high-end zooms aren't far off, and I also make good use

WILDLIFE ESSENTIALS

Tripods, monopods, and beanbags are all valuable for helping stabilise cameras with longer lenses. For moving subjects, it's important to have a bracket head on your tripod that enables you to swivel and tilt the camera to easily follow flying birds and so on. On safari, much of my photography is done from vehicles and, although you can get mounts to fix a bracket head to the windowsill, I prefer the humble beanbag. These can be readily moved from window to window or up to the roof-hatch to get the composition you want and, if used properly, offer excellent support.

▲ Lochan Na Stainge in the Scottish Highlands. Planning is a large part of landscape photography and knowing where the sun will either rise or set is vitally important. This shot was planned after consulting maps and visiting the area earlier in the day.

500MM WITH 1.4X CONVERTER, 1/640 SECOND @ ƒ/8, ISO 320

of my Canon EF 100–400mm $f/4.5$-5.6L II. However, cheaper zooms – particularly those offering a great range of focal lengths – tend to show quite marked distortions at the extreme ends of their range, so are perhaps best avoided for serious wildlife work'.

The need for fast and accurate focusing – as well as 'perfect' exposures – is brought into sharp relief when you realise that a lot of the time you won't get a second chance, especially if you're photographing a particularly rare or timid creature. To keep things in focus, Richard generally relies on his camera's AF, 'usually focusing on the nearest eye of the subject using either a selected AF point or the central one. If the subject is moving, I tend to switch quickly to AI Servo mode so the camera continues to shift focus and adapt to the movement. Firing off bursts of shots in Continuous shooting mode is also often the key to capturing a precise moment during bouts of activity'.

To deal with the exposure, Richard also relies on his camera to point him in the right direction: 'Evaluative metering is my norm, but I have gotten used to quickly interpreting the scene myself and dialing in any necessary exposure compensation to ensure that the camera is not misled by very dark or light areas in the surroundings'.

As you might expect, getting the right shutter speed is essential when dealing with potentially fast-moving subjects, especially when handholding long lenses. However, that doesn't automatically mean you have to set your mode dial to Shutter Priority, as Richard explains: 'I tend to use Aperture Priority because depth of field is the variable that I generally like to be in control of. It's important to be aware of the settings your camera is determining for you, though, and in my case, I keep an eye on the shutter speeds to make sure that I am still getting sharp images'.

The key thing to appreciate here is that while automatic and semi-automatic options can help you to get things right, they aren't guaranteed to do that. You still need to use your skills as a photographer to choose the most appropriate focus mode, AF point, or drive mode, for example, and to adjust the exposure if you think the camera's going to be fooled or the shutter speed (or aperture) it's giving you isn't appropriate. Your camera may be smart, but the photographer behind it needs to be smarter.

To see more of Richard's photography, or to find out about his photographic safaris, visit his website at ,www.richardgarveywilliams.com.,

RICHARD'S TOP TIPS

- Don't always feel you need to zoom in and fill the frame. Backing off a little might allow you to say something about the animal's relationship to other individuals or its surroundings – these are often the more interesting shots.

- The eyes are the 'windows to the soul' so focus precisely on these, especially the nearest one, to ensure more emotive portraits.

- Study and, if necessary, research your subjects. This will not only help you to be with them in the right place at the right time, but it will also help you to anticipate any interesting interactions or behaviour, so that you are ready to capture it appropriately.

- Pay attention to the background, particularly things that might draw attention away from your subject. In the natural world we don't have the luxury of using artificial backdrops or asking our subjects to move, but a slight change in position can often give a very different background. Alternatively, select a wider aperture to throw the background out of focus.

- Lighting, composition, and precise timing are often what make images stand apart from the crowd. So, study these, and experiment with and practice their application.

▶ Zooming out to include aspects of the environment often creates a stronger image, as with these grizzly bears in Alaska.

100MM, 1/80 SECOND @ f/16, ISO 250

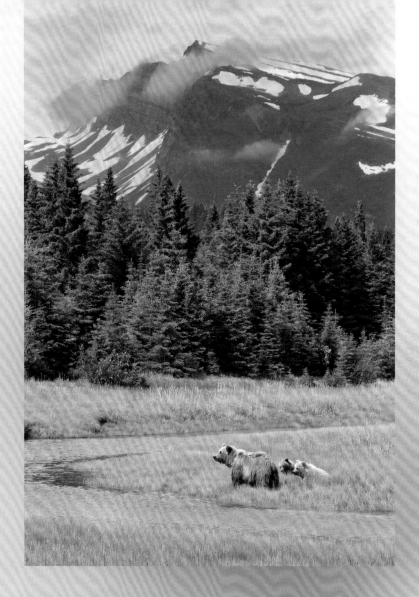

▶ Despite a shutter speed of just 1/40 second (and a long lens), a beanbag ensured a sharp shot of this red-billed oxpecker on a Cape buffalo in Kenya.

500MM, 1/40 SECOND @ f/7.1, ISO 400

Focus

Photographers spend a lot of time talking about getting things in focus or parts of a picture being out of focus, but what does it actually mean?

First off, the important thing to understand is that a lens focuses at a single distance, known as the plane of focus. No matter what, only those parts of a scene that are at that specific distance are in focus – everything (yes, everything) else is out of focus to some degree. The easy way of thinking about this is to use the sheet of glass analogy illustrated below.

However, depth of field enables more of a scene to appear in-focus, so that areas in front and behind the plane of focus appear acceptably sharp. The key word here is acceptably: although it might look as though everything in your shot is sharp, only the elements at the focal plane are truly in focus.

The reason this is important is simple: for pretty much every shot you take, you will want to get a certain part of it in focus. That doesn't mean more or less sharp or acceptably sharp; it means tack sharp. So, just as you (should) want to get the exposure spot-on when you shoot, the same applies to focus. In fact, you could argue that getting the focus right is even more important, because exposure (like most other settings) can be tweaked and corrected on your computer if you shoot Raw. Focus, on the other hand, is very hard to adjust after a shot is taken, because it's a primarily optical trait.

RIGHT Focusing your lens is like placing a sheet of glass parallel to the camera. No matter whether the focus distance is near, far, or somewhere in between, only the parts of your scene or subject that are at that exact distance are in focus. Everything nearer to, and further from, the camera is out-of-focus to a certain degree.

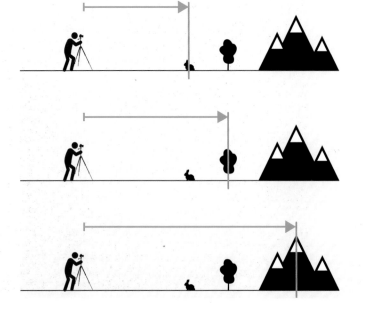

KEY:

| Plane of focus
⊢→ Focus distance

RIGHT Telephoto focal lengths at very short distances with wide apertures means the depth of field is going to be vanishingly shallow. Here, it was essential to get the tip of the nose and the eyes in focus; the rest of the face falls out of focus behind these features.

Autofocus

For a lot of your photography, autofocus will be your best friend, quickly snapping your subject into focus.

ERROR! ERROR!

If you find yourself facing a flashing Error ('Err') message and your lens isn't focusing, the first thing is not to panic. Start by checking to make sure the lens is mounted correctly – even if it appears to be OK it's a good idea to remove it and refit it. If the error continues, check the electronic contacts on the camera body and lens, as dirty contacts are a common cause of lens-related issues. If that still doesn't work, try switching to manual focus and checking that the lens turns freely and focuses that way. If it doesn't, then you can start to panic (or call your local repair centre).

There are two types of AF technology used in digital cameras: phase detection (which is mainly seen in DSLRs) and contrast detection (which is generally reserved for mirrorless cameras and Live View modes). Although the technology behind each system is very different, there's really no need to go under the hood on this. Suffice to say, if you put them head-to-head, the verdict would be that phase detection is quicker, while contrast detection systems are generally more accurate. However, this is a bit like comparing apples and oranges, because the bottom line is that both are equally capable of focusing a lens automatically. What is perhaps more important is how the systems are employed and how you can get the best from them, and that's precisely what we will be exploring over the following pages.

DRIVE MODES

AF modes shouldn't be confused with drive modes. Single and Continuous shooting modes refer to whether a single shot or multiple shots are taken with a single press of the shutter release button; they have nothing to do with focusing.

AF Modes

Autofocus modes tell your camera how you want the AF to behave. Although different manufacturers have different names for their modes, most are based on the following trio:

SINGLE SHOT

When your camera is set to Single or One-Shot AF (or your manufacturer's equivalent setting), the lens will try and focus using the active AF point (or points) when you press the shutter-release button down halfway, or activate the AF system some other way (such as back-button focusing, outlined on page 217). Once the focus is established, it won't change unless you take a shot or release and re-press the shutter button.

CONTINUOUS

Set to Continuous or AI Servo, your camera's AF will initially target the area under the active AF points (more on this on the following pages), but it will constantly adjust the focus if your subject moves, possibly even switching to different AF points if it needs to. The camera will keep making tiny adjustments to the focus right up until you take your shot, which helps ensure that the focus is right at the exact moment you fire the shutter.

LEFT Built in the 12th century, St. Enodoc Church on England's Cornish coast is known for two things: its twisted spire and as the final resting place for the poet Sir John Betjeman. For static subjects like this, Single Shot AF makes perfect sense.

AUTO

Auto or AI Focus AF is an amalgamation of the other two modes. When you first switch to Auto, the camera is in Single Shot mode, so it will lock and hold focus as outlined above. However, if it detects that your subject moves, the AF will automatically switch to Continuous so it can adjust the focus accordingly. In theory, this sounds like the perfect solution, as it covers all eventualities, but in reality, it's not quite perfect (if it were, it would be the only AF mode). The problem is, like any automated option, it relies on the camera making a judgment call. Sometimes that means it can get it wrong, switching modes (and focus) for no obvious reason.

RIGHT Continuous AF can be a good choice when you're photographing moving subjects. However, you need to be aware that the camera can make an exposure even when the focus isn't set, so just because it is trying to maintain focus, that doesn't mean your shot will be tack-sharp.

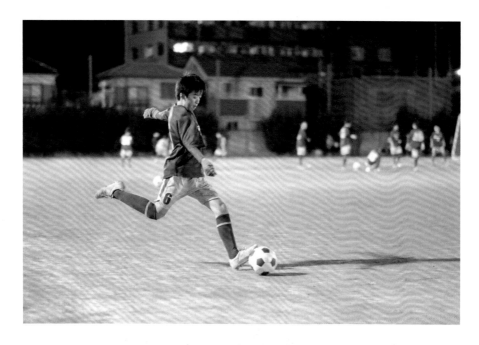

	SINGLE SHOT/AF-S/ONE-SHOT AF	CONTINUOUS/AI SERVO AF	AUTO/AI FOCUS AF
GOOD FOR	• Static subjects, such as landscapes and architecture • Locking focus and recomposing	• Moving subjects, such as sports, wildlife, and street photography*	• Subjects that might move before you shoot
NOT SO GOOD FOR	• Moving subjects (your subject will likely move between the focus locking and the shutter firing)	• Static subjects (focus can shift unnecessarily) • Conserving battery power (constantly driving the AF system drains battery)	• Moving subjects (if you absolutely know your subject is going to move, use Continuous AF) • Static subjects (if you know your subject isn't going anywhere, use Single Shot AF)

*Note that Continuous/Servo AF cannot always keep up with extremely fast-moving subjects.

AF Technology

As mentioned earlier, there are two types of AF technology widely used in digital cameras: phase detection and contrast detection.

Phase detection AF is employed by the majority of DSLR cameras. At a basic level, it works by creating a pair of images from the light coming through the lens. The relative position of these images is then assessed. If they are offset, the camera not only knows they are not in focus, but also knows how far out they are, and whether the point of focus needs to be closer to or farther from the lens. It can then adjust the focus accordingly.

By comparison, contrast detection AF (which is generally found in mirrorless cameras and in Live View mode on DSLRs) works by assessing the contrast of the area you want to focus on. The

area will be in focus when the contrast is at its highest (out-of-focus elements have lower contrast). However, the camera will only know if contrast is going to improve by adjusting the lens, and it will then only know which way to adjust it by actually doing it, which means the lens might first move in the wrong direction, and then pass the optimum focus point before coming back to it. As this might suggest, contrast-detection AF is typically slower than phase detection focusing, especially in low-light conditions when contrast is naturally lower. However, it can often be the more accurate of the two technologies.

AF Points

While AF modes tell your camera how you want it to focus, AF points tell it where. AF points are the small squares or dots that you see through the camera's viewfinder or on the rear LCD screen, which usually

BELOW This is the type of subject that would pose few problems for most AF systems, as there are plenty of high-contrast edges to lock on to. The challenge would be to get the system to lock on to a specific part of the tree.

light up when you focus on something. Each of these points can be used to try and set the focus, and we'll look at how that works on the following pages.

There are two things that are usually worth looking out for when it comes to AF points, the first of which is quantity. Generally speaking, the more AF points you have, the closer they have to be to each other, so the more likely it is that one of them will be located over the exact area you want to focus on. It also makes it easier to track moving subjects – especially if they're small in the frame – as the camera can switch more easily from one point to another as the subject moves around.

The other aspect to watch for with AF points is their spread. This is how they are distributed across the frame: some cameras bunch them toward the centre, others spread them more liberally across the frame in a grid-like pattern, and others opt for a diamond formation. The key thing here is that a wider spread will mean you can usually focus far more easily on areas closer to the edges of the frame, without having to move your camera. Combine a wide spread of AF points with a high quantity and you're well on your way to having a first-rate AF system.

BELOW The quantity and spread of AF points (sensors) varies not only between manufacturers, but also between their camera models. As a general rule, pro-spec cameras tend to have a greater number of AF sensors than enthusiast cameras, making it easier to focus on a specific point, or faster to lock on and track a subject.

NIKON

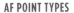

PENTAX

CANON

SONY

AF POINT TYPES

Even in the same camera, not all AF points are guaranteed to be equal. In most DSLRs, for example, the majority of AF points (or sensors) are linear, which means they can only accurately assess focus in one direction (horizontally or vertically). However, some AF points are cross type, which essentially means two linear sensors are used at right angles (creating a cross shape). In this way, the AF point can assess focus both horizontally and vertically, which makes it more sensitive and therefore quicker and more accurate. Most often, the central AF point(s) will be cross type, which makes it the ideal option if you like to lock focus and reframe your shots), rather than changing AF points.

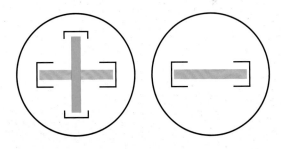

ABOVE Linear focus sensors (right) can struggle to lock on elements running in the same direction as the sensor; they work best when parts of the scene run across the focus sensor. Cross-type sensors (left) don't have this problem, as they can assess focus both vertically and horizontally.

FACE DETECTION

An increasing number of cameras feature face-detection technology, which is designed to make focusing quicker and more accurate when you're photographing people. At a basic level, face detection simply looks for round-ish shapes in the frame, which have two small circles halfway up and a larger circle below them – a simple representation of a face, eyes, and mouth respectively. The camera will then set the focus so the face (or faces, if there are more than one) are sharp.

AF Point Selection

Of course, having the highest number of AF points spread across the widest possible area is not going to help if the camera is unable to choose the right focus point to start with. For this reason, most cameras will give you several options when it comes to choosing which AF point(s) it uses to set focus.

MULTI-AREA

When all of the AF points are active, the camera will basically choose your subject for you. Based on position, size, distance, contrast, and a heap of other things, it will attempt to identify what it thinks is the most important part of a scene, and choose the most suitable AF point (or points). Now, the obvious problem here is your camera – while it is smart, it isn't sentient. It doesn't know what you're photographing (or why), it's just making educated guesses. And, while it can get it right a lot of the time, it can also get it wrong. This is when you need to start taking control.

LEFT With so many obvious lines and contrasts, few cameras would struggle to focus accurately on a scene like this.

BELOW Multi-area metering hands control of the AF points to your camera. It can activate as many points as it chooses to set focus, basing its decision on the size, shape, distance, and contrast (among other things) of the elements of the scene.

FOCUSING TRACKING

Also known as Dynamic AF or Predictive Focus, focus tracking is used in conjunction with Continuous AF to maintain focus on a moving subject by trying to predict your subject's movement and automatically switching AF points if necessary. So, if your subject is moving from right to left, the camera automatically switches from an AF point at the right, to the central point, and then an AF point at the left to track it and maintain focus.

GROUPS & ZONES

If your camera lets you, you can reduce the number of AF points the camera will use by selecting a specific group of focus points, or a zone. This activates some (but not all) of the AF points, so you might choose a central group if your subject is at the centre of the frame, a group to the left or right of the frame for off-centre subjects, or a group that's above or below the centre of the frame for higher or lower subjects. This doesn't guarantee the camera will get the point of focus right, but it does narrow the options down, and is particularly useful for shooting moving subjects using focus tracking (see below).

NOTE: Many recent cameras – particularly high-end models – boast an array of ever-more-sophisticated group and zone AF options that enable the size and shape of the group to be controlled more precisely.

BELOW Choosing a group of AF points tells the camera where to expect your subject to be, making it a good option when you want to target a moving subject in a specific part of the frame. There is no standard group or zone pattern. Some camera may even offer multiple options, allowing you to change the size or spread of the group.

ABOVE This is group point selection.

ABOVE This is single-point selection.

ABOVE This is multi-area point selection.

BELOW Single AF point selection puts you in charge. You choose which AF point is right and the camera will use it to try and focus on that part of the scene.

SINGLE-POINT SELECTION

If there's a specific part of a scene or subject that you want to focus on, then choosing a single AF point is a logical choice. Of course, this works best when there's an AF point sitting over the area you want to focus on. If not, you may find it quicker and easier to select the central AF point and then focus and reframe your shots, as outlined opposite.

Alternatively, switching to Live View will usually enable you to use a roving AF point that can be positioned anywhere within the image area. This is ideal when your point of focus lies at the edges of the frame, outside the traditional AF point array.

LEFT For this candid portrait, I specifically wanted to focus on my subject's eyes, so activated a suitably positioned AF point.

Selecting An AF Point

How you choose and change AF points varies from camera to camera, but it typically goes something like this:

1 Set the camera to its single AF point selection mode. If necessary, press (and possibly hold) the AF point selection button on the back of the camera.

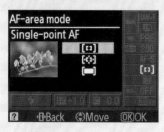

2 Looking through the viewfinder, the selected AF point will usually light up when you half-press the shutter-release button – the default is the central AF point.

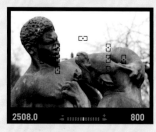

3 Turn the camera's main control dial or use the directional buttons on the back of the camera to move through the AF points.

4 When the AF point you want to use is illuminated, release the button. The camera will now use your chosen AF point for each shot you take – simply repeat the process to change it again.

Locking Focus & Reframing

You don't always have to navigate multiple AF points: Sticking with the central AF point and locking the focus is often a quicker route to the shot you want.

1 Make sure your lens (and camera, if necessary) is set to AF, with the AF mode set to Single (or its equivalent).

2 Press the AF selection point button on your camera (if necessary) and use the control wheel or directional pad to select the central AF point.

3 Target your intended point of focus with the central AF point and half press the shutter-release button (or use your back button) to focus.

4 As long as you hold the shutter-release button down halfway, your focus will remain locked, allowing you to turn the camera and reframe your shot.

5 With your shot reframed, press the shutter-release button down fully to make the exposure.

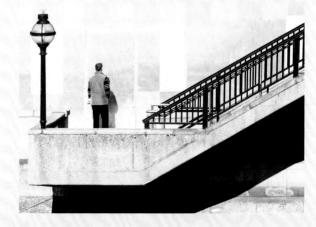

Manual Focus

While autofocus is great in the majority of situations, it's not the perfect solution for every shot you take: Sometimes, focusing manually is a far better option.

Apart from phones and a lot of point-and-shoot models, most cameras will let you take over and adjust the focus manually. This is great, because it means you can decide where the optimum point of focus is (and, let's face it, picking the precise point of focus is fairly important). To help you get things right, your camera will usually provide a couple of focusing aids, depending on whether you use the viewfinder (where applicable) or Live View.

If you're focusing through the viewfinder on a DSLR or mirrorless camera, the AF focus confirmation light – which is usually found at the bottom of the viewfinder on a DSLR – will light up when the area under the currently selected AF point is in focus (even though the AF system itself is disabled). Alternatively, if you prefer to shoot using the camera's rear LCD screen (Live View), you will find you can zoom in on the preview image, magnifying the detail so that you can focus on it more accurately (as described opposite).

But why would you want to focus manually to start with? Well, let's take a look at the reasons – some of them might surprise you!

Off-Centre Subjects

When there isn't an AF point placed conveniently over your intended point of focus, and you don't want to lock the focus and reframe your shot, switching to manual is the answer. This works best if you're using Live View to frame your shots, as you can zoom in to view the detail, no matter where it is in the frame; using the viewfinder, you would have to gauge the focus accuracy by eye (or take a test shot and assess it on screen).

Moving Subjects

Believe it or not, with some fast-moving subjects, manual focus is preferable to autofocus. This may sound counterintuitive, because turning the lens by hand must be slower, right? Well, yes and no. If you know where your subject is going to be, then you can pre-focus at that distance manually. For example, if you're shooting an air show, you can pretty much guarantee that the overhead displays will be at infinity focus. So, rather than lose shots while the AF tries (and fails) to lock on to a passing plane, simply focus manually at infinity and you're good to go. Similarly, if you're shooting at a race track, you can focus at a point on the track that the vehicles pass on every lap and simply pick them off as they come by each time, rather than praying your AF keeps up with the action.

Live View MF

1 Switch your lens (and camera, if necessary) to manual focus.

2 Activate Live View and frame your shot. There will usually be a focus area indicated on the screen – here, it's a red box. Use your camera's control pad (or touchscreen) to move the focus area so it's over the part of the scene you want to focus on.

3 Use the playback zoom button to zoom in on the preview image and the control pad or touchscreen to more accurately target your chosen focus point.

4 Turn the lens to focus. If the screen is heavily pixelated and you can't tell what's going on, try zooming back out slightly so you can see image detail and not just pixels.

RIGHT With exceptionally fast-moving subjects, your camera's AF may simply not be able to get a lock before they exit the frame. In this case, pre-focusing manually can help you get the shot.

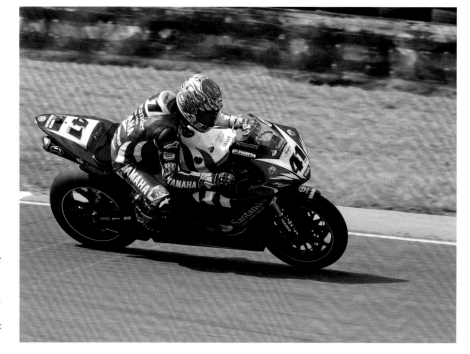

Shooting from the Hip

Street photographers who shoot from the hip rather than framing their shots through the viewfinder or LCD screen will typically use something called zone focusing, which relies on manual focus to keep their shots sharp. You start by focusing manually at the distance you want to shoot at. This is usually determined by the focal length – wide-angle lenses are typically used with shorter focus distances. Then, the aperture is chosen to give a decent depth of field, effectively creating a zone of acceptable sharpness.

For example, if you used a 28mm focal length on a full-frame camera and focused at 1.8m with an aperture of $f/8$, roughly everything from 1.2–4m would fall within the depth of field and appear acceptably sharp (you can work out the minimum and maximum distance using a depth-of-field calculator (see page 223). Now, as long as your subject is in the zone, you can be confident that you will get sharp results, without raising your camera to your eye and worrying about where to focus.

Low Contrast

Most mirrorless cameras use what is known as contrast detection AF. As the name suggests, this system relies on contrast to determine the point of focus, which isn't always ideal if you're photographing a low-contrast subject or find yourself in a low-contrast situation (fog or mist, for example, or low-light conditions). So, if you find your lens is struggling to lock on, switch to manual.

Shooting Through

Whether it's photographing your child through railings in the park, an animal through a mesh fence at a zoo, or anything that you can see out of a window, your camera's AF system can prove reluctant to focus through something. Instead, you're likely to end up with those railings, that fence, or the mucky glass in focus, while your subject is an unrecognizable blurred shape in the background. The reason this happens is because your camera's AF can't deal effectively with the various overlapping layers at different distances, and in this situation, its programming tells it that the closest element is usually the subject, so that's where it should focus. Turn to manual and you can set the focus at any distance you choose.

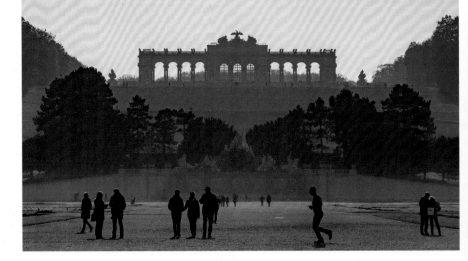

RIGHT Zone focusing means that everything in a predetermined distance range will be acceptably sharp, allowing you to shoot quickly, without having to worry about where to focus.

Consistent Focus

Certain multi-shot techniques, such as HDR and stitched panoramas need the focus to remain constant while you take a series of shots. Autofocus can work in these situations, or it can misbehave and decide to defocus and refocus at a slightly different spot for no obvious reason. Focusing manually means you can set the focus and leave it. Unless you knock the lens, the focus isn't going to change.

Precise Focus

Setting the hyperfocal distance, macro photography, and focus stacking are all techniques that rely on precision focusing. Manual is definitely the way to go here, especially in conjunction with Live View, so you can really get into the scene to pick your point of focus.

ABOVE Mist and fog reduce contrast, making it harder for your camera's AF systems to accurately identify your subject. When this happens, focusing manually is the simple solution.

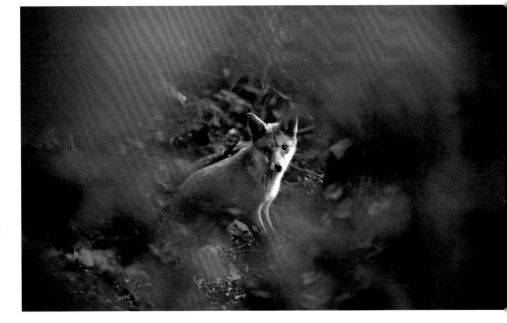

RIGHT This was a chance encounter with a fox cub in a local woodland. With little hope of getting any closer, I had no choice but to shoot through a break in the undergrowth. To prevent the lens hunting back and forth (potentially frightening my quarry), I switched to MF and focused manually.

Hyperfocal Distance

Understanding hyperfocal distance is by no means essential, but for certain types of photography, it can help you maximise your depth of field.

ABOVE This old manual focus lens has a colour coded depth of field scale. Here, the aperture is set to ƒ/16 (blue) and the corresponding blue marks above show the depth of field. In this case, everything from 10ft (3m) to infinity would fall within the depth of field.

Depth of field extends approximately 1/3 in front of the point of focus and 2/3 behind it. This is great for close-to-middle distance subjects, but as illustrated below, you could lose a whole heap of depth of field if your subject is a long way off and the lens is focused at infinity. Beyond infinity, there's no extra sharpness due to depth of field, so you're effectively wasting 2/3 of your potential zone of sharpness.

The hyperfocal distance prevents this by giving you a closer focusing distance that will ensure everything from half that distance to infinity falls within the depth of field. So, rather than infinity being your focus point, it becomes the furthest limit of the depth of field: Infinity will still be sharp in your final shot, but much more of the scene closer to the camera will appear sharp as well. This is a classic technique used by landscape photographers, especially when there are foreground elements close to the camera that they want to keep sharp.

It is not an easy technique to use, though. For a start, hyperfocal distance isn't a single magic number. First, it is dependent on the aperture being used: A smaller aperture setting delivers a larger depth of field to start with, so has a closer hyperfocal distance than a wider aperture. Second, the focal length of the lens also plays a part: Wide-angle lenses produce a larger depth of field than telephotos, so a wide-angle lens will have a closer hyperfocal distance.

So, before you can set the hyperfocal distance, you need some way of determining what that distance is. In the past, photographers would head out with pages and pages of printed charts covering various focal length and aperture combinations. Nowadays, there are countless websites that will help you generate charts that you can print yourself (often with the added advantage that your camera's sensor size can be taken into account as well).

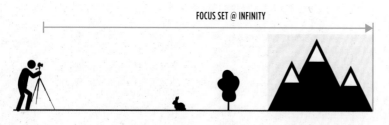

FOCUS SET @ INFINITY

LEFT When you focus at infinity, depth of field can only extend toward the camera (top). This might be sufficient to keep distant elements looking sharp, but areas closer to the camera will look distinctly out-of-focus.

However, focus at the hyperfocal distance (bottom) and the depth of field will not only extend in front of the plane of focus, but also beyond it, all the way to infinity. As a result, much more of your scene will appear in-focus.

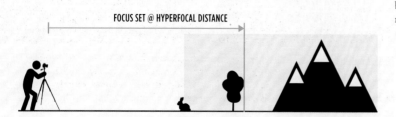

FOCUS SET @ HYPERFOCAL DISTANCE

KEY:
| Plane of focus
→ Focus distance

Once you have determined the hyperfocal distance, you need to focus (usually manually) at that distance. Again, this is not necessarily easy because few modern lenses have distance settings or focus scales on them, and even those that do are unlikely to have that super-specific hyperfocal distance you just worked out. The answer? Guesstimate the distance and focus there. It might seem strange with all the technology available to us, but setting the hyperfocal distance on a modern lens often comes down to roughly gauging the focus distance. Still, with a little practice (and a good eye for distances), it is still possible to set the hyperfocal distance, or at the very least ensure that you aren't wasting quite so much of your depth of field.

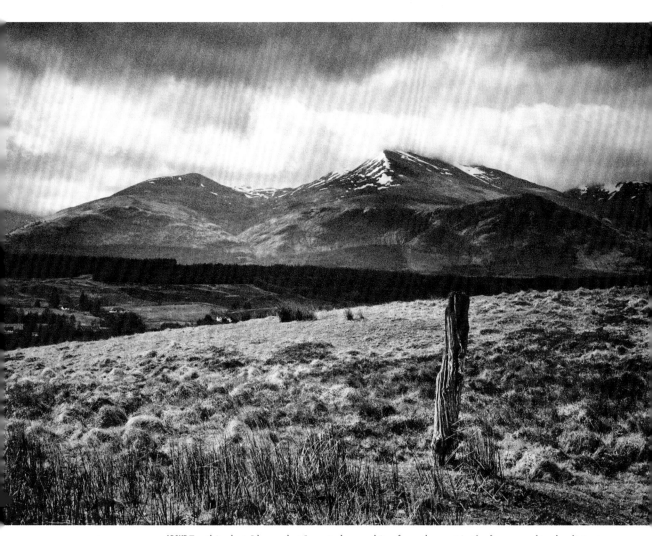

ABOVE For this shot, I knew that I wanted everything from the post in the foreground to the distant mountains to be acceptably sharp, so setting the hyperfocal distance was the way to go. Because I was shooting using a vintage 35mm SLR, this was fairly straightforward – depth of field and distance scales were both marked on the lens (see opposite).

Focus Stacking

The closer your subject is to the lens, the shallower the depth of field will be. This becomes painfully apparent in macro and close-up photography, when depth of field is often measured in millimeters.

If you're shooting film, there's not much you can do to avoid this, but digital photography has a trick up its sleeve when it comes to expanding the depth of field: focus stacking. As with HDR, focus stacking is a multi-shot technique that relies on you taking multiple images and then combining them using editing software into a single, finished photograph. While HDR uses a sequence of different exposures to create its end result, focus stacking needs you to adjust the focus point between the different frames.

Once you've shot your sequence, your chosen software takes the sharp section of each image and uses that to create the final composite. By having a series of exposures with different focus points, you effectively end up with a photograph with a greater depth of field than a single shot could possibly achieve. How great that depth of field is limited only by the number of shots you take and the effective range of your lens' focus.

Shooting a Stack

1 You don't want the exposure to change between shots, so switch to Manual mode and set your aperture, shutter speed, and ISO. An aperture setting in the region of $f/11$ is a good starting point.

2 Switch to manual focus and focus on the area of your subject closest to the camera that you want to appear in focus. Take your first shot.

3 Adjust the focus so the point of focus is slightly farther away from the camera, and take another shot. The key here is to make a very slight adjustment to the focus, so the depth of field of the successive shots overlaps.

4 Repeat the process, adjusting the focus by a tiny amount and taking a shot. Keep doing this until you have a sequence of shots covering the nearest part of your subject that you want in focus all the way to the most distant part. For this tiny bird skull I needed to shoot 20 frames.

Processing a Stack

5 There are dedicated focus stacking programs available, such as Helicon Focus, or you might be able to do it in your image-editing program. I'm using Photoshop, and the process begins by loading all the images into a single stack. To do this, choose *File >* *Scripts > Load Files into Stack* from the top menu and locate your images.

7 Once your images are aligned, and with all the layers still selected, choose *Edit > Auto-Blend Layers*. Check *Stack Images* and *Seamless Tones and Colours* from the dialogue, press *OK*, and sit back and wait while Photoshop does its thing (note that this can take a while).

6 Photoshop will load each of your images into a layer. Select all the layers by holding the Shift key and clicking on the first and last layer in the Layers palette. Then, choose *Edit > Auto-Align Layers* and select *Auto* from the *Projection Options*. This will make sure your whole sequence is aligned perfectly.

8 Each of your layers will now have its very own layer mask, which reveals the in-focus areas in the individual image and hides the rest, effectively extending your depth of field in the process. You can go in and fine tune each mask if you need to, before flattening the image down.

RIGHT A single exposure taken using a 60mm macro lens (with an extension tube of roughly 25mm) at an aperture setting of ƒ/8, results in a very shallow depth of field, even though the aperture is quite small.

FAR RIGHT Focus stacking takes a lot longer to shoot and process, but it enables you to radically increase the zone of sharpness.

MACRO
Andy Small

Andy Small has always been passionate about nature, but he became fascinated with close-up work when he spent a year in Australia in 1991 and began to photograph bark and flora. When he got back to the UK he bought his first macro lens – a Pentax 100mm – which coincided with him moving into a house with a large garden, along with his wife who is an avid gardener. However, it wasn't until 2003 – after 18 years as an art teacher – that Andy decided to leave the classroom and become a full-time artist, specialising in botanical subjects. He now regularly exhibits his work, and sells direct to the public at events such as the Royal Horticultural Society's flower shows at Chelsea and Hampton Court Palace.

Initially shooting on film, using high-end Contax cameras, Andy switched to Nikon in 2008, when he bought his first digital camera, the D300. Today he uses a D800E, which – thanks to its full frame, 36-megapixel sensor – is perfect for capturing the stunning detail in his subjects. Of course, to get the best from any camera sensor, you need to use a top quality lens, and Andy was keen to continue using Zeiss lenses, which he had used with his Contax film cameras.

MACRO ESSENTIALS

What I have found indispensable is a tabletop studio setup that I have designed for holding my subject matter, reflectors, and various backgrounds, while enabling me to use natural window light to backlight my subjects. Beyond that, all of my images have been produced using the best macro lens and the best tripod I could justify at the time.

'The Zeiss 100mm ƒ/2 Makro-Planar T* is the lens that I currently use most of the time. I've had a couple of Zeiss macro lenses and the quality is second to none. Although this is a 1:2 lens, with the D800E's 36mp sensor, it produces images that can be greatly enlarged, and ƒ/2 is great for selective focusing. In general, I find that the longer focal lengths work best, and I prefer 100mm for plant portraits. It means you can be a good distance from the subject, but still have plenty of options when it comes to diffusing and blurring detail in background'.

▼ This image was taken from above using a tripod and natural window light. Originally, it was a colour transparency, but I scanned it and converted it to black and white in Lightroom.

CONTAX RTS III WITH ZEISS 100MM MACRO LENS, FUJI VELVIA TRANSPARENCY FILM (ISO 50)

Although a lens will typically have a 'sweet spot' in its aperture range, where the image quality is at its highest, this is all relative when you're using what is arguably one of the finest lenses available, on one of the finest cameras. 'I don't use a particular aperture just because it is the optimum for image quality; it's the picture effect that's the most important thing. In the studio, depth of field is my main concern, so if I want to maximise the depth of field I'll use $f/22$; if I want to use selective focusing I will open the lens to $f/2$. Usually, this will be set in Aperture Priority mode, because I'll be using a tripod, and shutter speed isn't a concern, although Shutter Priority can be useful if I'm outside in windy weather or want to make sure I freeze or blur a moving subject.

'Because I mainly shoot in the studio, I can control the lighting and rely on in-camera metering. I'll use centre-weighted metering for my plant portraits, to make sure that the background doesn't affect the exposure too much, and bracket my exposures over and under the camera setting. I tend to favor slight underexposure so I don't lose highlight detail, so I'll shoot up to five exposures, 1 to 2 stops over and under, to make sure I get the perfect shot'.

Ultimately, a high-quality camera and lens, combined with careful technique is all that Andy needs. 'I've used a variety of accessories at various stages, but don't use any at present apart from my macro lens – I don't like to get too hampered by equipment. Flower arranging holders (ikebana dishes) for keeping flowers upright and alive are great, and accessories that help hold subjects in place are useful too, but the ones I use tend to be homemade out of bits of wire. I prefer to keep things simple and a superb quality macro lens is all I've required over the years'.

You can see more of Andy's stunning fine-art flower photography, and order prints, at www.andysmall.co.uk.

ANDY'S TOP TIPS

- Invest in a quality macro lens: a focal length of 100–105mm is a good choice.
- Keep camera movement to a minimum. Use a sturdy tripod with mirror lock-up and a remote release or self-timer.
- Learn what lighting best suits your subject: backlighting is ideal for flowers, with reflectors to lighten dark areas.
- Learn about composition and experiment: this can turn the ordinary into the spectacular.
- Treat your subject and background equally: positive and negative shapes make up the whole picture.

▶ This image was backlit using window light, reflectors, and black background.

CONTAX RTS III WITH ZEISS 100MM MACRO LENS, FUJI VELVIA TRANSPARENCY FILM (ISO 50)

▶ My default setup for practically all of my studio images is to backlight the subject using window light, with reflectors to bounce light back onto it. The background is then chosen depending on the subject and the effect I am after.

NIKON D800E WITH ZEISS 100MM ƒ/2 MAKRO-PLANAR T* LENS. 1/3 SECOND @ ƒ/22, ISO 100

PART 4

Composition

So far we've concentrated on the science of photography; on how exposure, light, and lenses help to give us a technically correct view of the scene in front of us. However, this is not enough to create a great photograph: a stunning image also needs to be well composed. A lot of photographers turn off when they hear that word – composition – but all it really means is how the various elements in the frame come together. Or, to put it another way, how you make the scene or subject you are photographing beautiful.

What Is Composition?

According to my computer's dictionary, composition is 'the action of putting things together; formation or construction' and 'the artistic arrangement of the parts of a picture'.

These are pretty sound definitions (thanks Apple!), but if you like to keep things real simple then my take on it is this: Composition is what appears in the frame and where. Yet, while this describes what composition is, it doesn't help us identify the what and the where, or give us any indication of how we should be approaching them.

This is where pages and pages of compositional rules can come into play, which say where various picture elements could (or should, according to some people) go in the frame, how we could arrange them in relation to one another, and how our choices can affect the viewer's understanding and appreciation of our images. It's where we get into the right and wrong of what goes where, and talk turns to the structure of a photograph rather than if we like it or not. It's where a lot of people's eyes glaze over.

So... fully aware there's a risk of causing glazed eyes, I'll be running through a selection of the rules of composition in this chapter. However, there is one very important thing to appreciate: Although these rules may be printed on the page, that doesn't make this a rulebook. Instead, the concepts covered on the following pages should only be seen as guidelines.

While these guidelines can help you to bring a formal structure to a photograph, and create order from the chaotic world in front of the lens, it's important that you don't lose sight of the fact that you have absolute freedom to let that chaos run riot across your sensor or film. It may be that people don't understand your work, but that doesn't make it wrong. Who knows, that jumbled mess you create with your camera today, could be as valid to photography in years to come as Picasso's cubist paintings are to the history of art

RIGHT At a most basic level, composition is about what appears in the frame, and where. This shot may look simple, but a whole host of decisions had to be made, such as how many pebbles to include, how close to get, what angle and height to shoot from, and so on.

ABOVE When you have one focus point (easy to choose when it's a portrait), you need to think carefully about where you position it in the shot. Classic compositional rules might help here; equally, they might not.

RIGHT How various elements in the frame are balanced is a key part of composition. In this instance, I offset the detailed dome of St Paul's cathedral in London with the side of a passing van.

Composition Basics

Composition starts with a couple of fundamental decisions: which way round you hold your camera, and the shape of its sensor.

GRIP FOR PORTRAITS

A lot of interchangeable–lens cameras (especially DSLRs and DSLR-styled mirrorless models) let you add a supplementary battery grip. As well as giving you additional power, these may also feature a second shutter-release button and control wheels/buttons that make using the camera for portrait-format images as natural as it is for landscape-format shots.

Orientation

Unless you're using a square-shooting medium format camera like a gorgeous Hasselblad 500 or classic Rolleiflex TLR, the photographs you take are going to be rectangular. As discussed on the following pages, there are numerous rectangular formats in use, but what they all have in common is that they present you with a choice: the choice to shoot with the longest sides of the frame at the top and bottom (often referred to as a horizontal, or landscape, orientation), or with the longest sides of the frame at the right and left (upright, or portrait, format).

Your first compositional decision is quite simply to recognise that you have a choice. It might sound obvious, but it's quite easy to find yourself shooting everything landscape, because that's the natural orientation of most cameras. Shooting a portrait-format shot means turning the camera 90 degrees, which makes it ever-so-slightly less ergonomic, and that means it's ever-so-slightly less instinctive.

Having recognised you've got a choice, the next step is to decide which orientation is best suited to your subject. Now, it's easy to assume that landscape orientation is best for landscapes, scenic shots, and anything else outdoorsy, while portrait orientation is better when people are the main subject – the clue is in their names, right?

Well, a lot of the time that's true, but don't fall into the lazy trap of thinking it's always true. There's no reason why landscapes can't be shot in portrait orientation and look just as striking (if not more so), and nothing is stopping you from shooting portraits in landscape format. It's all about which option works best for your subject.

Most of the time, it will be fairly obvious which orientation is most appropriate. The majority of scenes and subjects will have one edge, side, or other element (which can be physical or implied) that's longer than the other, and the tendency would be to run this parallel to the longest edge of the frame. So if you were faced with some towering trees, for example, you'd most likely choose to shoot in a portrait orientation, so the long edge of the frame echoes the direction of the trunks.

ABOVE Some subjects cry out for a specific orientation: Sweeping views, for example, almost demand to be shot in landscape orientation. Using a panoramic format can also focus attention on the subject by removing large areas of otherwise empty foreground and sky.

However, if you were photographing a large group of people, the group as a whole would likely be wider than it is tall, so the general shape of your subject (the group, not the individuals) would be horizontal; shooting landscape would make more sense.

At other times, it might be less obvious which orientation will work best, if your subject is fairly square or circular, for example. The simple solution? Shoot both and decide later!

RIGHT These two images were taken from the same spot, using the exact same camera settings and focal length. The only difference between them is the orientation of the camera, which has a profound affect on the composition. The vertical image follows the curve of the arch, pulling attention to its shape; the horizontal shot communicates space and accents just how huge the interior is.

CROPPING CAUTION

All digital sensors are a fixed size, so they have an intrinsic or native aspect ratio. When you set an alternative aspect ratio, the camera simply discards part of the image that the sensor records; while this effectively changes the aspect ratio, it also means the resolution of the image is reduced.

Aspect Ratio

As well as the orientation of your camera, the aspect ratio of your images also plays an important part in how you see – and present – the world around you. The aspect ratio is the ratio of the shortest edge of the frame to the longest, which is determined by your camera's sensor or film format.

In photography's history, there have been countless aspect ratios employed, ranging from the 1:1 (square) format to the 3:2 ratio of 35mm film, and panoramic ratios of 2:1, 3:1, and even more elongated shapes. Contemporary consumer cameras employ either a 3:2 or a 4:3 ratio sensor; the rectangular 3:2 ratio encompasses full-frame and APS-C sized sensors, while Micro Four Thirds sensors conform to the slightly squarer 4:3 ratio (although, surprisingly, the aspect ratio has nothing to do with the Micro Four Thirds name).

Now, there's not much you can do about the (physical) aspect ratio of your camera's sensor or film format, but it's worth appreciating that you are rarely (if ever) limited to that specific shape. Not only do a lot of digital cameras offer multiple aspect ratios that you can switch between before you shoot, but in-camera processing will often allow you to resize and reshape images on the memory card after they've been saved. And, of course, once your photographs are on your computer, you can crop them freely in your image-editing software.

This is great, because a lot of times you will find that you want or need to alter the aspect ratio of your shots. It might be that you want to tighten up the composition or tweak it somehow; crop the shot to lose something from the edges or corners of the frame that you didn't notice when you made the exposure; or simply that you want to get the shot you saw to start with (I quite often find myself cropping to square or elongated panoramic formats because that's what I had in mind when I took the shot).

However, while it's massively helpful to have this flexibility, you need to be aware that as soon as you change the aspect ratio or crop into an image, you start to reduce the resolution of the photograph, because you're to throwing away pixels. If you're using a camera with plenty of pixels or you're only going to use the resulting photograph at a small size, this might not be too much of a problem, but it's worth bearing in mind if you're planning an extreme crop and want a sizable print at the end of it. In this situation you might find that you're better off creating a multi-shot image to realise your perfect aspect ratio at a healthy resolution.

1 : 1

4 : 3

5 : 4

3 : 2

16 : 9

THIS PAGE Although the sensor or film in your camera is a fixed size, there's nothing stopping you from changing the aspect ratio of your photographs, either by cropping in-camera (if you have that option), or after the shot's been taken, using image-editing software or on an enlarger's baseboard. This shot has been cropped to five popular formats, ranging from square (1:1) to panoramic (16:9). No one image is wrong (or right), they are all just different.

Viewpoint

In general, you'll find that most photographs are shot from a very similar viewpoint, which is approximately 1.5–1.8m above the ground. Why? Because that's our typical eye level.

This isn't surprising, because a lot of the time we're photographing things that we see around us that have caught our attention. In this sense, the camera becomes an extension of our eyes and brain, so we naturally raise it to our eye to record and preserve the things we're looking at from the exact same viewpoint we're experiencing them.

Now, there's absolutely nothing wrong with wanting to record the world around you as you see it, and a whole heap of great shots have been taken this way. Shooting from eye-level is particularly effective for news, documentary, and sports photographers, as it gives the impression that we're witnessing an event for ourselves. What the camera sees from 1.5–1.8m off the ground is going to be pretty much the same thing you'd see if you were stood in the same spot. In this way, an eye-level viewpoint is as close as we can get to actually feeling as though we're there.

Images shot from eye-level are not without their drawbacks, though. The main problem is familiarity. Precisely because a photograph taken at eye-level is so natural and familiar to us, we

tend to accept it more readily. It doesn't necessarily challenge us or make us stop and look for longer, unless the subject is particularly compelling or unusual. However, drop your camera down, or raise it up and you'll be offering a different view of the world; a viewpoint that is less familiar. This in itself can be enough to hold the viewer's attention, even if your subject has been photographed thousands of times before.

The great news is that lowering your viewpoint is simple: You just need to crouch, kneel, or even lie on the ground to look up at the world. Elevated viewpoints are slightly harder to achieve, but look out for walls, benches, or anything else that you can stand on. Even holding your camera above your head to give you a foot or two of extra height is enough to give your shots a fresh perspective. Alternatively, see if there are any buildings that you can (legally) enter and photograph from, or for a real bird's-eye view, why not try out a drone? However you do it, exploring higher and lower positions should always be on your mind when you shoot.

RIGHT As well as determining what appears in shot, your viewpoint can also add a narrative to your images, especially when it comes to shooting portraits. Photograph your subject from below their eye-line and your subject will stand over you, suggesting dominance and power as they look down on the viewer. However, shoot from above, looking down on them, and the roles are reversed – they will appear to be meek or sweet. Shooting from your subject's eye-level (regardless of their/your respective heights) evens the relationship out, producing the most neutral relationship.

Drone photography lets enthusiast photographers get a bird's-eye view of the world without the need for a similarly elevated budget. Just be aware of the rules and regulations before take-off!

Climb a few flights of stairs, and you'll find yourself seeing things that just aren't visible from the ground.

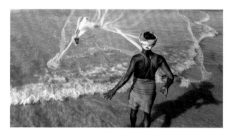

Getting yourself a metre or so off the ground will turn you into a giant, looking down on your subject from on high. This can make a huge difference to your photographs, so look for walls, benches, or anything else you can stand on to raise yourself off the ground,

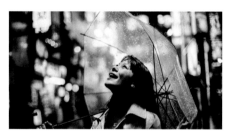

Eye-level shots will certainly work when you want to deliver a natural and unchallenging viewpoint. However, the eye-level viewpoint is also the staple of the casual snapshot, so images can potentially be overlooked quite easily.

Shoot from a height of one metre and you've started shooting in Toddlervision. Things starts to look taller than we (adults and older children) usually experience them, creating a sense of disquiet and unease.

Lie on the ground and you'll get a worm's-eye view of the world. It's a viewpoint that's so far removed from our everyday life, it's virtually guaranteed to make people take a second look.

Classic Rules

There are countless compositional rules in art, most of which have their roots in painting. Some of these translate well into photography, providing you with a few go-to options for framing your shots.

Rule of Thirds

The rule of thirds dates back to the 18th century, and is by far the simplest compositional rule to understand and apply. It simply involves imagining that the frame is split into thirds, vertically and horizontally, so you end up with two vertical and two horizontal lines (as illustrated below). Some cameras allow you to project a thirds grid through the viewfinder or on the rear screen before you shoot. Key elements in your picture are then aligned with these imaginary lines, resulting in a more exciting composition.

The classic example is the horizon in a landscape. Placing it on one of the horizontal thirds lines will allow you to emphasise the sky or the ground (depending on whether you choose the upper or lower thirds line) and this often creates a stronger and more interesting result than having the horizon run across the centre of the frame.

The rule doesn't just apply to linear subject elements, though. The points at which the horizontal and vertical thirds lines intersect are great for positioning the focal point of an image – a small building in a landscape,

a rock in a seascape, or one of your subject's eyes in a portrait, for example.

Whether you use the lines or the intersections, the basic premise is the same: key elements of your image are moved away from the centre of the frame, which is pretty much guaranteed to make your photographs look thoughtful and composed (rather than amateurish snapshots).

However, because it's so straightforward (and so effective), it's also the most commonly used compositional tactic. Some people will use it for every photograph they take. There's absolutely nothing wrong with this (they're your photographs, so you can choose how you take them), but you should be aware that your images can start to look a bit samey if you always shoot using the rule of thirds.

LEFT Applying the rule of thirds means imagining that the frame is divided into three equal parts, horizontally and vertically. These imaginary lines and their four intersections are then used to align and position key parts of the scene.

BELOW/RIGHT This simple shot was taken with a lo-fi toy camera, using the rule of thirds to position the hydrant away from the centre of the frame (right).

BELOW/RIGHT Using the rule of thirds with a landscape image is a great way of emphasising either the sky or the foreground, depending on which element is most interesting.

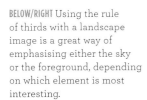

Golden Ratio

The golden ratio predates photography by a good 2000+ years, and despite having been used widely in art, it has its roots in mathematics. The first description of it appeared in Euclid's *Elements*. The Greek mathematician explains that, 'A straight line is said to have been cut in extreme and mean ratio [what we now call the golden ratio] when, as the whole line is to the greater segment, so is the greater to the lesser.' I know that's not easy to follow, so I've illustrated it below, but the upshot is the ratio has a numerical value, which is 1:1.618.

This ratio has been used by a whole heap of artists, architects, and designers, as it is claimed to create a natural harmony (in fact, it is believed that the number is often found within patterns in nature). It has also been employed by photographers as a means for dividing the frame with more imaginary lines. This time, though, there are multiple applications of the ratio, which deliver three different sets of 'guidelines' to help you frame your shots, as shown opposite.

RIGHT The golden ratio makes a lot more sense when it's shown visually. Essentially, a line satisfies the golden ratio if it can be divided into two parts (A and B), where the ratio of A to B is the same as the ratio of the whole line (A + B) to A. The math behind this looks something like this (right) and gives us the value 1.618, which is also referred to by the Greek letter 'phi' (ϕ):

$$\frac{A + B}{A} = \frac{a}{B} \equiv \phi$$

RIGHT This vintage-styled shot uses the grid formed by the golden ratio to align the main chimney and the roof of the building at the right, while the pair of waterside cranes sit on the lower intersections of the grid.

GOLDEN RATIO, THREE WAYS

The first application of the golden ratio uses it to create a grid that is not too dissimilar to the rule of thirds, although the lines and their intersections are closer to the centre of the frame. As with the rule of thirds, the lines can be used as a guide to placing horizontal and vertical elements in the scene, while the intersections are a great place for key focal points.

The second application uses the golden ratio to divide the frame into a 'golden rectangle' (A). The smaller rectangle is then divided again, and again, and again, to produce ever-decreasing golden rectangles (B). As before, these boxes can be used to position the various bits of the scene you are photographing.

A variation of the golden rectangle sees a curved line linking each of the boxes to create a 'golden spiral'. Composing a shot with this spiral as a guide is said to create a natural 'flow' to an image, although it's hard to visualise when you're shooting.

Because it's a mathematical model, the golden ratio can really do your head in. Although the golden rectangle and golden spiral have underpinned countless classic paintings, it's hard to apply them to a photographic subject that cannot be moved or manipulated, and equally challenging to visualise them through the viewfinder when you shoot.

The good news for photographers is that the rule of thirds is based on a fundamentally similar principle to a golden ratio grid, and delivers similar results. It far easier to imagine the frame split into thirds, rather a ratio of 1:1.618!

RIGHT This silhouetted communications tower was placed using the golden rectangle as a guide. This positioning technique is also known as 'rebatment of the rectangle' or, simply, 'rebatment'.

Golden Triangle

The golden triangle is not necessarily a rule you will call on that often, but it's still worth tucking it away at the back of your mind, just in case. Like the rule of thirds and the golden ratio, the start point is the imaginary division of the frame. This time, the division is initially created by a line running from one corner of the frame to its diagonal opposite. A second diagonal line then extends from the initial line at a 90-degree angle into one of the remaining corners. It's perhaps easier to explain this visually, so take a look below.

Because the golden triangle is based on diagonal lines, its main strength is in helping you place diagonal elements within the frame (as opposed to the rule of thirds, which is better suited to horizontal and vertical elements). As with the other rules, key parts of the scene are aligned with the imaginary guidelines, and specific focal points are ideally positioned where the lines intersect.

BELOW The primary diagonal line in the golden triangle can run in either direction across the frame, with one or two secondary lines extending from it.

RIGHT If you apply the golden triangle to this shot, you can see that the rock in the foreground and the distant building sit not only on the primary diagonal crossing the frame, but also on the intersections of the secondary lines.

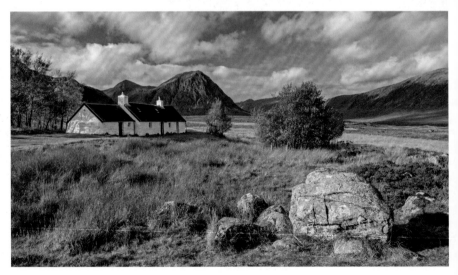

Rule of Odds

The rule of odds is really simple to understand: Odd numbers of items work better in a photograph than even numbers of the same things. So, if you are photographing more than one of something, three or five of those somethings will be more interesting than two or four.

Why is this? Well, it's mainly because the human brain naturally likes to organise the things that we see around us. When there's an even number of items, it's simple to pair them off, which quickly and easily allows the brain to create balance and harmony before it moves on to other things.

However, with a photograph, we don't want the viewer's attention to wander so quickly. Instead, we want them to pause and look at our pictures for longer, which is where the rule of odds comes in. If you hit the viewer with an odd number of items, their brain can't tidy them as quickly – no matter what it does, one of the items will always be the odd one out. This process not only takes a little longer, which means more attention is paid to the photograph, but it also creates a subliminal excitement that the brain finds intrinsically more interesting.

ABOVE Cover up Mr. Lonely at the left of centre, and your eye will go straight to the shameless birds at the right. However, leave him uncovered and the eye flits between the couple and the singleton, creating more visual tension and holding attention for longer. (Note also how the rule of thirds has been used – the birds at the far left and right are on the intersection points of the lower thirds line.)

Central Subjects

Some of the classic rules of composition have been around far longer than photography, so there's no disputing that they work, but that doesn't mean you can't ignore them from time to time.

The rule of thirds and the golden ratio, spiral, or triangle all suggest that the subject should not be central in the frame. It's no coincidence that if you look at the work of a lot of professional, semi-professional, or even slightly experienced photographers, you'll see that the majority of their photographs will have the main subject positioned away from the middle of the picture. In some cases, this will likely be an unconscious decision, but in many more instances, it is because the photographer has intentionally followed one (or more) of the rules.

As if to confirm this, people who have absolutely no need or desire to take their photography beyond snapshots (which is, by far, the majority of camera users), and a lot of photographers who are just starting out, will have a tendency to place their subject bang in the middle of the picture. This actually makes perfect sense, because when you place something in the middle of the frame it's the obvious way of saying 'this is the most important part of this picture'. It's no coincidence that a lot of your camera's exposure and focusing options are biased toward the centre of the frame as well.

Consequently, central subjects are often seen as the work of less skilled photographers, and a lot of aspiring photographers will try and avoid the centre of the frame like the plague. They will position their subjects at the very top of the frame, the bottom, the sides, or even the corners – anywhere, just so long as it isn't in that amateur spot at the centre of the picture.

However, there is absolutely no reason why you can't have a central subject. In fact, in some cases, moving the subject away from the centre can weaken a shot. Sure, it may demonstrate that you understand a few compositional rules (or, at the very least know the rule of thirds), but that doesn't automatically make your shots better – sometimes it can even look contrived.

RIGHT For this minimal location shot, positioning the rock in the centre of the frame suited the square format of the camera I was using. However, I spent a while experimenting with the shooting distance until the rock appeared at what I felt was the right size for the frame.

FAR RIGHT Here, the horizon is running straight across the centre of the frame, with the camera positioned low to fill up the foreground with the reflective pond.

When it came to framing
this shot of a London church
dwarfed by modern city
buildings, I knew I wanted
the church in the middle
of the frame – anywhere
else, and the surrounding
buildings would have gained
too much importance.

Lines

Lines permeate almost all photographs, and how you use them within the frame can play a large part in how your viewer navigates the picture.

Physical & Implied Lines

Lines come in two forms: physical and implied. Physical lines are pretty self-explanatory. Curved or straight, these are the road markings, walls, the horizon, a meandering river bank, or pretty much anything else that provides us with a clearly defined and easily identified edge. Physical lines can also be created when multiple (and often similar) elements are linked together visually, as in a line of people or a line of trees.

Implied lines are more subtle. This type of line is essentially imagined by the eyes and brain, rather than being something we could go and put a hand on. When we look at the world around us we subconsciously link things together. At a fundamental level, our eyes scan a scene, jumping from one element to another in a linear fashion, and we love to connect things that are related. For example, if

we were on the beach and there were two beach balls in front of us, we would naturally connect them with an implied line.

Implied lines can also be created by even less obvious sources. Something as simple as the direction of someone else's gaze is enough to make us turn our head to see what they might be looking at, especially when there's space in front of them that allows us to follow their gaze.

RIGHT Lines are all around us, especially in man-made environments, and heading to an urban area with your camera is a great way of exploring and playing with these fundamental elements. This shot is all about the lines created by walls, walkways, and their respective shadows.

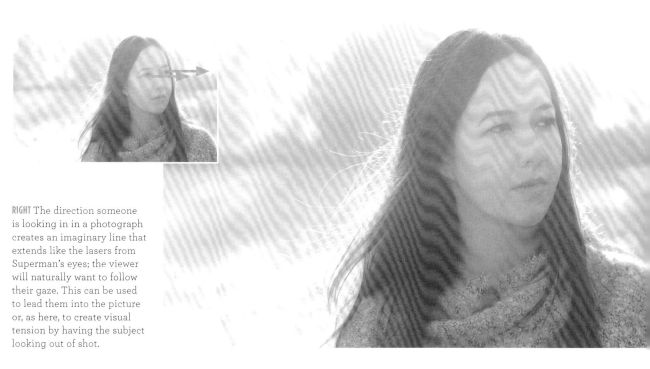

RIGHT The direction someone is looking in in a photograph creates an imaginary line that extends like the lasers from Superman's eyes; the viewer will naturally want to follow their gaze. This can be used to lead them into the picture or, as here, to create visual tension by having the subject looking out of shot.

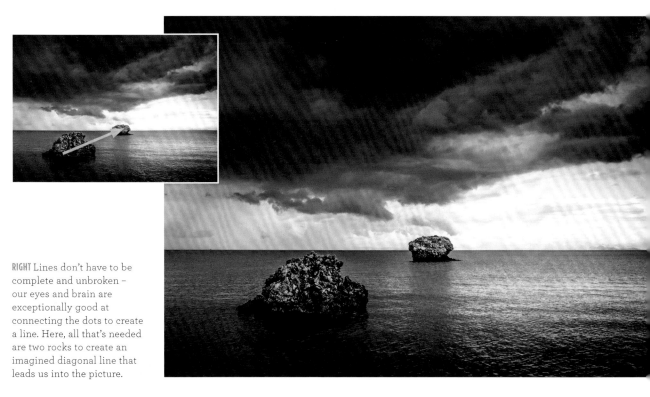

RIGHT Lines don't have to be complete and unbroken – our eyes and brain are exceptionally good at connecting the dots to create a line. Here, all that's needed are two rocks to create an imagined diagonal line that leads us into the picture.

ABOVE/RIGHT Two different subjects, with one common approach: using a wide angle lens and converging lines to direct the viewer's attention. However, while this is an effective way of directing attention, it doesn't encourage the viewer to explore the rest of the frame. Note that lines don't necessarily need to be obvious – in the shot at right, the two hanging lights form an imagined diagonal line that draws us into the shot.

Leading Lines

Regardless of whether your lines are physical or implied, they have one thing in common: the power to guide the viewer around an image, leading them through a picture on what is often described as a visual journey. Leading lines are the lines in a picture that subliminally tell the viewer's eyes to go here. Perhaps the most obvious example is straight, parallel lines that appear to converge as they get further away from us; railway lines and roads extending into the distance, or buildings with walls that appear to get closer to each other as they rise up into the sky. The convergence creates an almost literal arrow-point that demands the viewer looks toward the vanishing point. This is a great way of leading your viewer to your subject in double-quick time (especially when you use a wide-angle focal length to exaggerate the effect).

While converging lines are high-energy and (literally) to the point, sometimes you will want to take your viewer on a longer and slower journey through a picture, giving them time to take in various elements en route. Curved lines are great for this; rather than taking a direct route from A to B, they can arc through the frame, meander back and forth, or even take us on a circuitous journey around the frame when the curves are more circular.

ABOVE/RIGHT The strong curves in this image take the eye down and around in a spiral, off into the distance.

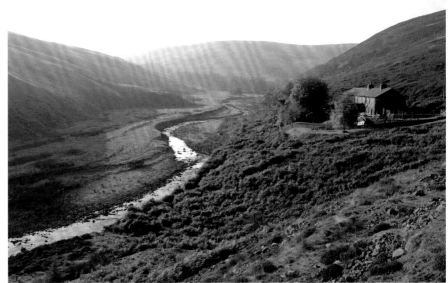

ABOVE/RIGHT The strong curves in this image take the eye down and around in a spiral, all the way up to the top.

BELOW The direction in which a curve bends can change the pace of a picture. In western cultures, a curve that appears to bend upward from left to right (the direction we read in) will create a slower picture than one that arcs downward. Why? Because the former suggests a slower, uphill journey, while the latter is indicative of, faster downhill travel, as demonstrated by flipping this image to reverse the direction of the curve.

Line Direction

As well as leading the eye, lines also have a part to play in the energy of an image, depending on whether the line is horizontal, vertical, or diagonal. Horizontal lines are the most restful of the three, and this is arguably because we have a natural affinity with this type of line. From birth, the king of horizontal lines – the horizon – is ever-present in our lives; even when we can't see it, the idea of it is always there. Horizontal lines in an image are natural reminders of this, and so bring us familiarity and a sense of the image being grounded. This is especially true when there's a single strong line in an image; regardless of what that line is, we will subconsciously associate it with a horizon.

Horizontal lines in an image can also act as barriers. Like walls and fences (both quite common in our everyday lives), unbroken horizontal lines in an image prevent us – or at least dissuade us – from crossing them visually. Instead, they encourage us to follow the line toward the sides of the frame, rather than allowing our eye to drift up or down through a picture. However, this isn't necessarily a negative – an unbroken horizon (or horizontal line) can enhance the sense of space in a horizontal format shot, which is great when you're shooting a sweeping view.

While horizontal lines are restful, vertical lines have more energy. These are the lines that we associate with trees, plants, columns, tall buildings, and any other objects that rise from the ground in defiance of gravity. Consequently, vertical lines are strong and lively, and add a sense of height to an image; this is enhanced when you shoot with the camera in an upright (portrait) format orientation.

The final type of line – diagonals – is the most dynamic of all. Part of the reason for this is because diagonal lines don't run parallel to the frame edges, so they're always going to tilt in one direction. Therefore, a diagonal line has a natural imbalance, which creates a sense of movement and tension in an image: when you're dealing with diagonals, you're dealing with lines that are traveling uphill or downhill, creating strong leading lines, and potentially forming a converging pair.

However, because of the movement they can create in an image, diagonals need to be used carefully. Unless a strong diagonal line is leading to a focal point of some sort, or a continuous diagonal is broken by something in the image, it's easy for the viewer's eye to be whisked along the line and continue out of the frame.

RIGHT Just as a horizontal wall acts as a physical barrier in the real world, it will act as a visual barrier in a photograph. In this instance the wall has the same basic effect. It blocks our journey into the picture, reinforcing the idea of a fortification or defence.

FAR RIGHT Vertical lines are strong and solid and have greater energy than horizontals. This can be enhanced by shooting in an upright format; cropping this shot to a panoramic shape made the verticals even stronger.

THE POWER OF LINES

This series of simple illustrations shows how a single line in a rectangle (indicative of a photograph) can have a different feel to it, depending on its direction and the shape of the frame. A vertical line in an upright frame appears more energetic than a horizontal line in a horizontal frame, but diagonals are more dynamic still, especially if the line appears to be racing downhill.

RIGHT Remember how the direction of a curve changes the pace of a picture? Well, the same rule applies to diagonal lines. Here, the eye moves faster when it's going downhill than it does traveling uphill. As a result, the far-right image appears more restful.

RIGHT The diagonal lines in the background of this shot inject a 'dynamic' energy. If the lines were parallel to the frame edges, the photograph would feel more settled.

Line Direction,
continued

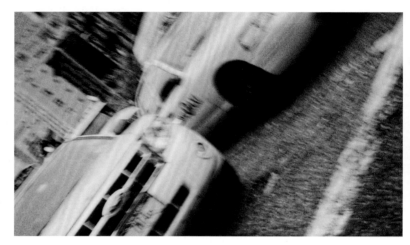

RIGHT The dynamic diagonals in this shot were created by holding the camera at my side and shooting from the hip as I crossed the road. Coupled with the blur introduced by a slow shutter speed, the shot gains a frenetic energy, yet the taxi cabs were moving at the same speed as those in the shot below.

LEFT There's no shortage of diagonals in Rotterdam's famous cube houses. But shooting them head-on failed to communicate the disorienting feeling of the architecture. Shooting up at an awkward angle captured the precariousness of the buildings.

RIGHT I exaggerated the diagonals in this shot by shooting from close to the Empire State Building, looking up. This created strong converging lines, which were emphasised by tilting the camera slightly.

MASTERCLASS

ARCHITECTURE
Janie Airey

Although she has been a professional photographer for 18 years, London-based Janie Airey didn't begin to specialise in architecture until 2012 when she was commissioned by the ODA (Olympic Delivery Authority) to capture some of the breathtaking venues designed for the London 2012 Olympic Games. Her images received a lot of publicity, which naturally led to more architectural commissions – both national and international – from a variety of architectural practices, design agencies, and corporate clients.

Although her work encompasses a broad range of architectural styles, Janie is particularly drawn to modern architecture 'because of the clean lines, good light, bold and sometimes pioneering design, ambitious form, and sustainability (hopefully). The style I enjoy shooting most is creating very two-dimensional, almost graphic images. I try and keep things simple, with lots of space in the image to reflect the build – this naturally tends to suit modern architecture more. I also try and tell the story of the building and show its "fabric", so I love capturing textures and slices, as well as the wider, more commercial shots that illustrate the building as a whole'.

At the moment, Janie uses a trio of Canon EOS 5D Mark II bodies, each fitted with a different zoom lens. 'Prime lenses are often preferred by architecture photographers, as are tilt-shift lenses, but it's purely a personal choice. I don't use tilt-shift lenses because I find them too restrictive – they tend to make you tripod-bound and limit spontaneity.

'I like to move around a lot, and won't use a tripod unless it's absolutely essential. I shoot quite quickly and like to explore the space completely. Sometimes I'll lie down or get up high, shoot into the light or down a wall, and zoom lenses work better for this. I also don't crop my images in post-production, so a zoom lens lets me capture the frame exactly as I want it in-camera. I love the Canon 80–200 $f/2.8$ lens and the Canon 24-70mm $f/2.8$ – and very occasionally I'll use a 16–35mm – but I don't think it's a good idea to restrict yourself by getting obsessed with focal lengths.'

Nor does Janie follow a prescribed set of self-imposed 'rules' when it comes to her exposures: 'I always have the cameras set on Manual and shoot Raw files, because I like to control what the camera is doing and get the best results. But not everything has to be shot at $f/22$ so it's all in focus. That can actually lead to an busy image, where your eye doesn't know what to look at first. I'll sometimes shoot at $f/2.8$, especially when doing details that show the fabric of the building. A shallow depth of field can make for some lovely effects in detail images'.

ARCHITECTURE ESSENTIALS

Some people would say a tripod is a key accessory for architecture photography, and a lot of the time that's true. However, it doesn't apply to Janie's style of photography. 'My most useful accessory is probably a really comfy camera backpack and something to lie on, as I invariably end up lying on a floor somewhere to get a nice shot. A polarising filter is sometimes handy for modern glassy architecture'.

▶ Run Run Shaw Creative Media Centre, Hong Kong
ARCHITECT: DANIEL LIBESKIND

28MM, 1/400 SECOND @ ƒ/2.8, ISO 125

◀ Pallant House Art Gallery, Chichester, UK (modern extension to existing old build)
ARCHITECT: LONG & KENTISH

70MM, 1/2500 SECOND @ ƒ/4.5, ISO 100

▲ Aquatics arena at London's Olympic Park, UK
ARCHITECT: ZAHA HADID

24MM, 1/250 SECOND @ ƒ/3.5, ISO 100

▲ Aquatics arena at London's Olympic Park, UK
ARCHITECT: ZAHA HADID

24MM, 1/80 SECOND @ ƒ/2.8, ISO 800

Like most professionals, Janie has developed a somewhat innate ability to set her exposures based on experience. 'Having originally trained and worked with light meters and colour temperature meters, I've learnt to gauge the amount of light in a room or outside and make an educated guess when it comes to setting the correct exposure. If you know how to read a histogram, it's useful to check this, especially if you don't have the ability to shoot or process a Raw file. If there's a key shot, I may occasionally shoot with the camera tethered to the laptop so I can get an instant visual with full data, but mostly I judge my exposures off the screen and then if anything needs tweaking, I adjust it in Capture One Pro'.

However, for Janie, post-processing is not just about fine-tuning images: 'Processing is crucial. The "recipe" you use to process your Raw file makes all the difference to your images. It might be pulling down highlights, adding contrast, tweaking the colour balance, taking out certain hues, or whatever else, but it's where you give the image your preferred look or style. Personally, I don't crop. I always try and get the desired shot, full-frame, in-camera – but the processing is crucial'.

Of course, all the processing and camera skills in the world won't help if you don't know where to begin, so Janie suggests you should, 'Find a building or space that inspires you or that you simply love looking at, and then set to work "explaining it" visually. Imagine it's for an editorial in a magazine and you have to show various elements. If it's your first project, don't pick something too tricky. Avoid anywhere that's really dark or has mixed lighting so that technically you can keep it simple. This will make it easier for you to work out why a shot is successful or not. It could be a house, a church, a sporting arena, a gallery – just pick a building with an interesting shape, that has good light and isn't too busy, and move around it. The key thing is to look! Look up, look down, look inside, look outside, look everywhere, and look from everywhere!'

You can see more of Janie's outstanding architecture photographs on her website, www.aireyspaces.com.

JANIE'S TOP TIPS

- Move around to vary your angle, and don't just shoot from eye level.
- Know your camera. Everyone has 'happy accident' shots that turn out great, but if you want to recreate that winning photograph, you need to learn what caused it and why it worked.
- You don't need to have lots of expensive equipment; developing a 'good eye', understanding light, and using your camera in the best way is more important. If you do want to start investing in kit, spend the money on a lens – quality is all in the glass.
- If you can, shoot Raw, and use a good program to process your images.
- Keep it simple.

▲ Jockey Club Innovation Tower, Hong Kong
ARCHITECT: ZAHA HADID

24MM, 1/125 SECOND @ ƒ/3.2, ISO 1000

Other Considerations

It's entirely up to you whether you apply any of the predetermined formal rules to your photographs or not, and there are plenty of other compositional devices that you can pick and choose from as well.

Balance

The various objects and elements in a picture carry what is known as a visual weight, which can be based on the object's size, shape, colour, and amount of detail. To create harmony in an image, these various elements need to be balanced; if not, a photograph can become top-heavy, bottom-heavy, or feel as though it is somehow off-kilter. Perhaps the simplest way of explaining this is as the visual equivalent of a seesaw (or weighing scales), as illustrated opposite.

The most obvious way of creating visual balance is with a symmetrical subject at the centre of the frame, so the left and right sides (or top and bottom) of the frame mirror one another. However, while this may create instant harmony, symmetrical images are very easy for the viewer to

read. In a visual sense they don't offer any challenges, so the risk is that they won't hold the viewer's attention for long.

More interesting results come when you have an asymmetrical balance in your photographs, so one heavy element is balanced by multiple lighter objects or by the negative space surrounding it, or multiple elements are used to create an overall balance. These types of image also tend to appear more natural, as the world around us is rarely experienced in perfect symmetry (even our faces are asymmetrical).

BALANCE OF WEIGHT

It's important to realise that visual weight doesn't just operate horizontally – it also works from top to bottom, and diagonally across the frame as well.

RIGHT Symmetrical subjects will create naturally harmonious compositions. In this instance, the negative space of the sky also balances the busy foreground.

Weighing In

The visual weight of an object is determined by a number of factors, and it is the combination of these that determines how heavy or light an element is.

AN ELEMENT WILL USUALLY HAVE **MORE** VISUAL WEIGHT IF IT IS:

Bright

Larger

Yellow

Red

Saturated

Detailed

Toward the edge of the frame

AN ELEMENT WILL USUALLY HAVE **LESS** VISUAL WEIGHT IF IT IS:

Dark

Smaller

Blue

Green

Desaturated

Lacking detail

Toward the centre of the frame

In this series of illustrations, the seesaw represents the photographic frame and the various shapes illustrate the visual weight of elements and objects in the image. Harmony is created when the two opposing sides balance each other out; if either side is too heavy then the picture – like the seesaw – becomes unbalanced.

ABOVE A single object at the centre of the frame will always be naturally balanced.

ABOVE Two objects, of equal visual weight, equidistant from the centre of the frame will also balance each other.

ABOVE Dealing with three or more identifiable objects opens up your balancing options: a single visually heavy object can be offset by multiple lighter objects, depending on how many there are and where they appear in the frame,

ABOVE Of course, you don't have to create harmony in all (or any) of your photographs: shifting the balance to create an unbalanced or disharmonious result can add tension and create a sense of intrigue.

Weighing In, continued

RIGHT In this shot, the two small, dark figures at the left side of the frame balance the flagpole at the right – the pole may not be as large, but it is brighter and the flag is saturated and red. The sky and ground areas also balance one another, because although the sky is larger and brighter, the ground is far more detailed.

RIGHT Foreground, background; vertical, horizontal; light, dark; detail vs. empty space. The left and the right sides of this shot are playing off of and balancing each other along multiple dimensions.

ABOVE/RIGHT This is a perfect illustration of asymmetric balance: The light water and dark beach at the left are balanced perfectly by the inversely proportional light and dark areas at the right. Had the sea and stone areas been of equal size, either side of the groin, the result would still have been balanced, but the resulting symmetry would not have created the same visual tension.

Negative Space

Negative space refers to the areas around your main image elements that aren't actually considered part of the subject, so it could be a plain sky or a blurred background in an outdoor shot, or the surface you put a still-life subject on. Yet, while negative space isn't the important bit of the shot, it is an important part of the composition (as is everything in the frame), because it has its own visual weight. Consequently, negative space can be actively used to balance a composition.

Negative space also has practical applications in photographs that are destined to have text added to them, for use in adverts, magazine covers, web pages, or any other form of design where the image has to be overlaid with text. In this context, the negative space becomes the perfect background for type, as there's no detail to fight with the lettering.

BELOW The sky isn't the subject here, so in this context, it's considered negative space. For this photograph, I decided that the small, bright, detailed CCTV cameras needed to be balanced by a large expanse of the dark, plain blue sky.

Level Horizons

Okay, so this isn't a classic painting rule, but it is a fundamental compositional concept that can help any photograph succeed when it shows the horizon. The rule is simply that when the horizon appears in a photograph, it should be horizontal (the clue is in its name, after all). If you're shooting handheld, this isn't always easy, but an increasing number of cameras feature built-in levels that give you some sort of indication as to whether the camera is level or not. If your camera has this feature, use it!

Alternatively, if you're using a tripod, it may have some sort of spirit bubble built in to it, which will help you set your camera up straight. If not, you can spend a few quid on a hotshoe level that slides into the top of your camera.

And if none of that appeals, then almost every image-editing program has a straighten tool that will let you set things right, so there really is no excuse for a sloping horizon in any shot. Ever!

ABOVE/RIGHT The horizon in a seascape is especially unforgiving, as it's typically flat and unbroken. This makes it really important to keep it level, as the slightest tilt will be immediately obvious. The image at the right was tilted by just 0.5 degrees and this is enough to make it look wrong.

Pattern & Texture

Patterns and textures exist all around us, in both the natural world and the man-made environment. They can make great photographs because the human brain likes the soothing nature of repeating elements. The crucial thing is to make sure that the pattern doesn't get lost, which is easily achieved by filling the frame (either by using telephoto or macro lenses, or by cropping), or by shooting against a plain background that doesn't compete for attention.

It is also useful to set an aperture that ensures everything is equally sharp, as the eye will naturally be drawn to parts of a picture that are sharper than others. Of course, this isn't essential, and you can even use it to your advantage. One part of a pattern that is sharper than the rest (or a different colour, or size, or contrasting in some other way) will immediately create a strong, attention-grabbing focal point thanks to its same-but-different appearance.

BELOW This street scene is full of patterns, from the line of buses to the windows and street lamps in the background, and the side of the bridge in the foreground. However, a tight, panoramic crop was needed to really emphasise the patterning.

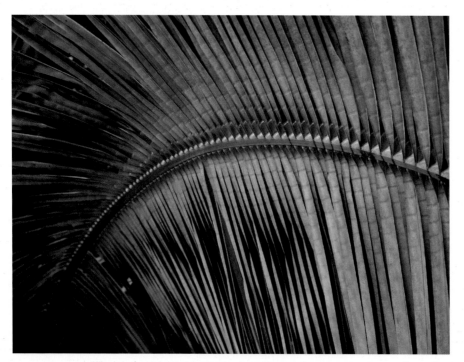

RIGHT A long, 450mm equivalent focal length was used to fill the frame with the repeat pattern of office block windows. Be warned, though – this type of shot will make any lens distortion painfully apparent!

LEFT Filling the frame with this palm frond makes the most of its curved shape and the repeating pattern of its leaflets. A cool, harmonious colour treatment enhances the sameness.

Minimalism

Minimalism is all about stripping your photographs back to a few key elements, rather than filling the frame with detail. As a result, minimalist images tend to have a single, simple subject – perhaps in silhouette – which is often shown against a plain background. This is particularly effective in black and white, as the potential distraction of colour is removed. Trees jutting out of a snow-covered landscape, with a flat, bright sky are a classic example of a subject that works well, as are posts or driftwood emerging from water, taken using an extremely long exposure, or silhouetted birds perched on a telephone wire.

Of course, subjects that work well also tend to be the ones that are photographed in this way most often, so while it's great practice to follow the well-trodden themes, try to seek out – or even construct – your own minimal compositions as well. One great way to do this is to get close to your subject and isolate a very specific part of it: Rather than worrying about revealing what the subject is, concentrate attention on abstract lines and shapes instead.

You can also 'minimalise' an image during processing, first by cropping it, and then by adjusting the exposure and contrast to reduce the tonal range. You might also use your software to convert your minimalist

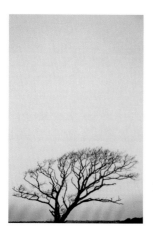

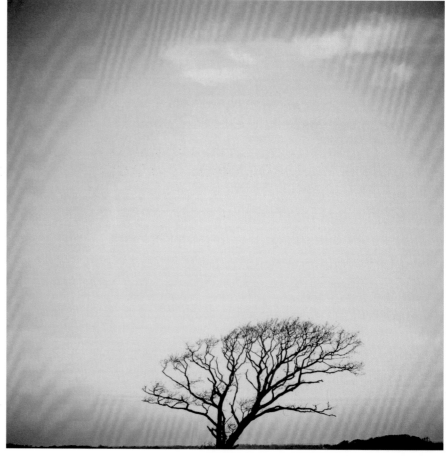

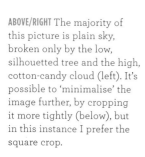

ABOVE/RIGHT The majority of this picture is plain sky, broken only by the low, silhouetted tree and the high, cotton-candy cloud (left). It's possible to 'minimalise' the image further, by cropping it more tightly (below), but in this instance I prefer the square crop.

shots to black and white, but this isn't always necessary. Colour images can be just as effective when the colour palette is limited to a few related hues. This is easy to do when your subject has a naturally harmonious colour scheme, or it can again be achieved when you process your images.

While it might seem relatively easy to shoot almost nothing, minimalist images are actually highly demanding. The main problem (and the main benefit) is that the viewer will latch on quicker and

more strongly to a single point in an otherwise empty frame than they would to the same point in a crowded image, so while you may not have much in the frame, what is there becomes far more prominent. Consequently, the positioning of your key element(s) is crucial. This is a great time to both exploit the rules of composition and experiment with less conventional approaches; image elements at the extreme edges of the frame, and large swaths of featureless sky can work particularly well with minimal landscapes, for example.

RIGHT Deliberate overexposure and high-key, low-colour processing has reduced the form of this building to a few dark lines, exaggerating the minimal nature of the composition.

RIGHT This minimal still-life 'landscape' was created by placing a piece of dried grass on a sheet of white paper on a lightbox.

Frames

Paintings have had frames around them for hundreds of years, serving to both enhance and protect the contents. A frame also acts as a natural container for the image, which clearly tells us where the picture starts and ends, and in doing so, it draws us to the contents. Now, I'm not suggesting you need to stick a frame around every picture you take (whether that's a physical frame around a print or a digital border), but the idea of using a frame as a device within your pictures is definitely something you could (and should) think about.

Anything that appears toward the sides of a photograph – usually running parallel to frame edge – can start to act like a frame, so look for walls in architectural studies, a window to look through that literally frames your subject, position an arm to frame the face of a portrait subject, or employ the classic cliche of overhead branches in a landscape shot. Whatever you choose will create a visual barrier at the edge of the picture, which basically tells the viewer that 'there's nothing to

see beyond this point'. This naturally directs the viewer's gaze back toward the centre of the photograph, helping to emphasise the subjec,t and holding the viewer's attention for longer.

A good way of creating a frame within the frame is to use an aperture that restricts depth of field, so the frame element is thrown out of focus, and the subject is sharp. This will prevent the frame from becoming too interesting in its own right (at which point it will compete with the subject), and because we're drawn to sharply defined parts of a picture more than blurred areas, our eye is again sent back into the photograph. You can also employ dark framing elements for much the same reason – we are drawn more to brighter areas than those in shadow.

ABOVE Using your subject's hands is a great way to frame their face in a portrait. In this shot, not only do the hands act as a frame, but the model's arms have been positioned so they create diagonal leading lines, like two converging sides of a triangle.

RIGHT Frames can be just
the ticket when you're
unsatisfied with how
you're capturing a subject.
Here, the heavy overcast
skies weren't doing this
beautiful cathedral any
justice. By using this
(perhaps heavy-handed)
frame, the sky loses its
dominance at the top
of the image, and pulls
attention directly toward
the church.

RIGHT For this still-life shot,
I introduced two shapes
cut out of black card to
represent trees. A carefully
selected aperture ensured
they fell outside the depth
of field, with their blurred
forms contrasting with the
sharply focused subject.

Colour

Unless you're planning to shoot exclusively in black and white, a basic understanding of colour theory can help you learn how and why some compositions work better than others.

Colour theory is a vast subject, to which many weighty academic tomes (and some not-so-academic texts) have been devoted. There's simply no chance of covering it in full here, so the best I can do is scratch the surface to get you started.

The Colour Wheel

At the heart of colour theory is the standard colour wheel (shown at right), which can be traced back to the 17th century when the British physicist, Sir Isaac Newton, discovered the visible spectrum within white light.

Today, there are countless variations on the colour wheel: some contain more colours than others; some are based on paint colours (rather than light); some

display a range of values for each hue; and others have turned the wheel into a sophisticated three-dimensional colour model.

The most useful wheel for photographers is one that takes the colours in the visible spectrum (from violet to red) and bends the rainbow to make a wheel. It is this simple circular arrangement, as shown in the accompanying colour wheel, that we'll use to explore the fundamental aspects of colour in your compositions.

COLOUR DEFINED

The Munsell Colour system is a widely used method for describing colour based on three discrete attributes: Hue, Value, and Chroma (or HVC).

Hue is essentially the colour; so it determines whether it is red, green, blue, yellow, or anything in-between.

Chroma (saturation) is the purity of the colour: The more saturated it is, the purer and more intense it appears.

Value (brightness) denotes a colour's lightness on a scale between black and white.

ABOVE Using colour is not just about making sure that you get the white balance technically correct. For this shot of a glacier, I decided that the natural colour (left) was too warm, so I deliberately cooled the colour down during processing (right). Although it's the same photograph, the blue colour bias of the second image gives a stronger sense of a physically low temperature: The colour enhances the sense of 'cold'.

Colour Connotations

As well as their visual appearance, colours also have certain connotations attached to them. At a basic level, colours are seen as either warm or cool, and this can immediately give an image a sense of physical temperature, from icy cold to fiery hot. By extension, we then feel certain things about this two colour groups: Cold is generally unappealing, so a visually cool image will tend to push the viewer away more than a warmer-coloured picture that we would naturally find more inviting.

The difference between warm and cool is something you can exploit quite easily in digital photography, simply by tweaking the colour temperature in-camera, or by adjusting the colour at the processing stage. A classic example is warming up a portrait, which will automatically make the subject seem more approachable and a warmer character. Conversely, a cool-toned portrait can make the sitter appear standoffish.

Individual colours also have their own connotations. However, it's important to realise that some of these meanings are subject to cultural differences. For example, in Western cultures (the basis for this list) black is often associated with death and mourning, whereas white is worn by mourners in China.

ABOVE A standard colour wheel showing a range of hues and values based on the spectrum of visible light.

ABOVE The warm/cool split sees fiery colours such as reds, oranges, and yellows on one side of the divide and icy blues and greens on the other. Simply using opposing colours – one warm and one cool – is enough to introduce eye-catching contrast into an image.

Harmonious Colour

Harmonious (or analogous) colours are those that sit adjacent to each other on the colour wheel, and share a similar brightness level. Because the colours are so close to one another in both hue and value, neither one will stand out more than the rest, which results in photographs with a gentle, calming feel to them.

Because the colours are closely matched, images based around a harmonious scheme are often seen as somewhat recessive, which is particularly true when pastel colours are used. However, regardless of hue these aren't images that are necessarily going to leap off the page at you, nor are they going to try and overpower you, which can make them less tiring and more visually refined.

ABOVE Harmonious colours typically consist of one colour on the wheel and its immediate neighbors.

ABOVE Although the reds in this image are intensely saturated, there are few other colours to fight with them, so an overall harmony is created. Compare this image with the shot of the same subject against a different background on page 276.

MONOCHROME

Although the word monochrome is typically associated with black-and-white images, it also applies to colour images that use different values of the same hue (i.e., lighter and darker versions of the same base colour). As the only thing changing is the brightness of the colour, not the colour itself, the image will have a natural harmony.

Monochromatic (and near-monochromatic) colour schemes can be found quite easily, especially when you start to explore the world in close-up.

BELOW The blue sky and purple shuttering create a harmonious colour scheme in this abstract image. (The bright sparkles at the centre were caused by a light-leaking shutter on a cheap, fake Leica camera.)

SPLIT COMPLEMENTARY

A split complementary colour scheme uses three colours: one on one side of the colour wheel and then the two immediately adjacent to its true complement. This colour scheme will also pack a punch, but because it uses the colours either side of the complementary colour, it is slightly less aggressive that straight complementary.

Complementary Colour

While harmonious colour schemes can readily retreat into the background, the same cannot be said for complementary colour schemes. A complementary scheme consists of colours that sit directly opposite each other on the colour wheel. Because they are naturally opposed to one another, these colours typically create bold, dramatic colour schemes.

Precisely how bold and dramatic the scheme is will depend on the brightness and saturation of the colours used. Especially pale, dark, or low-saturated hues will tend to reduce the drama, while heavily saturated, intense colours will enhance it, culminating in colour 'vibration' when equally vivid hues fight with one another (an effect whereby the edges of adjoining complementary colours appear to 'shimmer').

This drama is the perfect way of getting an image to stand out, which is perhaps why it is used so heavily in advertising images and graphic design work when attracting attention is paramount (magazine covers are a great example of this). However, while high-energy colour schemes are almost guaranteed to catch the viewer's eye, they can quickly become waring – they can almost be too intense for us to look at them for long. In this instance, split-complementary and near-complimentary colour schemes can offer a little respite, as can the introduction of a third, more neutral hue such as black, white, or grey.

ABOVE Complementary colours are those that sit directly opposite one another on the colour wheel, such as red and green.

LEFT This is the same robot featured on the previous page, but the background has been changed from red to green. Doing this has made a dramatic difference: Rather than blend with the background, as it did previously, the figure now stands out, thanks to the bold, complementary red/green colour scheme.

OPPOSITE This minimal still-life shot is all about complementary colours and bold, graphic shapes. Although it looks simple, getting the right balance between the blue and the orange was essential.

RIGHT This was part of the same series as the comb on the previous page, but here the violet/pink hair curler was set against a saturated yellow background.

FAR RIGHT To make these plastic teeth stand out, green was the natural background choice, but it needed to be as bright and saturated as the red to ensure impact. The resulting colour scheme could be described as childish, which is perfect for the subject.

RIGHT As orange and blue are complementary colours, it's hardly surprising that the flaking layers of paint on a wooden bench caught my eye. I got as close as my standard zoom lens would allow to really fill the frame with the abstract patterning.

ABOVE/RIGHT A dramatic variation in colour contrast comes in the form of warm and cool colours. Blue and orange are often found in various intensities in the natural and manmade world. With this sunrise shot, the hue of the sky was shifted from a dusty red-brown to a saturated yellow, to better complement the blue in the foreground.

ABSTRACT
Ryan Bush

Ryan Bush is a fine-art photographer based in Los Gatos, California. He's been photographing since 1996, often using less conventional techniques, such as multiple exposures and 3D photography to explore themes of consciousness, the visionary experience, our connection with nature, and the mysteries hidden in the mundane. His work has been exhibited nationally and internationally, and is in numerous collections including the Museum of Fine Arts Houston, the Stanford Medical Center, and the C.G. Jung Institute of San Francisco.

When Ryan started taking photographs, he noticed he was naturally drawn to rhythms, shapes, and composition – the cornerstones of abstract imagery. 'I found that by isolating subjects from their surrounding context, photographs could take us into a timeless, contemplative place. With abstract photography, we don't have to go to another continent to find something interesting to photograph, everything around us is just waiting to be rediscovered through the camera's eye'.

'I would define abstract photography as that where it's not immediately recognizable what is being captured, or the emphasis is on visual elements (such as composition, colour, contrast, or texture) rather than the subject matter. In other words, it's the opposite of representational photography.

'There are plenty of ways you can go about achieving this, but my style is meditative and contemplative. Sometimes my photographs are very clean and Zen-like, while other times, I want to overwhelm the eye with complexity, but I'm always focused on using photographs of everyday things to evoke states of consciousness other than that of our ordinary, rational, grasping minds.

'I'm inspired by finding the sacred hidden in the mundane, especially in things that aren't obviously beautiful, such as my Compositions series of overhead electric wires. I'm also inspired by using photography to express the ineffable, such as in my Writing the Divine series, where I wrote phrases related to consciousness and spirituality over and over on sheets of translucent paper, then stacked them up and photographed them. When it comes to abstract photography, photographers should use any technique they're interested in, as long as it works with what they're trying to say, or helps them figure out what they're trying to say (rather than being a technical gimmick that feels gratuitous, or done just because you can).

'I'm often inspired by music, and listening to 'looping' music like Zoe Keating led me to experiment with multiple exposure photographs, as in my Multiple Visions series. Although you can use Photoshop to combine multiple exposures together, it often becomes a rational, analytic process, rather than a spontaneous, meditative one, so I created the images in-camera, by overlapping four to eight exposures.

ABSTRACT ESSENTIALS

Although you can take a lot of amazing abstract photographs with a normal lens, a telephoto lens and a macro lens (or some other way to get close-up photographs, such as extension rings) will give you a lot more flexibility when it comes to working with subjects that are farther away, or really small.

▶ In the Present, 2009

This was taken from my series Writing the Divine. I wrote the phrase 'in the present' over and over, and then used extension tubes to take an extreme close-up photograph. If you focus on anything intently enough, even a simple word like 'the' has immense meaning.

HASSELBLAD 205FCC WITH PLANAR 110MM ƒ/2 LENS AND EXTENSION TUBES, 1 SECOND AT ƒ/5.6, ISO 100

▶ Composition #112, 2007

By slightly overexposing this shot, the sky became white, providing the perfect background to silhouette the overhead wire and transform them into a mandala.

HASSELBLAD 205FCC WITH PLANAR 110MM ƒ/2 LENS, 1/30 SECOND @ ƒ/16, ISO 100

MASTERCLASS

'I use a Hasselblad 205FCC with a digital back, or a Canon EOS 5D Mark III for my work. With both cameras, I'll generally use in-camera spot metering and Aperture Priority, so I can base the exposure on a precise point and control the depth of field. I'll check the histogram and look at the photograph to see if I got the desired result, but deliberately adjusting the exposure is often essential for getting an abstract photograph rather than a literal reality. I highly recommend relentless experimentation, rather than getting hung up on technical details – mistakes can sometimes be exactly what we need to get a creative photograph, or to take our work in a new direction.

▶ **Multiple Vision #1, 2012**

My Hasselblad doesn't have a built-in means of creating multiple exposures, so for this image [of tree branches] I fitted a neutral density filter to give me a long shutter speed. I then held the shutter open and made each exposure manually, by briefly uncovering the lens.

HASSELBLAD 205FCC WITH PLANAR 110MM f/2 LENS, 30 SEC. @ f/2, ISO 100

'To start with, I'd suggest you find something that catches your eye visually – perhaps something with an interesting pattern, geometric shape, or texture, and explore it with your camera. Don't worry about if you're doing it 'right' or not, just photograph it many different ways, and find the beauty in it that only you can see. Pay attention to the entire photograph, including the negative space, any distracting elements in the background, and whether it matches how you thought the photograph would turn out. Keep iterating, relentlessly experimenting until you are happy with the result or decide to move on to another subject'.

To see more of Ryan's out-of-this-world imagery, visit his website at www.ryanbushphotography.com.

RYAN'S TOP TIPS

- Isolate your subject from its context. Avoiding any extraneous or distracting elements will transport your subject from 'ordinary reality' into a new world of its own.

- To fine-tune a composition, think about how your eye moves around the image. Where does your eye go first, next, and so on? Does your eye get 'stuck' anywhere? Ideally, you want the viewer to be able to explore your images without hindrance.

- Explore the world through your camera, by watching the live preview or looking through the viewfinder. Learn how your camera sees, and how that's different from your own sight.

- Know what you want your photographs to say, or use your photographs to figure that out.

- Experiment relentlessly.

PART 5

Post-Processing

The idea of processing photographs is not a new one.
From the dawn of photography, paper, glass, film,
and countless other materials have been subjected to
myriad chemical treatments to process a picture.

At a fundamental level, digital photography is no
different – all that has changed is that we now work on
our images in a lightroom rather than a darkroom, and
we no longer need to get our hands wet while we do it.

Why is Processing Necessary?

All digital images need processing in some way, and it's up to you whether that happens primarily in-camera (as discussed in earlier chapters) or using software on your computer.

HARDWARE

A few years ago, no discussion about digital image editing would be complete without 'Mac versus Windows' and 'desktop versus laptop' arguments. Today, things are somewhat easier because it's hard to buy a computer (Mac or Windows) that isn't suitable for image processing. Sure, some will be faster than others, but even the cheapest PC will push your pixels for you. The main thing is to make sure you have plenty of memory (RAM) and ample hard-drive space to store your pictures.

Of course, today, you can also use tablets or even your phone to edit our pictures. My advice? Don't. Yes, your tablet's got a great screen, but it's still smaller than most computer monitors, and tablets don't really have the same processing power when it comes to heavy-duty editing.

That doesn't mean the tech's redundant, though – far from it. An ever-growing number of cameras will let you shoot remotely (and wirelessly) using a tablet or smartphone. Not only is this a great way of previewing your images on a larger screen, but it also lets you apply quick corrections and filters to your shots on the fly, so you can get them online in minutes, or even seconds after they've been shot.

In this chapter we're going to concern ourselves with post-processing, which is the processing that happens after you've taken your shot, usually on a computer. This type of image processing falls into two broad camps: the technical and the creative.

Technical processing is all about getting things right. It's about optimising the exposure in an image, getting the white balance spot-on, controlling contrast, saturation, and sharpness, and a host of other tweaks and changes that ensure your image is – from a technical standpoint – good. It is often done in an attempt to make the image as true to the scene or subject as possible, but it also forms the basis for further creative adjustments. If you're shooting JPEGs, then most of this should be done in-camera, because processing your images after the fact can degrade image quality. However, when you're shooting Raw, a lot of these things can – and arguably should – be adjusted and set in post-processing.

Creative processing applies equally to Raw and JPEG files, and this is where you start to make your images your own. It can include multi-shot techniques such as HDR and stitched panoramas, or it can involve using a plethora of filter effects, combining multiple elements from different images, manipulating colour and contrast in an unnatural way, or perhaps converting a photograph to black and white.

A lot of the time, post-processing involves both technical and creative adjustments, but as processing possibilities are virtually endless (especially when it comes to the creative use of filter effects) I'm going to concentrate on the key concepts here, which will lead you to a great-looking shot, regardless of whether you shoot JPEG or Raw.

RIGHT/OPPOSITE: Processing can be used to achieve technical accuracy (the right white balance, exposure, colour, and so on), or it can be employed for creative effect. With this shot, I was more interested in creating an atmosphere than achieving a pixel-perfect reality.

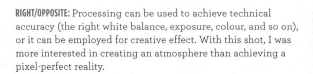

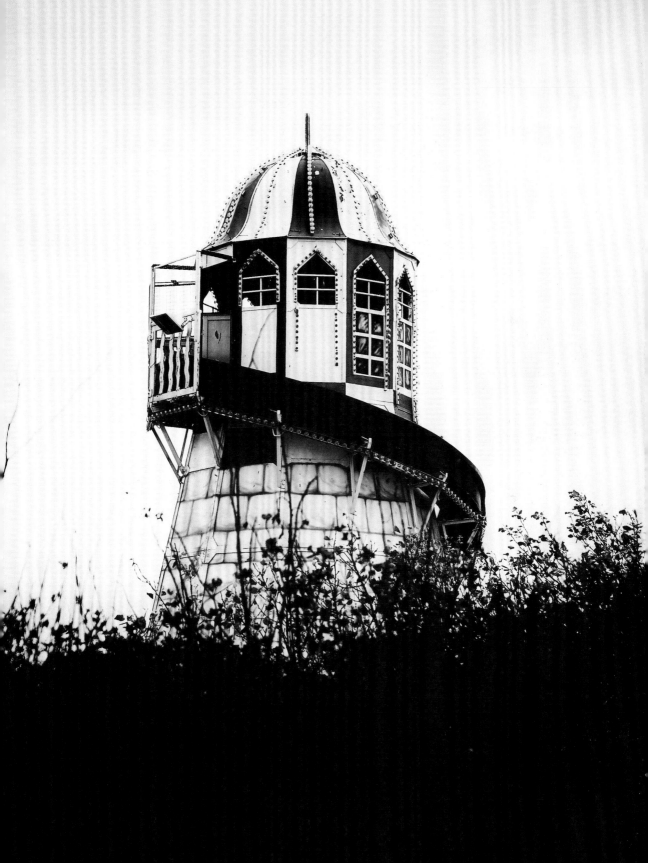

Software

Without software on your computer (or other digital device) you're going to struggle to do much with your digital photographs. But with so many options, what exactly should you be looking for?

Image Editing

Unless you plan on only shooting JPEGs and processing them in-camera (which is limiting) an image-editing program should be at the top of your software-buying list. At the most basic level, this program should let you fine-tune the fundamental aspects of your images, including exposure, colour, contrast, and conversion to black and white. However, most editing software lets you do way more than that, enabling you to process Raw files, perform sophisticated manipulations, and apply a whole range of filter effects.

When it comes to this type of software, there's one software company that sits at the top of the pile: Adobe. Whether it's the longstanding classic, Photoshop, its slimmed-down offspring, Elements, or the photographer's newest friend, Lightroom, Adobe has established itself as the number-one player in the image-editing market. However, there are plenty of alternatives that shouldn't be discounted: Programs such as Corel's PaintShop Pro, DxO's OpticsPro, Phase One's Capture One, and the freeware favorite, GIMP, all come with their own unique advantages. Unfortunately, with so much choice, there's no way I can tell you which is

LEFT There are countless programs available that will do the same or similar things, so it's worth downloading trial versions to see what works for you (and what doesn't). This image was run through three programs in total before I was happy with the result: Photomatix Pro for tonemapping, CameraBag for the vintage tone, and Photoshop for finishing.

best for you. Even if one program stood head-and-shoulders above the rest in terms of its features, I don't know what you want to do, or how you'd prefer to do it. So, the best advice I can give is to try a couple of options for yourself (most offer free trials) and see which one feels best for you. Don't be afraid to mix things up a bit, either – I once stuck resolutely to Photoshop, but now use a variety of programs, depending on what I'm trying to achieve.

Catalogues & Keywords

When you're choosing software, it's also worth considering how you're going to keep track of your images. Knowing where on your hard drive you can find a dozen shots from a week ago is one thing, but locating one specific image from years ago amongst hundreds, thousands, or hundreds of thousands of images is never going to be easy. Cataloguing your images and adding keywords (see box at left) can

help ease the pain here, but you will need some sort of digital asset management (DAM) software. This can be an integral part of an image-editing program (as is the case with Lightroom, Capture One, and others), or it may be that you need a standalone program (such as Adobe Bridge if you're using Photoshop).

In each case, the software that you use will let you see all your images in one place, no matter how widely scattered they are across your hard drive(s). You will then be able to search through them visually, and narrow your searches down using date, camera, focal length, aperture, ISO, keywords, rating, or any other element that's recorded as part of the image's metadata (non-image-forming data that's automatically embedded in every shot).

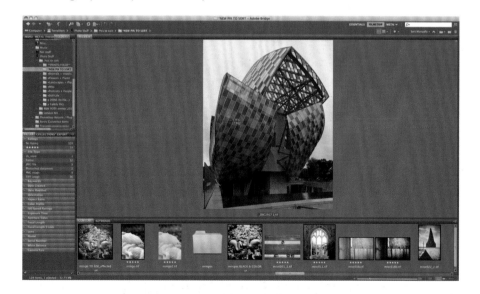

ABOVE My image naming is shambolic at best. I have folders full of images with the filename 'Misc' followed by a number; an import that use the camera's original naming system; and others that have a vaguely relevant title (I can at least guess what the subject of the file 'Vuitton' is!). However, it doesn't really matter how or what you name your images if you add keywords to them because the keywords will let you quickly and easily target specific shots based on content. I tend to use Adobe Bridge to bring a little order to the chaos.

Specialist Software

A lot of higher-end image-editing programs are designed to do pretty much everything you want them to, from general retouching and image optimisation, to stitched panoramas or creating HDR images from multiple exposures. On one hand, this is great, because it means one piece of software can cover all of your options. For years, I never strayed beyond Photoshop for this very reason (and because Mac-compatible editing software was fairly hard to come by).

However, just because your editing program can do something, that doesn't mean it is the best option for it. This is where specialist software can prove useful. For example, if you find yourself shooting more and more HDR sequences, you might want to look at Photomatix, which is designed purely to create HDR images, and comes with a huge range of tonemapping controls that allow you to create the exact image you want.

Alternatively, if a life without colour is more your thing, you might choose to explore any one of a number of dedicated black-and-white tools, including standalone programs such as Macphun's Tonality. Or, if you're looking for a range of stylised filter effects, then perhaps Never's CameraBag will tick the right boxes? The bottom line is, whatever your particular specialty may be, there is likely to be a single, focused program that can help you, and as these programs are only designed to do one thing, they often do it far more comprehensively than general image-editing software.

The downside is that you can quickly find the costs adding up as you expand your software arsenal, as well as your hard drive. It can also mean you end up working across multiple applications, which can slow your computer down. However, there is a handy solution here: plugins.

LEFT/ABOVE I ran this image through Nevercenter's CameraBag app, combining a number of the program's preset looks (above). The software also offers an array of image-editing tools, which let you perform a host of essential edits to your Raw and JPEG files.

Plugins

A large proportion of specialist programs can work either as a standalone program or as a plugin (or both). Unlike a standalone program that you open from your desktop, Programs/Applications folder, or wherever else it's hidden on your hard drive, a plugin is installed into another program (in this case an image-editing program) to expand the host program's capabilities. The advantage here is that you don't need to work across multiple applications; you can access all of your plugins from your image-editing program.

However, the important thing to note is that plugins have to be compatible with the image-editing software you're using. For purely commercial reasons, this means that the most popular programs (such as Photoshop and Lightroom) tend to have access to the widest range of plugins, while less mainstream products have a smaller pool of add-ons to choose from. In some instances, this might not matter too much (Photomatix also works as a standalone program, for example), but some applications, such as Google's Nik Collection (which contains the fantastic Silver Efex Pro black-and-white tool), will only operate as plugins.

FREE PLUGINS

Prior to March 2016, Google's Nik Collection had a price tag of £150, but the premium plugins are now available for free. That's great news for photographers, but slightly less welcome if you're a software developer trying to earn a few quid from alternative offferings.

RIGHT Photomatix is a dedicated HDR tool, and one of the most popular specialist programs available. As well as operating as a standalone program, you can also use it as a plugin with Lightroom (Photomatix Pro) or Photoshop Elements (Photomatix Elements).

Workflow

When we talk about a workflow, we're talking about how your images flow from your camera to your computer, through your editing software, and then to print, online, or other outputs.

The important thing to understand here is that your workflow will be personal to you and your way of shooting. For a start, you might want – or need – to include stages that I don't, for example, or you might prefer to do things in a slightly different order. Presented here are fairly generic workflows for Raw and JPEG images, outlining what happens where, and in what (suggested) order.

This isn't, however, set in stone. You might find you can take it and use it as it is, running through each and every step, but it's far more likely there will be some stages that just don't apply to you and your photography, and others that you might want to do in a different order. The important thing is that you're getting the results you're after.

RIGHT *Here's a typical Raw workflow.* Most of a Raw image's characteristics are set at the processing stage, so a typical Raw workflow is predominantly screen-based. The main things to concentrate on at the capture stage are exposure and focus; everything else can be adjusted, revisited, and optimised on your computer.

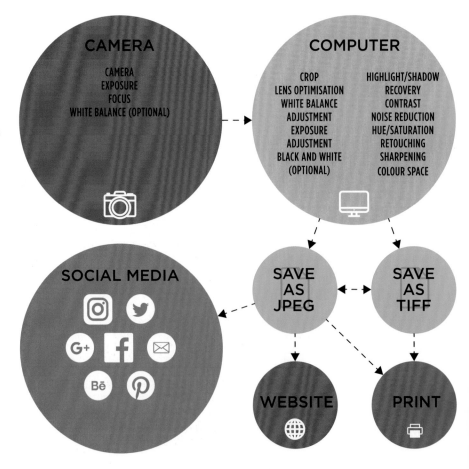

RIGHT It's very easy to transfer your photos from your camera to your computer and think you're done with backup. But that's not at all the case! You've just moved them from one place to another, and your photos are one disaster away from being lost forever. It's best to transfer your photos to at least two separate hard drives, and ideally, you should keep one of those drives 'off-site', i.e., another location, like your office, a friend's house, or even a dedicated archiving service.

RIGHT And here we see a typical JPEG workflow. JPEGs and there's an overlap as to what can be set in-camera and what can be done on the computer. To a certain extent, this depends on whether you want your images to be ready out of the camera: Direct printing and built-in Wi-Fi have made it increasingly easy to bypass the computer if you want to. Of course, you can process JPEGs on your computer as well, but the thing to remember is that your options are far more limited than they are with Raw. It's much easier to irretrievably degrade a JPEG image than a Raw file.

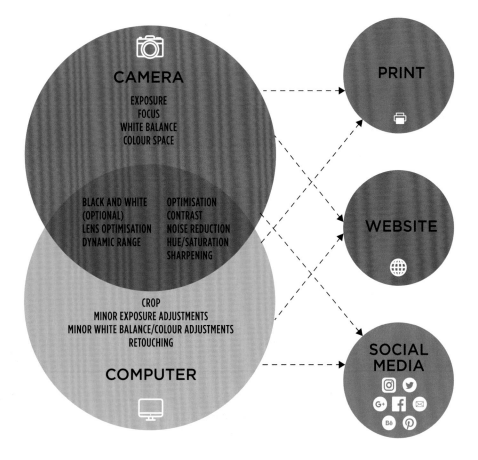

Essential Edits

With so many tools, panels, and dialogues, image-editing programs can be overwhelming. The good news is that if you stick to a few essential editing stages, most of those tools can be ignored until you find your feet.

There are really only seven elements that you need to think about when it comes to processing a photograph, and these are: cropping, exposure, contrast, colour, retouching, resizing, and sharpening. Working through each of these steps – in this order – is the backbone of image optimisation.

Over the following pages, we'll explore the processes for each, using Adobe Photoshop and Adobe Camera Raw to show various options, depending on whether you shoot JPEG or Raw files. Why Photoshop? Simply because it's the longest-standing image-editing program, and its tools and features can be considered the standard. As such, a lot of the things you can do in Photoshop – and the ways in which you do them – translate to many other programs as well.

Cropping

There's a school of thought (often attributed to the great street photographer, Henri Cartier-Bresson) that photographs should be presented in full, and that a skilled photographer shouldn't need to crop their work. Now, I'm not going to dispute the fact that it's a good idea to get as much right in-camera as you can, but I draw the line at framing (and suggest you do too). Sometimes you just need to crop.

However, while cropping isn't quite the sin that some people suggest it is, it is important to appreciate that it's always a lossy process. No matter how mild or wild the crop, whenever you cut into an image, you're discarding pixels; and the more you crop, the more you lose, which can restrict the maximum print size. With that in mind, it pays to previsualise the crop at the shooting stage and frame your shots as accurately as possible in camera, so you trim as little as possible at the cropping stage.

LEFT I planned to make this a square shot the moment I raised my camera to my eye, so cropping was an essential first post-processing step.

Cropping in Action

1 Select the Crop tool from your image-editing program's toolbar – the classic crop icon is a pair of L's that represent the traditional photographer's cropping aid (two L-shaped pieces of card).

2 Most programs will let you activate a grid or guides to aid composition when you crop. For example, Photoshop lets you overlay guides for classic compositional rules, including the Rule of thirds and Golden triangle.

3 You can usually set a specific aspect ratio for your cropped image, enabling you to specify whether you want the crop to retain the same aspect ratio as the original, or if you want it square, panoramic, or some other format. Alternatively you can leave the crop unconstrained, so it's not fixed to a single ratio.

4 Set the area for your crop by clicking on the image and dragging a rough crop box on your image. This doesn't need to be precise because…

5 …you can use boxes at the corners (and sides if the crop area is unconstrained) to fine tune the crop.

6 Finally, perform the crop by pressing the Enter key, choosing OK, or clicking on whatever other icon your software uses (some use a check mark).

NOTE: When you crop a Raw image, no pixels are discarded. Instead, the software makes a note of the crop and applies it when you export the Raw file as a TIFF or JPEG, or open it in your image-editing program. This means you can go back to the Raw file and edit or undo the crop at any time.

Exposure

Most cameras have all the tools you need to get your exposures spot-on, in-camera. However, things won't always go according to plan every time you release the shutter. If you're shooting something spontaneously, for example, you won't have time to assess your histograms and tweak the exposure, so sometimes getting any exposure – even if you know it's wrong – can be better than no exposure at all.

This is where shooting Raw is the ideal option. Thanks to its greater bit depth, there's a much greater chance you'll be able to pull back the exposure when you process a Raw file. You may experience a slight increase in noise if you're lightening an underexposed image, but providing your exposure is within roughly 2 stops of correct, you'll usually be able to get a decent result.

Shoot JPEGs, and things are less rosy, as the smaller bit depth gives you less room to maneuver. Although you can make an exposure lighter or darker, you can't do this to the same degree as if you had shot Raw, and any areas that are clipped in-camera will also be impossible to recover. Consequently, it's more important to get your exposures right in-camera when you're shooting JPEGs, although any exposure correction should be avoided if at all possible.

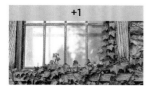

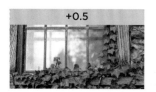

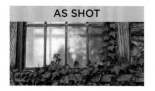

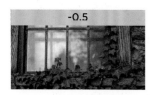

LEFT/ABOVE The Exposure tool in most editing programs uses a slider that attempts to replicates your camera's exposure compensation control, enabling you to lighten or darken an image. However, while most cameras let you make your changes in 1/3- or ½-stop increments, software typically allows much finer adjustment of the exposure. Adobe Camera Raw lets you tweak the exposure in 1/100-stop increments. Different manufacturers deliver exposure control in different ways, but the best tools are those that try and protect the highlights and shadows from clipping. For this image, I started with a exposure adjustment of -0.50 to darken the mood.

JPEG Exposure

If you shoot JPEGs, you'll need to be careful not to make radical exposure adjustments, because it's easy to ruin your images. The problem is, JPEGs have less exposure latitude, so it's easier for highlights to clip and shadows to block up, with little chance of recovering any useful detail from those areas. However, just because you can't make major adjustments, that doesn't mean you can't make some changes. But with so many adjustment tools on offer, which one should you be reaching for?

Most image-editing programs have an Exposure tool, which sounds as though it should be your first (and only) option. However, while they can do a pretty decent job with some subjects (as here), they can struggle with others.

The problem is, adjustments tend to affect the entire image equally. If you darken an image, it's like pulling a grey veil across it, and any white highlights will simply turn grey, which never looks natural. Similarly, when you lighten an image that already has some light areas, the highlights blow out to white very easily.

+0.5

AS SHOT

ABOVE/LEFT Photoshop's Exposure tool does a great job when there aren't extremes of light or dark in a JPEG image to start with. If there are, they can easily be clipped as midtones are made lighter or darker.

Personally, if I ever want to tweak the exposure of a JPEG, I'll head for Photoshop's Levels tool. Based around a histogram, Levels not only lets you see the tonal distribution of an image, but it also lets you adjust it. To make a change to the exposure, all you need do is slide the middle (grey) pointer under the histogram to the left to darken the image, or to the right to lighten it. You can also use the sliders at either end to manipulate the shadows and highlights: Drawing the black slider toward the middle will deepen the shadows, while moving the white slider toward the middle will brighten the highlights.

LEFT Correcting the underexposure in this shot simply meant opening Levels and bringing the White (right) slider in to the end of the histogram. Immediately, my whites became white once more.

Contrast

It's easier to add contrast when you're post-processing your images than it is to reduce it, so contrast control should start when you take a shot. Unless you're using JPEGs straight from the camera, shooting flat (with low contrast) makes a lot of sense. This means setting a Picture Style with reduced contrast, or setting a low contrast level in a custom Picture Style. This is particularly important when your scene is naturally high in contrast to start with, as setting the contrast too high at the shooting stage can clip shadows and highlights. With JPEGs, it's impossible to retrieve highlight detail once an area has blown out to white, so once it's gone, it's gone for good. There's a greater margin for correction if you're shooting Raw, as the improved bit depth will hold more information to start with (something we'll look at on pages 314–315).

Brightness/Contrast

In the past, Photoshop's Contrast slider (found in the Brightness/Contrast dialogue) was nothing short of a travesty; it seemed that the slightest increase would blow out the highlights and block up the shadows, while a modest decrease would turn everything to an unappealing homogenous mush. If you want to see just how bad it was, open the Brightness/Contrast dialogue and check the Use Legacy box before you make your adjustments.

Thankfully, Adobe came to its senses and developed a far more refined algorithm, which now protects your highlight and shadow detail, and prevents things from looking too bad. Yes, extreme settings might be too much, but for general JPEG contrast tweaks, Brightness/Contrast has got your back – at least until you're ready to explore Curves (which we'll look at on page 320).

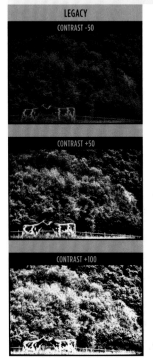

LEGACY CONTRAST

Photoshop's Contrast tool has come a long way. You can still use the Legacy processing (shown left), but the results are rarely attractive. Keeping Use Legacy unchecked (shown right) produces much better results, and avoids clipping as much as possible.

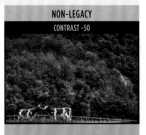

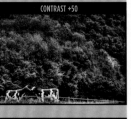

Adobe Camera Raw

Adobe Camera Raw's Contrast control is a world away from the Brightness/Contrast version you'd be looking at for your JPEGs. There's also a Clarity slider, which gives you another option when it comes to adding impact to your images.

BELOW (TOP ROW) When you use Adobe Camera Raw (or Lightroom) to process your Raw files, the highlights and shadows don't become horribly burned out or blocked up. This is because the algorithms behind it are designed to hold the tonal extremes to prevent clipping.

BELOW (BOTTOM ROW) ACR's Clarity slider delivers midtone contrast, which is a bit like combining a contrast boost with sharpening. If you increase Clarity, images usually gain more punch, which is often a good thing. However, dial the Clarity below 0 and things aren't quite so nice.

CONTRAST 0 / CLARITY 0

CONTRAST 100 / CLARITY 100

ABOVE For my final processed shot, I took Adobe Camera Raw's Contrast and Clarity sliders to the max, setting them both at +100. The result is far more intense and impactful than the original shot above.

CONTRAST -100

CONTRAST -50

CONTRAST +50

CONTRAST +100

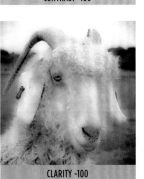
CLARITY -100

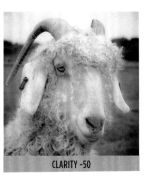
CLARITY -50

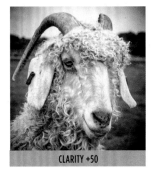
CLARITY +50

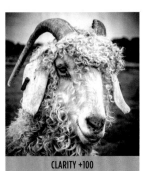
CLARITY +100

Colour

The biggest cause of colour problems is white balance. It could be that the camera's Auto White Balance setting has got it wrong, or you've accidentally set the wrong preset, or it's the right preset, but it doesn't quite match the colour temperature of the light, or the light's changed and no longer matches your custom white balance, or, or, or – there are countless instances when WB can go awry.

If you're shooting Raw, then you're laughing when this happens. The great news here is that the white balance isn't fixed in a Raw file, so when you process your pictures, you can pick an alternative preset, dial in a specific colour temperature, or target a should-be neutral area of your image, enabling you to quickly set things right. Shoot JPEGs, and colour correction becomes slightly harder (but not impossible).

EXPOSURE FIRST

Exposure and contrast can both affect colour, which is why you should make any necessary exposure/contrast adjustments first.

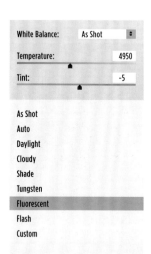

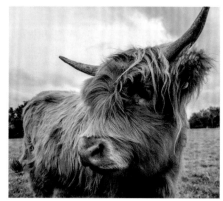
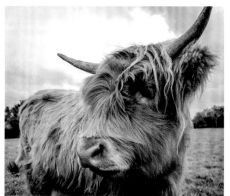

LEFT/ABOVE Shoot Raw and adjusting the white balance can be as easy as selecting an alternate preset from a drop-down menu. This also makes it much easier to experiment with the wrong settings – for this shot, I changed from As Shot to the Fluorescent preset.

SATURATION / VIBRANCE

Changing the hue of an image, you can also adjust the intensity of the colour. Photoshop gives you two tools for this: Saturation and Vibrance (both found under the Image > Adjustments menu). Saturation is the most primitive tool of the pair, and it's easy to overcook it – dial in too much saturation, and your colours will quickly become eye-poppingly false. By comparison, Vibrance is a much gentler option. Although it too increases the vibrancy of images, it protects colours that are already quite heavily saturated.

AS SHOT | VIBRANCE +100 | SATURATION +100

ABOVE Although Vibrance enhances colour intensity, it does so intelligently, so colours that are already vivid – like the blue roof on the pagoda shown here – aren't overcooked. Saturation, on the other hand, is happy to enhance all colours equally, sometimes leading to garish results.

Colour Balance

In Photoshop, the Colour Balance tool (*Image > Adjustments > Colour Balance*) let you adjust the individual colour channels (red, green, and blue) in the highlight, midtone, and shadow areas. This makes it pretty powerful for correcting the colours in your JPEGs.

Here, I've got a shot taken with the wrong white-balance setting (it happens!), which has resulted in an overly warm image. If I had shot Raw, this wouldn't have been a problem – I'd just need to change it when I processed the file (see opposite). But, since this is a JPEG, things aren't quite so straightforward. Because this shot has a fairly uniform colour cast, the highlights, midtones, and shadows have all been treated in a broadly similar fashion using Colour Balance: red has been decreased (increasing cyan), while green and blue have been increased (decreasing magenta and yellow). However, the tonal areas have had different levels of correction applied, as in this example the most significant changes were needed in the midtone areas.

AUTO COLOUR

Every image-editing program has an automatic colour-correction option, even the full version of Photoshop. Just like your camera's Auto mode, you've got no control over the result, so you might not get what you want. However, it shouldn't be ignored entirely – selecting Image > Auto Colour from Photoshop's menu only takes a second or two and is easily undone if you don't like the result. In the image above, it's done a perfectly acceptable job, and was a lot quicker than fiddling with the Colour Balance.

COLOUR BALANCE

Colour Levels:	-3	+3	+39
Cyan:			Red
Magenta:			Green
Yellow:			Blue
Shadows		Midtones	Highlights

COLOUR BALANCE

Colour Levels:	-20	+10	+20
Cyan:			Red
Magenta:			Green
Yellow:			Blue
Shadows		Midtones	Highlights

COLOUR BALANCE

Colour Levels:	-2	+9	+18
Cyan:			Red
Magenta:			Green
Yellow:			Blue
Shadows		Midtones	Highlights

Retouching

By the time you get to this stage, your image will be looking pretty tidy. It will have your preferred frame shape; it will be as bright or dark as you want it; the contrast will be set; and the colours will echo your creative vision. However, there may still be parts of the image that you'd rather weren't there, which is where retouching comes in.

At the mild end of the retouching spectrum are minor touch-ups to remove rogue elements in a scene that you couldn't crop out in camera, or unwanted blemishes created by dust on the sensor. At the opposite end of the scale is serious retouching work that alters reality – cutting and pasting elements from one shot into another; removing elements such as people from the frame; or the wholesale restructuring of something in the photograph.

How far you go with your retouching will largely depend on your style and genre of photography, but here, we're going to limit it to essential edits that will help you to tidy your images, rather than reconstruct them. It's worth noting that not all Raw editors allow you to retouch your images in this way, so it may be that you need to export your Raw file as a TIFF or JPEG before you move on to retouching.

The Tools

The image-editing programs that are serious about letting you push pixels will have numerous retouching tools that you can call on. This is a selection of Photoshop's heavy-duty arsenal, but many programs offer a similar range of tools (albeit with slightly different names). As is usually the case when there are multiple options, experimentation and practice are key, but you also need to be aware that to successfully touch-up an image, it's likely that you'll have to use several different tools – it's rare that one tool will work for every part of an image.

 PATCH

The Patch tool is perfect when you need to get rid of marks from a large area of continuous tone and there's a similar area of unaffected tone in your image; if you've got a large amount of dust marks in one part of the sky, for example, but none in another. To patch your image, you simply draw around the area you want to correct to make a selection. Then, you click and drag the selection to the area you want to copy, and when you release the mouse button, Photoshop copies your patch and tries to blend it automatically with its new surroundings.

 ## CLONE STAMP

The Clone Stamp is simple: You hold down the Option key and click on the image to choose a source area to clone from, then click elsewhere on the image to copy that area, effectively cloning one part of the image onto another. This manual approach works well when you want to retouch a very specific part of an image that contains fine detail, as you can choose precisely what is copied and to where. However, it's easy to end up with obvious retouching marks if your source area is a different colour or tone to the destination.

 ## SPOT HEALING BRUSH

The Spot Healing Brush provides you with automated retouching: Simply select the tool, set the brush size, and click on the part of the image you want to retouch. Photoshop will analyze the area for obvious differences (the defect you want to remove) and automatically remove it based on the information in the surrounding areas. This is an incredibly effective way of dealing with obvious blemishes on a plain background (dust marks in a sky, for example), but it can struggle when you're working near irregular edges.

 ## HEALING BRUSH

The Healing Brush is something of a halfway house between the fully manual Clone Stamp and the fully automatic Spot Healing Brush. Like the Clone Stamp, you start by selecting an area you want to use as your source. However, when you click to replace the correction area with the source, Photoshop automatically attempts to blend it to avoid any obvious edges.

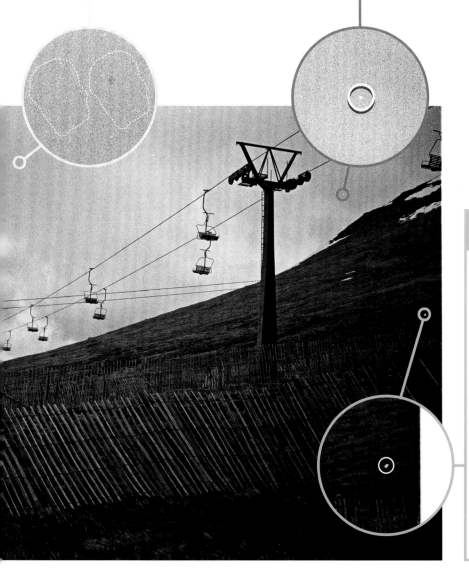

Resizing

For all intents and purposes, your image is finished by the time you get to this stage. It should be looking as good as it can, so it's time to decide what you're going to do with it, whether that's to make a print for your wall, post it online, or something else altogether. The key thing to appreciate here is that different uses require different size images, so you may need to make your image bigger (upsize it) to create a poster or large-scale print, or you might need to make it smaller (downsize it) to share it online.

Therefore, the penultimate stage in your image's journey is resizing it. Obviously, it's impossible to cover every possible permutation of camera resolution and output size, but the chart below (and the guides opposite) should help point you in the right direction.

Input/Output

Not sure whether your images need to be made bigger or smaller, or what settings to use? This illustration shows a range of typical output sizes and resolutions, along with a number of common camera (input) options.

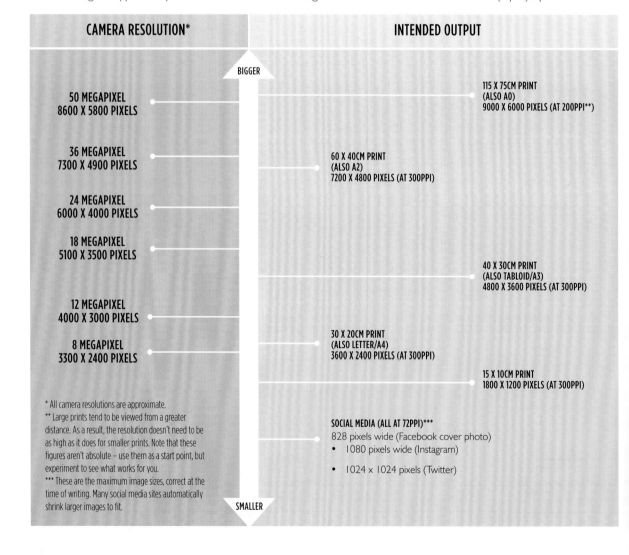

CAMERA RESOLUTION*

BIGGER

50 MEGAPIXEL
8600 X 5800 PIXELS

36 MEGAPIXEL
7300 X 4900 PIXELS

24 MEGAPIXEL
6000 X 4000 PIXELS

18 MEGAPIXEL
5100 X 3500 PIXELS

12 MEGAPIXEL
4000 X 3000 PIXELS

8 MEGAPIXEL
3300 X 2400 PIXELS

INTENDED OUTPUT

115 X 75CM PRINT
(ALSO A0)
9000 X 6000 PIXELS (AT 200PPI)**

60 X 40CM PRINT
(ALSO A2)
7200 X 4800 PIXELS (AT 300PPI)

40 X 30CM PRINT
(ALSO TABLOID/A3)
4800 X 3600 PIXELS (AT 300PPI)

30 X 20CM PRINT
(ALSO LETTER/A4)
3600 X 2400 PIXELS (AT 300PPI)

15 X 10CM PRINT
1800 X 1200 PIXELS (AT 300PPI)

SOCIAL MEDIA (ALL AT 72PPI)***
828 pixels wide (Facebook cover photo)
• 1080 pixels wide (Instagram)
• 1024 x 1024 pixels (Twitter)

SMALLER

* All camera resolutions are approximate.
** Large prints tend to be viewed from a greater distance. As a result, the resolution doesn't need to be as high as it does for smaller prints. Note that these figures aren't absolute – use them as a start point, but experiment to see what works for you.
*** These are the maximum image sizes, correct at the time of writing. Many social media sites automatically shrink larger images to fit.

JPEG Exposure

In Photoshop, Image Size (found under the Image menu) is your one-stop-shop when you need to change your picture dimensions. However, it's not a particularly intuitive dialogue, so you need to be aware of a few key things:

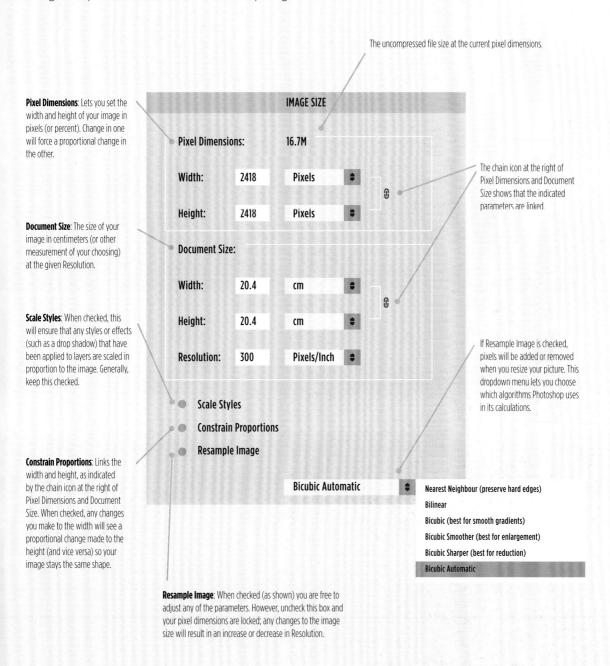

The uncompressed file size at the current pixel dimensions.

Pixel Dimensions: Lets you set the width and height of your image in pixels (or percent). Change in one will force a proportional change in the other.

The chain icon at the right of Pixel Dimensions and Document Size shows that the indicated parameters are linked.

Document Size: The size of your image in centimeters (or other measurement of your choosing) at the given Resolution.

Scale Styles: When checked, this will ensure that any styles or effects (such as a drop shadow) that have been applied to layers are scaled in proportion to the image. Generally, keep this checked.

If Resample Image is checked, pixels will be added or removed when you resize your picture. This dropdown menu lets you choose which algorithms Photoshop uses in its calculations.

Constrain Proportions: Links the width and height, as indicated by the chain icon at the right of Pixel Dimensions and Document Size. When checked, any changes you make to the width will see a proportional change made to the height (and vice versa) so your image stays the same shape.

Resample Image: When checked (as shown) you are free to adjust any of the parameters. However, uncheck this box and your pixel dimensions are locked; any changes to the image size will result in an increase or decrease in Resolution.

IMAGE SIZE

Pixel Dimensions: 16.7M

Width: 2418 Pixels
Height: 2418 Pixels

Document Size:

Width: 20.4 cm
Height: 20.4 cm
Resolution: 300 Pixels/Inch

Scale Styles
Constrain Proportions
Resample Image

Bicubic Automatic

Nearest Neighbour (preserve hard edges)
Bilinear
Bicubic (best for smooth gradients)
Bicubic Smoother (best for enlargement)
Bicubic Sharper (best for reduction)
Bicubic Automatic

RESIZING IN ACTION

Let's say that you want to resize a photograph to use it online, but you also want to make a print (of a kitten, because everyone loves kittens, right?). This will need two different resizing actions, resulting in two unique files.

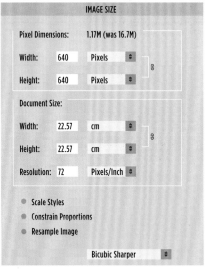

IMAGE SIZE		
Pixel Dimensions:	1.17M (was 16.7M)	
Width:	640	Pixels
Height:	640	Pixels
Document Size:		
Width:	22.57	cm
Height:	22.57	cm
Resolution:	72	Pixels/Inch

● Scale Styles
● Constrain Proportions
● Resample Image

Bicubic Sharper

IMAGE SIZE		
Pixel Dimensions:	65.9M (was 16.7M)	
Width:	4800	Pixels
Height:	4800	Pixels
Document Size:		
Width:	40.64	cm
Height:	40.64	cm
Resolution:	300	Pixels/Inch

● Scale Styles
● Constrain Proportions
● Resample Image

Bicubic Smoother

TO MAKE AN IMAGE SMALLER, FOR THE WEB, YOU NEED TO MAKE THREE KEY CHANGES:

- Resolution needs to be set to 72ppi (the screen standard).

- Resample Image should be checked (choose Bicubic Sharper from the dropdown options).

- The desired width and height should be set

UPSIZING AN IMAGE FOR PRINT ALSO REQUIRES THREE ADJUSTMENTS:

- For prints, I set the Resolution of 300ppi (although some people use lower values).

- Again, Resample Image should be checked, but this time choose Bicubic Smoother from the dropdown options.

Sharpening

Pretty much every digital image needs sharpening, although precisely how much is necessary will depend on a combination of factors. It might sound counterintuitive, but most digital imaging sensors are designed to introduce a very slight softness to images, due to their use of an anti-aliasing filter (we'll take a look at why this is in the next chapter). So, you may need to crisp up your photographs.

You might also find that your images are slightly soft due to camera shake through slight mis-focus, or it could be that your lens is naturally soft (a common trait with some kit lenses and superzooms). In each case, sharpening your shot can help, but it's worth noting that it's impossible to bring out detail that isn't there to start with – no amount of sharpening will bring an out-of-focus image into sharp relief.

Although sharpening can be set in-camera, this is rarely a good idea, because sharpening is the least reversible in-camera process, so if you get it wrong when you shoot, you're stuck with it. It can also limit the other processing you can do, so unless you're shooting JPEGs and absolutely need the image to be ready now, in-camera sharpening is best set at its lowest level and left there (or switched off altogether).

If you're tempted to disregard this advice then it's also worth bearing in mind the amount of sharpening needed for an image will vary depending on a range of factors, as outlined on page 309. There's no one-size-fits-all answer here, so you really are better off sharpening your images when you can see them at a large size on your computer monitor and have finished all your other edits.

Unsharp Mask

Although the technique of using an unsharp mask lies in the days of analogue printing presses, it remains the underlying principle for a lot of digital image sharpening techniques, including Adobe Camera Raw. It works by creating a blurred version of the image and subtracting that from the original. This determines where the edges lie in the image, and contrast is increased in these edges to effectively give the impression of increased sharpness. In most programs, successful sharpening relies on three key controls:

- **Amount** essentially controls how much contrast is added along the edges.
- **Radius** sets how wide the sharpening effect is: a low radius will target very precise edges, while a high radius will apply sharpening across a wider area.
- **Threshold** determines how much difference there should be between two areas before they are considered an edge. The higher the threshold, the greater the difference needed before sharpening is applied.

COLOUR BLANCE

100%

Amount:	150	
Radius:	0.9	Pixels
Threshold:	5	levels

What's important is that every image has different sharpening requirements, so use your software's preview as a guide, and make sure you're viewing the image at 100% (actual pixels) so you can accurately see what's going on. As a very general guide, images with

SMART SHARPEN

There is a wide range of options when it comes to sharpening your images; Photoshop has five dedicated sharpening filters, as well as other tools you can use. For JPEGs, my recommendation is Smart Sharpen, found on the filters menu, although even that can be applied in multiple ways.

RIGHT The first option is to combine a high amount with a low radius. This gives a strong sharpening effect across a small area, which really sharpens up edges and fine detail, but also exaggerates any noise or JPEG compression artifacts. Note that you want to choose Lens Blur from the Remove dropdown list.

RIGHT The second option is to combine a low amount with a high radius. This gives a weaker sharpening effect across a much wider area; edges aren't quite so pronounced, but nor are noise or JPEG compression artifacts.

LEFT/RIGHT These shots show both approaches at both images' print sizes.

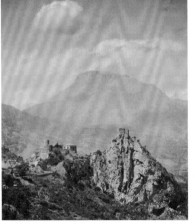

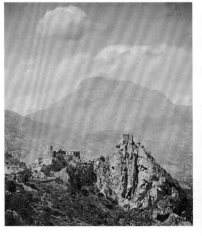

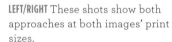

ABOVE Noise also affects sharpness, but perhaps not in the way you'd imagine. While higher noise levels can obscure fine detail, they also create a greater impression of sharpness: This is the same image with a small amount of noise added, but no additional sharpening.

MORE SHARPENING NEEDED	LESS SHARPENING NEEDED
• Camera sensor has anti-aliasing filter	• No anti-aliasing filter
• Image shows slight camera shake	• No shake present
• Image slightly out of focus	• Image in focus
• Lens slightly soft	• Lens tack sharp
• Lots of fine detail in photograph (such as hair)	• Lots of featureless areas in the scene (such as sky)
• Image being printed	• Image being used on screen/online
• Large print size	• Small print size
• Printing on matte paper	• Printing on glossy paper

∨

RETOUCHING
MISS ANIELA

Originally, Miss Aniela was the pseudonym used by the self-portraitist and author, Natalie Dybisz, but it is now the name of her business, which she runs with her producer partner Matt Lennard. Miss Aniela's distinctive blend of fashion and fine-art encompasses both commercial and personal projects, with work appearing in Vogue Italia, NY Arts, and El Pais, as well as being shown at London's renowned Saatchi Gallery. The photography couple also run the Fashion Shoot Experience event, which offers photographers the chance to join the Miss Aniela team and shoot in beautiful houses around the world.

The unique Miss Aniela 'look' utilises multiple elements blended seamlessly to create bold and 'painterly' images with a definite surrealist edge. However, although there can be significant retouching involved, that doesn't mean the photography is less important than the processing. 'It's hard to say whether either is more important', says Natalie, 'as they both contribute to the final result. Increasingly, I try to use less Photoshop and more real props to create more of an authentic "set", but with the right skills you can create amazing effects in Photoshop for a fraction of the cost, energy, and time involved in building a real set.'

However, sometimes there's no other option but to shoot or source individual elements, and bring them together digitally. 'It's important to try shoot the elements of a composite in the same way, to get them to match in the final piece. Lighting is the most important thing to get right, as it's the most difficult to adjust in Photoshop. It's difficult to change the lighting direction on an object in Photoshop, other than by rotating it or changing its position. This is the biggest thing that catches people out when it comes to making composites. If you've got a bird composited into a sky and the light direction of the sun doesn't match the light on the bird it will stand out, even if it's small in the frame.

▼▶ For this shot (opposite), Natalie stitched two images together to capture the grandeur of her location (A), before dropping in a separate shot of her model (B & C). During the processing she also swapped the model's head for one with a slightly different pose (D).

LOCATION SHOT:
24MM, 1/10 SECOND @ ƒ/3.5, ISO 160

DRESS SHOT:
29MM, 1/20 SECOND @ ƒ/4.0, ISO 80

'Exposure and colour are much easier to manipulate, and you can play with levels and colour balance to force something to match its new surroundings. There are always limits, of course – changing something from red to green is harder than changing it from red to pink – and the more tweaking from its original state, the more degradation to quality. You can also blur and soften elements, add noise, transform and change perspective, all to make an element fit into a composite'.

Successful compositing is not just about making the elements match, though. To get seamless results like Natalie's, you also need to ensure that none of the pieces in the visual puzzle stand out thanks to dodgy selections and cut-outs. However, while some people turn to specialist selection and masking plug-ins, Natalie relies on a tool that we can all access: 'Good old-fashioned patience. Zoom in as close as possible and take your time! Cut a bit away from the edge, feather the selection, and then layer-mask the element so you can more accurately adjust its edges with a brush on different hardness levels'.

The processing itself takes place on a 27-inch Apple iMac, which Natalie recently upgraded to 16GB RAM and a solid state hard drive. 'Upgrading my computer has helped speed things up massively, especially for big files. I'm working on a 12GB file at the moment, which has up to 100 layers at a time. Keeping my computer as clear as feasibly possible also helps, and I store most of my data on external drives to ensure that Photoshop's scratch disks don't become full'.

As well as retouching and combining her images in Photoshop CC, Natalie also uses PTGUI software for stitching multiple frames together. 'I often stitch my images in a panoramic photomerge because I like to showcase the beautiful locations I shoot in. It also delivers a higher resolution final image, which maximises the quality of my extra large fine-art prints. So a typical shoot would involve photographing a model in a big beautiful dress in a grandiose location, with a little of the environment around her. Then I'd typically shoot more of the room either up and down, or left and right, to stitch in later'.

RETOUCHING ESSENTIALS

Although compositing takes place on a computer, Natalie sees a tripod as a 'technical essential for creating stable shots, either for panoramic stitching, masking out an element such as a light, or for using slower exposures for exposure blending. I often don't like using a tripod, but when it's for a composite, it's vital. Another thing I'd suggest is a boom arm for lighting, which can dangle into shots and be retouched out later'.

NATALIE'S TOP TIPS

- Be flexible and open-minded when it comes to adding things into composites. Sometimes an element you expected to work just doesn't look right – accept it and move on to a better one.

- Over-dodging can look ugly very quickly. I much prefer to lighten parts of an image using the exposure brush in my Raw conversion software.

- It's as important to zoom in on detail, as it is to zoom out and look at the bigger picture. You should do this throughout the retouching process, because some things will look great close up, but awful from far out, and vice versa.

- If you want to do a lot of transformational retouching to a person's body, don't shoot them against any lines; avoid having walls, doors, windows, skirting boards, pillars, and so on in the background!

- If you're inserting an element into a composite and it doesn't work, try using a different angle of the same object (if you can). A different angle can lead to success.

'Years ago I used to play with HDR exposure blending as well, but these days I find there is enough quality in the Raw files from my Nikon D810 that I can comfortably bring out enough from the shadows and highlights'.

Ultimately, Natalie tries not to obsess too much about what her images go through, concentrating instead on producing stunning high-quality work. 'Sometimes I use a little Photoshop to create the final result, sometimes a lot. I've learnt to just accept that every image has different needs'. And that's advice that even the most fervent pixel-pusher can learn from.

To see more of Natalie's stunning assemblages, visit www.missaniela.com.

▲ This surrealist dreamscape saw a model photographed in a chateau (A) combined with a stock image of an icy landscape. In cases like this skillful blending is need to ensure that the lighting, exposure, and colour of the various elements are the best possible match (B, C & D).

CHATEAU SHOT:
24MM, 1/160 SECOND @ f/5.6, ISO 64

LIT USING BRONCOLOR PARA 88 STROBE AND LUPOLUX HMI/LEDS.

ICESCAPE: STOCK

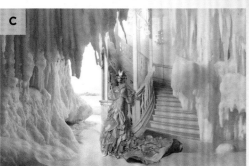

Advanced Edits

As you become more proficient with your software, you might want to explore some of its more advanced tools or try out some techniques that will allow you to perform more sophisticated edits.

Bit Depth

The greater the bit depth of an image, the greater the range of colours it can contain. If you shoot JPEGs, your camera will deliver an 8-bit image, which means JPEG images can contain about 16.7 million colours. Now, that sounds pretty impressive, and it's certainly good enough to enable a JPEG to produce a seamless, high-resolution, continuous-tone photograph. However, when you shoot Raw, your camera will record either 12- or 14-bit images, which means a greater number of colours. When you convert a Raw file, you can then decide whether to output it as an 8-bit image or as a 16-bit image, containing up to 281 trillion colours.

So, this automatically means that 16-bit digital photographs are better than 8-bit images, right? Well, not really. The human eye can differentiate between only around 10 million colours. So we're just not equipped to see much difference between an image containing 16.7 million colours and one containing 281 trillion colours.

Your image-editing software can see the difference, though. Whenever you adjust the colour or exposure, your software applies various algorithms to the image data, basically changing the numbers in the background – all those 0s and 1s – that make your digital image 'appear'. At times, this means rounding the numbers up or down, and this is the underlying process that starts to degrade your image. However, if you start with more numbers (a greater bit depth), the rounding process doesn't necessarily kick in as soon, so the image retains its integrity for longer. In practical terms this means that using a higher bit-depth will allow you to make a greater number of adjustments.

BIT DEPTH	PROS	CONS
8-BIT	• More than enough colours for a photorealistic result • Fully compatible with all image-editing tools and most programs (including word processors). • Allows you to use JPEGs to minimise file size • The Internet standard	• Images can start to fall apart if you make multiple exposure or colour changes, or make any extreme adjustments. This typically results in posterisation or banding, where smooth colour transitions become noticeably stepped.
16-BIT	• Allows a greater number of edits without affecting image quality • Allows more aggressive edits to be made without an adverse effect on image quality • More scope for highlight and shadow recovery	• Larger file sizes require more storage space • Not all editing tools (particularly plugins and filters) work with 16-bit images • Cannot use JPEG compression (usually saved as TIFF files) • 16-bit files can't be used online

LEFT/BELOW I was aware that this shot (left) would need to be processed a great deal to achieve the look I was after, so the answer was to shoot Raw and output the already quite heavily edited file as a 16-bit TIFF. I could then carry on adding textures and tweaking the colours to reach my intended goal (below).

UPSAVING

If you shoot JPEGs, you get 8-bit images out of the camera. Although your editing software will let you change these to 16-bit, there's zero benefit to this: The software won't suddenly add trillions of colours.

16-BIT RAW CONVERSION

Although 16-bit images are generally considered better, this only applies if your way of working includes heavy use of image-editing software after the Raw conversion stage. If your adjustments are all made to the Raw file, there's no real benefit to exporting it as a 16-bit image.

Layers

Although Layers won't make your editing non-destructive in the same way that editing a Raw file is, they're the next best thing if you're planning to shoot and edit JPEGs. They're also essential if you're looking to do any compositing work. The easiest way to understand layers is to think of them as sheets of acetate or tracing paper that sit on top of your image (your background layer). What you do on any one sheet (layer) will visually affect the layers beneath, but they will not actually modify the underlying image.

One essential use for layers is to add various elements in a composite image. As each element is on its own layer, you can move it and edit it independent of the background and any other layers. This is useful when it comes to fine-tuning selections and cutouts (especially around the edges of your component). By default, if you copy and paste from one image into another, the copied element will automatically appear on a new layer.

BELOW Layers are like transparent sheets of acetate: When you view them stacked you get the full picture, but each one can be adjusted and changed independently.

THE LAYERS DIALOGUE

Photoshop's Layers dialog has plenty going on, so it's worthwhile spending some time to familiarise yourself with the various options.

BLENDING MODE
Determines how the layer interacts with other layers in terms of its colour, transparency, and tone. The default is Normal.

OPACITY
Sets the transparency of the layer: the lower the Opacity, the more transparent it will be, allowing underlying layers to show through.

FILL
Determines the transparency of any layer styles.

LAYER MASK
Shows whether the layer has a mask attached, and provides a thumbnail preview of the mask (see opposite).

LAYER NAME
Layers can be named to make their content more obvious.

ACTIVE LAYER
The layer you're working on will be highlighted (here in blue).

LOCK OPTIONS
Lets you lock various layer elements.

LAYER VISIBILITY
Toggles the layer on and off so you can see its effect.

LAYER THUMBNAIL
Shows what the layer contains.

ADD LAYER STYLE
Applies a style to a layer, such as a drop-shadow or outer glow.

ADD LAYER MASK
Adds a mask to the layer (see opposite).

CREATE NEW FILL OR ADJUSTMENT LAYER
Adds a new adjustment (or fill) layer, as described opposite.

CREATE LAYER GROUP
Lets you group layers together into an easily identifiable folder.

DELETE LAYER

CREATE NEW LAYER
Add a new, blank layer. You can also drag an exiting layer onto this icon to duplicate it.

Adjustment Layers

Adjustment layers differ from regular layers in that they don't actually appear to contain anything: If you look at an adjustment layer on it's own, it just looks empty. This is because an adjustment layer contains invisible instructions (rather than image data), which tells your editing program to make some sort of change to all the layers beneath it.

Usually, you can pick from a range of preset layer options (left) which include a host of familiar tools, such as Hue/Saturation, Colour Balance, Levels, Curves, or Black & White. In each case, you'll be able to make the same adjustments to the layer as you would when choosing the tool from the main menu, but with one important difference: It doesn't actually affect the image. Because of this, you can go back into the adjustment layer at any time to tweak it, reduce its effect (via the Opacity slider), or remove it altogether if you change your mind.

As you can apply multiple adjustment layers, it's possible to perform and refine all of your essential edits (and a few more advanced ones), and only apply them to your image (by flattening the layers down) when you are absolutely satisfied with the work you've done. It's not quite non-destructive editing (there are some things that still need to be done to the image itself), but for JPEG files, it's as good as it gets.

LAYER MASKS

An alternative to making selections is to use layer masks to build up the edits on your images. The art of masks could form a chapter in itself, but in a nutshell, the idea is that a mask can be used to conceal and reveal certain parts of a layer.

Masks rely on you painting in the areas you want to reveal/conceal, using your editing program's various brush tools. This makes masks a slightly more natural process than the selection tools on the toolbar. An added bonus is that a mask can be edited at any time: You simply select the relevant mask and paint to modify it.

RIGHT To create this image, I manually combined four shots taken at different exposure settings. Each layer had a mask controlling what was (and wasn't) shown in the final image. As you can see in the Layers screenshot, the mask appears next to the layer thumbnail. Parts of the mask that are black indicate that part of the layer is concealed, while white on the mask means an area is revealed. Editing the mask simply requires you to paint into it with the relevant colour.

Lens Correction

As you saw in Part 3, no lens is truly perfect. They all exhibit defects to a certain extent, whether it's vignetting, distortion, or chromatic aberration. Luckily, the defects for a specific lens design are measurable, so we can determine precisely how much vignetting is produced by a Nikon 21mm wide-angle lens, for example, or the level of distortion apparent in a Canon 55–200mm zoom at a 135mm focal-length setting.

Software algorithms can then be created that reverse the defects, so vignetting, distortion, and chromatic aberration can all be dialled out. In some instances, this can be done in-camera, so the image is corrected before it is saved, which is great if you're shooting JPEGs, although you're usually limited to a finite number of the camera manufacturer's own lenses.

Alternatively, the correction can be applied during post-processing. This is usually preferable, as it allows you to access a much wider range of camera and lens combinations, including third-party lenses. However, there will always be some combos that aren't supported, particularly if you're using alternative lenses or vintage glass or a digital camera body. In these instances, manual correction is the only option.

Pick a Profile

Although Photoshop and Lightroom have a range of built-in profiles for correcting your images automatically, I'm a big fan of DxO's OpticsPro software. Emerging from the company's in-depth digital camera and lens testing program, OpticsPro was originally designed as a fully automated image optimiser that read the EXIF data, identified the equipment being used, and corrected all the defects in the photograph. Today, the software has been expanded into a more rounded image optimisation tool (with a particular emphasis on Raw processing). The company's FilmPack software is also worth a look if you want to experiment with some pretty authentic-looking film effects.

Lens Correction Filter

As well as having a comprehensive list of preset camera and lens profiles that you can apply automatically, Photoshop's Lens Correction filter (*Filter > Lens Correction*) offers a full set of tools for manually correcting geometric distortion, chromatic aberration, and vignetting.

RIGHT There was some quite obvious vignetting in this shot, but Photoshop had the perfect profile to dial out the corner shading automatically.

THIS PAGE I used an original Lensbaby with some extreme movement applied to it for this photograph, which meant a high level of fringing and no automatic profile. However, a few minutes with Photoshop's Lens Correction filter quickly cleared things up.

BEFORE

AFTER

Curves

The Curves adjustment is a great tool for making precise changes to the tones in your image, whether that's to fine-tune the overall brightness of the image, to add or reduce contrast), or perhaps to create a crazy solarised effect in the style of Man Ray. However, as versatile as Curves is, it isn't the most intuitive tool you will come across, which is why many people steer clear of it. Once you know how to use it, it can be quite useful.

BLACK MIDTONE WHITE

DARKS LIGHTS

LEFT/RIGHT In Photoshop (and most other programs), the curve consists of two main elements. The first is a histogram. As with a regular histogram on your camera, the horizontal axis represents the tones in the image, running from black at the left to white at the right.

The second element is the curve, which starts as a straight line running from bottom left to top right. Again, this line relates directly to the tones in the image (black at the left, white at the right, and all other tones in between).

In this illustration, the coloured dots on the line correspond to the coloured marks on the image, so you can see where the dark, mid, and light tones in the image fall on the curve. (Note: the magenta at the top right of the curve represents pure white, which isn't seen in this image.)

Adjusting Curves

To manipulate the tones in your image, you simply click on the relevant part of the curve and drag the curve up or down. As long as you don't move the end points, the black and white points in your image are effectively locked down, which prevents clipping. Here is a selection of basic Curves adjustments:

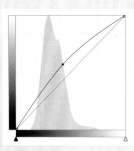

LIGHTEN MIDTONES
To lighten the midtones in your image, add an adjustment point toward the centre of the curve and pull it upward.

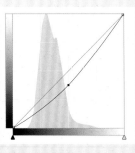

DARKEN MIDTONES
Adding an adjustment point toward the centre of the curve and pulling it downward will darken the midtones.

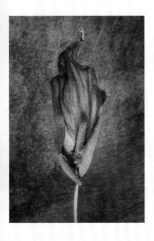

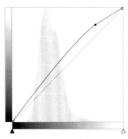

LIGHTEN HIGHLIGHTS

Select a point toward the right of the curve and you'll start to manipulate the highlights: drag the point upward to lighten (as here) or down to darken.

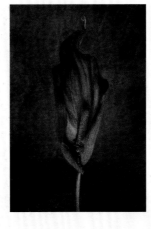

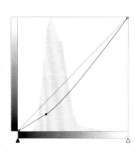

DARKEN SHADOWS

If you add a point at the left of the curve, you can darken the shadows (by dragging the curve downward, as illustrated), or lighten them by lifting the curve.

S-CURVE

An 'S-curve' (named after its lazy S-shape) is perhaps the most common curves adjustment. An S-curve lifts the highlights and darkens the shadows, raising contrast without clipping.

MULTI-POINT CURVES

You're not limited to one or two adjustment points. For my final curve, I essentially combined an S-curve with a midtone lift to intensify the shadows, lift the midtones, and lighten the highlights. I then went on to split-tone the image (as outlined in pages 344-345).

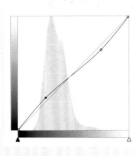

REVERSE S-CURVE

Reversing the S-curve, so the shadows are lifted and highlights are darkened will reduce the overall contrast of your image.

Noise Control

Camera manufacturers are increasingly cranking up the maximum ISO in their cameras. This is arguably one of the most significant advances in digital photography in the past few years, and as ISO settings have increased, so too has the noise floor on cameras, so where ISO 800 might once have been a bit noisy, now we can find ourselves shooting clean images at ISO settings of 1600 or more.

However, no matter how advanced your camera is, at some point, noise is going to be an issue. It might not be until you reach ISO 3200, but it will eventually start to affect your image. It's also true that the best in-camera noise reduction in the world won't be any use to you if you've got an archive of images from an older camera, or if you shoot using more than one camera. Your system camera might have cutting-edge noise reduction, but it's unlikely that your smartphone is going to be quite so sophisticated. Thankfully, your image-editing software will probably have a range of tools to help you silence those noisy shots.

Manual Chroma Noise Reduction

Chroma noise appears as coloured speckles in your image, which rarely looks good (unlike luminosity noise, which can give images an underlying texture that is at least slightly reminiscent of film grain). The trick to successfully removing chroma noise from your JPEGs is to target the colour, without affecting the detail in the image. In Photoshop, that means combining blurring and Lab Colour.

1 The first step is to convert the picture into Lab Colour mode (*Image > Mode > Lab Colour*). Unlike RGB mode (which divides the image into red, green, and blue colour channels), Lab mode splits a picture into a Lightness channel and two colour channels (a and b). This means you can adjust the colour independently of the black-and-white Lightness image, so you can reduce noise without affecting detail.

This shot was taken at a high ISO, without any in-camera noise reduction. The chroma (colour) noise is pretty horrendous, but there's no reason why the image can't be

LAYERS	PATHS	CHANNELS	
👁		Lab	⌘ 2
👁		Lightness	⌘ 3
👁		a	⌘ 4
👁		b	⌘ 5

2 Open the Channels window (Window > Channels) and click on the 'a' channel to select the first colour channel. Use Photoshop's Median filter (Filter > Noise > Median) to reduce the noise in this channel. For this image, a setting of 15 removed the noise, but all images are different.

Repeat the process with the second colour channel – the 'b' channel – applying the Median filter again, using the same settings.

3 Click on the Lab channel in the Channels window to see all three channels combined into a full-colour image again. Applying the Median filter to the two colour channels will have dramatically reduced the colour noise in the image, but it will also decrease the colour intensity slightly – this is easily fixed by boosting the Saturation.

The corrected image prior to an increase in saturation and sharpening. The colour noise is gone, but the detail has been retained.

Selective Edits

Often, you'll want to make universal changes to your image – to adjust the exposure of a shot, tweak the contrast, sharpen it, and so on. Other times, though, you might not need to make such universal edits. In fact, sometimes this type of global adjustment can do as much harm as good. Why? Because sometimes the action that's needed to optimise one part of an image can be detrimental to another part of it.

For example, when you sharpen an image, you only need to sharpen edge detail. Sharpening the blue tones in the sky of a landscape, or the skin in a portrait just isn't necessary. It won't make them look sharper because they're fairly continuous areas of flat colour. The best that will happen is that you'll sharpen any underlying noise.

Noise is often most apparent in areas of flat tone, whereas it can be less noticeable in more detailed areas. So, noise reduction can often benefit those skies and skin tones, but adversely affect detailed areas, where the processing can start to remove detail as well as noise.

In both cases, what's needed is a more selective approach to editing. This type of local adjustment can also help you when you want to make other small-scale changes, such as boosting the contrast in one specific area using Curves, darkening or lightening a particular part of the image using Levels, or perhaps even creating a colour pop effect by converting part of the image to black and white while leaving one small part in colour. Whatever the purpose, you'll need to start by selecting the area you want to target.

RIGHT The high contrast of the lighting here was begging for a black-and-white conversion, but the gentleman's jacket was much brighter than the rest of hit outfit, and he wasn't appearing as strongly against the bright background – he needed to have a uniformly dark figure. So only the jacket was selected and adjusted (a combination of pulling up the black point and shifting the hue) until it matched the trousers, shoes, and umbrella in tone.

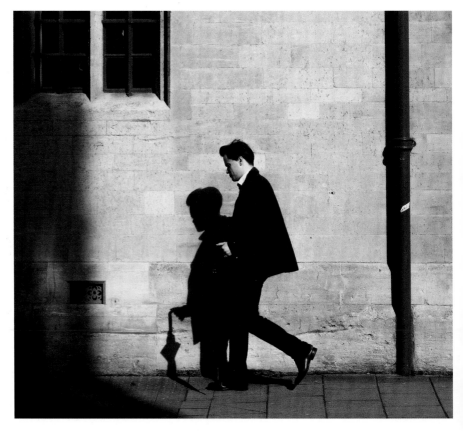

Selection Tools

Most editing programs have an array of selection tools to help make your life as easy as possible, but you still need to pick the right tool (or tools) for the job. These are a range of Photoshop's tools, but they tend to have equivalents in other programs.

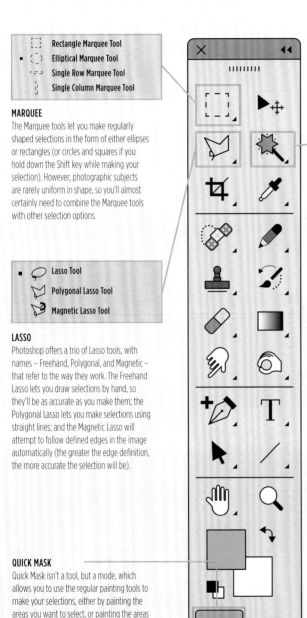

	Rectangle Marquee Tool
■	Elliptical Marquee Tool
	Single Row Marquee Tool
	Single Column Marquee Tool

MARQUEE

The Marquee tools let you make regularly shaped selections in the form of either ellipses or rectangles (or circles and squares if you hold down the Shift key while making your selection). However, photographic subjects are rarely uniform in shape, so you'll almost certainly need to combine the Marquee tools with other selection options.

	Lasso Tool
■	Polygonal Lasso Tool
	Magnetic Lasso Tool

LASSO

Photoshop offers a trio of Lasso tools, with names – Freehand, Polygonal, and Magnetic – that refer to the way they work. The Freehand Lasso lets you draw selections by hand, so they'll be as accurate as you make them; the Polygonal Lasso lets you make selections using straight lines; and the Magnetic Lasso will attempt to follow defined edges in the image automatically (the greater the edge definition, the more accurate the selection will be).

QUICK MASK

Quick Mask isn't a tool, but a mode, which allows you to use the regular painting tools to make your selections, either by painting the areas you want to select, or painting the areas you don't want to select. Usefully, you can convert an existing selection into a quick mask, and then modify it using the painting tools.

QUICK SELECTION

With this semi-automated selection tool you paint roughly over the area you want to select and Photoshop will attempt to identify edges and tidy the selection for you. It works sometimes, but not always – a clear-cut edge is a distinct advantage!

	Quick Selection Tool
■	Magic Wand Tool

MAGIC WAND

When you click on a tone or colour in your image with the Magic Wand tool, Photoshop will attempt to automatically select similar tones/colours from the entire image (you can control how similar the tones/colours need to be by adjusting the Tolerance). This is a great way of making selections based on colour, but for greatest accuracy, it is best to set a low Tolerance and Shift-click to add to the selection.

COLOUR RANGE

Select: ✎ Sampled Colours

☐ Detect Faces
☐ Localised Colour Clusters

Fuzziness: 97

Range:

● SELECTION IMAGE

COLOUR RANGE

Colour Range hides under the Select menu, and opens a dialog that allows you to make selections based on colour (similar to the Magic Wand). You can either sample colours in the image yourself to select them, or pick from a preset range of colours (including skin tones). The Fuzziness slider can then be used to set just how wide or narrow the selected colour range is.

SELECTIONS IN ACTION

Although you can (theoretically) use a single selection tool, most of the time, you'll find that you need to use multiple selection tools to make the most accurate selections or to go back and fine-tune the selected area. The following walkthrough – a simple colour popping exercise – demonstrates how you can create, refine, and control your selections.

1 My starting point is a shot of an empty physalis calyx on a round wooden table from a doll's house. The plan is to convert the table (and its surrounding background) to black and white, while leaving the calyx in (muted) colour.

2 My first selection starts with the Freehand Lasso tool, drawing loosely around the calyx to make a rough selection. The selection will be indicated by a set of 'marching ants' (black and white flashing lines) that appear to move around the image.

3 Different images will require you to use different tools to refine the selection, but here, I'm going to switch to the Magic Wand, setting its Tolerance to 8. Holding down Alt (Windows) or Option (Mac) while I click with the tool lets me subtract from my existing selection, taking it to the edge of the calyx.

4 To get to this stage, I just kept Alt/Option-clicking on the table with the Magic Wand. Each click narrows the selection down a little more, tightening it around the seed pod.

5 Although the magic wand selection got me pretty close, it also picked up a couple of bits of calyx as well, so I need to add these back to my selection. You can add to a selection by holding down the Shift key while you select; in this instance, I'm using the Freehand Lasso to refine my selection.

6 Keep going, holding down Shift if you need to add to it, or Alt/Option if you need to subtract from it: These keyboard controls will work with any of the toolbar selection tools. It will also help if you zoom in so you're really seeing the edges – I like to make my selections with the image at least 100% (or Actual Pixels), zooming in to maybe 200–300% at times.

7 When you're happy that your selection is accurate, it's a good idea to feather it before making any adjustments to the image. This simply means softening the edge of the selection so the adjustment you make won't have an abrupt transition. If your selection is accurate, feathering it by 1 pixel (using **Select > Modify > Feather**) will be enough.

8 With this image, I have one final step before I can make my changes. Because I want to change the background to black and white, I need to reverse my selection; at the moment it's the central calyx that's selected, so that's what would be affected by any changes. To invert a selection use **Select > Inverse**.

9 Finally, you can make your local adjustment, whether that's S-curves, Levels, Colour Balance, Saturation, or even a filter effect. Here, I started by making a change to the intensity of the background.

RIGHT Selective edits have a lot of uses. Using the steps on this page as a starting point, I went on to desaturate the background, make localised brightness and contrast adjustments to the table using Curves, and boost the intensity of the physalis calyx.

ABOVE There's no denying it – the built-to-budget kit lens that took this shot just isn't sharp. However, just because the lens is junk, that doesn't mean the images it takes have to go in the trash: Photoshop can save them.

Edge Sharpening

A mantra that's commonly repeated in photography is 'buy the best lenses you can afford', and it really is great advice. It's really easy to get carried away by new camera launches, and fall for the marketing pitch that promises us the latest-and-greatest camera model will be everything we need to improve our photography. While that might be true to a certain extent, the lens you use is more important, because that's the part that initially gets the light to your sensor: If it doesn't do that job well, everything that follows will be compromised, no matter how amazing your camera is.

As we've already seen, not all lenses are equal, and some – especially certain kit lenses that are built to a budget price – are not always delivering the results that your camera is capable of. The shot I'm using here (above left), demonstrates this perfectly. I know that the DSLR I was using can take a good (sharp) picture, because it's done it thousands of times before.

However, with this specific budget kit lens attached to it, it's simply appalling. Despite the camera's AF locking on the boat, the shot just isn't sharp, and nor are the majority of images taken with the same lens.

Now, the temptation is to sharpen the whole image to bring back some much-needed clarity, but because the picture's so soft, the amount of sharpening needed would be very high and that would almost certainly lead to a great deal of noise in flat areas, such as the sky, and distinct halos around the finer detail. Instead, what you'll need to do is target very aggressive sharpening to just the edges of the detail areas, so only those edges appear sharper.

1 The first step is to identify the edges in the picture. To do this, head into the Channels window and identify the colour channel that exhibits the greatest contrast between the detail you want to sharpen and the flat tones that you don't. Here, the Green channel is the best of the three.

2 Duplicate your chosen channel by dragging it onto the Copy icon at the bottom of the Channels window. Then, with the duplicate channel selected, use the Find Edges filter (*Filter > Stylise > Find Edges*) to identify the edges within the image.

3 The outlines in the resulting line drawing are effectively the edges that you want to sharpen, but to better isolate them, you need to make sure they're black, and any areas you don't want to sharpen are white. You can do this using Levels: Drag the black slider to the right and the white slider to the left to boost the contrast and create a strong black-and-white line image.

4 Next, convert your line drawing into a selection using Photoshop's Colour Range tool. When the Colour Range dialog opens, click on the image to choose the black lines, and tweak the Fuzziness slider to ensure that any lines that are dark grey (rather than pure black), are also selected. Click on OK and you'll get the standard marching ants selection around the black lines.

5 So your selection applies to the whole image, delete your copied colour channel and click on the RGB channel in the Channels window, so you're working on the photograph as a whole. The selection will remain active.

6 Finally, sharpen those edges! Photoshop's Smart Sharpen filter (*Filter > Sharpen > Smart Sharpen*) is good for this: choose Lens Blur from the Remove option drop-down list, and set a high Amount and a high Radius to combat the softness. Although the sharpening is high, it's only being applied to the selected edges, so it won't affect the rest of the image. As the detail shot shows, the difference between this and the from-camera shot is vast.

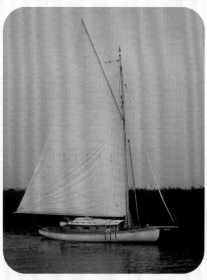

ABOVE This is the final shot, processed to give it a vintage vibe (and with a touch of added noise to make it appear even sharper).

Stitched Panoramas

If you like to shoot landscapes, seascapes, cityscapes, or any other type of 'scape, then you'll definitely want to know about panoramic images. The long, thin frame shape is often ideal for photographing sweeping vistas, but without large swaths of sky or dead foreground. Although you can shoot as normal and then crop to a panoramic format or shoot using a panoramic aspect ratio, both of these options will eat into the image you take, reducing the number of pixels and potentially limiting the maximum usable image size – and why would you want to shoot a big view that can only be printed small? No, a much better answer is to create a multi-shot, or 'stitched', panorama, which creates a panoramic image from multiple frames. In an instant, the resolution of your image will skyrocket, and that stunning 'scape can be shown in all its glory.

PANORAMA VARIETY

You don't have to stick to making just horizontal panoramas: the same technique can be used to shoot vertical panoramas as well.

Nor do you have to shoot single-row panoramas – by panning the camera upward as well as horizontally, you can create super-hi-res stitched images.

SHOOTING

Shooting for stitched panoramas is a bit like shooting for HDR in that you need to think about it at the capture stage. In this instance, you need to follow a few simple steps before you trigger your shutter:

1. Set your camera up on a tripod. You can shoot handheld if you want, but it's easier if your camera is mounted on a tripod.

2. Line your camera up at one end of the scene you want to photograph. It doesn't matter which end you choose.

3. Switch to Manual and set your exposure. Any automatic exposure settings could cause the exposure to change between frames. For most landscapes, you'll probably want to set the aperture in the region of $f/8$–$f/16$ to give a decent depth of field.

4. Choose a preset white balance or make a custom WB: You need the colour to remain consistent between shots, so don't rely on Auto WB.

5. Take your first shot and check the histogram. If the exposure is off, fine-tune and shoot again.

6. Once you've nailed your first shot, turn the camera slightly in order to frame the next part of your panorama. The key here is to make sure your second frame overlaps the first – your software will need some overlap to line up your shots. Overlapping by 1/3 of the frame is usually more than enough, but it's better to have more than too little.

7. Shoot your second image, turn the camera, and shoot your third, remembering the all-important overlap. Continue turning the camera and shooting until you've covered your scene from end to end.

ABOVE It doesn't matter if you turn the camera from left to right or right to left when you shoot your initial images: what's more important is that the individual images overlap and that your camera settings (particularly exposure and white balance) remain consistent across the sequence.

PROCESSING

Back at your computer, download your images and open up your stitching program. You might want to try a specialist program for this, such as PTGUI (like Miss Aniela on pages 310–313), but Photoshop's Photomerge tool can also do the job, as outlined here.

1 If you shot Raw, the first step is to process your images. Once processed (or if you shot JPEGs), open Photoshop and choose *File > Automate > Photomerge* from the main menu. Use the dialog's browser to locate your image sequence on your hard drive, and then check Auto from the Layout options and Blend Images Together from the bottom of the dialog. Click on OK to continue.

2 Photomerge will now chug away and try to create a seamless panorama from your images. When it's done, each individual image will appear on its own layer with a layer mask attached. Sometimes, the result will be great right away, but other times, you might need to zoom in and refine the masks a little. Don't rush this stage, because the more accurate the masks are, the better your stitched panorama will be. Here, for example, there's a slight issue across the top of the distant mountains that needs fixing.

3 When you're happy your masks are as pixel-perfect as they're going to be, flatten down the layers (*Layer > Flatten Image*) so you're not working on a bloated file.

4 Because of the way the process works, you'll probably have a slightly ragged edge to your image, but it's nothing the Crop tool can't handle.

5 Your flattened and cropped panorama is now ready for any additional processing, so you can convert to black and white, punch up the colour and contrast, filter it, or whatever else you feel it needs before saving and sharing.

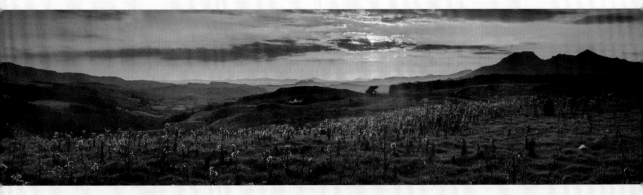

Black & White

Black-and-white photography has been revolutionised thanks to the digital age, as we no longer have to get our hands wet in the darkroom to create monochrome masterpieces.

Of all the creative twists you can give a photograph, stripping it back to shades of grey is by far the most popular. It may be because black-and-white pictures have a timeless feel that harks back to seemingly more innocent times; perhaps because they're seen as more arty than colour images; or purely because we love their pared-down, abstract appeal in an otherwise busy world of colour. Whatever the reason, it's easier than ever to explore black-and-white photography, as every camera lets you shoot in monochrome; editing software lets you convert your colour images to black and white; and

some desktop photo printers will even let you print your colour shots in greyscale.

Unless you absolutely need to use your black-and-white shots straight from the camera, the best option is to shoot in colour and use your image-editing software or a dedicated black-and-white plugin to convert your files. This is simply because most programs and plugins will give you far more control over the process than your camera. It also means you'll have a colour version, so if you later decide that you don't like the black-and-white shot, you can go back and rework it.

WHERE?	PROS	CONS
IN-CAMERA (JPEG)	• Get a black-and-white result straight away • You can see the monochrome result on the screen when you shoot (in Live View). • You can apply colour-filter effects to modify the tonal range. • Most cameras let you apply cyanotype and sepia toning effects (and possibly others as well).	• If you only shoot JPEGs, the monochrome effect is fixed; you don't have a colour option. • Limited range of filter and toning effects (but better than none!).
POST-PROCESSING (INCLUDING RAW)	• Most editing programs offer multiple conversion options, so you can choose the best one for you. • You typically have a huge range of control over the tonal range of your monochrome conversion. • You can emulate darkroom effects, such as dodging and burning and localised contrast control. • Offers expansive range of toning effects • You can use dedicated black-and-white plugins that promise even greater creativity.	• Images need to be processed and worked on after they've been shot. • Arguably too many filter options are available; it's easy to spend inordinate amounts of time making incredibly minor adjustments.
PRINTER	• Requires virtually zero effort, other than checking a greyscale print option.	• Often provides little (if any) control over the result.

ABOVE Black-and-white photographs are naturally abstracted from the colour world, and have an innate timeless quality to them. Although this photograph was taken in the 21st century, it was given a heavily stylised treatment reminiscent of the very earliest 19th-century photographic processes.

RAW VS. JPEG

Raw files are always in colour: even if you set a monochrome mode in-camera, you can undo it when you process the shot.

If you shoot Raw and JPEG simultaneously, you can tweak the in-camera contrast and filter options to preview how your image could look, then simply recreate the effect with your Raw file during post-processing.

Basic Conversions

The most rudimentary black-and-white conversions will simply remove the colour from your photographs, transforming colours into shades of grey. This is usually the route taken by your camera if you set an unmodified monochrome Picture Style, or if you choose to desaturate a photograph or change it from RGB to Greyscale in your editing software.

Although this will get you a black-and-white image with little or no fuss, it's pretty much guaranteed that it won't give you a great black-and-white image. The problem is, when you desaturate an image, the colours are turned into shades of grey based on how bright they are. As a result, yellow and light blue could easily convert to the same light grey, or mid-red and mid-green might both convert

to an identical mid-grey tone. So, while the difference between colours will be blatant in a colour image (especially with complementary colours such as red and green), they can start to merge together if they convert to the same grey tone. The result? You will end up with a drab black-and-white picture lacking any wow factor.

DESATURATE

CONVERT TO GREYSCALE

ABOVE This is the standard colour wheel that you saw in the previous chapter, converted to black and white in Photoshop using the Desaturate command and by changing the mode from RGB to Greyscale. Although the two conversions are slightly different (particularly when it comes to the brightness of the yellow) neither is ideal, as there is no control over how the colours turn into shades of grey. The Desaturate option is especially disappointing, with very little difference between the various hues.

ABOVE The blue clothing and orange background contrast strongly in colour, but when you remove the colour by simply desaturating the image, much of the impact is lost. Compare this to the examples on page 337.

ABOVE/RIGHT A simple monochrome conversion isn't always a bad thing. For this delicate floral study I wanted a relatively flat result, so I was happy just to desaturate it and let the blue/green and brown colours all turn a similar shade of grey.

Advanced Conversions

To liven up your black-and-white conversions, you need some way of controlling how the colours are turned into grey tones. The answer lies in coloured filters, which are used by film photographers to manipulate tonal range. Plain-coloured filters allow wavelengths of the same or similar colour through, and block wavelengths that are different. So, a red filter allows red wavelengths through (as well as some orange, yellow, and violet), while blocking blues and greens. The effect on the image is that reds appear lighter and blues and greens appear darker – ideal for darkening the sky in a landscape shot, for example.

With digital cameras there's little need to use plain coloured filters over the lens. Most cameras have built-in coloured filter effects that digitally filter the image, and if you're shooting JPEGs this is a whole lot easier (and cheaper) than using physical filters in front of the lens.

However, converting colour to monochrome on your computer is a better option still. All decent Raw conversion software and image-editing programs will have an array of digital colour filters that allow you to control how colours turn into tones. Unlike their camera-based equivalents, software filters tend only to target their own colour; so while a red filter in front of the lens would lighten reds and darken blues, a software-based red adjustment is only going to lighten or darken the reds. If you want to affect blues, you would need to make a separate adjustment. The advantage here is precision, as you can tweak and tune in a way that was simply not possible on film; the downside is that it's easy to get bogged down when you have so many options available to you.

+ GREEN

+ CYAN

+ BLUE

THIS PAGE Photoshop's Black & White dialog lets you adjust different colour groups, so you can control how the colours translate into grey tones: increasing the value for a colour lightens it, while decreasing the value darkens it. Some programs offer even more colour-tuning options, for even greater control over the conversion process.

	▢ ◯	**Black & White**
Preset:	Default	⇕
✋	● Tint ▢	Auto
Reds:		40%
Yellows:		60%
Greens:		40%
Cyans:		60%
Blues:		20%
Magentas:		80%

+ YELLOW

+ RED

+ MAGENTA

BLUE FILTER

THIS PAGE As well as manually tweaking the filtration, the Photoshop Black & White dialog offers a range of Preset options. This is the same image from the previous pages, but with a range of traditional filters applied. The difference between the filtered and unfiltered black-and-white conversions is obvious (but note how similar red and yellow are in this instance)!

GREEN FILTER

Default

Blue Filter
Darker
Green Filter
High Contrast Blue Filter
High Contrast Red Filter
Infrared
Lighter
Maximum Black
Maximum White
Neutral Density
Red Filter
Yellow Filter

Custom

RED FILTER

YELLOW FILTER

LEFT For this manual black-and-white conversion, I chose to darken the greens and cyans and lighten the reds and yellows.

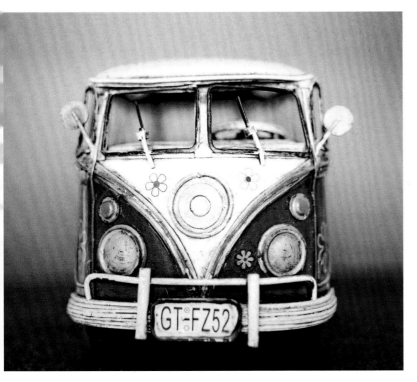

Reds:	41%
Yellows:	70%
Greens:	−25%
Cyans:	−61%
Blues:	78%
Magentas:	−8%

Raw Conversion

Adobe Camera Raw and Lightroom share a very similar set of tools, and this extends to their black-and-white conversion options. I'm using Lightroom here, which will work with Raw and JPEG files alike.

Note that it offers a couple of additional colours in its mixing dialog compared to Photoshop, which is perfect in this instance.

1 The conversion process starts by checking the Greyscale option, which gives a simple monochrome conversion.

2 The Greyscale Mix sliders are where you can start to manipulate the conversion. Here, I've reduced (darkened) Orange, which darkens the upper section of the building.

3 Increasing (lightening) Yellow lifts the bottom section of the building, further separating the upper and lower sections.

LEFT The original colour image contains distinct layers of colour, which simply disappear in a basic monochrome conversion. Without any separation between the pink and yellow boards, the shot looks too flat, but this is easily resolved with a few simple filter tweaks.

4 Reducing Aqua and Blue darkens the glimpses of sky, increasing the contrast at the top of the shot...

5 ...and sliding the Green slider over to the left darkens down the windows.

ABOVE Following a couple of Contrast and Clarity tweaks, the conversion is finished. The result? A strong black-and-white with plenty of punch where I want it, and clear separation of the originally similar tones.

Dodging & Burning

For anyone looking to produce prints in a traditional darkroom, dodging and burning are essential skills to learn, as they can transform a competent print into an outstanding one. I'm not going to go into the mechanics of darkroom printing, but in a nutshell, the processes involve giving certain parts of the print a longer exposure to make them darker (burning), or a shorter exposure to make them lighter (dodging). In this way, elements within the image can be made to advance or recede (burning the background to make it darker will make the subject stand out more, for example); and the contrast of small areas can be controlled precisely (such as burning in highlights to make them less stark).

Like most darkroom effects, dodging and burning have their digital equivalents, which are equally useful. As before, the techniques discussed here are simply my preferred way of working (in Photoshop), and they can be applied to any image, regardless of the whether you generate your black-and-white shots in-camera or via software.

Like many image-editing programs, Photoshop's toolbox includes both Dodge and Burn tools, which are a logical start point. However, I tend to limit their use to small areas of the image that need precise adjustment – for larger areas, I'll make selective Levels or Curves adjustments.

1 You'll find the Dodge and Burn tools in Photoshop's toolbar; they're nested so you'll need to click and hold on the relevant icon to switch between them.

2 The tool options at the top of the image window reveal various controls for the Dodge or Burn tool, but the four that are most useful are:

BRUSH SIZE RANGE EXPOSURE PROTECT TONES

3 Start by setting the Brush Size and its Hardness. I tend to work with a soft brush a lot of the time, so the adjustments I make blend into their surrounding areas. To me, this gives a more authentic look, as dodging and burning in the darkroom is rarely ultra-precise.

4 Next, choose the Range. This is the tonal area that the tool will affect, and your options are Highlights, Midtones, or Shadows.

Shadows
Midtones
Highlights

5 Exposure determines how intense the dodging or burning is. A word of warning here: very small values (in the region of 5%) are best here, as the tools are quite strong when you apply them.

Exposure: 5% ▾

6 Finally, check the Protect Tones box if you want to reduce the chance of clipping when you lighten highlights or darken shadows. Generally speaking, clipped shadows (which will be pure black) are more acceptable than clipped highlights, so you may want to switch between having Protect Tones active or not, depending on the tones you are working on.

7 Now, it's simply a case of clicking and dragging your mouse to dodge or burn your chosen tones. Because you're using a low Exposure value, you may need to go over your target area several times to build up the effect, but as with choosing a soft brush, this helps to avoid any obvious edges appearing. As you work on your image, vary the Brush Size as necessary – and its hardness if you want to – and switch the Range to alter your target tones.

BELOW For this woodland scene, I dodged and burned to concentrate attention at the centre of the image. This meant burning in some of the brighter leaves around the edges of the frame so they were less obvious, and darkening the shadows at the centre to increase contrast.

BEFORE

AFTER

Toning

When black-and-white prints were made in the darkroom, toning was as much a technical necessity as it was a creative endeavor. Toners were (and still are) routinely used to prolong the life of a print, modify contrast, or change the monochrome from grey to some other colour, depending on the toner used.

Today, we obviously don't need to chemically tone our digital prints to preserve them, and there's certainly no practical reason why a black-and-white digital image needs to be toned. Instead, toning is a purely cosmetic exercise, designed to enhance the look of a monochrome image and perhaps lend it a vintage vibe.

Image-editing software makes toning incredibly easy, and it is also far more controllable than traditional chemicals. Whereas you would be limited to sepia/

brown, blue, and a few other colours with chemical toning, image-editing software provides a near-infinite range of colour options, with ultra-precise control over the hue and saturation. You can now tone your images with any colour, no matter how subtle or garish it is, and if you change your mind, you can simply undo it and start again.

However, despite the huge possibilities, most image-editing programs have a core set of pre-programmed toning options that attempt (with varying degrees of success) to emulate classic photographic print tones. Consequently, all it takes is a click of your mouse, and you can instantly give your images a sepia, blue, green, selenium (purple/brown), or gold (blue) tone. It is also just as easy to recreate the look of a vintage printing style, such as cyanotype or any one of the brown print process – a selection of such looks appear opposite.

ABOVE Photoshop's Black & White option not only lets you convert a JPEG or TIFF to monochrome, but you can tone it as well. Once you've set your filters for your monochrome conversion, simply check the Tint box at the bottom of the dialog and use the Hue and Saturation sliders to add a tone and control its intensity.

ABOVE You can tone a Raw file in Adobe Camera Raw (or Lightroom) via the Split Toning palette. Use the Hue and Saturation sliders in the Shadows section of the dialog to set the colour and intensity of your tone, leaving the Highlights sliders set at 0. Then, to apply the toning effect to the mid-to-light parts of the image, as well as the darker areas, shift the Balance slider to the left.

ABOVE Most image-editing programs will give you a selection of preset toning options – this is a selection of preset options from three applications I routinely use (Photoshop, DxO Optics Pro, and CameraBag), some of which are more pleasing than others.

TOP ROW, FROM LEFT Photoshop Hue/Saturation Cyanotype, Photoshop Hue/Saturation Sepia, DxO Optics Pro Ferric Sulfate, DxO Optics Pro Sepia

BOTTOM ROW, FROM LEFT DxO Optics Pro Gold, DxO Optics Pro Selenium, CameraBag Explorer, CameraBag Cyanotype

Split-Toning

As well as toning prints with a single chemical toner, some traditional darkroom workers like to split-tone their black-and-white shots. This involves using two toners, one after the other, to give the shadow and highlight areas in the print a different colour. The actual result depends on which toners are used (and in which order); the density of the original print; the dilution, age, and temperature of the chemicals; the toning time; the paper the print was made on; and several other factors. The upshot of all these variables is that you're virtually guaranteed that a wet (darkroom) split-toned print will be a unique and unrepeatable artwork.

Now, on the one hand, you could argue that image-editing software has taken a slightly hit-and-miss process and perfected it: It is far easier to split-tone an image digitally; the process is far more controllable; you can tone with an endless array of colour combinations; toning is consistent; and you can save your favorite colour combos and apply them identically to multiple images.

The counter-argument (and one that is just as valid) is that software has removed the soul from split-toning, replacing one-off prints with regimented, production-line products.

Either way, split-toning is another option if you want to add colour to an otherwise grey image. By far the most popular approach (both chemically and digitally) is a sepia/blue split that delivers warm yellow/brown/red highlights, which contrast beautifully with cool cyan/blue-tinged shadows. Obviously, you can experiment with alternative colours if you want to, but for me – and this is just personal opinion – echoing the traditional toning colours, and working with warm and cool tones will help you avoid unnecessarily garish results.

Split-toning a Raw file is easy if you're using Adobe Camera Raw or Lightroom, because there's a dedicated Split Toning panel (which can also be used for a straight tone). Simply use the Hue and Saturation sliders under Highlights to set the colour and intensity of the highlights, and the same sliders under Shadows to set the tone for the darker areas. The Balance slider determines which colour is more dominant.

Photoshop's Colour Balance (*Image > Adjustments > Colour Balance*) is a super-simple way of adding a split tone to a monochrome TIFF or JPEG image, although the results can be fairly primitive.

1 With your black-and-white image open, select *Image > Adjustments > Colour Balance* from the main menu. Make sure that Preserve Luminosity is checked at the bottom left of the dialog – this ensures that the image brightness is preserved.

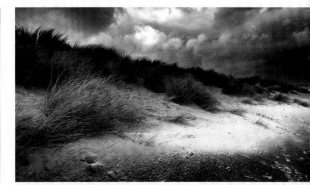

2 Click on the Shadows button and use the three colour sliders to set your highlight tone.

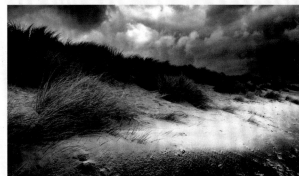

3 Click on the Highlights button and use the three colour sliders to set your highlight tone. At this point, it's likely that your highlights will blow out, but this can be recovered.

4 Use Levels to bring the highlights back. Move the white slider under Output Levels to the left. For this image, I've also adjusted the black Output Level slider to subtly lift the shadow.

PART 6
In the Bag

It's more than likely that you've already got a camera of some description, and hopefully it does everything you ask of it. However, there may come a time when you want to move on (and move up), or simply explore alternative options. You may wonder what else is out there and what it offers you.

In this section, we look at digital cameras and the technology inside them, as well as their old-school counterpart – film. We'll also explore how a few simple steps can improve your results from both.

Camera Types

There are numerous camera designs available, and the range of styles is constantly evolving as manufacturers try different things to make their camera the best. Choosing which one is right for you will largely depend on what you want to use it for and, of course, your budget.

Digital SLR Cameras

For a long time, digital SLRs (or DSLRs) were the only choice for serious photographers. This has to do with a number of factors: Their large sensor sizes compared to compact and bridge cameras offered the best image quality practically available; these cameras were a natural evolution from 35mm film SLRs, enabling people crossing over from film to continue using lenses they already owned; and finally, DSLRs were simply perceived to be the highest standard in digital cameras.

Arguably, the main benefit of a DSLR is the size of its sensor. APS-C and full-frame sensors are the most common, and they deliver high-quality images, even in low-light levels. This benefit is followed closely by the optical viewing system, which provides you with a real, through-the-lens view of your subject and gives a DSLR its name.

However, as mirrorless cameras have matured in recent years, they have increasingly eaten into the DSLR market. Consequently, a DSLR is no longer the only choice, although it is still a compelling one (and remains the tool of choice for the vast majority of professional photographers).

ABOVE DSLRs come in an array of sizes and colours, and fall into three broad categories: entry level, such as the Olympus OM-D E-M10; mid-range, like the Sony Alpha A77II; and professional, like Canon's EOS 1Dx Mark II.

DSLRS AT A GLANCE

Good for: Photographers who want or need the flexibility offered by an expansive camera system.

PROS	CONS
• Most DSLR systems are backed by an established (and comprehensive) range of lenses, flashes, and other accessories.	• Cameras are typically big and bulky compared to most other designs.
• Image quality: Full-frame and APS-C sensors (and, to a lesser extent, Micro Four Thirds sensors) enable clean images, even at high ISO settings.	• It's easy to get locked into a system once you have a couple of lenses and accessories.
• Optical viewfinder: gives a real, optical view of the world, rather than a digitised screen.	• Viewfinder doesn't always provide 100% coverage, especially on enthusiast models.
• Fast AF systems and frame rates (which is why DSLRs still bristle along the sidelines of most sporting events).	• Can have a steep learning curve; there is a host of options to navigate through (many of which you might not need).
• Perception: DSLRs are associated with proper photography, so immediately look more professional than a more compact design.	• Mirror slap: When the mirror used for the optical viewfinder flips up, it can cause minor vibrations that affect image sharpness.

DSLR ANATOMY

Although there are three main categories of DSLR, they typically share many key features (albeit in slightly different configurations).

1. Shutter-release button
2. Pentaprism
3. Front control wheel
4. Interchangeable lens
5. Lens-release button
6. Finger grip
7. Drive mode selector
8. Viewfinder
9. Rear control wheel
10. Function buttons (various)
11. Multi-selector
12. Live View button
13. Rear LCD
14. ON/OFF switch
15. Movie recording button
16. Hotshoe
17. LCD panel

SENSOR SIZE

The size of a camera's sensor plays an important part in the quality of its images. Most DSLRs use APS-C or full-frame sensors, with Olympus relying on the slightly smaller Micro Four Thirds sensor size.

GET WHAT YOU PAY FOR

One of the key differences between enthusiast and professional DSLRs is the build quality: pro cameras tend to be more rugged, and often feature weatherproof seals to protect them from dust and moisture.

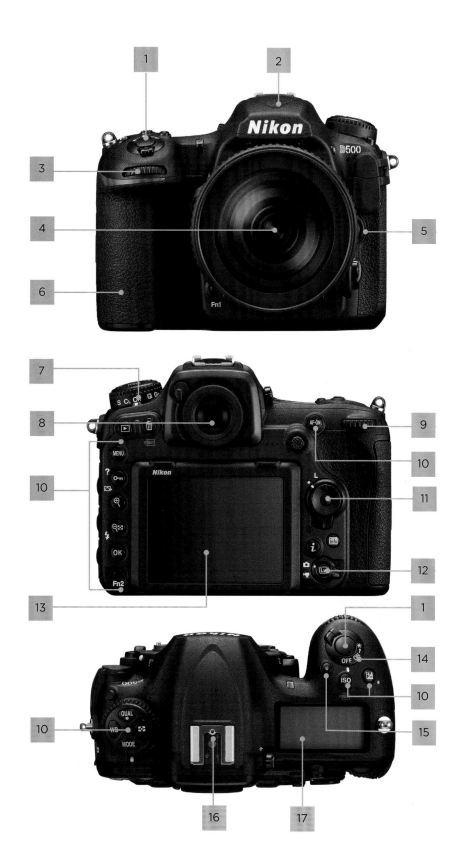

SENSOR SIZE

Most CSCs use APS-C or Micro Four Thirds sensors, although the use of full-frame sensors is slowly growing as professional mirrorless cameras appear from the likes of Sony and Leica.

Mirrorless Cameras

Whereas DSLRs are very much an evolution of 35mm film SLRs, mirrorless cameras (also known as compact system cameras or CSCs) have been developed from the ground up as digital cameras. This has led to new lens mounts being designed, new viewfinder technologies, and new camera body styles (although, somewhat ironically, some of the most popular CSCs are those that emulate historical cameras).

The main difference between a mirrorless camera and a DSLR is the way in which you view your subject. Rather than using a system of mirrors and prisms to direct the image projected by the lens to an optical viewfinder (like looking through a window), a CSC shows the image on the rear LCD or through an electronic eye-level viewfinder (essentially like looking at a small TV screen).

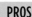

The main benefit of this system is that the design of the camera no longer needs to accommodate those mirrors and prisms, so size and weight can be reduced to compact camera proportions (if so desired). However, that hasn't meant a reduction in quality, with most CSCs using the same sized sensors as their DSLR stablemates (including even full-frame sensors in some instances).

A further benefit of viewing your images electronically is that the camera can give you a live preview of many of the camera settings, so you can see if the exposure is a little too light or dark, or if the white balance is off when you frame your subject, and it's easy to make corrective adjustments before you shoot. Consequently, if you want DSLR performance in a compact camera format, a CSC could well be the answer.

MIRRORLESS AT A GLANCE

Good for: Photographers looking for a small, lightweight camera that doesn't compromise on image quality.

PROS	CONS
• Camera bodies can be smaller and lighter than their DSLR counterparts.	• AF systems are usually slower than DSLR cameras (although the gap is constantly narrowing).
• Image quality: Full-frame and APS-C sensors (and, to a lesser extent, Micro Four Thirds sensors) enable clean images, even at high ISO settings.	• Lens ranges are generally less expansive than the more established DSLR systems.
• Electronic viewfinder allows you to preview exposure, white balance, and other adjustments before you shoot.	• Using an electronic viewfinder and/or rear LCD to frame your shots drains the battery more quickly than using an optical viewfinder.
• Lens adaptors allow virtually any lens from any manufacturer to be used on a CSC (albeit with some restrictions).	• Electronic viewfinders are ultimately small digital screens: This doesn't offer the same natural view of an optical viewfinder.

ABOVE While DSLRs tend to share a similar design ethos with one another, mirrorless cameras come in a variety of forms, including retro-styled cameras like Fujifilm's X-Pro2 (top); compact-style cameras such as Panasonic's GX8 (centre); and those that look more like DSLRs, as is the case with Sony's full-frame A7R (bottom).

CSC ANATOMY

The layout of mirrorless cameras varies almost as much as their designs, but there are usually several common traits.

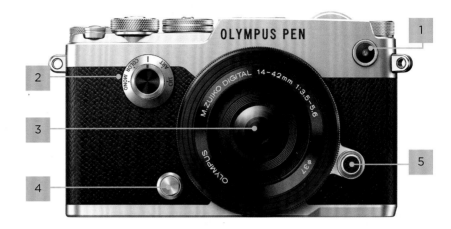

1. Self-timer lamp

2. Filter effect dial

3. Interchangeable lens

4. Depth of field preview button

5. Lens-release button

6. Hotshoe

7. Mode dial

8. ON/OFF switch

9. Viewfinder

10. Shutter-release button

11. Movie recording button

12. Rear LCD

13. Exposure compensation dial

14. Rear control wheel

15. Function buttons

Bridge Cameras

When DSLRs were in their infancy and carried four-figure price-tags, and most compact cameras offered little more than point-and-shoot simplicity, bridge cameras made a lot of sense. They got their name from the fact that they bridged the divide between the two technologies, taking the styling and controls found on a DSLR and marrying those qualities with a more affordable compact-camera sensor. On top of this was an integral zoom lens offering an incredible focal length range that covered most eventualities.

Today, however, the market has changed: Entry-level DSLRs are dirt cheap and many mid- to high-end compacts have a full range of sophisticated manual controls. This has left bridge cameras bridging... well... not very much. What manufacturers have done instead is expand their built-in zoom ranges to satisfy those photographers who don't want to bother with interchangeable lenses, but still want a camera with an expansive zoom range and DSLR looks. Consequently, cameras offering a zoom in excess of 30x (something in the region of 24–720mm or more) are now common, while a number of cameras have zoom lenses the equivalent of a 20–1200mm zoom lens on a full-frame camera.

Unfortunately, such extreme focal lengths in a single lens lead to significant distortions and aberrations, which typically means the in-camera processing has to be quite aggressive to compensate. This can lead to compromises in image quality (softness and a lack of detail are common), which isn't helped by the small-sized sensors used in many of these cameras: Noise is often also a problem.

RIGHT The hybrid status of a bridge camera extends to its design: some look like compact cameras (as with the Nikon Coolpix L840, right), while others look more like DSLRs (as is the case with Samsung's WB2200F, far left).

BRIDGE CAMERAS AT A GLANCE

Good for photographers who want an all-in-one solution covering an extreme focal length range that would be impossibly expensive to match with a DSLR or CSC.

PROS	CONS
• Lens covers extreme range of focal lengths. • Fixed lens means you don't need to change lenses, so there's almost no way for dust to reach the sensor. • Some (not all) models possess DSLR/CSC-style levels of control, including fully manual shooting modes and Raw capture. • Far less expensive than a DSLR or CSC with lenses covering the same focal length range.	• Sensor sizes are typically smaller than those used in DSLRs and CSCs, resulting in noisier images. • Lenses tend to exhibit pronounced distortions and aberrations due to the extreme focal length range covered. • Often have a more limited range of shutter speeds and apertures than DSLRs and CSCs.

Compact Cameras

Today's compact cameras come in a bewildering array of shapes and sizes, with varying levels of sophistication and performance. At the top end of the scale are compacts that rival DSLRs/CSCs in terms of the specification, level of control, and image quality on offer, thanks in no small part to the use of APS-C sensors and high-quality lens designs. Although expensive to buy (a high-end compact can cost as much as, if not more than, a DSLR or CSC), this type of compact makes a great walkaround camera when the bulk of an interchangeable-lens model simply isn't needed.

At the opposite end of the compact camera scale are low-cost models that rely on fully automated modes for point-and-shoot simplicity. Combining small-sized sensors with more basic lenses, this type of camera tends to produce images that are prone to noise and lack detail. Although this was once a booming market, smartphones are steadily killing off this end of the compact camera market, which is hardly surprising – why would you want to buy a camera when your phone can produce similar results?

RIGHT Compact cameras range from highly automated point-and-shoot models such as Nikon's S6900 (complete with a built-in selfie stand and reversible screen, left), through mid-range cameras like Canon's G9X (centre), all the way up to Sony's pro-spec RX1R (right), complete with a full-frame sensor.

RIGHT Rugged cameras represent one section of the compact market that has an enduring popularity. Waterproof and shockproof, these are cameras designed for roughing it in the great outdoors, shooting in situations where other cameras would crumble.

DIGITAL COMPACTS AT A GLANCE
Good for photographers who want a pocketable go-anywhere camera.

PROS	CONS
• Compact, pocketable, all-in-one design.	• Most compacts have small sensor sizes that result in noisy images at high ISO settings.
• Can often take a compact camera where a DSLR or CSC would be banned	• Cannot expand the camera, so if your needs change, the camera may not be suitable any more.
• A few (high end) models offer manual modes, Raw shooting, and large sensors for DSLR/CSC-style performance (usually at a comparable price).	• Only the more expensive cameras offer Raw shooting; most are JPEG-only.
	• Often have a more limited range of shutter speeds and apertures than DSLRs and CSCs.

Digital Medium Format

Although full-frame digital SLRs are undoubtedly the weapon of choice for most pro photographers, for some, there is a need to go even bigger, which means venturing into the rarefied world of medium format. Unlike DSLRs and CSCs, there aren't dozens of medium format cameras to choose from, and those that do exist are generally backed by a relatively modest number of lenses; systems tend to be small and focused, rather than offering something for every single shooting scenario.

However, this is a small price to pay, because what you get in return is for many people the Holy Grail of digital photography: a large sensor. Just as full-frame sensors can offer superior image quality to APS-C sensors, so medium format sensors have the potential to be better still. Not only can more pixels be squeezed onto the sensor's surface, resulting in higher resolution images (think 50–200 megapixels), but the photosites

creating those pixels are typically larger as well, meaning they can capture more light. We'll look at sensor technology on the following pages, but in the simplest sense, larger pixels translate into a better dynamic range, smoother tonal transitions, and sharper results.

Of course, there is a price to pay for having what – on paper at least – adds up to a near-perfect digital solution, and in this instance, the price is financial. The best of the medium-format digital cameras (with a lens) typically run to five figures, while extra lenses typically cost thousands more. This makes medium format digital photography an exceptionally expensive proposition, where you can expect to pay as much for a camera and lens as you would for a new car. That said, there was a time when the same could be said of a DSLR, so who knows what will happen in years to come. Maybe someday soon we'll all be shooting high-resolution, 200-megapixel images on medium-format compacts?

RIGHT PhaseOne's XF100MP (right) may give off a slightly retro medium format vibe, but its 53.7 x 40.4mm sensor delivers highly detailed 100-megapixel images. By comparison, Hasselblad's X1D (far right) is based on a futuristic-looking mirrorless design that makes it smaller than some full-frame DSLRs. Yet, despite its diminutive size, it can still pack a punch thanks to its 43.8 x 32.9mm, 50-megapixel sensor.

DIGITAL MEDIUM FORMAT AT A GLANCE
Good for photographers who demand the ultimate image quality.

PROS	CONS
• Large sensor sizes mean high-quality, high-resolution images – the ideal choice if you shoot for billboards or demand every last detail be recorded.	• Prohibitively expensive for most enthusiasts (and a lot of pros).
• Models with leaf shutters allow flash sync at all shutter speeds.	• Generally slower to use than smaller format cameras.
• The epitome of professional – unlike a DSLR, everyone doesn't have one.	• Heavier and bulkier than smaller formats.
	• Generally limited lens ranges.

Other Options

So far, we've touched on all of the mainstream camera options, but those are not the only photographic tools you can call upon. Depending on your goals, you may need something a little more esoteric to achieve the exact end result you are searching for.

PHONES & TABLETS

Smartphones have had a major impact on the low-end compact camera market, and this is set to continue as manufacturers further explore the technology. Samsung has already launched a phone with a built-in compact camera style zoom lens (below right), while Sony has developed a range of high quality 'lens cameras' (below left) that combine DSLR lenses and an APS-C sensor with your phone (or tablet), controlling all the shooting settings.

DRONES

If you want to shoot from the sky, then you seriously need to consider a drone. If you're starting out, there are plenty of fixed-camera models to help you get used to aerial photography, with myriad models to move up to once you've mastered your flying skills. DJI is widely accepted as the market leader, with its incredibly popular Phantom series dominating the enthusiast marker, while for those with grander ideas, the company has teamed up with Hasselblad to create a high-end medium-format shooting platform. Don't expect it to come cheap, though. A setup like this will run you tens of thousands of pounds (image below).

ACTION CAMERAS

Action cameras are big business right now, enabling you to shoot where other cameras would fail. These small, light, shockproof, and waterproof cameras are a favorite among extreme sports fans, with a wide-angle lens that puts you right at the heart of the action. Although they are best suited to shooting high-resolution video, some models can also turn in a decent still image, and things are only going to improve. Recent developments have seen cameras such as Nikon's KeyMission 360 (below) set to arrive on the scene. Fitted with dual lenses and sensors, this extreme camera looks to offer a full 360-degree view as it shoots, for a truly immersive experience.

Sensors

It doesn't matter if you shoot with a DSLR or a smartphone, or anything in between. When it comes to creating a digital image, your camera's sensor is a fundamental part of the process.

At a basic level, most digital imaging sensors work in the same way: They essentially gather the light that comes through the lens and convert it into a digital signal. Believe it or not, that's more than you need to know about sensor technology to take great pictures, because understanding the intricacies of how a sensor works will not (and cannot) help you with your photography. What it can do, though, is tell you why some cameras produce images that are better than – or at least different to – other cameras' images, which in turn can help you navigate the complex field of resolution, sensor sizes, and so on that you will invariably encounter when you set out to buy a camera. So let's look at the tech inside our cameras.

Anatomy of a Sensor

The sensor in a digital camera is made up of a number of layers, each of which plays an important part in the creation of a digital photograph.

1: IR CUTOFF & ANTI-ALIASING FILTERS

Light passes through a filter that removes non-image-forming Infrared light. Traditionally, there would also be an anti-aliasing filter that would introduce a very slight blur to prevent any moire patterns (see opposite).

3: BAYER PATTERN FILTER

The light-sensitive photosites at the base of the sensor only record the intensity of the light reaching them, not the colour. A Bayer filter array filters the light so it is either red, green, or blue: From these three primary colours, a full-colour image can be created (see opposite).

2: MICROLENSES

The filtered light passes through microlenses that help to focus it onto the individual photosites below.

4: PHOTOSITES

The light (in the form of photons) ultimately reaches a grid of photosites, which can be thought of as light-gathering wells. During an exposure, the photons are collected by each photosite where they generate an electrical charge: the more light there is at any particular point in the scene, the more photons are gathered, and the greater the charge.

5: ANALOG-TO-DIGITAL CONVERSION

In-camera systems measure the electrical charge at each photosite and convert it from an analogue signal into a digital one: This digital signal goes on to form a single colour pixel in the final photograph.

Creating Colour

Although your camera is capable of producing some stunning colour images*, the light-gathering photosites on the sensor are colour blind: They can only record the brightness of the light reaching them, and not its colour.

To achieve a full colour image requires the addition of a filter over the sensor. Although different filter designs have been explored over the past decades, the standard is a Bayer pattern filter made up of red, green, and blue filters (with twice as many greens as red or blue, to match our own colour vision).

With the filter in place, each photosite can record not only the brightness of the light, but also a red, green, or blue value, depending on the filter sitting above it. The in-camera processing can then apply algorithms that effectively compare neighbouring pixels to determine what its actual colour should be: this process is known as demosaicing.

ABOVE The image at the left shows (in an exaggerated form, for clarity) what your camera's sensor sees when you take a photograph. Essentially, it's a monochrome image overlaid with a grid of red, green, and blue filters. Complex processing is used to convert each pixel in the image from red, green, or blue into full colour, to deliver your final image (right).

*Not all cameras record in colour: As far back as the late 1980s, Kodak was developing monochrome DSLRs, and this is something that Leica continues to explore.

ANTI-ALIASING FILTERS

A lot of camera manufacturers fit an anti-aliasing filter (or optical low-pass filter) in front of the sensor. This is a clear filter that softens the image very slightly overall to combat moiré and prevent false colour results when fine, repeating detail appears in an image – in fine fabrics, for example.

However, although the anti-aliasing filter prevents certain artifacts, it also softens images overall, which is why digital photographs need sharpening.

A recent development (and one that is being seen more often) is for manufacturers not to fit an anti-aliasing filter. The result is images that appear sharper and more detailed, albeit with a risk of colour artifacts in certain (quite specific) conditions.

LEFT With an anti-aliasing filter in place, moiré is prevented, but images are softened very slightly overall.

LEFT Without an anti-aliasing filter edges (and images) are sharper, but there is an increased risk of moiré in certain situations.

Resolution

You can't talk about sensors without talking about resolution, as it's often one of the headline features – if not the headline feature – when a new camera is launched. Resolution is given as a megapixel value, which tells you how many millions of pixels are created to form the largest possible image from the sensor; so a 24-megapixel camera has a sensor creating images made up of 24 million pixels, and so on. The pixel count – or resolution – relates directly to the number of photosites (see opposite), as each individual pixel is created by a single photosite.

The resolution of a sensor is important, because it gives you an idea of image size. The physical size of the sensor plays a part here (more on that shortly), but if you had two sensors that were the same size, but with different resolutions, the one with the higher resolution would let you print or display your images at a larger size before the individual pixels become noticeable. Put simply, a 24-megapixel sensor will produce bigger images than an 18-megapixel sensor, and a 36-megapixel sensor will eclipse them both.

As well as enabling you to display your images at a larger size, a higher resolution sensor will potentially be able to record finer detail as well. This is because the pixels/photosites need to be smaller, and this makes them more precise (smaller pixels can define smaller points in an image). Again, this assumes two sensors that are the same size, but with different pixel counts.

Pixel Pitch

It would be nice to say at this point that resolution is the be-all and end-all of image quality, and that a higher resolution is always better, but unfortunately, that's simply not the case. The problem is, the more pixels you have, the smaller the photosites that create them need to be. While this may help with the recording of fine detail, it also means the photosites are less capable of recording light (the wells that gather the photons are smaller, so the charge they generate is weaker). This can lead to a reduced dynamic range (with an increased risk of highlights blowing out) and higher chance of noise, as fewer image-forming photons are gathered.

FEWER PIXELS
(lower resolution)

Sensor Size

Now, what we have seen so far creates a fundamental problem: On the one hand, it's good to have more pixels, but on the other hand, the more photosites you have, the smaller they need to be. This is where sensor size also plays a part.

It's a simple fact that if you have 24 million pixels (photosites) on an APS-C sensor measuring 23.5mm x 15.6mm, they will be smaller than 24 million pixels (photosites) on a full-frame sensor measuring 36 x 24mm. For example, Nikon's D7200 (24MP APS-C)

has a pixel pitch of 3.91 microns, whereas the Nikon D610 (24MP FF) has a pixel pitch of 5.9 microns. The upshot? The full-frame camera has a greater dynamic range, lower noise levels, and delivers a greater tonal range.

Alternatively, instead of larger pixels, a bigger sensor can give you more of them. For example, Canon's full-frame EOS 5DS has a pixel pitch of 4.14 (similar to the APS-C Nikon camera above), but it has 50.6 million pixels in total, so it's producing images that are significantly larger.

WHAT'S A PIXEL?

The word pixel is a bastardised contraction of 'PICture ELement', and refers to the smallest part of a digital image. A single pixel is simply a square (or rectangle) of a specific colour and brightness. However, combine enough of these tiny building blocks, and make them small enough, and full-colour images can be created.

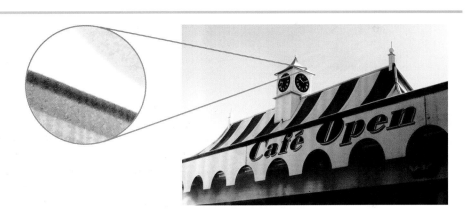

LEFT In a very simple way, this set of exaggerated illustrations demonstrates why more pixels result in more detail. The graphics were created using Photoshop's Mosaic filter, but the underlying principle is the same: the more pixels you have, the more detail can be resolved.

However, this is not the only thing that determines image quality – sensor size, pixel pitch, and in-camera processing all have a part to play as well.

MORE PIXELS
(higher resolution)

Camera Essentials

Although a camera and lens are the stars of your photographic gear, there are plenty more items you will need in your bag.

Batteries

It's a boringly simple fact that the vast majority of electronic devices — cameras included — need a battery to get them going. If you're shooting with a smartphone or tablet, then making sure your battery's fully charged is pretty much all you'll want or need to do, but if you're using a DSLR, an extra battery (or two) might be useful. This is especially true if you're heading out on an extended photo trip; know you've got a pretty active shutter finger; think you'll be using the camera's built-in flash a fair bit; and/or like to use the rear LCD screen to frame and review your shots. With a mirrorless camera, additional batteries are even more important, as you'll be using a power-draining LCD or electronic viewfinder to frame your shots.

Nikon's ELN-EL15 battery is typical of the high-capacity lithium cells found in larger DSLR cameras.

GET A GRIP

Most DSLRs (and some mirrorless cameras) let you attach a battery grip to the camera. The grip will often accommodate a couple of batteries, so you can shoot roughly twice as many frames before running out of power. It also makes your camera easier to hold for portrait format shots, with a lot of grips featuring an additional shutter-release button and control dials for this very purpose.

LEFT Some camera grips have holders that let you use regular AA batteries. These batteries won't necessarily last as long as your regular camera battery but are a useful backup option.

RIGHT If you're using one of the latest Canon EOS 5D cameras, the BG-E11 grip will let you use two batteries.

Memory Cards

Most digital cameras store images onto a memory card, and there's a bewildering array of options. However, your choice of memory card will really come down to four things: the memory card type, its speed, its capacity, and your budget.

CARD TYPE

The type of memory card you need is determined by your camera. In most cases, it will be either CF (CompactFlash; still found in some DSLRs) or SD (Secure Digital; used in the vast majority of DSLR, mirrorless, and compact cameras). In general, SD cards are more robust, as they use flat electrical connections to transfer data to and from the card: CF cards rely on rows of pins inside the camera that slot into the card, and these pins are notorious for getting bent if you're not careful (resulting in an expensive repair bill).

SPEED

The speed of a memory card refers to how fast it can read and write data; the faster the card, the more shots you can take in quick succession and the quicker they'll be downloaded to your computer. Card speed is typically given as a class rating that indicates its minimum write speed; as an 'MB/s' (megabytes per second) figure that indicates the transfer speed; or as an 'x' figure that relates to the card's speed compared to a standard CD-ROM drive (so a 32x card is 32 times faster than a CD-ROM drive). In each instance, the higher the value, the faster the card. Fast cards are most useful if you like to shoot movies, or rattle off continuous bursts of high-resolution Raw frames. For more sedate subjects, speed becomes less of an issue.

CAPACITY

Memory-card capacity is the same as hard-drive capacity on your computer; it simply indicates how much data can be stored on the device. Memory-card capacity is usually measured in gigabytes (GB) and the higher the capacity, the more images you can store. However, it's worth remembering that memory cards can fail, potentially losing all of the data they contain in the process. For this reason, some people – myself included – would rather use multiple smaller-capacity cards, rather than a single high-capacity card. If your camera has dual memory card slots then it's usually possible to mirror your shots so they're recorded to both, which offers another level of image security.

BUDGET

Only you know how much you're willing to spend on a memory card, but the cost equation is pretty simple: The faster the card and the higher its capacity, the more expensive it will be.

COMPACTFLASH MEMORY CARD

CARD TYPE

CAPACITY

TRANSFER SPEED (MEGABYTES PER SECOND)

VIDEO SPEED (VIDEO PERFORMANCE GUARANTEE/VPG RATING)

ULTRA DIRECT MEMORY ACCESS (UDMA) RATING

SD MEMORY CARD

LOCK

CARD TYPE

CAPACITY

SPEED (CLASS RATING)

SPACE FOR NOTES/ LABEL

Bags

How you choose to carry your camera and what you choose to carry it in is largely down to you: Some people want to ensure their equipment is cocooned in a bag containing the thickest, softest padding possible, while other people are happy with it banging around in an old shopping bag.

Between these two extremes there are myriad pouches and bags to keep your gear in, although there's no such thing as the perfect bag (despite what the manufacturers will tell you). The bag that's right for you will have everything to do with your chosen style of photography; where you take your pictures; how you get to/from your photographic location; how much kit you have; how much kit you intend to have; and many other considerations as well.

So, the best advice I (or anyone else) can give is to head on over to your local friendly camera store and see what they've got to offer. If you can, take your camera kit with you and see how it fits and how easy it is to access. To get you started, the grid below shows you some of the good and bad points for the various options.

RIGHT This type of heavy-duty plastic case is waterproof and crushproof, making it perfect for storing or transporting your equipment.

CENTRE A small shoulder bag makes an ideal everyday bag for a camera and a couple of lenses.

FAR RIGHT For landscape and other location photographers, a backpack can make a lot of sense: It's easier to carry a heavier load for longer when the weight is distributed across both shoulders.

	PROS	CONS	GOOD FOR
SHOULDER BAG	• Easy to access equipment without taking the bag off.	• Uneven weight distribution: All the weight is on one shoulder, which can become tiring with a heavy load or if carrying your kit a long distance.	• Situations where you need to constantly access your kit quickly; street photography or reportage.
BACKPACK	• Weight is evenly distributed; good for carrying equipment a long distance.	• Need to remove the bag to access your gear (slow).	• Carrying your kit a long distance; landscape and some wildlife photography.
HARD CASE	• Ultimate protection for your kit, especially when traveling and it will be out of your hands/sight.	• No good for carrying equipment by hand over any great distance.	• Storing and transporting equipment; studio photography.
POUCHES, HOLSTERS & BELTS	• Allows you to distribute your kit however you choose. • Enables you to build up a custom carrying system that can be modified depending on what you need to carry.	• Can become expensive. • Has a paramilitary air about it: no-one wants to be mistaken for a combatant.	• Situations where you need quick and easy access to your kit, and want to keep both hands free; photojournalism.

Remote Releases

A remote release is a great way of triggering a tripod-mounted camera without actually touching it, which helps minimise the risks of camera shake caused by you physically pressing down on the shutter-release button.

There are two types of remote release: wireless models and corded versions. Wireless is a neater and truly remote solution, which alleviates any risk of you pulling the camera, but a corded release is usually more instant when it comes to triggering the shutter

GPS

If your camera is GPS-enabled it will add location data (latitude and longitude) to an image's EXIF data when you shoot – this is known as geotagging. This information adds another searchable option to the image, which can be handy if you want to find all the shots you took in a specific location; certain programs and websites will also use this data to display your images on a world map, which is another great search tool.

Some cameras have GPS built in, so it's only a menu option away, while others rely on external GPS adaptors to geotag your images. However, there are also cameras that simply don't have a GPS option available to them.

LEFT Canon's GP-E2 GPS receiver can record latitude, longitude, altitude, direction, and time to an image's EXIF data, helping you pinpoint precisely where and when a shot was taken.
© Canon

Wireless

An increasing number of cameras feature wireless connectivity, so you can upload pictures directly to your social media site of choice or send shots to your tablet or PC for processing without having to try and remember exactly where you've put your USB cable or memory card reader. If wireless isn't built in, there may be a suitable adaptor for your camera, which will simply plug in and give it a wireless connection option.

Alternatively (or if there isn't a suitable adaptor for your camera), you can give your camera a wireless upgrade by fitting an Eye-Fi or Toshiba FlashAir memory card; these are proprietary SD memory cards with built-in Wi-Fi.

Film Isn't Dead

When digital cameras entered the mainstream, many commentators confidently heralded 'the end of film'. Yet while the market for film has undoubtedly shrunk, it has not disappeared entirely.

FILM CHOICES

The variety of film available to you depends on the format you're using: As the format size increases, the range of film available diminishes.

It's fair to say that the early years of the 21st century were not kind to a lot of the long-established photographic players: Minolta first became Konica-Minolta before being absorbed by Sony; Pentax was swallowed up by Ricoh; Polaroid ceased its instant film production; and Kodak... well... it would be putting it mildly to say that the company that brought photography to the masses has struggled in recent years. However, despite the huge shake-up of the photographic industry, film didn't face the absolute end that many had predicted. In fact, in recent years, you could even say it has seen something of a resurgence, as Lomography continues to cater to the analog market, The Impossible Project has taken over where Polaroid left off, and young photographers who have been brought up purely on pixels are now looking for their first film fix.

And why not? Film may be an old technology that's less immediate and more expensive than digital, but there's still plenty we can learn by using it. At a very basic level, there's a cost attached to every frame you shoot, and unless you've got money to burn, this should make you stop and think a little longer before you press the shutter-release button. That means thinking a little more about the exposure you set, where you focus, and what you include in the shot to start with. It's about working out what might go wrong before you fire the shutter, and doing everything you can to get it right in camera, knowing that it's going to be hours if not days before you see the result, by which time, there could be zero chance of reshooting.

Although this might mean film isn't as easy or as quick or as cheap as shooting with a sensor, the upside is that it will potentially make you a better photographer. Why? Because it's encouraging you to think more about the fundamentals of photography, and those same things will apply no matter what camera you go on to use.

RIGHT When film was the only option, there were countless options on the market. However, that's sadly not the case today and many of the products shown here haven't been available for many years.

Film Formats

Okay. So I'm going to assume that if you're reading this you've decided to give this film thing a go (or at the very least you're not totally turned off by the idea). If you haven't got a camera already, then your first decision is which format to go for. Image quality is generally better as the film is larger. We'll look at some of the camera options over the following pages, but you've generally got three choices:

35MM

Cameras taking 35mm are in plentiful supply, and some are pretty darned cheap as well. Like a full-frame digital sensor, a film frame measures 24 x 36mm, and you'll get either 24 or 36 shots per film, depending on the film you choose.

MEDIUM FORMAT

Medium format cameras take 120 or 220 roll film. There's a range of camera styles and images sizes, and equally wide range of prices: A no-frills TLR might set you back as little as £30, while a Hasselblad in mint condition could cost you 100 times that.

LARGE FORMAT

Large format film comes in sheets, not rolls. Although you won't have as many options when it comes to the film you can use (and it will cost you considerably more) this is made up for by the quality of the image. To give you an idea of the potential of large format film, if you scanned a 4x5-inch (10x12.7cm) sheet of film at 4000 dpi, you would end up with an image in excess of 285 megapixels.

FILM TYPES

	PROS	CONS	NOTES
COLOUR TRANSPARENCY (E6 / SLIDE FILM)	• Rich, saturated colours, especially with low ISO films. • Low grain levels make it possible to enlarge images more than with negative film. • Can view images directly – no need to print them.	• Limited dynamic range, easy to clip highlights and block up shadows. Exposures need to be accurate. • Limited range of film speeds (ISO 400 is usually considered fast).	• Shooting transparency film is like shooting JPEGs: You need to get it right in-camera, as there is less scope for changes later on. • Easier to scan than colour negative due to its clear base.
COLOUR NEGATIVE (C41 / PRINT FILM)	• Wide exposure latitude: Even if your exposure is a couple of stops off, you can still save the shot. • Wide range of film speeds (up to ISO 1600) • Colour can be fine-tuned at the printing stage.	• Higher level of grain than a transparency film of the same speed. Images can't be enlarged as much. • Negatives need to be printed or scanned to be viewed as a positive image.	• Shooting negative film offers more chance to recover the exposure or make changes to the colour after the shot has been taken. • Harder to scan than transparency film, due to the orange base.
BLACK-AND-WHITE NEGATIVE	• Wider exposure latitude and dynamic range than colour film. • Easy to process at home. • Black and white has an inherent classic quality. • Easy to push or pull the development to effectively give the film a higher or lower ISO.	• Negatives need to be printed or scanned to see the positive image. • No colour (obviously!), so images are not true to life.	• A great option if you want to start shooting film. • Easy to scan, as there's no colour information to worry about.

Film vs. Digital

A lot has been made in the past comparing and contrasting the two, and it continues to be discussed online and in magazines. My advice is to view such arguments with scepticism. The two technologies are fundamentally different. As such, there is no one right answer (where one is arguably superior in one area, the other might inch ahead in another). The points below are just some of the arguments for and against film and digital technologies, both practical and philosophical.

GRAIN

The biggest difference between film and a digital sensor is that film relies on physical and chemical reactions. Whereas digital sensors produce electronic noise when the ISO is increased, images shot on film contain grain (specifically, faster films use larger, more sensitive silver-halide crystals in their emulsion, and it is these crystals that appear as grain in the developed image). The key difference is that grain is random in appearance, and is not that unpleasant – some people like to shoot fast 35mm black-and-white film specifically because of the gritty results.

DYNAMIC RANGE

In the early days of digital cameras, the dynamic range of film was far better than that of sensors. Today, however, the reverse is true: The latest digital sensors can typically record a higher dynamic range than both colour and black-and-white negative film, and even outperform the capabilities of colour transparency.

HIGHLIGHT ROLL-OFF

This is perhaps one area where film still surpasses digital capture. With a digital image, there is a very distinct cut-off point where things turn pure white, but with film, the transition is more gentle. As a result, burned-out highlights don't appear quite so stark.

BELOW On page 356 you saw how sensors are constructed and capture light. This is a similar (simplified) example of how black-and-white negative film is made.

1 The emulsion layer consists of gelatin emulsion containing light-sensitive silver halide crystals. When they are exposed to light (and chemically developed), these crystals darken to form an image. The more light they receive, the darker they become, which creates a negative.

2 The film base, or support layer, is simply there to provide something for the emulsion to sit on. Modern film uses a transparent plastic base, but in the past, glass plates were used instead.

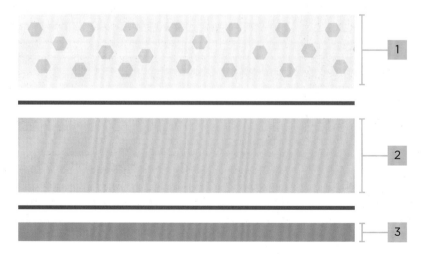

3 The back of the film typically contains an anti-halation coating, which is designed to prevent light bouncing back through the film. This layer is washed off when the film is processed.

ISO

Nikon's flagship D5 DSLR has an expanded ISO setting of 3,280,000; the fastest available film is Ilford's Delta 3200 (ISO 3200). Do you need an ISO of 3.28 million? Will you ever need it? Arguably not, but with an increasing number of digital cameras, the ability to shoot an (albeit noisy) image in almost zero light is there if you want it. The ability to change ISO on a shot-by-shot basis is perhaps more significant.

COLOUR

Shoot film, and most of your colour decisions come at the shooting stage. Usually this starts with your choice of film (daylight-balanced or tungsten-balanced), and depending on your subject, may then require the addition of colour correction filters (especially if you're shooting under fluorescent lighting). A digital camera's white balance is way quicker, easier, and more accurate.

RESOLUTION

When you start to talk about the resolution of film compared to digital you're getting into a which-is-best argument. The simple answer is that it depends on the film format, the type of film, the processing, how it's scanned or printed, and the digital camera you're comparing it to. Accept they're different and move on.

COST

In general, film cameras are cheap (and unlikely to lose any more value); whereas a shiny new DSLR will be worth a fraction of its list price in a year or two. However, film and processing costs are a constant drain, as is scanning if you choose not to do it yourself.

TIME

The widely accepted view is that digital is quicker than film. Certainly, the images can be seen immediately on the rear LCD,

and shared within seconds, but if you shoot Raw, you will still need to process your work – and the more you shoot, the longer it will take. In some ways, dropping off a roll of film at a lab and collecting your transparencies or prints a few hours or days later actually takes less time (unless, of course, you then want to scan and edit your shots).

CONVENIENCE

While you can argue that having a lab process your film and make prints is more time-efficient than sitting in front of a computer working dozens of digital images yourself, it's nowhere near as convenient. The decline in film's popularity has meant a decline in labs to process it, so unless you live next door to one you'll have to travel to drop your film off or risk sending it in the mail.

LEGACY

The history of photography is dominated by photographers who used analog cameras. Film was the medium used by the Masters of photography to not only shape the medium, but in many cases the world around us: think of a single iconic image and the chances are it will have been shot on film. That isn't to say that digital cameras aren't producing equally celebrated image-makers, simply that film has been around much, much longer, so has a nostalgic – perhaps even romantic – appeal that digital capture does not.

TANGIBILITY

With film you get something tangible: you can hold a negative or slide, unlike a digital image. There's something strangely reassuring about being able to hold your pictures in your hand (even if film is more fragile); it's as if they are somehow more real.

DIGITAL PIXELS

FILM GRAIN

ABOVE At the most basic level, film and digital technologies are different, which I feel makes any direct comparison redundant. Film images are based chemical reactions, resulting in grain, while digital images are constructed from pixels.

Film Camera Types

With its long and varied history, it's not that surprising that there are plenty of different film cameras available, ranging from exceptionally simple models to incredibly sophisticated designs.

ABOVE With manual exposure and manual focus, a mechanical SLR like the Pentax K1000 is a great way of learning the fundamentals of photography.

35mm SLRs

For much of the latter half of the 20th Century, 35mm SLRs dominated the amateur photography market, and extended into certain professional genres where the ability to shoot quickly and travel lightly was the foremost concern. There isn't space to cover each and every model, as there were simply so many. No single camera design, before or since,has attracted so many manufacturers and produced so many cameras, lenses, and accessories.

At the bottom end of the sophistication scale are fully mechanical, fully manual cameras that offer little more than a means of varying the shutter speed. Yet despite their absolute simplicity in today's terms, clunkers such as the Pentax K1000 and Nikon FM2 were the starting point for hundreds of thousands of photographers who needed to grasp the fundamentals of exposure and focus and wanted a near-

indestructible camera. More sophisticated models added semi-automated modes and alternative metering patterns to the mix, while later SLRs saw the introduction of the complex multi-area metering patterns and autofocus systems that would eventually cross over to their digital successors.

Yet no matter how primitive or advanced the camera was when it was first launched, all 35mm SLRs have one common trait: Their used value has plummeted in the digital age. A camera that once cost thousands of pounds may now cost less than one hundred, and if you choose carefully, the lenses you use on your DSLR or CSC will swap right over. This means you can give yourself the chance to shoot film without having to invest very heavily at all: The chart at the top of the opposite page offers a few suggestions to help get you started.

The viewing system in an SLR is what gives this camera type its name. Here's how it works:

1. Light enters the lens
2. A mirror inside the camera directs the light upward...
3. ...to a pentaprism in the top of the camera.
4. The light is reflected from the top of the camera to the front...
5. ...and then exits the camera via the viewfinder.

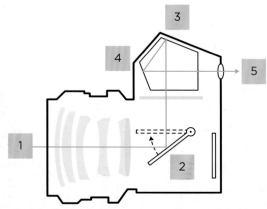

MODEL: Pentax K1000 (1976)

KEY FEATURES: Manual focus, manual exposure

FOCUS; manual exposure

LENS MOUNT: Pentax K

LENSES COMPATIBLE WITH: Pentax K-series DSLRs

MODEL: Olympus OM-4Ti (1986)

KEY FEATURES: Manual focus, highlight/shadow spot metering

LENS MOUNT: Olympus OM

LENSES COMPATIBLE WITH: Olympus E- and OM-series DSLRs and PEN-series CSCs (all via adaptor)

MODEL: Canon EOS 1 (1989)

KEY FEATURES: 1 zone autofocus, 14 custom functions, 2.5fps drive rate

LENS MOUNT: Canon EF

LENSES COMPATIBLE WITH: Canon EOS DSLRs

MODEL: Nikon F100 (1999)

KEY FEATURES: 10-segment Matrix metering, 4.5fps, automatic exposure bracketing

LENS MOUNT: Nikon F

LENSES COMPATIBLE WITH: Nikon D-series DSLRs

LEAST SOPHISTICATED ←——————→ MOST SOPHISTICATED

35MM SLR ANATOMY

Nikon's F6 was the last high-end 35mm SLR to be produced by any camera maker, and marked the pinnacle of the company's film-camera development. Note how many of the design features and controls are echoed in its latest DSLRs, such as the D500.

1. Function buttons (various)
2. Shutter-release button
3. Metering mode selector
4. Hotshoe
5. Pentaprism
6. Film rewind crank
7. Accessory sockets (behind cover)
8. Interchangeable lens
9. Depth-of-field preview button
10. Finger grip
11. Front control wheel
12. ON/OFF switch
13. LCD panel
14. Viewfinder blind
15. Viewfinder
16. Rear control wheel
17. Multi-selector
18. AF mode selector
19. Mid-roll rewind
20. LCD screen
21. Film window
22. Drive mode selector

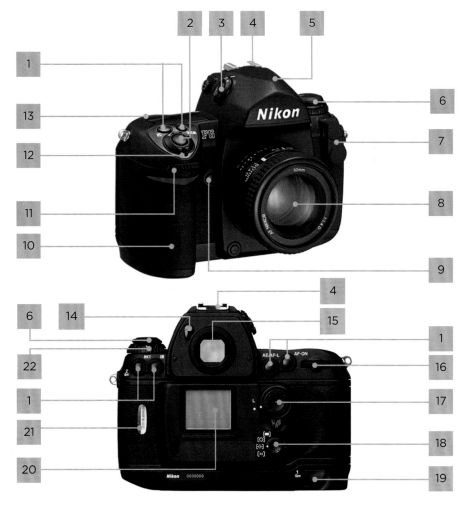

369

35mm Rangefinder

Although SLRs were the most prolific type of 35mm camera, they weren't the only one. For some people, the only true 35mm camera was (and is) a rangefinder, as developed by Leica and copied by numerous other (predominantly Soviet) manufacturers.

The main difference between an SLR and rangefinder is the viewing system. A modern parallel is the difference bewtween DSLRs and CSCs: Like a CSC, a 35mm rangefinder camera doesn't use a pentaprism and mirror, which makes for smaller, lighter, and quieter camera systems than their larger 35mm counterparts.

This made rangefinders the preferred choice of many photojournalists and street photographers, although limited lens ranges meant they were less widely used for other genres.

ABOVE Leica's IIIf ranks among the most iconic cameras of all time, combining German precision engineering with some of the best lens designs ever produced.

35mm Compact

In its day, it seemed as though everyone had a point-and-shoot compact, which was taken out to record birthdays, holidays, and other special events. For the rest of the time, those little cameras sat languishing in drawers, often containing a half-used roll of film.

Although the majority of the hundreds of thousands of now-unwanted plastic compacts are exactly that – unwanted – there remains a core of desirable models, including Rollei's 35-series cameras, various Minox models, and Lomo's LC-A, which has achieved cult status in recent years. However, the popularity of these models is often reflected by a large pricetag: You're paying as much for the name as for the product.

The good news, though, is that there are still compact cameras out there that can produce great results without an inflated cost attached: Olympus' XA series is well worth a look if this is for you.

ABOVE The Lomo LC-A has received far more attention in recent years than it did when it was launched, thanks mainly to the Lomography marketing machine. However, as its new-found popularity has grown, so too have secondhand prices.

	PROS	CONS
COMPACT	• You can stick it in your pocket and take it everywhere. • Some high-end compacts can deliver stunning results.	• Many high-end models have achieved collectible or cult status, keeping prices up, or inflating them to unrealistic levels.
RANGEFINDER	• Like a CSC, they're small and light, so they're great for street shots and photojournalism. • Often feature precision optics and take very sharp pictures.	• Limited lens selection compared to SLRs. • High-end models (particularly Leicas) retain their value.
SLR	• Wide range of used cameras and lenses available. • Cameras range from fully manual, to highly automated, so there's definitely something to suit your needs. • Many lenses will also fit digital cameras (DSLRs or CSCs, either directly or via and adaptor).	• Years of not being used may mean a full service is needed on an older camera body. • Lenses for 35mm SLRs that also fit DSLRs tend to hold their value, meaning there are far fewer used bargains out there.

Other Small-Format Cameras

SLRs, rangefinders, and compacts are only the tip of the small-format camera iceberg. Over the years, there have been countless variations on the theme, including the following, which still have something of an appeal to users and collectors alike.

TOY CAMERA

Just as Lomography has reinvented the Lomo LC-A (see opposite), so it has created a new photographic niche with its ever-expanding line of toy, or plastic, cameras. Although prices sometimes verge on the ludicrous for the latest designs, some of the older, multi-lens models (such as the Oktomat, right) can provide a bit of frivolous fun at a more modest price. This particular model shoots 8 sequential images on a single 35mm frame.

HALF FRAME

In the 1960s, there was a vogue for half-frame cameras that shot 18 x 24mm images on 35mm film, instead of full-frame 36 x 24mm negative. The obvious reason for this was cost: in shooting images that were half the size, twice as many could fit on a roll of film, so instead of 24 or 36 exposures per roll, you could get 48 or 76 shots instead. The most popular cameras of this type were Olympus' PEN models (the inspiration behind its current range of CSCs of the same name), although many other manufacturers had half-frame offerings of their own, including the Soviet Agat 18K pictured here.

110 FORMAT

110 film was a miniature format housed in a small plastic cassette, that in many cases became part of the camera itself. Although images are decidedly grainy due to the diminutive 13 x 17mm frame size, this is precisely what has helped fuel its recent resurgence and renewed appeal: the lo-fi images are everything that digital is not. Shown here is the Demekin 110, which has an ultra-wide fisheye lens (although it doesn't produce circular images).

INSTANT CAMERAS

You could argue that instant cameras aren't really a small format, because they produce large-ish prints: Fujifilm's Instax Mini 8, shown here, produces a 62 x 46mm image, for example. However, this is usually the end result, which is – to my eyes – small. The appeal of this type of camera is that it produces an instant image in a tangible format. Unlike a nebulous digital image, you can take a shot and physically hold it in your hand a moment later. The downside is cost: Instant film doesn't come cheap.

ABOVE Medium format cameras come in a wide range of shapes and sizes, including twin-lens reflex (TLR) models such as the iconic Rolleiflex (opposite), fixed-back SLRs like the Pentax 67II (above), and modular SLRs like Hasselblad's 500-series (opposite).

Medium-Format Cameras

For many years, medium format was the format of choice for most professionals and a whole generation of keen enthusiasts. The sole reason for this was image quality, as the larger the film format, the less enlargement is needed to get to any given print size, or the larger a print can be before the image quality become unacceptable. As a very rough guide, 35mm film is generally great for prints up to 20x30cm, but beyond that, grain can be a problem (depending on the film used, of course). By comparison, medium format cameras can produce images capable of much larger print sizes (although the camera and lenses you use play a major part in the quality).

At a basic level, medium format is any camera that uses 120 (or 220) roll film measuring approximately 6cm wide. However, unlike the 35mm film format, which largely settled on a single frame size, medium format covers myriad different frame shapes and sizes, as illustrated opposite. Therefore, choosing a camera first depends on you choosing a format, whether that's square, panoramic, or somewhere in-between.

Then, with your format decided, you can choose the style of camera you prefer, with options including rangefinder cameras (like the Mamiya 6 and 7 and countless vintage cameras), twin-lens reflex cameras (like a Rollei or Yashicamat), oversized SLRs (like the Pentax 67), or more

	PROS	CONS	GOOD FOR
RANGEFINDER	• Smallest and lightest medium format designs. • Some folding-lens designs are so compact they can be carried in a pocket.	• Can't switch between different film stocks mid-roll. • Not all models offer interchangeable lenses (and those that do tend to have a limited range available).	• Handheld shooting or situations where you want or need to travel light.
TWIN-LENS REFLEX (TLR)	• Large, bright waist-level viewing screen. • Waist-level shooting is great for portraiture, as it allows eye contact with your subject.	• Most models have a fixed lens. • Can't switch between different film stocks mid-roll. • Usually have a limited range of shutter speeds.	• A classic photography experience, especially for portrait photography (leaf shutters allow flash sync at all shutter speeds).
SINGLE-LENS REFLEX (SLR) WITH FIXED BACK	• Looks and handles like a 35mm SLR. • Usually offers in-camera metering, and possibly some automation. • Focal plane shutter offers fast shutter speeds.	• Can't switch between different film stocks mid-roll. • Big and bulky. • Focal plane shutter limits maximum flash sync speed.	• Most shooting situations, particularly those where a fast shutter speed is needed.
MODULAR SLR	• Can switch film backs mid-roll (from colour to black and white, and back again, for example). • Leaf shutters allow flash sync at all speeds. • Typically offers the biggest system of lenses and accessories.	• Can be big and bulky. • Tend to be the most expensive medium-format option (when lenses are taken into account).	• Most shooting situations: Modular SLRs from the likes of Hasselblad and Mamiya formed the backbone of countless professional kits.

modular SLR designs (like the Hasselblad 500-series cameras, Mamiya RB/RZ, and Bronica models). There simply isn't space to detail all of the types here, but the grid below will help you make a few fundamental decisions.

MEDIUM FORMAT ANATOMY

Although they are capable of producing exceptional images, medium format cameras such as this modular Hasselblad 500CM are incredibly basic compared to their smaller format cousins: There are very few controls, and even less in the way of automation.

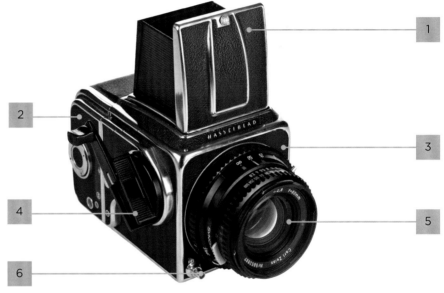

1. Waist-level viewfinder
2. Film back (film holder)
3. Camera body
4. Film advance crank
5. Lens (with leaf shutter)
6. Shutter-release button

BELOW Over the years, different manufacturers have developed cameras around a variety of medium formats, ranging from the enthusiast-orientated 645 format to the rather more specialist 6x17cm extreme panoramic format. However, the most enduring formats are the 6x6cm square (typified by Rollei's TLRs and Hasselblad's 500-series cameras) and the 6x7cm format (used by the Mamiya RB67, RZ67, and Mamiya 7, as well as the Pentax 67). The common formats are shown here to scale, along with the number of shots you get on a roll of 120 film (double this for 220 film), and a 35mm frame for reference.

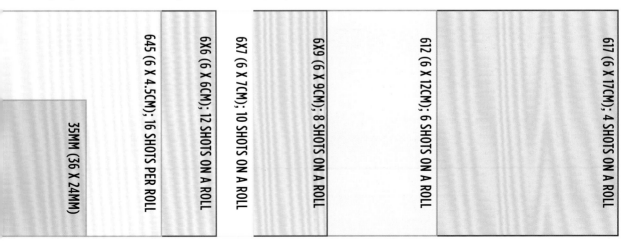

35MM (36 X 24MM)

645 (6 X 4.5CM); 16 SHOTS PER ROLL

6X6 (6 X 6CM); 12 SHOTS ON A ROLL

6X7 (6 X 7CM); 10 SHOTS ON A ROLL

6X9 (6 X 9CM); 8 SHOTS ON A ROLL

612 (6 X 12CM); 6 SHOTS ON A ROLL

617 (6 X 17CM); 4 SHOTS ON A ROLL

ABOVE There are two types of large-format camera: field cameras (top) and monorails (above). Field cameras are designed primarily for location work, and typically fold down to make them relatively small and easy to carry. Monorail cameras are bigger and bulkier, which generally makes them better suited to studio use. They also tend offer a more expansive range of movements (often using geared controls for precision) and greater bellows extension (for close-up and macro work).

Large-Format Cameras

At the top of the film-format tree are large-format cameras, which swap rolls of film for single sheets. The most common format is 4x5 (named after its 4x5-inch sheet film size), followed by 5x7, and 10x8; other sizes are also available, although these tend to be quite niche, with limited film stock options.

One of the main benefits of large-format cameras is the film size, and it really is a case of the bigger the better, because the larger the film format, the bigger the end result can be without grain being noticeable. For this reason, large format used to be (and still is in some instances) the weapon of choice for photographers shooting billboards or any high-end advertising.

In addition to large film sizes, camera movements are another reason why large format cameras are popular. Put simply, they enable you to do things that a rigid camera and lens design cannot, as detailed opposite.

However, large format isn't a format for impatient photographers: The cameras are large and heavy, and almost always necessitate the use of a tripod. Setting them up, focusing, metering, and shooting all take longer than they do with smaller formats, and images are viewed on a glass screen back to front and upside down. Even triggering the shutter is more involved than just pressing a button. Persevere, though, and you'll be able to record some super-high-quality images.

LARGE-FORMAT ANATOMY

In a world dominated by DSLR cameras and CSCs, large format cameras look and feel like they belong in another age. Yet despite looking quite different, field cameras and monorail cameras share the same basic structure.

1. Front standard
2. Camera back (with viewing screen)
3. Rear standard
4. Rear standard locking wheels
5. Focus lock
6. Bellows
7. Lens panel lock
8. Lens panel
9. Front standard locking wheels
10. Lens
11. Focus wheel

Movements

TILT

TILT

Tilting the lens is usually done for one of two reasons: to extend the depth of field at any given aperture (by tilting the lens forward), or to minimise depth of field (by tilting the lens backward). The former is commonly used in landscape photography to ensure front-to-back sharpness, the latter to create miniature-style images.

RISE/FALL

RISE/FALL

A rising front is the classic solution to converging verticals in architecture photography: It allows the back of the camera to remain parallel to the building, while the lens rises to ensure the top of the building remains in the shot. A falling front has a similar effect, albeit allowing the lens to see lower (which is needed less often).

SWING

TOP VIEW

SWING

Swinging the lens left or right changes the direction of the plane of focus. Rather than running parallel to the back of the camera, it will run across it so the sharpness of a photograph drops off toward the sides of the frame, with a vertical zone of sharpness at the centre.

SHIFT

TOP VIEW

SHIFT

Shifting a lens left or right is like a sideways rise/fall, effectively shifting what the camera sees to the side. This is especially useful when you're faced with photographing reflective surfaces, as you can use the shift movement to effectively get the camera out of the shot: With enough shift, you can photograph a mirror front-on without the camera being reflected in it.

LARGE FORMAT AT A GLANCE

Good for: Photographers who want the ultimate image quality and the technical and creative controls offered by camera movements.

PROS	CONS
• Large film size means high-quality images. (The larger the format, the higher the quality becomes.) • Camera movements enable you to correct common distortions such as converging verticals, maximise depth of field, minimise depth of field, alter the plane of focus, and more. • Lenses with leaf shutters allow flash sync at all shutter speeds.	• Film costs can be expensive. • Much slower to use than smaller format cameras (usually, but not always, restricted to a tripod). • Far heavier and bulkier than smaller formats. • Lens selection is limited • Learning curve is steep compared to rigid camera designs.

MASTERCLASS

DOCUMENTARY
Michelle Frankfurter

Born in Jerusalem, Israel, but now living in Maryland, USA, Michelle Frankfurter is a multi-award-winning documentary photographer. Since 2000, she has concentrated her lens on the border region between the United States and Mexico and on themes of migration. Her first book, Destino was published in September 2014, documenting the journey of Central American migrants across Mexico – a small selection of that work appears here.

But what exactly do we mean by documentary photography? Well, according to Michelle it 'demonstrates a concern for issues and themes relevant to the times in which we live. It is an unobtrusive, usually in-depth approach to storytelling, typically requiring that the photographer immerse him or herself in the lives of the subjects whose stories are being told.

'This requires a genuine curiosity about people. Unless you're making portraits, a documentary photographer works in an unobtrusive manner, without directing or guiding the action around him or her; however, the process requires that the photographer insert himself into the lives of others – an experience that can feel intrusive or awkward for both photographer and subject. For example, I prefer to work in very close proximity to the people I photograph – so close that we are almost touching. There is no question that the subject is aware of being photographed, but getting close makes for more intimate photographs'.

Although Michelle mostly shoots digitally, using Canon EOS 5D Mark III cameras, she has also used various medium- and large-format film cameras. 'Digital has come such a long way that at this point in time, I can't think of any reason to shoot 35mm film, but I still like the look of medium format. There's a certain kind of depth of field compression that happens with the format, which gives it a look and a feel all its own.

DOCUMENTARY ESSENTIALS

There is a lot you can accomplish with a camera and one lens. I would rather have one ultra-fast, fixed-focal-length lens, such as a 35mm or 50mm f/1.2 or f/1.4 than a bag full of clunky slow zoom lenses.

'Digital medium format is amazing, but it's cost-prohibitive. The gear is simply too expensive for most consumers and cash-strapped professional freelance photographers. For Destino I used a Bronica SQAi and Ilford HP5 120 film. Roughly 90% of the photos were taken with an 85mm lens, which is equivalent to a 50mm lens on a 35mm or full-frame camera. The 50mm, or normal focal-length equivalent, is my go-to lens. I don't know that there's a 'best' lens for documentary work – it's probably different for everyone – but I think, in general, it would have to be 35–50mm, because these focal lengths enable you to work closely with your subjects.

▶ Tunnel used by U.S. Border Patrol outside the twin cities of San Luis and San Luis Rio Colorado along the Arizona–Sonora border.

▼ A Salvadoran man, his wife, and his 18-month-old son ride a northbound freight train through the southern Mexican state of Oaxaca along with other Central American migrants. The nearly 13-hour train ride from Arriaga in Chiapas to Ixtepec, Oaxaca marks the first leg of the journey by freight train for migrants traveling across Mexico in an attempt to reach the U.S. border. Most will be caught and deported; others run a risk of being kidnapped by Los Zetas, a renegade battalion of a Mexican military unit initially deployed to combat drug trafficking, which has established a kidnapping ring targeting Central American migrants.

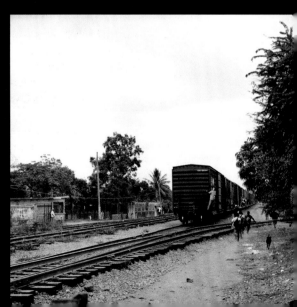

▶ Migrants chase after a northbound freight train in Tierra Blanca, Veracruz. Los Zetas maintain a high presence in Tierra Blanca and Medias Aguas, Veracruz, making it an especially dangerous region for Central American migrants traveling

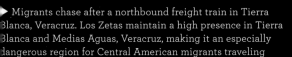

'I am generally a sloppy shooter and my exposures tend to be all over the place, especially when shooting things on the fly. I'm a lot more careful with exposures when I'm shooting medium-format film, though. Each roll only has 12 frames, and changing film is tedious and time-consuming (not to mention expensive). With the Bronica, I use a handheld light meter, even though the camera has a built-in one. Shooting film forces me to slow down and think a lot more before releasing the shutter.

'With my digital cameras I rely on center-weighted metering and a lot of checking the histogram. I generally shoot in manual, regardless of camera, as I feel as though I have more control over my settings that way. If I'm shooting digitally, I shoot Raw, and I like to overexpose a little bit, as most of the digital information lies in the right side of the histogram. So I overexpose slightly, then use the highlight recovery tool to push pixels to the left, thereby preserving the digital information and avoiding digital noise'.

However, despite using a mix of cameras, formats, and mediums, Michelle feels that what a documentary photographer has in their kit bag is of secondary importance. 'Building trust and getting access to subjects is often the most difficult part of being a documentary photographer. It requires a lot of time and patience, and you must be able and willing to step outside of your comfort zone in order to approach individuals whose background might differ dramatically from your own. The physical tools – the gear – are all a matter of preference and, as such, are not terribly relevant. Having a genuine concern, interest, and curiosity about people, and the ability or the willingness to overcome personal discomfort when attempting to build a relationship with the people you photograph are the most salient traits.

'You can have the best idea in the world for the most compelling story, but if the people involved will not allow you to photograph them, then you are stuck. Breaking down barriers and building trust is always the first and most difficult step. After that, there are logistical considerations – how will you physically position yourself where you need to be? When will the best photos happen? Under what kinds of lighting conditions will you be working? I once sat on top of a freight train boxcar in the pouring rain in pitch darkness, hoping to get at least two hours of daylight in order to be able to photograph the migrants with whom I travelled. In the end, I got lucky. The rain stopped and the dawn broke. I made some of the strongest images for the project on that trip, but if the train had arrived before the sun rose, it could have easily been a bust.'.

To see more of Michelle's work – including more of her Destino project – visit her website at www.michellefrankfurterphotos.com.

MICHELLE'S TOP TIPS

- Shoot Raw to maximise the potential of digital capture.
- Master the technical basics of photography, so you fully understand the relationship between shutter speed, aperture, and ISO.
- Be thoughtful in your compositions: Fill the frame, clean up the background.
- Think about depth of field and how you can make it shallow or deep to create a layered image.
- Be bold! Approach people. The worst thing that can happen is they'll say no.

▶ The Mexico border fence, as seen from the Arizona side during a ride-along with U.S. Border Patrol, Yuma Sector.

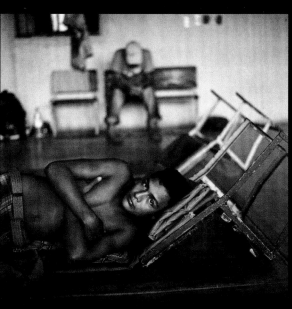

▲ Honduran migrant, Casa de la Misericordia migrant shelter, Arriaga, Chiapas.

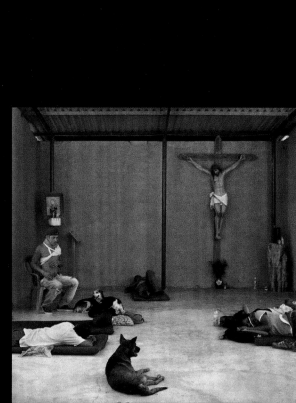

▶ Weary and injured migrants rest in the makeshift chapel of the Hermanos en El Camino migrant shelter in the small town of Ixtepec in the Mexican state of Oaxaca.

Developing Black-and-White Film

If you want to try shooting film and aren't afraid to get your hands dirty, black and white is a great place to start. Not only does it have a genuinely vintage vibe, but developing it yourself is pretty straightforward.

There's something incredibly rewarding about developing your own film, perhaps because it's the ultimate expression of taking control of your photography: Every step of the process – from loading the film through to the finished negatives – is you. Not only is it a great creative exercise, but

it's also a cost-effective one. For a modest outlay on a few key bits of equipment, you can process film after film for very little additional cost. It's not quite as cheap as shooting digital, but it's not going to have you hemorrhaging money, either.

Equipment

To process a black-and-white film, you'll need the following kit, which is widely available both new and used (sometimes at give-away prices as people turn their backs on film).

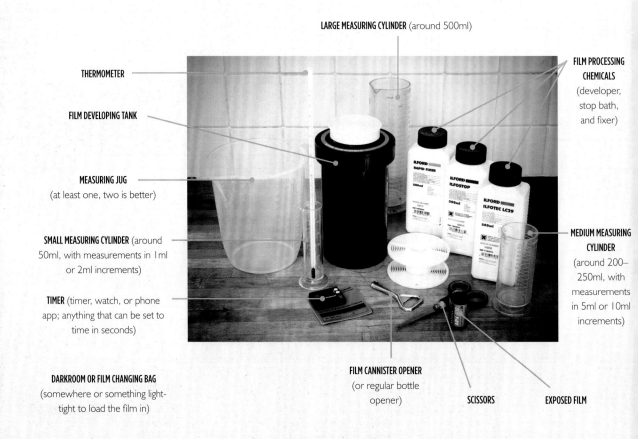

LARGE MEASURING CYLINDER (around 500ml)

THERMOMETER

FILM PROCESSING CHEMICALS (developer, stop bath, and fixer)

FILM DEVELOPING TANK

MEASURING JUG (at least one, two is better)

SMALL MEASURING CYLINDER (around 50ml, with measurements in 1ml or 2ml increments)

MEDIUM MEASURING CYLINDER (around 200–250ml, with measurements in 5ml or 10ml increments)

TIMER (timer, watch, or phone app; anything that can be set to time in seconds)

DARKROOM OR FILM CHANGING BAG (somewhere or something light-tight to load the film in)

FILM CANNISTER OPENER (or regular bottle opener)

SCISSORS

EXPOSED FILM

Loading Your Film

The first stage is loading your film into the developing tank. As the film is still sensitive to light, everything beyond step I must be carried out in complete darkness, whether that means going into a photographic darkroom, using a film changing bag, or simply working under the bed covers at night (it works, trust me). Because you'll be working blind, it is well-worth practicing this stage a few times with the lights on, using a scrap roll of film. Familiarising yourself with the process will really help when you're sitting in the dark trying to load a potentially prize-winning roll of film.

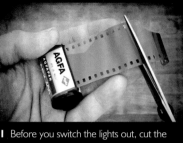

I Before you switch the lights out, cut the end of your film (the leader) so it's square. If your camera automatically winds all the film back into the cassette, don't worry – you can trim it at step 3.

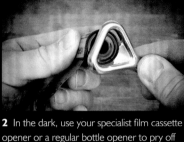

2 In the dark, use your specialist film cassette opener or a regular bottle opener to pry off the flatter end of the film cannister.

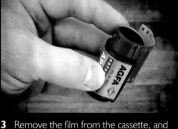

3 Remove the film from the cassette, and set the empty cassette to one side. If you didn't trim the end square at step I, now's the time to do it.

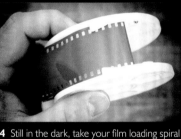

4 Still in the dark, take your film loading spiral and locate the two guide tabs on either side of the spiral. Slide the cut end of your film under these tabs and over the two trapped ball bearings behind them.

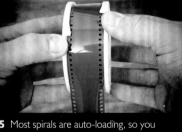

5 Most spirals are auto-loading, so you simply need to rotate ONE side of the spiral forward and back to draw the film onto it. Try not to touch the surface of the film.

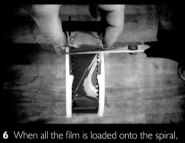

6 When all the film is loaded onto the spiral, cut the film to free it from its central spool.

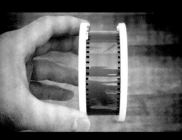

7 Turn the spiral a couple of times more to make sure the end of the film is loaded.

8 Slide the loaded spiral onto the developing tank's central column, and place it in the developing tank.

9 Double check your film is right at the bottom of the column and fit the light-tight lids to the developing tank. From now on, you can work with the lights on.

Preparing Your Chemicals

With your film loaded, it's time to mix your chemicals. For this walkthrough, I'm using a pretty standard three-step process comprising developer, stop bath, and fixer. Some people like to use distilled water to mix their chemicals, and some people use water instead of a stop bath, but it's up to you how you customise your process. Personally, I'm happy using water from the tap and a chemical stop.

I The quantity of chemicals needed to process a film is usually stamped on the bottom of the developing tank. This tank says I need 290ml of chemistry for a 35mm film, which is the minimum amount required for one roll of film: I always round it up to 300ml to make sure I've got enough chemistry in the tank, and also to make the math easier.

2 Fill a large jug with water, adding hot or cold to get it to a temperature of 20°C. Ideally, you want 4–5 times the chemical measurement on the tank (for mixing the other chemicals), so here I'd be looking to set aside 1200–1500ml of 20°C water.

3 Check the dilution for your fixer and work out how much you need. For example, the dilution for this fixer is 1:4, so to make up the 300ml of chemistry I need, I've got to mix 60ml of fixer with 240ml of my 20°C water. Set the mix aside.

4 Next, mix your stop bath. Here, the dilution is 1:19, which means 15ml of stop to 285ml of the 20°C water.

5 Check your water is still at 20°C (adding a bit of hot water if it's cooled slightly) and then mix your developer. In this instance, the dilution is 1:19 – just like the stop bath.

Processing the Film

Now it's time for the fun to start: the actual processing. This essentially involves pouring each of your mixed chemicals into your developing tank in turn, sloshing them around for a certain amount of time, and pouring them out. The key things to watch here are your timings and agitation. The more consistent you are with these, the more consistent your results will be.

1 Set the development time according to the film and developer you are using. There are usually times printed on the developer bottle's label, or you can find them online (see above).

2 Pour the developer into your tank and start the timer. The main thing now is to agitate your tank regularly and consistently.

3 Agitation simply means gently inverting your tank to get fresh chemistry onto the film inside. Usually this is done for 10 seconds (or 3 inversions) every minute during development.

4 Just before the time is up, start to pour out the developer. Have it out when the timer hits 0 and then add the stop bath. Stopping is a brief stage (~2 minutes), but you should agitate the tank again.

5 When the time's up, pour out the stop and pour in the fixer. Fixing the film is typically done for 10 minutes or more (check the fixer bottle for times), and you should always ensure that you fix your film for the recommended time.

6 After you've fixed your film, you need to wash it thoroughly. The easiest option here is to put your developing tank under a tap and let the water run – I use a special hose that came with the used developing kit I bought, but it's not essential. The main thing is you wash your film thoroughly.

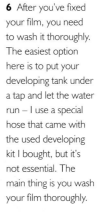

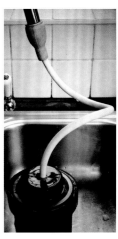

Drying the Film

Once your film has been washed, it's time to take it out of the developing tank, see what you've got, and hang the negatives up to dry.

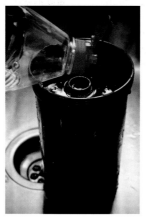

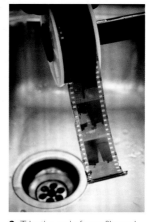

I Before you pour out your wash water, you might want to add a drop of wetting agent. This releases the surface tension on the film, helping it to dry without any watermarks. A cheap alternative to photographic wetting agent is dish soap: Add a couple of drops and stir the water gently before lifting your film out by the central column.

2 Take the end of your film and carefully start to pull it from the spiral. This is the moment where you see if you've got any shots on the film, or if something's gone horrible wrong.

3 Once your film is off the spiral, hold it at one end, hanging down. Place your index and middle finger either side of the film and slide them gently from top to bottom to remove the excess water. You can also buy a specialist film squeegee for this, but these tend to pick up dust and dirt that will subsequently scratch your delicate wet film.

4 Finally, hang your film up to dry. Again, you can buy special film clips for this, but I simply hang my film from a clothes hanger hooked over a shower rail, with a metal stationary clip at the bottom to weigh it down.

5 Once it's dry, your film can be cut into strips and slid into protective negative filing sheets. I like to use clear sheets to file my negatives, simply so I can see at a glance what's on them.

What Next?

What you do with your negatives after you've developed them is entirely up to you. If you've got the time, inclination, and access to the facilities, there's no reason why you can't head into a wet darkroom and make silver prints on photographic paper. This takes the idea of creating a photograph to its logical conclusion; and there's a huge amount of satisfaction to be had in stepping into the light clutching a beautiful, hand-crafted, one-of-a-kind print. A more common approach, though, is to take the processed negatives into the digital realm for finishing and printing. Once you've scanned them in, your black-and-white images can be treated like any other digital photograph. Dodging, burning, exposure, contrast, and all the other things we looked at in the previous chapter can come into play, enabling you to tweak and tune your shots in your image-editing software with much greater control than the traditional darkroom can offer. From there you can output your images using any one of a number of printing technologies, ranging from desktop inkjet photo printers to professional digital enlargers that will print your photograph onto traditional photographic paper, effectively returning it to the wet darkroom.

No Scanner?

If you've got a digital camera with some sort of macro or close-up function (ideally a DSLR or CSC with a macro lens) you don't need a scanner. Instead, you can digitise your black-and-white negative by photographing them. Sure, it's not the quickest or most sophisticated solution, but it has the potential to give you a decent digital file from your film-based original.

1 The first thing to do is to make yourself a film holder: two pieces of card with windows in them and a taped hinge is all you need.

2 Load a negative into your film holder and use a piece of tape to hold it shut.

3 Tape your film holder to a window, ideally so you're looking out to a bright background. The sky or a distant white wall is perfect.

4 Set up your camera on a tripod, in front of your mounted negative. Set the focus and exposure, and shoot!

5 Download your image to your computer, open it in your image-editing software, crop it, and invert it to change it from a negative to a positive. You can now carry on editing it as you would any other image (right).

Camera Handling

It doesn't matter if you're shooting film or using a digital camera: If you want to prevent camera shake, you need to hold your camera steady.

There are generally two ways of shooting: With your camera in your hand, or with it mounted on a tripod (or some other type of support). Which you use will depend on your style of shooting and preferred subject – a tripod is useless for most types of street photography, for example, but almost essential for the majority of close-up subjects. Let's explore the options.

Tripods

Choosing a tripod will involve finding a happy compromise between its weight, height, and price. However, as with lenses, my advice is not to be too cheap here: A decent tripod should easily outlast your camera. (I've still got my first tripod, which is over 20 years old and still going strong!) Here's an idea of what to look for:

TRIPOD HEADS

The two most widely used tripod heads are ball-and-socket (above) and pan-and-tilt (below). Ball-and-socket heads have a single locking knob that locks the head in place or releases it, allowing the camera to be twisted and turned freely in any direction. By comparison, pan-and-tilt heads have locking levers for each axis. This makes it easier to make specific adjustments, but also slower to set up. Because they are so different, it pays to get hands on with both before making a choice, although in both instances, a model with a quick-release plate makes it quicker to set up.

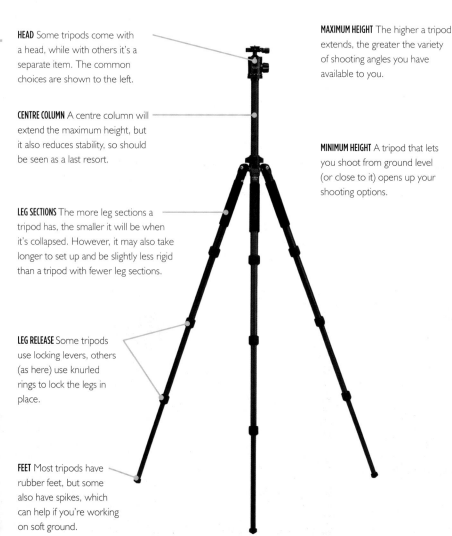

HEAD Some tripods come with a head, while with others it's a separate item. The common choices are shown to the left.

CENTRE COLUMN A centre column will extend the maximum height, but it also reduces stability, so should be seen as a last resort.

LEG SECTIONS The more leg sections a tripod has, the smaller it will be when it's collapsed. However, it may also take longer to set up and be slightly less rigid than a tripod with fewer leg sections.

LEG RELEASE Some tripods use locking levers, others (as here) use knurled rings to lock the legs in place.

FEET Most tripods have rubber feet, but some also have spikes, which can help if you're working on soft ground.

MAXIMUM HEIGHT The higher a tripod extends, the greater the variety of shooting angles you have available to you.

MINIMUM HEIGHT A tripod that lets you shoot from ground level (or close to it) opens up your shooting options.

BELOW LEFT Monopods are popular with sports photographers shooting from the sidelines with heavy lenses, but tend not to be used as prolifically elsewhere.

BELOW RIGHT Keeping your elbows tucked in, using your camera's eye-level viewfinder, and supporting the camera (and lens) with both hands will all help you avoid camera shake when you're shooting handheld.

Other Options

Tripods aren't the only option available to you: Other support methods may suit your shooting style better.

MONOPOD

A monopod will help support your camera, but the one-legged design is never going to be as stable as a tripod. It is better than handholding your camera, though, and always allows you to shoot more quickly.

BEANBAG

A beanbag is great if you've got something to rest it on, as it will hold a camera very steady and also offer a certain amount of protection to its underside. Wildlife photographers sometimes use them to shoot from vehicles, resting the 'bag on an open window ledge. In a pinch, a bag of rice can be used to achieve the same thing.

IMPROMPTU SUPPORTS

Walls, fences, railings, benches – there are countless solid surfaces that you can rest your camera on or lean against for support. This is particularly useful if you're shooting in low-light conditions and want to combine handholding the camera with a low ISO and a slow shutter speed.

Handholding

If you're handholding your camera, there are plenty of things you can do to help minimise the risk of camera shake:

- If your camera or lens has some sort of anti-shake technology, make sure it's activated.
- Set the fastest shutter speed you can. At the very least, this should be the reciprocal of the effective focal length (so 1/100 second with a 100mm effective focal length, 00 second with a 200mm EFL, and so on). This can be extended if anti-shake is being used.
- Hold your camera in both hands and keep your elbows tucked in. Support the lens if it's big and heavy.
- Stand with your feet shoulder-width apart, or put one knee on the ground to shoot from a low angle; don't just bend or crouch.
- Use the camera's eye-level viewfinder (if it has one) rather than the rear LCD screen.
- Don't hold your breath while you shoot.
- Press the shutter-release button down gently (rather than stabbing at it).
- Stop! It's surprising how many people think they can carry on walking while they take a picture.

Camera Care

If you've spent a lot of money on your camera and lenses, it makes sense to look after them. Not only will it mean your equipent will have the best possible resale value if you ever decide to part with it, but it will also ensure that the photographs you take with it look their best.

At its most basic, looking after your camera is about keeping it clean, which means removing any dirt, dust, or grime from the outside of the body and lenses. It's also important to keep the glass elements on your lenses as blemish-free as possible, because dust, fingerprints, and other marks can degrade the quality of the image reaching the sensor, creating patches of soft focus or increasing the risk of flare. A lens cloth and some cleaning fluid is my preferred choice here, but you can also avoid a lot of problems simply by fitting lens caps (front and rear) when your lenses aren't in use.

The other area that sometimes needs cleaning is the sensor, and there are two options here. With a little caution, it's relatively easy to do it yourself (as outlined opposite), but there is a risk involved – after all, you are physically touching the delicate filter in front of your camera's sensor. So, my advice is simple: If you have any doubts about doing it yourself, take it to your local photo store or service centre and pay a professional to do it for you.

General Camera Cleaning Kit

Some or all of the items shown below should form your basic cleaning kit.

COMPRESSED AIR: Good for general kit cleaning. Useful for camera bodies, lens barrels, and accessories, but do not use on camera sensors.

LIPSTICK BRUSH: Good for brushing dust off the outside of cameras, lenses, and accessories.

BLOWER BRUSH: Useful for removing dust from the outside of cameras, lens barrels, and accessories. With the brush removed, the blower can also be used to blow dust from sensors and glass lens elements.

LENS CLEANING FLUID: Used with a lens cloth (below) to remove fingerprints and other marks from the front and rear lens elements.

LENS CLOTH: Used with cleaning fluid to remove more stubborn marks, such as fingerprints, from glass lens elements.

LENSPEN: Has a retractable brush at one end to remove dust from the lens barrel and a specially coated tip at the other, which is designed to clean the front and rear glass lens elements.

ABOVE This basic sensor-cleaning kit contains everything you need to wet clean your camera's sensor yourself. Just make sure the swabs you buy are the right size and follow any instructions carefully.

Sensor Cleaning

It's not just the outside of your camera that needs to be kept clean – the inside will sometimes need attention as well. A lot of cameras have built-in sensor cleaning that vibrates the anti-aliasing filter to literally shake the dust away. These systems generally work well, but you can also help to keep your sensor free from dust simply by taking care when, where, and how often you change lenses.

However, assuming you do change lenses, it's almost inevitable that dust will eventually appear on the sensor, revealing itself as dark, out-of-focus spots on your images. When this happens (and assuming your in-camera cleaning doesn't deal with it) the only option is to clean the sensor manually. Thankfully, this is relatively easy to do, although it's important that you work carefully and follow the instructions that come with your cleaning kit.

1 You know there's dust on your sensor when you start to see dark marks in your images. These will be most noticeable in light, detail-free areas, such as a bright sky.

2 The first thing to do before you clean your sensor is to make sure your camera's battery is fully charged.

SETUP MENU
Format memory card
LCD brightness
Clean image sensor
Lock mirror up for cleaning
Video mode
HDMI
World time

3 Most cameras have a manual sensor cleaning menu option, which will expose the sensor so you can get to it.

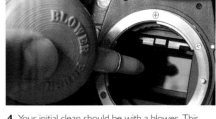

4 Your initial clean should be with a blower. This may be enough to dislodge any dust (take a shot of the sky to check if it's gone or not).

5 If the dirt is more stubborn, the sensor will need a wet clean. When it comes to wet cleaning, you need to follow the instructions that came with your cleaning kit, but the initial step is usually to add one drop of cleaning fluid to a swab, and wipe it once across the sensor.

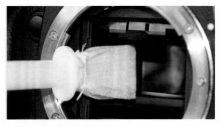

6 Then, turn the swab around so you're using the other side of it. Add another drop of cleaning fluid and wipe the sensor a second time: This should be enough to ensure it's spotless.

Reference

GLOSSARY

AEB (Automatic Exposure Bracketing)

Automated process where a number of shots (usually 3–7) are taken at different exposure settings. This is usually done under challenging lighting situations to ensure at least one exposure in the sequence is correct, or to create exposure sequences for HDR image blending.

AE-L (Automatic Exposure Lock)

A feature found on most cameras that enables you to lock the exposure, usually before reframing a shot. Can typically be achieved using a dedicated button or by pressing (and holding) the shutter-release button down halfway.

AF (Autofocus)

The camera moves elements within the lens to bring the scene (or part of the scene) into focus on the sensor. Once a slow and noisy process, autofocus (AF) is now the primary focusing method for most people, thanks to fast focusing motors and accurate AF sensors.

AF-L (Automatic Focus Lock)

Similar to Automatic Exposure Lock, but locks focus, rather than exposure. Again, you would typically do this before reframing a shot, either by using a dedicated button, or by pressing (and holding) the shutter-release button down halfway. AF-L and AE-L are often locked at the same time, so you may need to explore your camera's menu if you want or need to 'unlink' them.

Angle of View

The amount of a scene that a lens can 'see' and record to your sensor. Wide-angle focal lengths have a wide angle of view, so project more of the scene onto your sensor, while telephoto focal lengths have a narrower angle of view, effectively magnifying a smaller part of the scene you are photographing.

Anti-Shake

A prevalent technology used to counter camera shake. There are currently two options used by camera manufacturers: sensor-shift stabilisation and lens-based stabilisation. Each has its advantages and disadvantages, but both are better than no stabilisation when you're shooting handheld and the light level is low or the shutter speed is slow.

Aperture

A 'hole' within a lens that regulates the amount of light that can pass through. The aperture is usually variable, enabling you to let more or less light through the lens. The aperture also plays a fundamental role in determining depth of field.

Aperture Priority

A shooting mode where you select the aperture you want to use (usually to control depth of field), and the camera selects what it feels is the best shutter speed to give the 'correct' exposure.

APS (Advanced Photo System)

A short-lived film format that appeared in the mid 1990s and was discontinued just over a decade later. However, the name reemerged in reference to digital cameras with sensors that are broadly comparable in size to the APS-C film format (25.1 × 16.7 mm) and, less commonly, the APS-H format (30.2 × 16.7 mm)

Artifact

In photography, an 'artifact' is any unwanted element in an image, such as noise, chromatic aberration, vignetting, JPEG compression artifacts, and so on.

AWB (Auto White Balance)

In-camera white balance system that assesses the scene being photographed and automatically attempts to neutralise any colour cast.

Backlighting

Lighting coming from behind the subject, so directly toward the camera. Backlighting is ideal for creating silhouettes, but if you want detail in your subject you will either need to use a reflector or fill-flash, or increases the exposure (resulting in a vastly overexposed background).

Barrel Distortion

A type of optical distortion where lines in an image appear to bow outward at the centre, toward the edges of the frame (like the bulging sides of a barrel, hence the name).

Bracketing

Usually applies to exposure (see *Automatic Exposure Bracketing*), but many DSLRs and CSCs also allow you to bracket the white balance.

Bounce Flash

The technique of aiming a flash upward, toward a ceiling or reflector, so the light 'bounces' off it before reaching the subject. This effectively makes the light source larger, and therefore more diffuse. A flash with a swivel head will also let you bounce the light from the side – off a wall, for example – so it is slightly more directional.

Brightness

The intensity of light in an image.

Centre-Weighted Metering

An exposure metering pattern that reads the light from the entire image area, but biases the exposure toward the centre of the frame. Useful for photographing central subjects surrounded by a very light or very dark background.

Chromatic Aberration

An artifact in an image caused when different wavelength of light focus at slightly different points, creating a disparity in the relative focused images' size. This appears visually as a coloured fringe, typically along contrasting edges.

Clipping: When highlights in a photo become pure white or shadows become pure black they contain no detail. At this point they are said to be 'clipped'.

CMYK (Cyan, Yellow, Magenta, Key)

Cyan, Magenta, and Yellow are the three primary colours used in printing. The fourth colour – 'Key' – is Black, which is added because combining CMY doesn't deliver a true black.

Colour Cast

When an image has an overall colour tint, typically caused by an incorrect white balance setting, it is said to have a 'colour cast'. This is generally what your camera's white balance is designed to correct, although it can also be used intentionally to colour an image.

Colour Temperature

Light has a 'temperature', which is measured using the Kelvin (K) scale. The lower the temperature, the warmer (more orange) the light is. For example, daylight nominally sits at 5500K; incandescent (tungsten) light is warmer at around 3300K; and open shade is cooler, at approximately 8000K. Other lighting conditions will typically fall somewhere in the range 2000–10,000K.

Contrast

The range between the brightest and darkest points in an image. If the range is high, the image is 'high contrast'; if the range is low, the image is 'low contrast'.

Contrast-Detection AF

An autofocus system that uses subject contrast to set the focus point. This is typically used by DSLRs in Live View mode and with most (not all) CSCs and other mirrorless cameras.

Crop Factor

Value applied to the focal length of a lens to give its 'effective' focal length on a camera with a sub-full-frame sensor. For example, cameras with an APS-C-sized sensor have a crop factor of 1.5x or 1.6x. Crop factor is also referred to as *focal length magnification*.

CSC (Compact System Camera)

Interchangeable-lens camera design that doesn't have the same mirror and pentaprism as an SLR camera. Also referred to as *mirrorless* cameras, although this designation can also include bridge, compact, and other fixed-lens camera designs.

Depth of Field

The area of an image in front of, and behind, the point of focus that also appears acceptably sharp. Depth of field is determined by aperture, camera-to-subject distance, focal length, and sensor size.

Developer
Chemical solution used in film processing to reveal the latent image recorded on the exposed film.

Diffuser
An item that scatters light particles, making the light appear softer. Diffusers can range from manmade accessories to natural phenomenon, such as clouds.

dpi (Dots Per Inch)
Used to measure print resolution in terms of the number of dots (of ink) per linear inch of the print. The higher the dpi, the finer the print will be. Not to be confused with *ppi*.

DSLR (Digital Single Lens Reflex)
Interchangeable-lens digital camera design that uses mirrors and a prism to provide a direct view through the lens of the camera.

Dynamic Range
The range from bright to dark that a camera can record detail in, usually measured in stops. When the dynamic range of a scene is greater than the dynamic range of the camera, the shadows or highlights will be clipped.

EFL (Effective Focal Length)
Used to describe the angle of view of a lens when it is used on a camera that has a sensor smaller than full frame. The EFL is determined by multiply the focal length of the lens by the camera's crop factor.

EV (Exposure Value)
A single number given to various permutations of aperture, shutter speed, and ISO that combine to deliver the same exposure overall. Can also be used as an indicator of subject luminance. Knowing the EV of the subject, can give you an idea of the exposure settings required.

Evaluative Metering
Proprietary multi-area metering pattern used by Canon.

EVF (Electronic Viewfinder)
An eye-level viewfinder that uses a small digital display to compose images, rather than an optical viewfinder. EVFs are commonly used by CSCs and other mirrorless cameras. One advantage of an EVF is that is can emulate exposure, colour, and other camera adjustments, providing you with a more accurate preview of the photograph; downsides include lower resolution than an optical viewfinder and a greater drain on the camera's battery.

Exposure
To make an exposure is to allow light to reach the sensor in your camera. How much light you expose the sensor to, and how long you expose it for, is the cornerstone of photography. However, don't get sucked into thinking there's such a thing as the 'correct exposure' – the right exposure is simply the one that matches your vision.

Exposure Compensation
A camera function that allows you to adjust the exposure recommended by the camera, either because you know your picture-taking box has got it wrong, or you simply want a lighter or darker look. Use positive (+) exposure compensation to make images lighter; negative (-) exposure compensation to make them darker.

Exposure Metering
The act of measuring the light to determine the most appropriate exposure.

f/stop (also f/number)
Used to denote the size of the aperture in a lens (f/2.8, f/4, f/5.6, and so on), as a fraction of the focal length.

Fill Flash
A technique that mixes flash with the available ('ambient') light. Fill flash can be subtle (to lift shadows on a face, for example), or more obvious (to create a 'day for night' look).

Filter
1) Coloured or coated glass or plastic that's used in front of the lens to modify the light passing through it.
2) A tool in an image-editing program designed to replicate the effect of a lens filter, or process the image in a particular way.

Fixer
Chemical solution used in film processing to make the developed image permanent. Usually the last step of the development process, and one of the most important; a film that has been insufficiently fixed will darken if exposed to light, to the point that all images are lost.

Flash
One of the most commonly used forms of artificial photographic lighting. A charge is fired into a sealed tube of gas, resulting in a brief, bright burst of light.

Fluorescent
A continuous lighting technology that was widely discounted for film photography, due to the usually green colour cast it produced. However, in-camera white balance has now made it a viable cool-running light source.

Focal length: Technically, the distance between the optical centre of a lens and the focal point (sensor) when the subject is focused at infinity. However, in the real world it indicates the viewing angle of a lens: the shorter the focal length (18mm and 21mm, for example), the wider the viewing angle; the longer the focal length (150mm and 200mm, for example) the narrower the viewing angle.

Focal Plane

The plane at which the image passing through the lens is formed. For obvious reasons this coincides with the position of the surface of the film or sensor in the camera (and is indicated by the ⊖ symbol).

Focus Point

The point at which the light passing through the lens is brought together to create a 'sharp' image.

Full Auto

Shooting mode whereby the camera takes care of most (if not all) decisions, including exposure, colour, and so on.

Full Frame

Digital sensor format that is the same size as a 35mm film frame (36 x 24mm).

Grain

An artifact found in photographs taken on film, created by the light-sensitive silver halide crystals used to record the image: the larger the crystals, the more sensitive the film (higher ISO), and the grainier the image.

Grey Card

A card that is the same tone as the 18% grey that a camera's exposure meter is calibrated for. Can be used for taking accurate spot meter readings and setting white balance.

Greyscale

An image comprised solely of shades of grey; more commonly referred to as black and white, or monochrome.

HDRI (High Dynamic Range Imaging)

A photographic technique that combines multiple shots taken at different exposure settings to accommodate the dynamic range of a high-contrast scene.

High Key

A photograph that is comprised primarily of light tones, with few (if any) dark shadows.

Highlight

The brightest part of a scene or image.

Histogram

A graph showing how the tones in an image are distributed. Useful for gauging exposures in-camera, as it is more reliable than the rear LCD screen, which can be affected by the ambient light (the rear screen will look brighter in low light conditions and darker in bright conditions).

HMI (Hydrargyrum Medium-arc Iodide)

Cool-running, daylight-balanced, flicker-free, continuous light source. Widely used in the movie industry and also used in some photographic applications.

Hotshoe

An electronic flash connection found on top of most DSLR cameras and many mirrorless cameras (with the exception of some older Sony cameras). A main contact on the hotshoe is used to trigger the flash (this is common to all cameras), while additional contacts are used for proprietary ('dedicated') features, such as automatic flash control.

Hue

Essentially, hue refers to how red, how green, how blue, and so on, a colour is.

Incident Light Reading

A light reading method that measures the light falling onto the subject or scene. Has the advantage of being uninfluenced by the brightness or darkness of the subject itself.

ISO (International Standards Organisation)

A throwback to film, which has an ISO speed to indicate the sensitivity of the emulsion to light. Today, ISO is also used to give a comparable 'sensitivity' indication for a digital sensor.

JPEG (Joint Photographic Experts Group)

A file type that processes the image in-camera, then compresses the image data to make file sizes smaller. To achieve this, some of the data is discarded permanently: at low compression/high quality settings this may not be noticed, but artifacts can start to appear in images that have been heavily compressed (or opened and resaved/recompressed repeatedly).

Kelvin (K)

The unit used to measure colour temperature, named after William Lord Kelvin.

Large Format

In film photography, 'large format' refers to a film format based on cameras that use sheet film of 5 x 4 inches and larger, rather than rolls of film.

Layers

A feature of most image-editing programs that allows individual elements to be isolated and treated separately to the rest of the image, or enables editable adjustments to be made to the image as a whole.

LCD (Liquid Crystal Display)

The standard technology used for the rear screens on digital cameras and electronic viewfinders.

LED (Light Emitting Diode)

Core technology used by many video lights and an increasing number of photographic lamps. Has the advantages of low-power consumption and bright light output; the colour temperature can also be adjusted on some units.

Lens Flare

A type of artifact caused when non-image-forming light passes through the lens, usually resulting in an overall veiling of the image or distinct, coloured polygons appearing in the image.

Levels

Image-editing tool that is widely used to control the black and white points in an image, as well as its overall brightness.

Light Meter

A tool that measures the intensity of the light in a scene (or part of a scene) to help gauge the exposure required. Light meters are either built in to the camera, or a separate, handheld unit.

Live View

DSLR camera feature that allows images to be viewed and composed on the rear LCD screen. Once a rarity, every DSLR now has Live View.

Lossless Compression

A method of compressing digital image files that does not result in the loss of any data; Raw and TIFF files can have lossless compression applied.

Lossy Compression

A method of compressing digital image files that reduces the file size by discarding a certain amount of data; JPEGs use lossy compression.

Low Key

An image comprised primarily of mid– to–dark tones, with few (if any) highlights. The opposite of *High Key*.

Macro

Strictly speaking, any image at a reproduction ratio of 1:1 ('life size') or greater.

Macro Lens

A lens capable of shooting macro (1:1) images. Sometimes used more loosely to refer to lenses with more modest close-up capabilities.

Manual Mode

Shooting mode where you set the aperture, shutter speed, and ISO. Gives you absolute exposure control (and no one but yourself to blame if it's wrong).

Matrix Metering

Proprietary multi-area metering pattern used by Nikon.

Medium Format

A film format based on roll film; modern medium format cameras use 120 (and sometimes 220) film with a width of approximately 60mm. In digital photography, medium format refers to a camera with a comparable sensor size.

Megapixel

One million pixels are described as 'one megapixel'.

MF (Manual Focus)

To focus the lens, you turn it by hand. It may seem like an old-fashioned approach, but in some situations MF can be quicker and more accurate than using AF.

Mirrorless camera

Any camera that doesn't use mirrors and a prism in the viewing system, such as CSCs, bridge cameras, and compacts.

Monochrome

An image made up of various shades of a single colour; often used interchangeable with black and white, but monochrome images can include toned photographs, such as sepia or cyanotype.

Multi-Area Metering

An exposure metering system that divides the scene to be photographed into multiple areas or segments that are measured individually. The results are then averaged out to determine the overall exposure.

NFC (Near Field Communication)

A wireless technology that's being seen increasingly in digital cameras as a means of wirelessly transferring images.

Noise

Non-image-forming artifacts that appear in an image at high ISO settings and/or when long exposures are made. There are two types of noise – chroma noise, which appears as red, green, and blue coloured speckles in an image, and luminosity noise, which appears as an underlying 'gritty' texture.

Noise Reduction

In-camera or software-based process designed to counter the effects of noise. There will typically be separate options to deal with noise caused by high ISO and long exposures, but both need to be treated with care – set at an overly aggressive level they can start to remove detail from images, as well as the noise.

Overexposure

When an image is brighter than you want, either because the aperture is to wide, the shutter speed is too long, and/or the ISO is too high. Deliberate overexposure can create a 'light and airy' look to your images.

OVF (Optical Viewfinder)

The eye-level viewfinder used by SLR cameras to view the image projected by the lens.

Panoramic

An elongated image format that gives a long, thin image. Commonly used for landscape photography when you want to record a sweeping vista without an excessive amount of sky or foreground. 'Stitched panoramas' use multiple exposures to create high-resolution panoramic images.

Phase-Detection AF

An autofocus technology that creates a pair of images from the light passing through the lens and compares them using dedicated AF sensors to determine focus. The main advantage is focusing speed; this system is used in DSLRs (and an increasing number of CSCs).

Picture style

Also known as Picture Controls, Creative Styles, Picture Modes, and Custom images, depending on the make of your camera, these are preset options that offer a selection of colour effects, from bold and vivid, to subtle and less saturated. Only applicable if you shoot JPEGs – the Picture style of a Raw file can be changed or removed when you process the file.

Pincushion Distortion

An optical distortion whereby the image appears to be 'sucked' toward the centre, resulting in lines toward the edges of the frame bowing inward.

Pixel

The smallest building block of a digital image, short for 'picture element'.

ppi (Pixels Per Inch)

A measure of an image's resolution in terms of how many pixels appear per linear inch: the greater the number of pixels, the higher the resolution.

Prime Lens

A lens with a single, fixed focal length. Although they are now widely overlooked in favor of zoom lenses, prime lenses have several benefits, such as wider maximum apertures, light weight, lower cost, superior image quality (sometimes), and better ergonomics for focusing manually.

Program mode

A shooting mode where the camera sets the aperture and shutter speed, but you have the option of adjusting the paired settings if, for example, you want to use a faster shutter speed or smaller aperture than the camera suggests. Program is a great way of exploring the basic relationship between aperture and depth of field and shutter speed and movement, while still letting the camera control the overall exposure.

Raw

A file type that consists of the 'raw', unprocessed data captured by the sensor. This makes it the 'purist' (and potentially highest quality) image a camera can record, although an additional processing stage is needed when the images are downloaded to your computer.

Red-Eye

A phenomenon caused when the light from a flash enters a person's eye, and reflects off their retina when a photograph is taken. The result is the once-black pupil becomes red, due to the light bouncing off blood vessels at the back of the eye. Typically caused when a flash is in close proximity to the lens, and is aimed directly at the subject (who in turn is looking straight back down the lens).

Red-Eye Reduction

A flash function that uses a pre-flash (or dedicated lamp) to make the subject's pupils contract, thus reducing the amount of light that can pass through the eye, strike the retina, and cause red-eye.

Reflected Light Reading

A light reading method that measures the light reflected from the subject or scene, as used by in-camera light meters. Has the advantage of letting you take light readings from various parts of a distant scene, but can be influenced into under- or overexposing by especially bright or dark scenes or subjects.

Reflector

A (usually portable) surface that's used to reflect light back onto the subject, either to fill in shadows or simply lift the exposure. The most commonly used reflector is white, but silver, gold, and even black all have their uses, as do other coloured reflectors.

Resolution

The number of pixels on the camera's sensor: the more pixels, the higher the camera's resolution.

RGB (Red, Green, Blue)

The additive colour primaries of light, and the foundation for all digital images.

Saturation

The intensity of a colour.

Sensor

The light-sensitive imaging chip inside a digital camera, where an image is first formed.

Softbox

A widely used lighting accessory for studio strobes and portable flash, which diffuses the light passing through it.

Shadows

The darkest parts of a scene.

Sharpening

In image editing, the process of increasing the contrast along edges to give the impression of improved sharpness.

Shutter

The mechanical (or electronic) device in a camera that opens to allow light to reach the sensor, and closes to end the exposure.

Shutter Priority

The opposite of Aperture Priority. In this shooting mode, you select the shutter speed you want to use (typically because you want to freeze or exaggerate movement in an image), and the camera selects what it feels is the best aperture to give the 'correct' exposure.

Shutter Speed

The time the shutter is open, exposing the sensor to light.

SLR (Single Lens Reflex)

Camera design that uses mirrors and a prism to provide a direct view through the lens of the camera to an optical, eye-level viewfinder.

Spot Metering

A metering pattern that takes a light reading from a very small part of a scene or subject; sometimes as little as 1%. This allows great accuracy, but it is easy to get the exposure wrong if you don't take your reading from a midtone area.

Stops

One stop is equal to the doubling or halving of light in an exposure, whether that's achieved using the aperture, shutter speed, or ISO.

Stop Bath

A chemical used in black-and-white film processing to rapidly halt the development process. Can be replaced with a plain water wash.

Sync Speed

The fastest shutter speed at which the sensor (or film) is exposed to light in its entirety, enabling it to be exposed by flash. At faster speeds, the film or sensor is exposed by a fast-moving 'slit' of light, so flash will only expose part of the frame. Only applies to cameras with a focal plane shutter: cameras with a leaf shutter (typically medium- and large-format cameras) can sync with flash at all shutter speeds.

Telephoto Lens

A lens with a narrow angle of view, which effectively magnifies the subject being photographed.

TIFF (Tagged Image File Format)

A lossless film format that records a value for each and every pixel in an image. TIFF used to be a third in-camera file format (alongside JPEG and Raw), but due to the high resolution of modern cameras; the large file sizes TIFF creates; and the time it takes to write a TIFF to a memory card, it is no longer a viable in-camera option. However, TIFF is still widely used as a high-quality file format for archiving digital images.

TTL (Through The Lens)

Any camera system or function based on the light passing through the lens, including exposure metering, white balance, and so on.

Tungsten

A continuous lighting technology originally used in the movie industry. Although it was once a useful alternative to flash, the warm colour temperature makes it difficult to mix with daylight, while the heat generated by the lamps can quickly become unbearable in a small studio. Now widely replaced by fluorescent and (increasingly) LED lighting technologies.

Underexposure

When an image is darker than you want, either because the aperture is to small, the shutter speed is too fast, and/or the ISO is too low. Deliberate underexposure can create a 'dark and moody' look to your images.

Vignetting

An artifact typified by darkening at the corners of the frame. More common with wide-angle focal lengths than telephoto focal lengths.

White Balance

Tool used to adjust the colour response of the sensor to match the colour temperature of the light, thereby ensuring that 'white is white'. It can also be used to intentionally introduce colour shifts into your images. More important when you shoot JPEG files, as the white balance can be changed easily when you shoot Raw.

Wide-Angle Lens

A lens with a wide angle of view, which allows it to 'get more in'.

Zoom Lens

A lens that covers a range of focal lengths. The main advantage is that you don't need to change lenses to change your angle of view.

PICTURE CREDITS

Masterclasses

Landscape: David Taylor www.davidtaylorphotography.co.uk
Portrait: Ben Anker www.benankerphotography.co.uk
Sports: Ian MacNicol www.ianmacnicol.com
Interiors: Adrian Wilson www.interiorphotography.net
Food: Stuart Ovenden www.stuartovenden.com
Still Life: Daniel Brooke www.danielbrooke.com & www.danielbrookephotography.com
Fashion: Dixie Dixon www.dixiedixon.com
Street: Brian Lloyd Duckett www.streetsnappers.com
Macro: Andy Small www.andysmall.co.uk
Wildlife: Richard Garvey-Williams www.richardgarveywilliams.com
Architecture: Janie Airey / Airey Spaces www.aireyspaces.com
Abstract: Ryan Bush www.ryanbushphotography.com
Retouching: Miss Aniela www.missaniela.com
Documentary: Michelle Frankfurter www.michellefrankfurterphotos.com

INDEX

acknowledgements

First off, I'd like to thank Adam & Frank at Ilex for giving me the opportunity to write this book.

I'd also like to thank the exemplary photographers who agreed to share a Masterclass with me, and would encourage you to check out their websites to see more of their work – I've only been able to show the tip of their respective photographic icebergs here.

And, as always, I'm indebted to N for keeping the home fires burning when I was writing into the night, and to T and GM for dragging me out of bed in the morning to get me started again.

Finally, it's hello to the 'new boy', H. You can't read this yet, but you spent the first months of your life watching this come together (and distracting me from actually doing it...).

And finally, finally, a 'thank you' to you as well, for taking the time to buy or borrow a copy and read this far. It's always great to hear from the people who take the time to read my words, so feel free to drop me a line via www.cgphoto.co.uk to say 'hi'.

Cheers!